1,00

JOAN MIRÓ

THE DOCUMENTS OF TWENTIETH CENTURY ART
General editors, Robert Motherwell & Jack Flam

Other titles in the series by G.K. Hall & Co.:

JOAN MIRÓ

Selected Writings and
Interviews

Edited by Margit Rowell

Translations from the French by Paul Auster
Translations from the Spanish and Catalan
by Patricia Mathews

G.K. Hall & Co.
Boston 1986

Twayne Publishers, a division of
G. K. Hall & Co.
70 Lincoln Street
Boston, Massachusetts 02111

89 88 87 86 / 4 3 2 1

Miró, Joan, 1893–1983
 Joan Miró: selected writings and interviews.

 (The Documents of twentieth century art)
 Bibliography.
 Includes index.
 1. Miró, Joan, 1893–1983—Correspondence. 2. Artists—Spain—Correspondence.
3. Miró, Joan, 1893–1983—Interviews. 4. Artists—Spain—Interviews. 5. Miró, Joan, 1893–
1983—Literary art. I. Rowell, Margit. II. Title. III. Series: Documents of twentieth century
art (G.K. Hall & Co)
N7113.M54A3 1986 709'.2'4 86-7652
ISBN 0-8057-9956-7

Designed and produced by Carole Rollins.
Copyedited by Cecile Watters under the supervision of Michael Sims.
Set in 10.5/13 Janson by r/tsi typographic co., inc.

Contents

Illustrations

Preface

This book was conceived in 1981 while Joan Miró was still alive. When I first proposed to publish a collection of his writings, Miró was dubious. He wondered if they were interesting enough because, as he said, "I rarely speak about what is really going on inside me." But then he warmed to the idea, mentioning poems and letters that he considered "important." Nonetheless, he set one condition. He wanted the book to be absolutely faithful to the original writings. "Authentic," he said to me on June 22, 1981, in Barcelona. "No manipulation."

These then have been the guidelines for the selection and editing of the following texts. The objective was to let Miró speak, with his voice, his accents, his ideas. The result is not so much an art history book as a portrait of the artist in his own words. And, as in Miró's paintings, the artist's approach is sometimes meticulously detailed, sometimes fanciful, irruptive, but always a vivid weaving together of life and art.

The writings have been divided into seven chronological sections determined by the places Miró lived and worked. The texts may be divided into essentially three categories. There are the published interviews and statements, which have been chosen selectively with an eye for avoiding repetition and incidental anecdote. The two notebooks—of poems and working notes—have been taken from the study collection at the Fundació Joan Miró in Barcelona and have not been published before. Finally, there are the personal letters, almost all of which are also unpublished. These letters were found either in public archives or in the possession of the persons to whom they were originally addressed.

Miró's interviews present the artist in many different lights. It

should be noted that interviews always reflect to some extent the thinking or writing style of the interviewer. This is particularly true in the case of Miró who generally expressed himself in a laconic, nonliterary form of discourse, whereas the transcriptions of interviews by writers and poets such as Georges Duthuit and Yvon Taillandier show a more fluid and elaborate discursive style.

The poems and working notes, only two of many notebooks deposited by the artist at the foundation that bears his name, were chosen as representative of the two poles of Miró's creative personality: his pure poetic sensibility and his systematic, methodical nature.

Finally, the selection of letters was based on the same criteria as that for the published texts, as well as on accessibility. I did not intend that the selection should be exhaustive but that it include representative letters to key figures in Miró's life and career. Here personal anecdote has been deleted in order to focus on passages concerning the artist's creative life. Opening and closing salutations have also been deleted for stylistic consistency.

Since Miró was notoriously imprecise in his recollections of autobiographical events, sometimes even in regard to sequences of paintings, the reader is invited to consult the Chronology that has been established on the basis of much new material, some published here for the first time.

Occasionally references to Jacques Dupin's catalogue raisonné of the artist's work (Dupin, *Miró* [New York: Harry N. Abrams, 1960]) have been mentioned in the notes in order to identify particular paintings. The numbers following the mention "Dupin" refer to catalog numbers, not to be confused with page numbers.

In the translation of the texts, from Catalan, Spanish (Castilian), and French (practically none of the original writings was in English), the translators have tried to remain faithful to Miró's punctuation and style insofar as it was possible.

Acknowledgments

The following material was prepared with the assistance of many colleagues and friends to whom I would like to express my gratitude.

My first thanks are due to Joan Miró for his enthusiastic acceptance of the project. Without his help and support at the beginning stages, there would have been no book. I would also like to thank Pilar Juncosa de Miró for standing by the project during its final phase.

It is clear to all Miró scholars that no study of any aspect of the artist's life and work could be undertaken without referring to Jacques Dupin's monograph *Miró*, published by Abrams in 1960. I would furthermore like to express personal thanks to Jacques Dupin for his preliminary encouragement.

The following institutions communicated unpublished documents without which this volume would not be complete, and for this too I am deeply grateful: Biblioteca-Museu Balaguer, Vilanova i la Geltru; Biblioteca de Catalunya, Barcelona; Fundació Joan Miró, Barcelona; Musée National d'Art Moderne, Paris; and The Museum of Modern Art, New York.

The following individuals generously provided information, research, time, and moral support. I regret that space does not permit me to define the contribution of each and thank each separately: Pierre Matisse, New York; Michel Leiris, Paris; Rosa Maria Malet, Carmen Escudero, and Roser Baro of the Fundació Joan Miró, Barcelona; Teresa Basora Sugranes of the Museu Balaguer, Vilanova i la Geltru; Francesc Fontbona of the Biblioteca de Catalunya, Barcelona; Dominique Bozo and Christiane Rojouan of the Musée National d'Art Moderne, Paris; Sergi Aguilar, Rosa Amor, Francesc Català-Roca, Francisco Farreras, Joan Hernàndez-Pijuan, Elvira Maluquer, and Rosa

Maria Subirana, Barcelona; František Smejkal, Prague; and Caroline Birdsall and Anita McClellan of G. K. Hall, Boston.

I would like to extend special thanks to the two translators for their sensitivity to the texts and their patience and perseverance throughout the project: Paul Auster, for the translations from the French, and Patricia Mathews, for the translations from Catalan and Spanish.

I would also like to acknowledge a particular debt to Rosalind Krauss with whom I have had an ongoing dialogue about Miró for over twelve years that has been invaluable to my thinking.

I owe particular thanks to Jack Flam, editor of this series, for his careful reading and perceptive comments on the manuscript at a preliminary stage.

Finally I wish to thank my husband, Georges Noël, for his tolerance, patience, and understanding during the final months of what appeared to be an endless enterprise.

Introduction

To write a *history* of Miró's art is to work against the grain of his own enterprise. For Miró's preoccupations, and his genius, were *mythic* in character, assuming quite a different shape from the reality—linear, progressive, developmental—that history orders and records. Myth, as another kind of conceptualization and narration of events, is determined by a dominantly circular or recurrent structure. Mythmaking shows an attempt to remember and conserve not facts or dates but exemplary events and archetypal heroes and to actualize them as meaningful images in the present. Its oral, as opposed to written, origins create its intrinsic substance and style. For even though referring to a presumably collective past, it reflects the subjective selection and vision of each teller in his own time.

In one form or another, all artists are mythmakers. No matter what their sources, no matter what their style, their creation—the work of art—is real, actual, present. It is the transformation of an empirical reality into a physical presence, an emotional and intellectual experience that cannot be apprehended as other than an immediate reality to the viewer. Although many artists tend to obfuscate their sources and their objectives, this is not the case with Joan Miró. In fact, it may be said that Miró's art is an exemplary mythopoeic enterprise, a constant actualization of lived experience into art.

Miró's claim to reality in all its manifestations is legendary: "Have you ever heard of anything more stupid than 'abstraction-abstraction'?" he wrote in 1936. "And they invite me into their deserted house as though the marks I put on a canvas did not correspond to a concrete representation of my mind, did not possess a profound reality, were not part of the real itself!"[1] But how to define that "real"? As in any mythic

or poetic activity, it is the real transformed by memory. Miró's real, as he appropriated and reformulated it, was manifold. It was the daily physical and psychological reality of different cities and countrysides; it was the reality of a Catalan identity; it was the reality of a cosmic vision and that of an intense spiritual life. All these realities, of a present and a past that Miró lived or remembered—actively, intellectually, emotionally—were threaded together into the single vision of Miró the artist.

The first, existential, reality is fairly simple to reconstruct. Miró's urban landscapes included the artistic environment of Barcelona and Paris: the paintings he saw, the artists he knew, the poets he knew and read. His rural landscapes were essentially those of Montroig and Majorca (and briefly, but importantly, Varengeville-sur-Mer in Normandy): the harsh light, parched red soil, and rocky sculpted landscape of Tarragona and the cool, translucent, and poetic (as he called it) light of the Mediterranean.

Miró's Catalan nationalist reality is more complex to determine. Yet it is as significant a part of Miró's worldview. Starting in 1901, when a conservative Catalan nationalist party came to power, there was a resurgence of Catalan nationalist sentiment. Up to then, however, there was no active interest or memory of a Catalan history or Catalan culture. In a sense, the Catalan identity had to be reinvented. If mythology is the remembering of certain traditions or events that justify a people's present through a claim to a legitimate past, the Catalan renaissance of the early years of the twentieth century was just such an enterprise. And Miró's nostalgia for a Catalan visual arts tradition was nourished by the process that constitutes myths: a passionate exaltation of a forgotten past in order to legitimize a present.

So that although Miró spoke continually of a Catalan heritage, a Catalan identity, it was the task of his generation to invent not only a past but also a present. His poet friends, such as J. V. Foix, explored the Catalan collective memory for archaic forms and indigenous content in order to reinvent a Catalan voice. And Miró searched around him for a collective visual past. That eternal past, as he saw it, was Catalonia itself: its light, its soil, its tilled fields, its beaches in the sun. It was to be found in its mountains, its villages, its farmhouses, and its Romanesque churches with their stonework and frescoes. It consisted of every mountain peak, every blade of grass, every worn pebble. It inspired an intense, atavistic identification with the land and landscape.

Miró's favorite motifs, taken from the Tarragona countryside—carob and eucalyptus trees, insects, snails, and snakes—acquire a

mythical stature, along with the women and birds that are the most constant mythical figurations depicted throughout his long and varied oeuvre. His modes of transformation were diverse; he not only endowed trees with ears and gave animals and insects an almost human morphology, but he also reduced them to schematic ciphers or emblematic signs. At times he would flatten the landscape into a hieratic ordering of horizontal bands or depict the sky as an infinite field of blue. As in the operation of mythmaking, all these elements were disengaged from their original site and function and transferred—transformed in scale and meaning—to another context of significance.

Aside from his surroundings at Montroig, apprehended as a quintessential Catalan landscape, Miró also appropriated all primitivisms and folk art expressions into his heritage, thus expanding his Catalan identity to encompass many universal expressive conventions. What he claimed to admire in these popular styles were their simplicity of language, their immediate impact, their forms that derived from a collective iconography, and the anonymity of the artists. His constant references to Catalan Romanesque wall paintings in particular, familiar to him since childhood, evoke only one example of the primitive artistic forms that appealed to him. He was equally sensitive to the prehistoric cave paintings in the south of France and in Spain in which the figurative representations had magical functions. The possibility of controlling and directing human events, spiritual activities, even magical forces, through a spare yet intelligible vocabulary was infinitely attractive to Miró. And many of his own motifs, signifying hands, feet, sexual attributes, stars, and comets, implicitly suggest another reading, another realm of authority, probably inspired by these examples of prehistoric and prelinguistic signs. Thus even before his encounter with the Surrealists, he had been exposed to a repertoire of visual forms that, in their spiritual powers and human mystery, encompassed more than mere aesthetic concerns.

Miró "remembered" as well the mystical dimension of the Catalan temperament: not only the faith and belief that produced the flat proud brilliance and austerity of Catalan Romanesque frescoes, but the exacerbated spiritual exercises of St. Teresa of Aquila and St. John of the Cross. Miró's personal religion was comparable to a kind of peasant syncretism: a mixture of devout Christianity (Catholicism), animism or pantheism in regard to nature and an identification as well to cosmic forces, and asceticism, which, like that of the Spanish mystic poets, was achieved through a battle with his sensual, instinctive impulses.

Miró's spiritual life, his inner landscape, was as real to him as the

sun, an insect, or a blade of grass. At times, as his paintings show, it was his sole reality. At others, it merely served to color and transform his memories of things past or his perception of things present. For Miró's mythopoeic conscience rarely saw reality without a filter: the filter that translated any given truth into an Absolute Truth.

Thus Miró rediscovered and established a Catalan identity based on his own experience—a range of experience that was fundamentally Catalan. *Seny i Rauxa*—common sense and passion, pragmatism and exaltation are the character traits of the Catalan temperament. They are usually defined as a sense of the earth, of all grounded forces, combined with an exacerbated mysticism and an identification with an ineffable and incommensurable universe. Miró's space, colors, even his iconography, express both these things: the pull of the earth, by the Catalan peasant with outsized feet, and such motifs as snails, snakes, crawling insects, even trees and flowers; and escape from the earth's contingencies, by the motifs of ladders, birds, flying insects, stars, and comets.

Another Catalan for whom Miró expressed boundless admiration was Antonio Gaudí, and this is understandable. Gaudí showed an almost mystical reverence for nature, not only its creatures but its organic structure. Considered a mad visionary for his pullulating animal and vegetal forms and his structural eccentricities, it was his practical good sense and his supreme knowledge of materials and construction techniques that made his architecture the unique and unparalleled manifestation of genius for which it is finally recognized today. Thus, passion, good sense, and the audacity to formulate them constitute the spirit of Catalonia, the spirit that shaped Miró and that his art would embody.

The temporal pattern of myth is that of recurrence. And for most of his existence, Miró's life was patterned on the seasons. In the early years, he spent the winters in the city, the springs and summers in the country. In his country surroundings, he found the complete concentration and internalization that were necessary to generate his images and map his initial pictorial concepts. Transferred to the city, the intellectual stimuli and confrontation with other artists in a more worldly environment were as necessary to the elaboration and completion of his work.

The artist's oeuvre is marked by recurrent alternating styles as well. The most obvious are those that correspond to works, on the one hand, based on a study and transformation of the so-called real world and characterized by flat bright colors, boldly contoured shapes, experiments with materials (extending into ceramics and sculpture), and rec-

ognizable archetypal images. Opposite these, and in what appears to be a contradiction, are the open, cosmic, almost abstract paintings in which a tenuous line or a few spare signs coalesce on an empty field. Here Miró appears to have lost touch with outer reality and to refer solely to the inner "real" of the mind, the spirit, the imagination. In a sense, these two styles correspond to two aspects of the artist's personality: the extroverted or active and the introspective or meditative in which he claimed to be moved by forces greater than himself.

Thus Miró's oeuvre is a fiction based on his highly personal experiences of the world. The value of the following texts is that they show us the artist's initial realities as he lived them and their metamorphosis into the mythic expression of his painting style. They also show the artist's struggle to come to terms with his private realities and personal contradictions in order to transform them into the universal images he would present to the world.

Few of Miró's biographers describe in detail the Barcelona artistic context at the time Miró embarked on his career as a painter. Yet the situation in Barcelona was an important factor in shaping Miró's objectives and ambitions, as is seen in the artist's early letters.

Historically, Barcelona had always been a cosmopolitan city with an extremely active cultural life. During the first decades of the twentieth century, the period that concerns us here, although there was indeed some avant-garde activity, the visual arts stage was nonetheless dominated by the official associations of academic painters such as were found in most European capitals at that time. The more powerful associations in the Catalan capital were Les Arts i els Artistes and the Cercle Artístic de Barcelona. The members of the first painted either in an academic manner, or in a *Noucentisme* style. Noucentisme was a Catalan movement in art and literature that emerged around the turn of the century. It proposed a new classical style for the style of the future, turning its back on the sentimentalism, Romanticism, or Impressionism characteristic of the late nineteenth century as well as on Art Nouveau. According to its proponents, the new Catalan art was to be classical, objective, and Mediterranean, expressing the vocation of Catalonia as an exemplary Mediterranean culture. Its artists were influenced by the neoclassicism (but not the sentimentality) of Puvis de Chavannes, painting full-blown classical nudes or draped figures, and allegorical scenes in idyllic pastoral settings treated in muted pastels. Paintings by Joaquim Sunyer, Francesc d'A. Galí (one of Miró's professors), and Joaquin Torres-García (prior to 1916–17), offer good examples of this

style. In sculpture, the idealized female figures of Manolo (Manuel Hugué), José Clara, and Auguste Maillol issue from the same aesthetic premises.

The Cercle Artístic de Barcelona was identified as liberal, bohemian, and anticlerical. Although many valid artists were members of this group (including another of Miró's professors, Urgell, and the better known Isidre Nonell), it was nonetheless considered social and inclined to frivolous activities. These two associations more or less controlled the annual exhibitions such as the Spring and Autumn salons (Salon del Primavera and Salon del Tardor).

Miró and his friends, including E. C. Ricart, Ramon Sunyer, and Llorens Artigas, belonged to the Cercle Artístic de Sant Lluc, an association founded (in 1893) in reaction to the Cercle Artístic de Barcelona. Dedicated to St. Luke, the patron saint of artists, the tone of this group was set by high moral principles and Christian virtue (even though many of its members were agnostics).

Although Miró decried the strong academic elements of the Barcelona scene, he was also extremely critical of the artists who went to Paris and came back painting in an Impressionist style, like Frenchmen, he would say, "as though there was nothing more to the modernist sensibility than painting light."[2] Already at an early age, the artist was thinking in terms of a native Catalan sensibility. This was generated by an explicit historical situation. Although a conservative political party had been formed to fight for Catalan autonomy (La Lliga Regionalista) as early as 1901, it was only in 1913, the year Miró turned twenty, that the government in Madrid authorized an administrative decentralization. Thus, during the years 1915–19 (the dates of the earliest letters published here), Catalan nationalist sentiment was at its peak. Miró intended to participate actively in this Catalan renaissance and forge a Catalan identity in art—not a provincial or local Catalan idiom, but an "international Catalanism," by which he meant a universally meaningful style that nonetheless expressed inherently Catalan values.

There were of course avant-garde elements in Barcelona that contributed positively to Miró's development, even though these are barely mentioned in his early letters. The Dalmau galleries and the person of Josep Dalmau were a central focus of avant-garde artistic activity in Barcelona at that time. Dalmau opened his first gallery in 1906. In 1911, he moved to 18 calle Puertaferrisa, where he organized exhibitions of Catalan, Spanish, and foreign artists. Aside from mounting an important Cubist exhibition in 1912,[3] an exhibition of Persian miniatures in 1913, an Otto Weber show in 1915, exhibitions of Van

Dongen, Charchoune, Gleizes, and other Paris-based artists in 1916–17, and one of Miró himself in 1918, the galleries also served as an international meeting place during World War I. The Delaunays, Gleizes, Marie Laurencin, the critic Maurice Raynal, and Picabia (who published the first issue of *"391"* with Dalmau in January 1917) congregated at the Dalmau galleries, taking advantage of Spain's neutral wartime position. Here Miró saw his first French Cubist paintings and encountered Dada, which he would always say was a major influence in his life, representing a kind of freedom he had not imagined possible before.

In 1917, a large exhibition of French painting was also organized in Barcelona, where Miró would have seen a broad spectrum of artists, including Matisse, Redon, Cézanne, Courbet, and many others. He thus had some firsthand knowledge of French art through these exhibitions, but, although he found it admirable in many instances, he did not feel it was a viable model for his own work.

During this important seminal period, Miró was also introduced to avant-garde literature and poetry through his friends the poets J. M. Junoy and J. V. Foix. He read the many Catalan avant-garde magazines of the day (*D'aci i alla*, *Trossos*, *L'instant* or *L'aviat*, *Vell i nou*), which reported on artistic and literary activities at home and abroad and presented avant-garde French poetry in translation (as well as Apollinaire's "Calligrammes"). He had access to foreign magazines and reviews as well (for example, Apollinaire's *Les soirées de Paris*, Pierre Reverdy's *Nord-Sud*, Pierre-Albert Birot's *SIC*). At an early date, he read Walt Whitman's *Leaves of Grass*, first translated into Catalan in 1909.

During the years 1915–19, Miró never went abroad himself, not even as far as Madrid. His more fortunate friends reported to him on the Prado; Ricart spent six months in Florence where he gained firsthand knowledge of Futurism. But for Miró, Montroig, Barcelona, Vilanova i la Geltru, and other coastal villages, as well as the mountains and nearby Romanesque church sites (the region of Montseny, and the villages of Siurana, Prades), constituted his entire landscape.

Finally, there were the artists of Vilanova, a group that could be identified neither with academicism, Noucentisme, nor with a particular avant-garde. The artists in this group, particularly Ricart, Ràfols, and Rafael Sala, were Miró's most intimate friends. These artists lived and painted in Vilanova i la Geltru, about fifty kilometers from Barcelona, removed from the agitation and politics of the city. Nonetheless, they participated in the artistic life of the capital, exhibiting in the

salons and painting occasionally in a studio that Miró shared with Ricart at 51 baja de San Pedro. The paintings of these artists developed as did Miró's own: from a strident palette and vigorous brushstrokes in the portraits and still lifes of 1917 to a cooler range of luminous pastels, a flat almost transparent facture, and an analytical realist treatment of landscape subjects.

Starting in 1917, the critic "Apa" (Feliu Elias) and then Junoy spoke of Miró, Ricart, and Sala as the Vilanova school, singling them out for their bright palette and lack of sentimentality. Miró was not displeased with this affiliation in that it seemed to recognize their independence from the official modes and styles. Despite this recognition, however, it was still difficult to exhibit and make their voices heard. So, in 1918, Miró, Ricart, Ràfols and Sala, joined by Llorens Artigas and Francesc Domingo, banded together to form the Agrupació Courbet. Their allegiance to Courbet was not only for his realism but for his revolutionary stance. And in 1918 and 1919, although not officially recognized as an association, they exhibited as a group in the Barcelona salons in the rooms of the Cercle Artístic de Sant Lluc.

The Joan Miró who emerged from this environment was an artist who rejected identification with any recognized school or style, not only the provincial academicisms of Barcelona, but the international fashions of Impressionism or Cubism. It was clear in his mind that he had to go beyond all categories and invent an idiom that would express his origins and be authentically his own. In speaking of his ambitions and objectives, his recurrent leitmotivs were modern, classical, and realist: modern, as opposed to stagnant academicisms; classical, as Cézanne had striven to be a classical modernist; realist, as opposed to the arbitrary deformations of reality embodied in imported styles such as French Impressionism.

Yet until 1918, Miró's paintings—landscapes, still lifes, and portraits—appear to be everything but realist and classical. Although by principle Miró rejected Cubism and Fauvism, he clearly had assimilated their lessons. In their twisted perspectives, heavy brushwork, and strident color, his paintings show an awareness of Cubist structural principles and Fauve color. Since no one in the official Barcelona salons was integrating these styles, particularly in such a personal, subjective manner, by so doing, Miró declared his independence.

In 1918, Miró's paintings began to show a more tempered treatment. The explanation of this transition is implicit in his letters. Between 1915 and 1917—the years of his military service, his studio with Ricart, and his attendance of classes at Sant Lluc—Miró spent almost

nine months of every year in Barcelona. He was thus extremely af-
fected by the local art scene, and his paintings express his anger and
frustration. Starting in July 1918, the artist spent longer periods at the
farm in Montroig, where he meditated on nature, withdrew into him-
self, and pursued purely painterly investigations. Understandably this
new way of life brought about a pictorial transformation. He began to
concentrate solely on landscapes: open, rhythmically patterned, and
controlled. His color was flatter, paler, more lyrical. His drawing was
delicate and precise. Finally, it was in these paintings that Miró arrived
at a distillation of his experience and the singular realism of his first
personal style.

When Miró discovered Paris in early 1920, he was, in his own words,
overwhelmed—overwhelmed by the wealth and variety of paintings in
the museums of the French capital and overwhelmed by the stimulus of
the artistic and intellectual community. Yet after recovering from his
first impressions in the museums and galleries, Miró expressed disap-
pointment with his artist-contemporaries, except for Picasso, Matisse,
Derain, and Braque. Even then, he judged their paintings severely,
seeing too much facility and not enough struggle to go beyond accepted
standards and the demands of a flourishing market.
 Coincidentally, Tristan Tzara also arrived in Paris in early 1920,
thereby mobilizing the Parisian Dada movement. In fact, some of the
most scandalous Dada activities took place in March and May of the
same year. Dada represented the subversion of bourgeois values and of
traditional artistic forms. For Miró, coming from Barcelona, where he
had been exasperated by the bourgeois ideology and the predominantly
academic frame of reference, the activity of the Dada painters and poets
and their circle was infinitely appealing and meaningful. It would take
Miró some time to get his bearings. But, as he himself would claim,
once he did, it was his immediate encounter with poetry and the poets
more than that with painting and painters that opened his eyes and
suggested ways of going beyond his earlier realist style.
 Starting in 1922, many of the most avant-garde poets and writers
of the day congregated at the rue Blomet, where Miró and André
Masson had their studios. More often they came to visit Masson than to
see Miró, who already held to a tight working schedule and kept
somewhat to himself. Nonetheless, during that "heroic" period, Miró's
friends included Max Jacob, Michel Leiris, Roland Tual, Benjamin
Péret, Paul Eluard, Georges Limbour, and Armand Salacrou. Miró was
also impressed by the purity, authenticity, and complete commitment

of two such different figures as Antonin Artaud and Tristan Tzara, who came almost daily to the rue Blomet. He witnessed the hypnotic "sleeps" of Robert Desnos; he read Nietzsche and Sade, Rimbaud, Mallarmé, and St. Pol Roux. He attended readings of Jarry and Lautréamont.[4]

For the artists and poets of the rue Blomet, reason, tradition, and convention were the enemies of authentic expression. Their goal was to purify language of fixed structures and stale meanings in an attempt to reach a primordial level of discourse. In a sense, their objectives ran parallel to those of Miró's Catalan poet friends in their search for an authentic (national) voice, cleansed of stylistic conventions and stereotyped clichés.

The importance of these years in Paris—between 1920 and 1924—cannot be overestimated. It was a period of intense freedom, of sublime creativity, before the Surrealist movement came to the foreground, with its laws, dogmas, manifestos, and high priests. During this period, the poetry of Desnos, Péret, Eluard was excessive, unself-conscious, dislocated, visual. It was aerial, cosmic, filled with comets, stars, swallows, arrows; it was at once natural and supernatural, peopled with fantastic figures from the animal, vegetable, and mineral worlds; it was sensuous, humorous, and colorful; and it appealed simply and directly to the senses. Later, under the influence of Surrealism, some of the same poets would develop a more complex, deliberate, intellectual style. And once Breton crossed the threshold of the rue Blomet in 1924, a schism would develop within the group between those who officially joined the Surrealist ranks and those who did not.

Miró was among those who did not. He was unwilling to abdicate his newly found freedom, a freedom that allowed him to give full vent to his imagination. The general spirit of subversion and provocation authorized the use of all the images he had stored inside him, from the most magical to the most banal to the most fantastic to the most shocking, erotic, or scatological to the most preposterous or absurd. It allowed him to write words on canvas or interlace pictorial and verbal images. It encouraged him to project images as they came to him and abandon all learned conventions. Shading, modeling, perspective, figure-ground relationships, passages and contrasts, attention to scale were all ignored. What was important to Miró was the immediacy of his images, that they be impulsive, corrosive, eruptive, emptied of conventional meanings or allusions and purified to a primordial presence.

It was not just the freedom that interested Miró but also the

unprecedented structural and semantic possibilities that were discovered through experiments with randomness, dreams, or automatic writing. The example of the poets taught him to break apart traditional syntax, use inverted metaphors, invent compacted images with shifting meanings, or assemble incongruous visual motifs. The absolute balance that Miró had sought in his compositions prior to 1922 would be as absolutely abandoned thereafter and replaced by other organizational concepts: a stream-of-consciousness flow or linear narration across the canvas; constellations of connected or disconnected signs; a Mallarméen emptiness or a field of saturated color, articulated by signs vertiginously floating in space.

These processes—the use of randomness and accident, the free association found in dreams, the dislocation of syntax—allowed the poets to achieve an anonymous expression that corresponded to Miró's ambitions. Dream images are collective images, phantom images, that are sorted and brought to the surface by a process that eludes personal choice. Random processes are controlled by chance; and a breaking up and rearrangement of verbal or visual units is dictated by the verbal or visual material itself. In all these instances, the resulting expression is no longer of the *self*, but of the world. Furthermore, this premise of self-effacement before the forces of chance implied a total investment in the creative act, as though it were life itself. Only by accepting this stance could one hope to go beyond theater as did Artaud, beyond poetry as did Tzara, and beyond painting as did Miró.

Thus, Miró's imagination found its true form of expression through his contacts with the Dada poets and the Surrealist group. His paintings of 1923–24, such as *The Tilled Field, Catalan Landscape (The Hunter)*, and *Pastoral*, depict a poetic vision wherein interior images assembled from the most disparate sources replace the familiar landscape of Montroig. The paintings and drawings that followed throughout the 1920s, and in particular from the rue Blomet, would be at once the purest and most spare, the most complex and enigmatic of the artist's career. The sequence of works from that decade chart his passage from painting as a somewhat traditional exercise to painting as poiesis: an essential act. They no longer refer specifically to Montroig, Barcelona, or Paris. In a sense they no longer express Miró; they express a world. And they lay the foundations for all the artist would do thereafter.

Once Miró had discarded all traditional pictorial conventions, he would never return to them. With few exceptions, his subsequent paintings would remain free from perspective, gravity, illusions of vol-

ume, realistic modeling, shading, or color. His images would be sche-
matic and immediate. His syntax would be linear, constellatory,
dislocated. He furthermore developed the necessary discipline to cap-
ture his images and formulate them with clarity and precision.

When, in January 1927, Miró moved to the Cîté des Fusains, on
the rue Tourlaque, his style of painting changed. Already in late 1926,
his spatial organization began to tighten up and flatten out and his
iconography became more immediately legible, manifesting a preoccu-
pation with more purely pictorial problems. Although his intense expo-
sure to poetry had opened his eyes to certain devices and methods for
going beyond traditional pictorial conventions, Miró was a painter, not
a poet, and his ultimate aim was to adapt what he learned to a pictorial
expression. Furthermore, through his move to the rue Tourlaque, he
would be more in the company of painters. His immediate neighbors
included Bonnard (of whom he spoke with respect), Jean Arp, and Max
Ernst. René Magritte came to the rue Tourlaque on weekly visits to the
Belgian dealer Camille Goemans, and Miró saw him regularly.[5] Many
poets continued to visit at the rue Tourlaque, including Eluard, Péret,
and Desnos. Arp wrote poetry that Miró admired, Ernst had made
poem-paintings in 1923–24, and Magritte used literary conceits in his
paintings. But for Miró this period of his life was devoted to translating
his understanding of the spirit and structure of poetry into more explic-
itly painterly terms.

Coincidentally, the move from Montparnasse to Montmartre had
brought Miró geographically closer to the Surrealist group. And as the
authority of Surrealism came to dominate the literary and artistic
scene, it became imperative that Miró define his position in relation to
the group, a position that was equivocal, to say the least. Some of the
artist's closest friends had joined Breton's ranks (including Desnos,
Artaud, Eluard, Leiris), and Miró exhibited regularly in Surrealist
exhibitions. But while he was instinctively close to Surrealism—and
actually became a quintessential Surrealist painter almost despite
himself—he never signed a manifesto or became an official member of
the group. He had always disliked being identified with groups, move-
ments, or labels in general. And the absolute allegiance Breton de-
manded was antithetical to his nature. In particular, he rejected the
Surrealists' excessively intellectual and theoretical stance. Miró saw
himself as an individual and a painter, not as an intellectual. And he
intended to maintain his independence.

Thus, it was perhaps to avoid a facile identification with Surrealist
concerns (in terms of "dream imagery" or the subconscious, for exam-

ple), that Miró turned to a more precise and concrete kind of painting. He painted images that were more obvious depictions of landscapes and figures and abandoned the earlier, open, almost cosmic fields. He no longer scumbled his grounds but painted in pure flat colors. His motifs were closed, firmly contoured, and anchored (rather than floating) on the picture plane. He no longer used words or lettering in his paintings. He refused all poetic or metaphorical titles, preferring to use the simplest generic title possible: *Painting*. Yet nonetheless, his essential poeisis remained perceptible in the loose and laconic dispersal of motifs and their elusive enigmatic connotations. Painting, however, was the vehicle, the means, the praxis, the passage to concrete visible form.

Miró's decision to return to Barcelona in 1932 was ostensibly inspired by the fact that he found Parisian life too distracting. It is more probable that it was motivated by his extremely precarious financial situation. Aside from the fact that he now had a wife and child to support, the repercussions of the stock market crash in New York had by then reached Europe, and Pierre Loeb could no longer handle Miró's work entirely. Although Miró was enjoying some prestige in intellectual and artistic circles, and he had a few collectors (including René Gaffé and Jacques Doucet), he was still not able to make a living from his painting. By returning to his mother's house in Barcelona (his father had died in 1926), Miró would at least partly solve his economic problems.

It is indeed probable that the artistic scene in Paris did not particularly help his frame of mind, for Miró was undergoing a creative crisis. Already in 1928–29, after the "Dutch interiors," he had begun to question his own facility as well as the enterprise of painting in general. This was the period when, as he would say to Tériade, he wanted to "assassinate" painting. It was also the period that he did the *Spanish Dancer* (consisting of a feather and a hatpin), a series of almost abstract collages, and in 1930–31, his incongruous assemblages of "tasteless" or nonartistic materials and objects. The pressures of the Surrealists, who constantly observed, assessed, and criticized each other's work, served only to aggravate his orientation, as his writings and interviews show. Presumably his return to Barcelona and Montroig reflected his need for a more familiar setting in order to find himself. Except for occasional visits to Paris, he remained in Spain until the autumn of 1936.

In late October or early November 1936, Miró went to Paris with his most recent paintings before sending them to his New York dealer, Pierre Matisse. Although the Spanish civil war had broken out in July,

few people were aware of the gravity of the situation or of the turn the
war would take. By late November, however, it became clear that Miró,
because of his republican sympathies, could not return to Spain.

Miró remained in Paris until 1939. During these years of exile, the
artist's frame of mind was profoundly colored by events in Spain. Far
from his native Catalonia, and incapable of participating in its destiny,
he was unable to find his usual peace of mind. Living first in a hotel
room and then in an apartment with his wife and daughter, everything
seemed extremely temporary. For a time he painted in a room at the
Galerie Pierre. Throughout this period, he made constant plans to
return to Barcelona, where he thought he would resume the canvases
he had left unfinished. Despite his sense of dislocation, during this
period Miró produced some of his greatest works, which expressed an
inner turmoil and a profound desire to keep a hold on reality.[6]

In 1939, Miró and his family moved to Varengeville-sur-Mer in
Normandy. This return to the country, and withdrawal from the
world, brought him closer to the kind of communion with nature and
concentrated meditation he had known in Montroig. Here he began the
Constellation series, works on paper in which he experimented lavishly
with technique and that are among the high points of his career.

In June 1940, as the first bombs fell on Normandy, Miró and his
family returned, via Paris and Perpignan, to Spain. Although with the
outbreak of World War II republican sympathizers were allowed to
return, Barcelona was apparently not safe for Miró and his family.
They settled in Palma, near his wife's family, until 1942. During the
spring and summer of 1941 and 1942, Miró was able to visit Montroig,
where he attempted to collect his thoughts, assess the years of exile,
and prepare to start anew. During the past few years, circumstances
had constrained him to a limited production and a day-by-day exist-
ence. Now, at last, he could think ahead, and plot out his future work.
As his working notes show, Miró dreamed of all the projects he would
like to undertake—paintings, sculptures, prints, ceramics—and he
dreamed of having a large studio.

In the years immediately following World War II, life returned to
normal and Miró enjoyed his first successes. He exhibited regularly in
New York, had his first large retrospective exhibition, and received his
first architectural commissions. He traveled more extensively and even
lived in New York for nine months in 1947 to execute a mural painting
for a hotel in Cincinnati. These are the years when Miró found his true
working rhythm and achieved greater self-confidence and a freedom
from financial pressures. He recognized that his best working environ-

ment was in Barcelona and Montroig, removed from the frenetic artistic
and social activity of Paris or New York. At the same time, he remained
aloof from official activities and refused to be identified with Franco's
Spain. Aside from an exhibition of prints in Madrid in 1972[7] and
exhibitions in Barcelona in 1949, 1968, and 1972, Miró exhibited only
abroad until Franco's death. In a sense he lived in exile in his own
country. This was his choice. He furthermore identified himself as a
Catalan, not a Spanish, artist throughout these years.

The new studio that Miró built in Montroig after the war was still
not big enough to accommodate all the activities he now undertook. His
temporary exile in Palma—where he had visited since childhood but
never lived until this time—made him aware of the difference between
the soft light of the island and the harsh landscape of Montroig. He
realized that the two were complementary and equally necessary to his
vision. So in the early 1950s he bought a house and a plot of land in
Calamayor on Majorca and commissioned his lifelong friend Josep Lluis
Sert to build him a large studio.

The move to a new studio produced another transformation in
Miró's oeuvre. Upon his arrival, he sent to Paris for the crates of
paintings he had left there before the war. He then went through a
process of self-examination, destroying many works, overpainting oth-
ers, leaving others as they were. His new studio allowed him a greater
creative freedom than he had known before. It allowed him to spread
all his work around him, to work on several large paintings at one time,
and to reserve separate spaces for projects in different mediums. After
he began to work permanently in Majorca, he would spend less time in
Montroig.

Miró continued to travel. He went to Paris for brief visits. He
went to Gallifa to work with Artigas on ceramics and architectural
commissions. He went to the Maeght Foundation in Saint-Paul-de-
Vence and to Barcelona to work on prints, and to Barcelona and Paris
to work with casting foundries for his sculpture. But it was the isola-
tion of Majorca and its virtually undisturbed tranquillity that nurtured
his creative life and generated his ideas during the final years.

These then were Miró's outer landscapes and the context of the follow-
ing writings. Yet the letters also evoke an inner landscape of great
complexity. Here is where the artist's essential contradiction between a
fundamental irrationality and an equally fundamental practical sense—
Rauxa i Seny—is most vividly defined.

One might say that Miró had a Dada sensibility before any con-

tacts with the international movement or its prominent figures. This was already apparent in the early years in Barcelona. Miró was constantly in revolt, first from the materialist pressures from his family, then from the superficiality and immorality of society, and finally from all academicisms. Freedom was his obsession, freedom to break out from all established limits, whether social or artistic, and freedom to redefine the function and meaning of the work of art.

In the early years, this imperious need for freedom would express itself through anger. Subsequently it would be visible in a kind of furious execution (his so-called Fauve period), and finally it would be translated into a personal formal language that defied categorization and that referred at once to the simplicity and banality of the natural world and the hidden resources of his imagination.

Miró's energetic rejection of existing rules and his total investment in the search for an idiom that would transgress them is visible in his writings. His early writing style in personal letters is turbulent, at once naive and idealistic, angry and rebellious. His spelling, grammar, and punctuation are disorderly, subservient to the spontaneous flow of words and images that spill from his pen. In contrast to his hostility toward all aspects of the Barcelona art scene, his vision of nature at Montroig is poetic, colorful, and animistic; every detail is worthy of attention and breathes and pulsates to his eyes as it will subsequently be captured by his hand. This is his first contact with his true reality, one born of isolation, observation, and symbiosis, and born as well of a thirst for purity and hunger for escape from the contingencies of arbitrary authority in the so-called real world.

When Miró met the poets in pre-Surrealist Paris, the encounter served to focus his priorities and exposed him to new processes for liberating images, but it did not change his course. Miró already shared with the poets a state of mind, open to receive and transmit all sensations, from the basest, most denigrated, most human, most real, to the most inconceivable, invisible, unknown, and obscure. Like them, he was convinced that art was primarily a moral and poetic activity, disinterested and anonymous, beyond rules or theory, and certainly beyond the rules of any regimented social or artistic life.

The authenticity and consistency of Miró's disengagement from accepted norms and his extreme receptivity to all images, impulses, and sensations are manifest in his written poetry of the thirties. These poems are comparable to the best of Benjamin Péret and Robert Desnos in their un-self-conscious flow of freely associated motifs. His verbal images are visual, frontal, and abrupt; reminiscent of his painting, they

are without nuance, shading, or transitions. Sometimes naive or child-like, sometimes scatological (recalling Alfred Jarry), they show the purity of the word as a singular, eruptive—at once phonetic and plastic—unit, caught up in a rushing linear discourse. In Miró's desire for poetry and freedom, all shapes and motifs that came to him were of equal value, whether their source was in his inner vision or outer impressions, verbal or visual images, the structure and texture of music, poetry, visual events, tactile experiences, dreams, or reality.

But this receptivity was achieved through an exacting self-discipline; the Spanish mystic poets were among Miró's models. The mystical experience of St. Teresa of Aquila or St. John of the Cross was based an extreme awareness of the basic human impulses and temptations of the secular world that only a mental and physical conditioning could overcome. Although Miró was not a mystic, he was extremely committed to Christian belief. Many of his personal letters repeatedly express the necessity for a strong discipline of mind and body in order to achieve another state, another vision, another experience of the world: "the absolute of nature," he would call it in the early years; an "unreal reality," he would say later. It is moreover logical that the realm of the mystic poets whom Miró preferred was not unlike that of his own spiritual life as translated in his pictorial expression. The poems of St. Teresa of Aquila and St. John of the Cross are among the most ambiguous expressions of the mystical experience in the history of sacred literature, in which eroticism, sensuality, and spirituality are intertwined.

It has often been written that the creative state of receptivity that Miró reached during the 1920s may be ascribed to hallucinations or a trancelike condition and attributed specifically to his knowledge of the Surrealist experiments with hypnosis or the extreme hunger he experienced during those years. Whether or not this is true, it is probable that these were exercises the artist undertook deliberately in order to attain another vision, beyond daily reality, and that allowed him to reach beyond the limits of painting. Not only during this period but throughout his lifetime Miró would seek through one means or another to discipline his secular existence, achieve extreme states of concentration and thereby gain direct access to the realms of the imagination.

This state of sharpened awareness, concentration, and self-effacement is also found in the work of the secular poets such as Rimbaud and Mallarmé, whom Miró greatly admired. Both poets sought a derangement of the senses by which to lose touch with mundane experience and attain an impersonal level of discourse beyond

individual expression. "I am now impersonal," wrote Mallarmé, ". . . a potential in which the Spiritual Universe may see itself reflected and may develop through what was once my self."[8]

Miró would speak of a comparable anonymity in relation to his "hallucinatory," impersonal, or imaginary images, no longer anchored in his existential life. "Anonymity allows me to renounce myself but in renouncing myself, I come to affirm myself more strongly. . . .The same practice makes me seek the noise hidden in silence, the movement in immobility, life in the inanimate, the infinite in the finite, forms in space and myself in anonymity."[9] The Surrealist's appeal to the "unconscious," the mystic's ecstasy, the poet's "impersonal," even the Japanese calligrapher's conditioned passivity (which Miró at times evoked)—all are essentially different degrees and different names for the same release from reason and the same state of receptivity for images coming from another world.

Thus Miró's seemingly primordial, fantastic, or "Surrealist" images sprang from a concerted conditioning in order to achieve complete receptivity and direct access to the wellsprings of the imagination. Subsequently these images would be captured and formulated according to another discipline: rational, technical, professional. From an early age, Miró emphasized the importance of a rigorous working discipline, which was clearly related not only to provoking images but to capturing them in such a way that they would be meaningfully communicated and fully perceived. "Are you working hard?" he wrote to his friend Ricart, when they were barely twenty-one. "Or are you sleeping? It's too bad that you are not working." And the following year: "Are you working, or do you only pretend to work? I think you must work; this is the duty of a man with talent."[10] Every personal letter began with a statement on how his work was progressing. In interviews, Miró would outline in detail his working schedule and describe his manner of working on several paintings at one time (as early as 1918); or he would work simultaneously in several mediums in order to avoid becoming saturated with one work, one idea, one execution, only stopping when physical exhaustion took over.

This obsessive drive, which led him to an ironclad working schedule, extended into a meticulous and methodical attention to all practical details for the works' exhibition: how they should be framed and hung, how many should be exhibited, how the catalog should be laid out, and so forth. And once Miró began to work in printmaking and ceramics and on architectural commissions, he always worked alongside the technicians on every step of the process.

Miró's empirical realities and his contradictory humanity are the substance of his art. From these, through a combination of poiesis and praxis, passion and pragmatism, freedom and control, he would elaborate another reality of universal appeal. As the writings make absolutely clear, the "effortless" quality of Miró's art was achieved through a constant meditation on his identity and goals. They show the sources, the contradictions, the anxiety, and the struggle to come to terms with an individual existence. They reflect an attitude. The works of art Miró has left to the world show a sublimated actualization of all these elements. They are the mythic expression of an existence and an attitude in eloquent symbolic form.

Chronology

This chronology is largely based on primary source material: Miró's day-by-day correspondence, exhibition catalogs, and so on. Since it presents several discrepancies with existing Miró literature, it is important to emphasize on what bases it was established. Particular attention has been paid to the early years. In the exhibition listings, with a few exceptions, print or book exhibitions have not been recorded.

1893	*April 20*: Birth of Joan Miró Ferra, at 9 P.M. at 4 Pasaje del Credito, Barcelona. First child of Miquel Miró Adzerias, goldsmith and watchmaker, and Dolores Ferra, daughter of a Palma de Majorca cabinetmaker.*
1897	*May 2*: Birth of Joan Miró's only sister, Dolores, in Barcelona.
1900	Begins primary schooling at 13 calle Regomir. Drawing lessons with professor named Civil. Starting this year, summers with paternal grandparents in Cornudella (province of Tarragona) and with maternal grandmother in Majorca.
1907	End of secondary schooling.
	Attends business classes (at father's initiative) and, simultaneously, the famous art academy La Escuela de la Lonja where he studies with Modesto Urgell Inglada, a romantic landscape painter, and José Pasco Merisa, professor of the decorative arts.

*Spaniards usually inherit both their father's and their mother's family names, which, according to proper usage should read in Miró's case Joan Miró i Ferra. In English transcription, however, the *i* ("and") is usually dropped. Furthermore, most Spaniards usually retain the father's patronym and drop the mother's, a well-known exception being Pablo Ruiz Picasso. Some, however, prefer to keep both, such as the potter Llorens Artigas.

1910–11 Works as bookkeeper for Dalmau Oliveres, a firm dealing in hardware and chemicals.

Purchase of family farm in Montroig (province of Tarragona).

1911 Minor nervous breakdown followed by typhoid fever convinces father that Miró is unsuited for business career.

Retires for convalescence to Montroig.

Spring: exhibits one painting in the Sixth International Art Exhibit, Barcelona.

1912 Barcelona

April 20–May 10: Cubist exhibition at Galeries Dalmau, 18 calle Puertaferrisa; includes paintings by Marcel Duchamp, Gleizes, Gris, Laurencin, Le Fauconnier, Léger, and Metzinger.

Studies (1912–15) with Francesc D'A. Galí Fabra who teaches him to draw by touching objects with his eyes closed, introduces him to music and poetry, and takes him on excursions to surrounding mountains and villages.

Meets Josep Llorens Artigas, Enric C. Ricart Nin, and Josep F. Ràfols Fontanals, who will be lifelong friends.

1913 *October 15*: Enrolls in the Cercle Artístic de Sant Lluc (until 1918) for drawing classes.

Meets Joan Prats, who will also become a lifelong friend.

Exhibits three paintings in Eighth Exhibition of Sant Lluc circle, Sala Pares.

1914 *Autumn*: Rents studio with Ricart at 51 Baja de San Pedro.

December: accompanies mother to Caldetas, a coastal village north of Barcelona, for convalescence from typhoid fever.

1915 *January–February*: Caldetas.

Summer: Montroig.

October 1–December 31: military service, Barcelona. Will fulfill military service requirements for three months (October through December) of every year through 1917.

During other months, lives at home in Barcelona, paints in studio shared with Ricart, and summers in Montroig with excursions into surrounding countryside.

1916 Meets dynamic art dealer Josep Dalmau.

1917 Through Dalmau, meets Picabia who publishes *"391"* in Barcelona. Also Maurice Raynal.

April 23–July 1: large exhibition of French art in Barcelona,

presumably organized by Ambroise Vollard; includes paintings by Maurice Denis, Degas, Bonnard, Roger de la Fresnaye, Friez, Matisse, Monet, Redon, Signac, Vuillard, Carrière, Cézanne, Courbet, Cross, Daumier, Gauguin, Manet, Seurat, Sisley, Toulouse-Lautrec; makes a strong impression.

Summer: Montroig, with visits to Siurana, Prades, Cambrils.

Reads Apollinaire's poetry during military service period.

December 31: end of military service.

1918 *February 16–March 3*: first solo exhibition at Galeries Dalmau; preface by J. M. Junoy (64 paintings, drawings).

Founds Agrupació Courbet with Ràfols, Ricart, Rafael Sala, Francesc Domingo, later joined by Llorens Artigas; splinter group from Cercle de Sant Lluc, in reaction to more conservative members.

May 10: exhibits with Agrupació Courbet at Salon de Primavera in Sant Lluc room.

May 25: exhibits in Exposició d'Art, Palau de Belles Arts in Sant Lluc room (3 paintings).

June: exhibition of drawings by Agrupació Courbet at Galerias Layetanas.

July 1–early December: Montroig.

1919 *June 29–November 22*: Montroig.

June–July: exhibits with Agrupació Courbet at Salon de Primavera in room lent by Cercle de Sant Lluc.

August: excursions to Siurana, Prades; begins plans to go to Paris.

November: plans to exhibit at Salon de Tardor.

Gives up studio in Barcelona. The Agrupació Courbet virtually dissolves; some members leave for Paris.

1920 *Early March*: first trip to Paris. Stays at Hôtel de Rouen, 13 rue Notre Dame des Victoires; hotel run by Catalans where many Catalans stay, including poet Salvat Papasseit, writer José Pla, Ricart (arrived February 20), Llorens Artigas, Torres-García.

Visits the Louvre, the Musée du Luxembourg, Picasso's studio. Attends classes at Académie de la Grande Chaumière.

May 26: attends Dada festival, Salle Gaveau.

Mid-June: leaves Paris.

July–October 22: Montroig (spends first week of September in Cambrils).

October 26–November 15: exhibits in "Avant-garde French Art,"

Galeries Dalmau, along with Picasso, Severini, Signac, Metzinger, Laurencin, Matisse, Gris, Braque, Cross, Dufy, Van Dongen and others (3 paintings).

October 15–December 12: exhibits at Salon d'Automne, Paris in special exhibit of Catalan artists (2 paintings).

1921 *February 11*: visits Ingres Museum, Montauban (France).

Late March: second trip to Paris. Stays at Hôtel Innova, 32 boulevard Pasteur; paints in studio rented him by Catalan sculptor Pablo Gargallo at 45 rue Blomet; neighbor of André Masson; friendly with Pierre Reverdy, Tristan Tzara.

Visits from Paul Rosenberg, Daniel-Henry Kahnweiler.

April 29–May 14: first solo exhibition in Paris, Galerie La Licorne, rue de la Boétie; organized by Dalmau; preface by Maurice Raynal.

May–June: leaves Paris.

Late June to October–November: Montroig.

1922 *Early April–late June*: Paris. Continues to live at hotel and work in rue Blomet studio. Georges Limbour, Antonin Artaud, Armand Salacrou, Michel Leiris, Roland Tual are almost daily visitors.

July–Christmas: Montroig.

November 1–December 20: exhibits at Salon d'Automne, Paris (*The Farm*, lent by Léonce Rosenberg).

1923 *January–June*: Paris, living at hotel and painting in studio, rue Blomet.

July–October: Montroig.

1924 *March–June*: Paris; both lives and works at rue Blomet.

May 5: attends premiere performance of Raymond Roussel's *Etoile au front*, with Desnos, others.

July–October: Montroig.

Autumn: Paris, first at Hôtel Namur, 39 rue Delambre; then in furnished room, rue Berthollet; finally in apartment lent him by Jean Dubuffet on rue Gay-Lussac.

Meets Paul Eluard, André Breton, Louis Aragon.

November: publication of First Surrealist Manifesto.

1925 *March–late June*: Paris, 45 rue Blomet.

June 12–27: first solo exhibition at Galerie Pierre, 13 rue Bonaparte; preface by Benjamin Péret (16 paintings, 15 drawings).

July–October: Montroig; thereafter returns to Paris.

October 24–November 14: Paul Klee exhibition at Galerie Vavin-Raspail impresses him.

November 14–25: exhibits in "La Peinture Surréaliste," Galerie Pierre; preface by A. Breton, R. Desnos (*Harlequin's Carnival*). Attends Surrealist banquet for St. Pol Roux.

Christmas: Barcelona (one week).

1926 Paris: 45 rue Blomet.

Works with Max Ernst on scenic devices for Ballets Russes production of *Romeo and Juliet*, first presented in Monte Carlo on May 4. Subsequently presented in Paris at Théâtre Sarah Bernhardt on May18. Surrealists create a scandal.

July 9: Death of his father at Montroig; leaves Paris for Montroig via Barcelona. Summer at Montroig.

August: excursion to Gerona with mother.

Sells first paintings to collector René Gaffé.

November 19–January 1, 1927: exhibits in International Exhibition of Modern Art, organized by Société Anonyme, Brooklyn, New York (2 paintings).

1927 *By January*: moves to Cîté des Fusains, 22 rue Tourlaque, where neighbors include Max Ernst, Jean Arp, Pierre Bonnard, Max Morice, and Belgian dealer Camille Goemans.

March: Barcelona (briefly).

June: Paris, rue Tourlaque.

Early July: Montroig until February of following year with trips to Barcelona.

First book illustration: for *Gertrudis* by Catalan poet J. V. Foix.

November 13 (for one day): solo exhibition, Galerie Pierre, transferred since 1926 to 2 rue des Beaux-Arts.

Meets James Johnson Sweeney.

1928 *Late February*: Paris, rue Tourlaque.

May 1–15: solo exhibition at Galerie Georges Bernheim & Cie, 109 faubourg St. Honoré (organized by Pierre Loeb); 41 works; everything sold.

Early May: two-week trip to Belgium and Holland; visits museums where impressed by Dutch painting.

Early June: returns to Barcelona.

June 22: first trip to Madrid.

July–August: Montroig.

December: returns to Paris.

Meets Alexander Calder.

1929 *February*: Barcelona.

March 20–25: exhibits with Spanish painters and sculptors residing in Paris, Botanical Gardens, Madrid.

April: Paris, rue Tourlaque.

May 11–23: solo exhibition, Galerie Le Centaure, Brussels, organized by Pierre Loeb.

September: Barcelona, Palma, Montroig.

October 12: marries Pilar Juncosa in Palma de Majorca.

November–December: returns to Paris; takes apartment at 3 rue François Mouthon.

1930 *March–May*: Paris, rue François Mouthon.

March 7–14 and 15–22: two solo exhibitions, Galerie Pierre (Dutch interiors, recent work).

March: exhibits in "La peinture au défi," at Galerie Goemans, 49 rue de Seine, Paris; preface by L. Aragon (collages).

May 7–22: solo exhibition, Galerie Pierre ("Papiers Collés").

July 17: birth of daughter, Dolores, Barcelona.

October 20–November 8: first solo exhibition in the United States, Valentine Gallery, New York.

November 28–December 3: exhibits with Masson, Ernst, Man Ray on occasion of premiere showing of Luis Buñuel's "L'Age d'Or" at Studio 28, Paris. Paintings lacerated by right-wing demonstrators.

December: Barcelona and Palma.

First lithographs for Tzara's *L'arbre des voyageurs*.

Meets Pierre Matisse.

Has 6 works on regular exhibition at Gallery of Living Art (Gallatin Collection), New York University, New York.

1931 *January/February–June*: Paris, rue François-Mouthon.

January 27–February 17: solo exhibition, Arts Club of Chicago.

May–June: exhibits in "L'Ecole de Paris," organized by Umělecká Beseda, Prague.

July: Palma.

August–October: Montroig.

November–December: Paris.

December 18–January 8, 1932: solo exhibition, Galerie Pierre ("sculptures-objects").

December 18–January 8, 1932: solo exhibition, Valentine Gallery, New York (drawings).

1932 *January*: decides to spend more time in Barcelona. Moves back to parents' house at 4 Pasaje del Credito; has apartment and studio on top floor.

January–April: designs curtain, costumes, sets, accessories for Ballets Russes de Monte Carlo production of *Jeux d'enfants*, commissioned and choreographed by Léonide Massine. Opens in Monte Carlo April 14. Miró spends March–April in Monte Carlo. Presented in Paris at Théâtre des Champs-Elysées thereafter.

Summer: Montroig. Calder visits; gives *Circus* performance.

September 27–November 27: exhibits in "Poesie 1932," at S.V.U. Mánes, Prague (3 works).

November 1–25: first solo exhibition at Pierre Matisse Gallery, New York (works on paper).

December 13–16: solo exhibition, Galerie Pierre Colle, Paris (recent work).

December: exhibits in "New Spanish Art," Galerie Flechtheim, Berlin (2 works).

1933 Barcelona, Pasaje del Credito; visits to Paris.

May 3: *Jeux d'enfants* presented at Barcelona Opera House (Liceo).

June 7–18: exhibits in "Exposition Surréaliste," Galerie Pierre Colle, Paris (4 objects).

June 9–24: exhibits in group exhibition, Galerie Pierre.

July: solo exhibition, Mayor Gallery, London.

August: Montroig.

October 27–November 26: Salon des Surindépendants with Surrealist group.

October 30–November 13: solo exhibition, Galerie Georges Bernheim, Paris, organized by Pierre Loeb (recent work). Miró to Paris.

December 29–January 18, 1934: solo exhibition, Pierre Matisse Gallery, New York (paintings).

First etchings, for Georges Hugnet's *Enfances*.

Meets Kandinsky.

1934 Barcelona, Montroig, visits to Paris.

March 16–30: solo exhibition, Arts Club of Chicago.

May 3–19: solo exhibition, Galerie des *Cahiers d'art*, Paris (early and recent work).

October 11: solo exhibition, Zurich Kunsthaus. Does not go because of current "events" in Spain.

1935 Barcelona, Montroig, visits to Paris.

January 10–February 9: solo exhibition, Pierre Matisse, New York (paintings, works on paper).

January 15–28: exhibits in "Kubisme-Surrealisme," Den frie Udstillings Bygning, Copenhagen (3 works).

February 24–March 31: exhibits in "Thèse, Antithèse, Synthèse," Kunstmuseum, Lucerne (4 works).

Spring: visits Brussels.

May 11–21: exhibits in "'Exposición Surrealista," Gaceta de Arte, Tenerife (7 works).

Late June: Paris.

July 2–20: solo exhibition, Galerie Pierre, Paris (recent work).

October: Montroig.

November 29–February 2 (1936): "Mezinárodní Výstara I" (group exhibition), Galerie S. V. U. Mánes, Prague (17 oils, 1 sculpture, 11 works on paper). Miró to Prague.

December: Barcelona.

1936 Barcelona.

February 15–22: exhibits in "Abstract + Concrete," Oxford (3 works).

February 12–March: "L'art Espagnol contemporain," Jeu de Paume, Paris (2 paintings).

March 2–April 19: exhibits in "Cubism and Abstract Art," Museum of Modern Art, New York (5 works).

May 22–29: exhibits in "Exposition Surréaliste d'objets," Galerie Charles Ratton, Paris (1 object).

June 10–15: exhibits in "Exposición de arte contemporaneo," Santa Cruz de Tenerife (8 works on paper).

June 11–July 4: "International Surrealist Exhibition," New Burlington Galleries, London. Miró to London.

June 26–July 20: exhibits with Picasso, J. González, L. Fernandez, Galerie des *Cahiers d'art*; Paris.

July: Montroig.

July 17–18: outbreak of Spanish civil war.

November: Miró to Paris to exhibit paintings before sending them to Pierre Matisse in New York. Caught in Paris by events in Spain. Stays at Hôtel Récamier, 3 place St. Sulpice.

November 30–December 26: solo exhibition, Pierre Matisse Gallery, New York (retrospective).

December 7–January 17, 1937: exhibits in "Fantastic Art, Dada, Surrealism," Museum of Modern Art, New York (15 works).

December 16: Miró's family joins him in Paris.

First monograph on Miró, by Shuzo Takiguchi (in Japanese).

Collaboration with J. V. Foix, Robert Gerhard on ballet *Ariel* (never produced).

1937 *January–February*: Paris, Hôtel Récamier.

January–May: paints on mezzanine at Galerie Pierre.

Attends life classes at Académie de la grande Chaumière.

March: moves to 98 boulevard Auguste Blanqui, building owned by architect Paul Nelson.

April–July: paints *The Reaper* (now lost) for Spanish republican pavilion, Paris World's Fair.

May 6–June 2: solo exhibition, Zwemmer Gallery, London. Miró to London.

May 28–June 15: solo exhibition, Galerie Pierre (early paintings bought up by Loeb from 1921 exhibition at La Licorne).

June 9–14: exhibits in Surrealist exhibition, Nippon Salon, Tokyo (7 works).

June 23: group exhibition, Galerie Pierre.

July 12: opening of Paris World's Fair.

July 30–October 31: exhibits in "Origines et développement de l'Art International Indépendant," Musée du Jeu de Paume, Paris (9 paintings).

September 1–13: exhibits in group exhibition organized by magazine *Liniens*, Den frie Udstillings Bygning, Copenhagen.

November: sits for Balthus's portrait of him and daughter, Dolores (until late January 1938).

December 3–10: solo exhibition, Galerie Pierre, Paris (paintings on Masonite).

1938 Paris: boulevard Auguste Blanqui, until at least April.

January–February: exhibits in "Exposition Internationale du

Surréalisme," Galerie Beaux-Arts, Paris (12 paintings, various objects).

Learns etching and drypoint in Marcoussis's studio and with Roger Lacourrière and Stanley Hayter.

April 18–May 7: solo exhibition, Pierre Matisse Gallery, New York (paintings on Masonite, gouaches).

May 4–28: solo exhibition, Mayor Gallery, London (paintings, gouaches).

First summer in Varengeville-sur-Mer, Normandy, in house lent him by Paul Nelson.

Paints fresco: "Birth of the Dolphin" in living room of Paul Nelson's house, Varengeville.

November 24–December 7: solo exhibition, Galerie Pierre, Paris.

1939	Paris: boulevard Auguste Blanqui.

January 26: Franco's troops occupy Barcelona.

March 8–12: solo exhibition, Galerie Pierre, Paris.

April 10–May 6: solo exhibition, Pierre Matisse Gallery, New York (paintings).

August: rents villa "Clos des Sansonnets" in Varengeville (until May 1940).

September: World War II starts.

1940 *January–May*: Varengeville.

Friendly with Georges Braque.

January: begins series of gouaches, the Constellations.

March 12–31: solo exhibition, Pierre Matisse Gallery, New York (early paintings).

Late May–early June: bombing of Normandy: returns to Spain via Paris, Perpignan; settles in Palma.

1941 Palma; summer in Montroig.

March 4–29: solo exhibition, Pierre Matisse Gallery, New York.

Finishes the 23 Constellations.

November 18–January 11, 1942: first major retrospective exhibition, Museum of Modern Art, New York; organized and with monograph by James Johnson Sweeney.

1942 *February*: Palma.

Returns to Barcelona. Takes apartment at 9 calle Folgarolas and keeps studio at 4 Pasaje del Credito.

July 27–August 2: solo exhibition, The Lyceum, Havana, Cuba (watercolors and prints).

Summer: Montroig.

December 8–31: solo exhibition, Pierre Matisse Gallery, New York (paintings, works on paper).

1943 *March 24–April 7*: solo exhibition, Arts Club of Chicago.

October 19–November 15: solo exhibition, Galerie Jeanne Bucher, Paris (paintings, works on paper).

1944 *May 3–June 3*: solo exhibition, Pierre Matisse Gallery, New York (paintings).

May 27: death of mother.

First ceramics with Llorens Artigas.

First bronze sculptures.

"Barcelona series" of lithographs.

1945 *January 9–February 3*: solo exhibition, Pierre Matisse Gallery, New York (ceramics and Constellations).

March 27–April 28: solo exhibition, Galerie Vendôme, Paris.

1946 *January 24–March 3*: exhibits with Dalí, Gris, Picasso in "Four Spaniards," Institute of Contemporary Art, Boston.

1947 *February–October*: first visit to United States. Spends nine months in New York, painting mural for Cincinnati Terrace Hilton Hotel in studio lent him by American painter Carl Holty. Thomas Bouchard films him painting.

March: approached by Geneva-based publisher Gérald Cramer to illustrate bibliophile edition of Paul Eluard's *A toute épreuve* (originally published in 1930).

Etchings at Stanley Hayter's Studio 17 temporarily moved from Paris to New York during the war. Illustrations for Tristan Tzara's *Antitête*. Meets Jackson Pollock.

May 13–June 7: solo exhibition, Pierre Matisse Gallery, New York (paintings, works on paper).

Spring: exhibits in "Exposition internationale du Surréalisme," Galerie Maeght, Paris.

November 4–December 31: exhibits in "Mezinárodní Surrealismus" (group exhibition), Prague (1 oil, 2 gouaches).

November: returns to Barcelona from New York.

1948 Barcelona, visits to Paris.

March 3–April 4: mural for Cincinnati Terrace Hilton Hotel exhibited, Museum of Modern Art, New York.

March 16–April 10: solo exhibition, Pierre Matisse Gallery, New York (paintings, works on paper).

September 14–October 17: "Picasso, Gris, Miró," San Francisco Museum of Art.

October 26–November 28: exhibit travels to Portland, Oregon.

November 19–December: first solo exhibition at Galerie Maeght, Paris (paintings, ceramics).

1949 *April 9–May 3*: solo exhibition, Galerie Blanche, Stockholm.

April 19–May 14: solo exhibition, Pierre Matisse Gallery, New York (early paintings).

April 21–May 29: retrospective exhibition, Bern Kunsthalle.

April 23–May 6: solo exhibition, Galerias Layetanas, Barcelona, organized by critic R. Santos Torroella (57 paintings, drawings, prints, ceramics from Barcelona collections).

June 14–July 17: "Joan Miró–Otto Apt," collection of the Kunstverein, Basel Kunsthalle.

December 6–31: solo exhibition, Pierre Matisse Gallery, New York (sculpture, works on paper).

Publication of major monograph on the artist by J. E. Cirlot (Barcelona, Eds. Cobalto).

Finishes maquette for *A toute épreuve*.

1950 *May–June*: solo exhibition, Galerie Maeght, Paris (sculptures, objects, prints).

November: solo exhibition, Galerie Blanche, Stockholm.

Executes mural painting for Harkness Graduate Center dining room at Harvard University, Cambridge (commissioned by Walter Gropius).

1951 *March 6–31*: solo exhibition, Pierre Matisse Gallery, New York (paintings, sculpture).

September 1: solo exhibition, Galleria del Cavallino, Venice.

October–November: "Calder-Miró," Contemporary Arts Association, Houston.

November 20–December 15: solo exhibition, Pierre Matisse Gallery, New York (early paintings 1916–23).

December 8–21: solo exhibition, Galleria del Naviglio, Milan.

1952 *January 28–February 16*: solo exhibition, Kootz Gallery, New York.

March: visits Paris; sees Jackson Pollock exhibition, Studio Paul Facchetti.

April 15–May 17: solo exhibition, Pierre Matisse Gallery, New York.

1953 *June–August*: solo exhibition, Galerie Maeght, Paris.

November 17–December 12: solo exhibition, Pierre Matisse Gallery, New York (recent paintings).

Begins work in Gallifa with Llorens Artigas on large series of ceramics.

1954 *January–February*: retrospective exhibition, Kaiser-Wilhelm Museum, Krefeld; travels to Stuttgart, Berlin.

March: visits Paris.

June 19–October 17: Venice Biennial, grand prize for graphic work.

Continues work in ceramics.

1955 Continues work in ceramics in Gallifa.

Invited to execute two walls for UNESCO headquarters, Paris.

July 15–September 18: exhibits in Documenta I, Kassel (6 works).

1956 *January 6–February 7*: retrospective exhibition, Palais des Beaux-Arts, Brussels; travels to Stedelijk Museum, Amsterdam (February–March) and Kunsthalle Basel (March 24–April 29).

June-August: solo exhibition, Galerie Maeght, Paris (ceramics).

Autumn: moves to Palma de Majorca, into villa Son Abrines and large studio designed by Josep Lluis Sert. Sells house at Pasaje del Credito.

September: begins work with Artigas on ceramic walls for UN-ESCO building.

December 4–30: solo exhibition, Pierre Matisse Gallery, New York (ceramics).

1957 Palma; frequent trips to Barcelona, Paris, Montroig.

March: visits Altamira cave paintings with Artigas in preparation for UNESCO walls.

April: exhibition of complete graphic work, Kaiser-Wilhelm Museum, Krefeld; travels to Berlin, Munich, Cologne, Hanover, Hamburg.

May 13–June 7: solo exhibition, Pierre Matisse Gallery, New York.

August: begins work with Jacques Dupin on major monograph.

1958 *April 17–October 19*: exhibits in "50 Years of Modern Art," World's Fair, Brussels (5 works).

April 25–June 5: exhibition of *A toute épreuve*, Galerie Berggruen, Paris.

July–September: exhibits in group exhibition, Musée de l'Art Wallon, Liège.

Autumn: completes UNESCO walls; inaugurated November.

November 4–29: solo exhibition, Pierre Matisse Gallery, New York ("peintures sauvages," 1934–1953).

1959 *January 20–March*: presentation of the Constellations, Galerie Berggruen, Paris; text by André Breton.

March 18–May 10: retrospective exhibition, Museum of Modern Art, New York; travels to Los Angeles County Museum of Art (June 10–July 21).

April 21: second trip to United States.

Spring: solo exhibition, Pierre Matisse Gallery, New York (Constellations)

July 11–October 11: exhibits at Documenta II, Kassel.

Receives Guggenheim International Award for UNESCO walls.

1960–61 Executes ceramic wall with Artigas for Harkness Graduate Center, Harvard University, to replace earlier painting (see 1950). Wall exhibited in Barcelona (February 1961), Paris (February 1961), and New York (April 1961) before installation in Cambridge.

1961 *February 21–April 1*: "Calder-Miró," Perls Galleries, New York.

April: solo exhibition, Galerie Maeght, Paris (recent paintings).

June: solo exhibition, Galerie Maeght, Paris (mural paintings).

June: solo exhibition, Musée de l'Athenée, Geneva (prints and ceramics).

November: third visit to the United States.

November 7–25: solo exhibition, Pierre Matisse Gallery, New York (paintings, ceramics).

1962 *June–November*: retrospective exhibition, Musée National d'Art Moderne, Paris.

1963 *June–July*: solo exhibition, Galerie Maeght, Paris (ceramics).

November 5–30: solo exhibition, Pierre Matisse Gallery, New York (ceramics).

1964 *July 28*: inauguration of Fondation Maeght, Saint-Paul-de-Vence, with sculptures and labyrinth by Miró.

Execution (with Artigas) of ceramic mural for Ecole Supérieure de Sciences Économiques, Commerce et Administration Publique, St. Gall, Switzerland.

Summer: exhibits at Documenta III, Kassel.

August 27–October 11: retrospective exhibition Tate Gallery, London.

October 21–December 6: retrospective exhibition Zurich Kunsthaus.

1965 *May 4*: solo exhibition, Galerie Maeght, Paris (paintings on cardboard).

October–November: solo exhibition, Pierre Matisse Gallery, New York (paintings on cardboard).

November: fourth trip to the United States (New York, Chicago).

1966 Executes with Artigas large ceramic sculpture *Venus of the Sea* for underwater grotto, Juan-les-Pins.

Spring: solo exhibition, Marlborough Gallery, London.

August 26–October 9: retrospective exhibition, National Museum of Art, Tokyo.

October 20–November 30: exhibit travels to National Museum of Modern Art, Kyoto.

First trip to Japan; meets poet Takiguchi for first time.

First monumental bronze sculptures.

1967 *April–May*: solo exhibition, Galerie Maeght, Paris (solar and lunar birds).

Carnegie International Grand Prize for Painting.

May 18: mural installed at Solomon R. Guggenheim Museum, in honor of Harry F. Guggenheim's wife, Alicia.

November: solo exhibition, Pierre Matisse Gallery, New York (solar and lunar birds).

1968 *March 27–June 9*: exhibits in "Dada, Surrealism and Their Heritage," Museum of Modern Art, New York; travels to Chicago, Los Angeles.

June: honorary degree, Harvard University.

Fifth and last trip to the United States.

July–September: retrospective exhibition, Fondation Maeght,

Saint-Paul-de-Vence; travels to Hospital de la Santa Cruz, Barcelona (November–January 1969).

1969 *March 15–May 11*: retrospective exhibition, Haus der Kunst, Munich.

May: solo exhibition "Miró otro," organized by College of Architects, Barcelona.

November: second trip to Japan.

1970 *May–June*: solo exhibition, Pierre Matisse Gallery, New York (sculptures).

June 4: solo exhibition, Galerie Maeght, Paris (sculptures).

Monumental ceramic mural (with Artigas) for airport, Barcelona.

Three monumental ceramic murals and water garden for gas pavilion, World's Fair, Osaka.

December–January 1971: solo exhibition, Galleria Arte Borgogna, Milan.

1971 *June 26–August*: solo exhibition, Casino Principal, Knokke-le-Zoute.

October 3–November 28: "Miró Sculptures," Walker Art Center, Minneapolis; travels to Cleveland Art Museum (February 2–March 12, 1972), Chicago Art Institute (April 15–May 28, 1972).

October–November: solo exhibition, Galerie Maeght, Paris (works on paper).

1972 *January*: "Homage to Joan Prats," Galería Vandrès, Madrid (lithographs). Miró to Madrid.

February 1–March 12: "Miró Bronzes," Hayward Gallery, London.

March–April: solo exhibition, Pierre Matisse Gallery, New York (works on paper).

May: solo exhibition, Sala Gaspar, Barcelona (paintings, sculpture).

June 4–July 30: retrospective exhibition of sculpture, Kunsthaus, Zurich.

September 30–October 29: retrospective exhibition, Liljevalchs Konsthall, Stockholm.

October 27–January 21, 1973: "Joan Miró: Magnetic Fields," Solomon R. Guggenheim Museum, New York.

1973 *April*: solo exhibition, Galerie Maeght, Paris (paintings on burlap and tapestries).

April 14–June 30: solo exhibition, Fondation Maeght, Saint-Paul-de-Vence (sculptures, creamics).

Summer: ballet *L'oeil-oiseau*, scenario by J. Dupin, music by Patrice Mestral, sets by Miró, Fondation Maeght.

October–November: solo exhibition, Pierre Matisse Gallery, New York (paintings on burlap and tapestries).

October 9–January 27, 1974: "Miró in the Collection of the Museum of Modern Art," Museum of Modern Art, New York.

November 15–January 15, 1974: "Miró 80 Vuitanta" (80th birthday celebration), College of Architects, Palma.

1974 *May*: solo exhibition, Pierre Matisse Gallery, New York.

May 17–October 13: retrospective exhibition, Grand Palais, Paris; complete graphic work at Musée d'Art Moderne de la Ville de Paris; travels to Gulbenkian Foundation, Lisbon.

Inauguration of *Oiseau lunaire* (Lunar Bird), Square Robert Desnos (formerly 45 rue Blomet), Paris.

1975 *April–May*: solo exhibition, Pierre Matisse Gallery, New York (paintings, sculpture).

June 10: unofficial opening of Fundació Joan Miró–Centre d'Estudis d'Art Contemporani, in J. L. Sert building, Montjuïc Park, Barcelona.

Death of Franco.

December–January 1976: retrospective exhibition, Galeria Maeght, Barcelona.

1976 *April–May*: solo exhibition, Pierre Matisse Gallery, New York.

June 18: Official inauguration of Fundació Joan Miró. Exhibition of 475 drawings donated from artist's collection.

Pavement "Pla de Os," on Las Ramblas, Barcelona.

Ceramic mural for IBM Laboratories, Barcelona.

Prepares ceramic mural for Wilhelm Hack Museum, Ludwigshafen.

1977 *July –September*: solo exhibition, Musée d' Art Moderne, Céret (paintings, sculptures, prints).

Ceramic mural for University of Kansas, Wichita.

1978 *Spring–Summer*: first presentations of theater piece: *Mori el Merma*, Barcelona, Berlin, Rome, Belgrade.

May 4–July 23: retrospective exhibition, Museo Español de Arte Contemporáneo, Madrid. Retrospective of prints, Salas de la Dirección General del Patrimonio Artístico, Madrid.

September–October: retrospective exhibition, Sa Llotja, Palma.

September 20–January 22, 1979: "Dessins de Miró," Musée National d'Art Moderne, Centre Georges Pompidou. Presentation of *Mori el Merma*.

October–December: "100 Sculptures, 1962–68," Musée d'Art Moderne de la Ville de Paris.

November: solo exhibition, Galerie Maeght, Paris (paintings).

November 21–December 16: solo exhibition, Pierre Matisse Gallery, New York (recent work).

Monumental sculpture (*Couple d'amoureux*) for La Défense, Paris.

Ceramic mural for Victoria Museum, The Netherlands.

1979 *January*: solo exhibition, Seibu Art Museum, Tokyo, traveled to Nagoya, Fuknoto, Osaka.

March: "Miró Drawings," Hayward Gallery, London.

May 26/27–September 30: retrospective exhibition, Or Sanmichele, Florence (paintings), Museo Civico, Siena (prints), Palazzo Pretorio, Prato (sculpture).

June–July: solo exhibition, Galeria Maeght, Barcelona (recent prints and 4 sculptures).

July 7–September 30: retrospective exhibition, Fondation Maeght, Saint-Paul-de-Vence.
Doctor honoris causa, Barcelona University.

1980 *March 18–April 27*: "Joan Miró: The Development of a Sign Language," Washington University Gallery of Art, St. Louis; travels to David and Alfred Smart Gallery, University of Chicago (May 15–June 18).

March 20–June 8: retrospective exhibition, Joseph Hirshhorn Museum and Sculpture Garden, Washington, D.C.; travels to the Albright Knox Art Gallery, Buffalo, New York (June 27–August 15).

May–August: retrospective exhibition, Museo de Arte Moderno, Mexico City; travels to Museo de Bellas Artes, Caracas (September 7–November 9).

May 13–June 7: solo exhibition, Pierre Matisse Gallery, New York (sculpture, drawings).

Ceramic mural for Palacio de Congresos y Esposiciones, Madrid.

1981 *April 20*: unveiling of monumental sculpture, *Miss Chicago*, Chicago, Illinois.

September: costumes, sets for ballet "Miró L'Ucello luce," Venice (scenario by Jacques Dupin, music by Sylvano Bussotti, choreography by Joseph Russillo).

October 27–December 6: "Miró Milano": 7 exhibitions in museums and galleries in Milan.

November 6: unveiling of two monumental sculptures in Plaza de Pio XII and gardens of S'Hort del Rei, Palma de Majorca.

November 17–December 19: solo exhibition, Pierre Matisse Gallery, New York (early drawings, collages).

1982 *January*: "Miró L'Ucello luce" (see 1981), Florence.

April 21–June 27: "Miró in America," Museum of Fine Arts, Houston, Texas. Unveiling of monumental sculpture *Personnage et Oiseaux*, Houston.

June 5–September 10: retrospective exhibition, Fundació Joan Miró, Barcelona.

June 24: unveiling of monumental sculpture *Dona i Ocell* (Woman + Bird), Parc Escorxador, Barcelona.

1983 *April*: unveiling of monumental sculpture in patio of Ayuntamiento, Barcelona.

May–June: "Joan Miró: Anys 20" (paintings from the 1920s), Fundació Joan Miró, Barcelona.

May 26: solo exhibition, Galerie Adrien Maeght, Paris (sculptures, gouaches).

September 24–November 13: solo exhibition (sculpture), Karlsruhe, Städtische Galerie.

December 25: death of Joan Miró at Palma de Majorca.

December 29: funeral and burial in family vault, Montjuïc Cemetery, Barcelona.

I

Barcelona and
Montroig, 1915–19

1

[Autobiographical sketch].
Letter to Jacques Dupin, 1957[1]

In 1956, the French poet and critic Jacques Dupin
was commissioned by Harry N. Abrams to write a
monograph on Miró.[2] Over the next few years,
Dupin spent frequent and prolonged periods with the
artist, interviewing him about his life and work.
Although most of the biographical information was
collected orally, in the following letter Miró provided
the author with details about his early youth.

Since this letter contains rare firsthand references
to the artist's childhood—his family context, his
personality, his earliest school experiences, and his
precocious attachment to the world of nature—it
seems appropriate to present it at the beginning of
this selection, even though it was written at a much
later date. The first part of the letter concerns
practical matters and is of no interest here.

To Jacques Dupin. Montroig, October 9, 1957

Childhood

Very poor student. Had little to do with my classmates who called me an "egghead." Quiet, rather taciturn, and a dreamer, I understood nothing about the practical sciences. I was better in geography; often I guessed precisely the answer to the professor's question by pointing a stick at the map at random. I aspired to be a great engineer or a great doctor, but would never accept mediocrity.

My school was at number 13 calle Regomir, in Barcelona. The numbers 3 and 9 have always played a magical role in my existence. I was born in '93; during his lifetime my father bought a family vault in the cemetery in Barcelona, and these two figures are written on all the documents. I was born at 9 o'clock. I had a very strict upbringing. . . .

To escape from the daily drudgery, I took drawing lessons at the same school after the regular school day was over. My teacher's name was Civil. That class was like a religious ceremony for me; I washed my hands carefully before touching the paper and pencils. The implements were like sacred objects, and I worked as though I were performing a religious rite. This state of mind has persisted, even more pronounced. I was unable to copy a human face from a reproduction; however, I drew the leaves of trees with loving care.

Later, I went to a specialized business school. And again, to escape, I took art classes at La Lonja, with Urgell. Later, following my father's advice—who as a former clockmaker wanted to interest me in the goldsmith's trade—I took courses with Pasco, also at La Lonja, who taught the decorative and applied arts. Once I had finished business school, my family got me employed in a large hardware and chemicals store: Dalmau Oliveres. Very unhappy, and more of a dreamer than ever, with a spirit of rebellion at the same time, I continued to study with Pasco for a short while, but then I gave up everything and decided to play for all or nothing. Because of my nervous tension, I fell ill. In order to earn a living and paint at the same time, my family advised me to become a monk or a soldier. . . .

My mother had a strong personality and was very intelligent. I was always very close to her. She cried when she saw I was on the wrong track. But later, she took a great interest in my work.

My father was very realistic and absolutely the opposite of my

mother. When I went hunting with him, if I said the sky was purple, he made fun of me, which threw me into a rage.

I have only a vague memory of my grandparents. I know that my maternal grandfather was very fond of me. Starting as a simple cabinet-maker's assistant, he finally had his own business. He did not know how to read or write and he only spoke the Majorquin dialect.[3] He loved to travel and took the slowest trains in order to get his money's worth. He went as far as Russia, which at that time was really something. My maternal grandmother was very intelligent and romantic.

My paternal grandparents had no personality; they were black-smiths and peasants, and just good people. . . .

I am very fond of my sister, even though she is my exact opposite. I always look ahead and she looks back. She has a big heart. When we were young, since I didn't have a cent to buy paints and had to go long distances on foot because I couldn't afford the tram, she used to slip me a little money.

2

Letters to E. C. Ricart and J. F. Ràfols, 1915–19[1]

This first group of seventeen letters, written between 1915 and 1919 to his friends Ricart and Ràfols, shows Miró's developing personality between the ages of twenty-two and twenty-six. They reveal a young man who is absolutely sure of his vocation as an artist and whose cultural background, ambitions, technical concerns, and combative spirit are surprising, in contrast to the image of the artist—shy, unreflective, almost naive or primitive—that was broadly accepted once he became a public figure.

These early letters show Miró to be a leader in the battle against the social, political, and academic elements that then dominated the Barcelona cultural scene. They also contain long passages of reflection on what the future of art should be, thus providing invaluable insights into his specific goals. At the same time, they describe the artist's progression toward these objectives, as he discusses his own technical and stylistic evolution.

Finally, they reveal certain aspects of Miró's personality (his strong moral fiber, his self-imposed discipline, his deeply religious spirit, and his almost pantheistic respect for nature already as a young man), his cultural background (authors he has read, exhibitions he has seen, the artists he admires) and his knowledge of current international styles (Impressionism, Cubism, Fauvism, Futurism). They therefore present an extremely rich panorama of Miró's native context.

As these letters show, Barcelona represented a stagnant and stifling aesthetic milieu. But it also gave

the artist a sense of his Catalan heritage and identity, and a will to go beyond provincialism in order to forge a universal, but nonetheless Catalan, art.

To E. C. Ricart. Caldetas,[2]
January 31, 1915

From a village lovingly kissed by our well-sung Mediterranean and made fertile by a powerful light that descends upon this countryside, bringing alive enamel and stonework, I greet you and wish you good health.

From this lovely village of Caldetas I will continue our spiritual conversation interrupted since your last letter, written on Holy Innocents' Day.[3] . . .

Up to now I have been working hard, but for the past several days I have been feeling listless. I suppose this is caused by my extreme concentration during my last period, which revealed new problems, hitherto unknown to me, that must be solved. I feel that a new period of work may come once this lethargy has passed. . . .

"He who always looks ahead may sometimes falter, but he then returns with new strength to his task" (dixit Goethe).

During these days of grace I have also seen the trees and mountains joyously bedecked with the bridal finery of snow which covers them as it falls from the sky. This finery is gone again now: all nature once again spreads her maternal greenery.

Now, I will close that parenthesis and continue to answer your letter. To begin with, I read in one paragraph that *we will be seeing each other at the Circle*.[4] Are you still planning to enroll in the list of *Members* (in Castilian Spanish and with a capital M) of the *Circulo* (again, the Castilian word)? I feel that your good sense will not permit such a thing. Are you not aware of the repugnant atmosphere of *gambling* and *cocottes* that earns this place its livelihood while masquerading under the word "*Artistic*" (the word they use in Madrid) and aiming to deceive young and *distinguished* artists (or whatever they may be) in order to hide their repugnant and contagious sores?

Strong men like us don't have to let ourselves become involved in this, my friend. Some fellows we know have fallen for this humbug in all good faith; they have gone there to shine in those salons and have gloved servants in evening clothes open the doors and bow respectfully to them. Believe me, Ricart, and I am telling you this as a good friend, that no matter what you may be led to believe, you should continue to take shelter and refuge beneath the simple roof (what does it matter if it is simple, so long as it is beautiful) of the house that venerates our patron, Saint Luke,[5] and which is the mother of an entire generation of

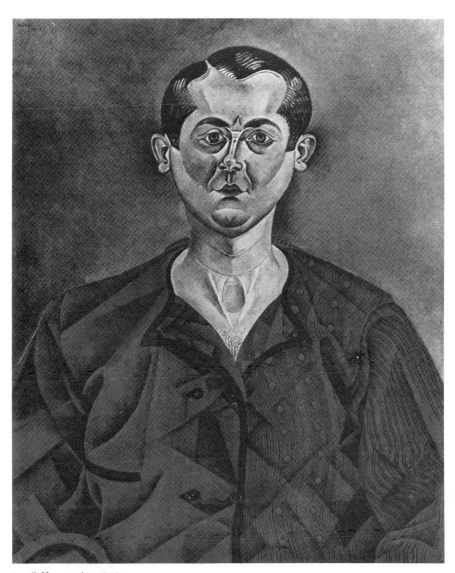

1 *Self-portrait*, 1919.

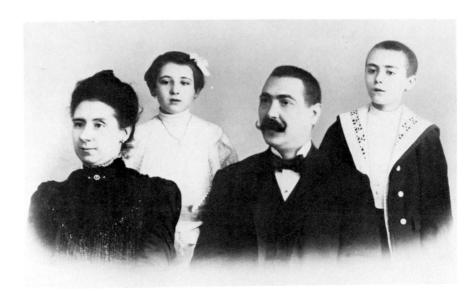

2 Miró with his parents and sister Dolores.

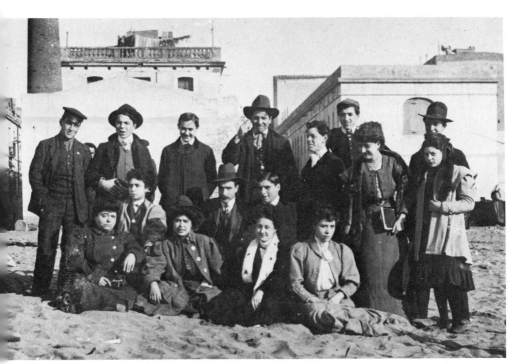

3 Group of students from Galí's art school on the beach near Barcelona, ca. 1912–14 (Miró standing, third from left).

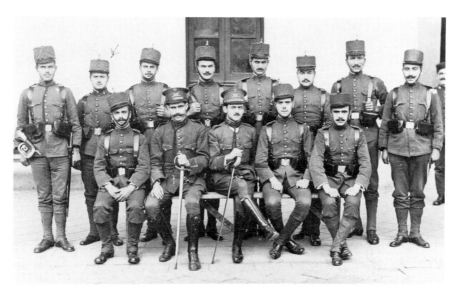

4 Miró during military service, 1915 (Miró standing, second from left).

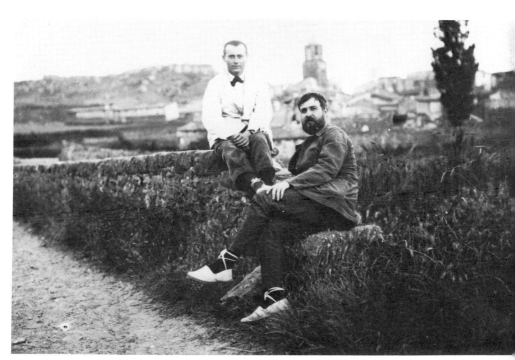

5 Miró and Ivo Pascual, Prades, ca.1917.

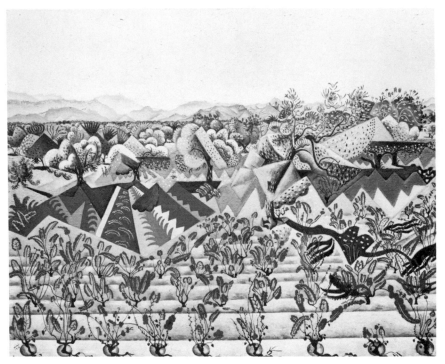

6 *Vines and Olive Trees*, 1919.

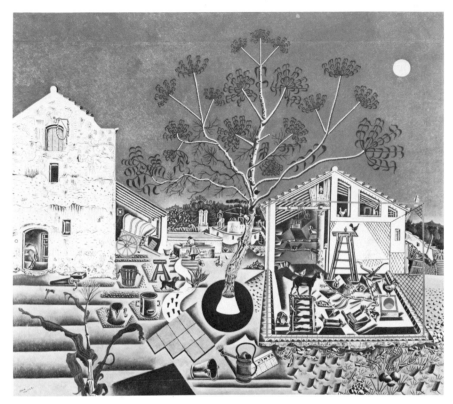

7 *The Farm*, 1921–22.

8 Miró's family's farm at Montroig.

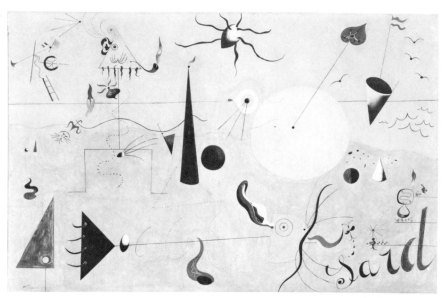

9 *Catalan Landscape (the Hunter)*, 1923–24.

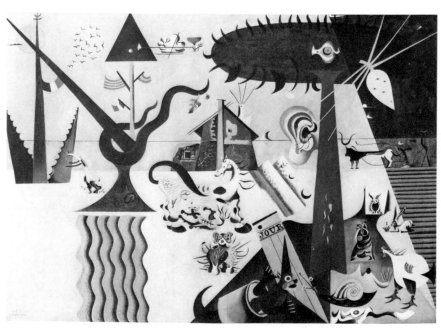

10 *The Tilled Field*, 1923–24.

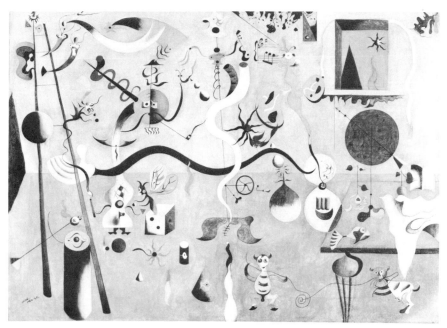

11 *Harlequin's Carnival*, 1924–25.

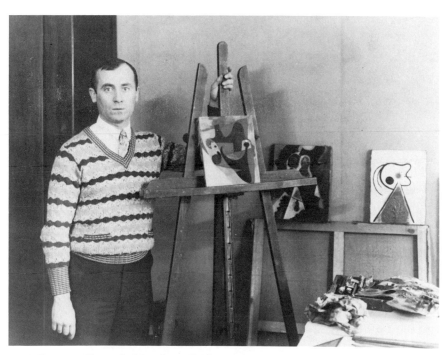

12 Miró, rue François Mouthon, Paris, 1931.

13 Miró, Malaga, 1935 (?).

true artists. Let us, the younger generation, gather around that image of the Sacred Heart that presides over the salon and valiantly continue our task of a truly Catalan artistic Renaissance, truly a child of this Catalonia so chastised by the men of Iberia.[6]

My serene friend, I see that I must argue with you today, but controversy is part of being good friends.

You advise me to remain pessimistic about my love life. "It is difficult for pain to last, soothed by sweet memories."

Mortals cannot aspire to complete happiness. That would be rebelling against God who was a man and suffered for us.

"Pain is the inseparable brother of pleasure"; the one cannot exist without the other.

"La souffrance, c'est le sacrement de la vie."[7]

Thus spoke Socrates and the modern Rodin. Let us serenely continue to be visionaries of life, my friend. When a thorny bush rips at the flesh we must think, "I was so happy and this cannot be!" Every wound serves as a reminder that we are mortal beings, doomed never to know complete happiness.

That's enough preaching (and about time!).

To E. C. Ricart. Barcelona, October 7, 1916

I worked hard this summer and really a lot. I am in Barcelona now (dressed as a soldier).[8] Incidentally, they are driving me crazy, so much so that it is impossible to do anything else. Still, I believe, God willing, that soon these infuriating army men will permit me some hours for painting and we will start the winter season in terrific form. What is my plan thereafter? To work very hard and live a full life wherein strolling in the mountains or gazing at a beautiful woman, reading a book or listening to a concert will suggest visions of forms, rhythms, and colors which will shape and nourish my spirit so that its voice will be stronger. And, above all, may God grant that I never lack for Holy Anxiety. It is thanks to her that men progress.

We have a splendid winter ahead. Dalmau is showing the Simultaneists: Laurencin, . . ., Gleizes, who wrote the book on cubism together with Metzinger. The classic Impressionists and the modern "Fauves" will be at the French exhibition.[9]

To E. C. Ricart. Montroig
[August 1917]

Something memorable about my life which you should know: as a soldier in these days of martial law I have been earning 40 pesetas a day plus food. In other words, I have begun to earn a living—I could even get married. When will you earn as much from your drawings! It is more profitable to be a soldier than a painter!

I have painted quite a lot, very interesting things: landscapes, still lifes, figures. . . .

The solitary life at Siurana,[10] the primitivism of these admirable people, my intensive work, and especially, my spiritual retreat and the chance to live in a world created by my spirit and my soul, removed, like Dante, from all reality (do you understand all this?) I have withdrawn inside myself, and the more skeptical I have become about the things around me the closer I have become to God, the trees, the mountains, and to Friendship. A primitive like the people of Siurana and a lover like Dante.

Enough of all that. You, mortal in the real world, are you tranquil?

I have received a marvelous letter from Artigas giving the details of the latest revolt (strikes in the suburbs of Barcelona).[11] He is a very charming and intelligent fellow.

To J. F. Ràfols. Montroig,
September 13, 1917

We are finishing up the summer and I haven't wanted to write before now, at the end.—I imagine that our friend Ricart must have told you that I have worked a lot this summer and visited many moutains and small villages.—Now I am waiting patiently for the end of the month when I will go to Barcelona and pick up my rifle again for three months, for the last time (Thank God!).

Among the things I have done this summer, I think there should be something which will interest you. I have done only landscapes except for one painting of a girl from Siurana and another of some seated women playing cards.

Everything else is landscape; the feeling of each one is very different and so is the execution. It is remarkable—and very sadly so—to see

how a man reacts the same whether he lives in a landscape where town and mountains are bitterly structured or when he observes a landscape in which everything is lyrical color and music. Everything moves him equally, he speaks in the same way, he is the same, and he paints the same; with the same feeling that he would paint Majorca, for example, he paints Toledo, changing only the "photographic" or realistic details. Apart from that he remains the same; he eats the same, walks the same, speaks the same.—The opposite sort of man sees a different problem in every tree and in every bit of sky: this is the man who suffers, the man who is always moving and can never sit still, the man who will never do what people call a "definitive" work. He is the man who always stumbles and gets to his feet again.—Not the other. He walks calmly; when he is tired he sits down and his works are of absolute perfection (!) both in drawing and color, faultless but empty. The other man is always saying *not yet, it is still not ready,* and when he is satisfied with his last canvas and starts another one, he destroys the earlier one. His work is always a new beginning, as though today he was just beginning to paint.—

For me, the Art of the Future, after the grandiose French Impressionist movement and the liberating post-Impressionist movements, Cubism, Futurism, Fauvism, all tend to emancipate the artist's emotions and give him absolute freedom.

I believe that tomorrow there will be no school ending in "ism" and we will see a canvas of a racing locomotive painted in a style that is completely different from a landscape painted at 12 noon.[12] To a free spirit, everything in life produces a different sensibility and what we would like to see on the canvas is the vibration of a spirit, a very heterogeneous vibration.—All the modern schools have waved their banners and, for Impressionism—"peindre n'importe quoi"[13]—it was to paint light, for Fauvism to synthesize, for Futurism to paint movement. To paint a big-city street with tall buildings, the sounds of honking horns (don't sounds contribute to the vision of things too?), with people rushing about madly, and with streetcars and subways, you cannot use the Impressionist style; and this landscape I see before me as I am writing: olive and carob trees and vines and lots of light, produces an emotion totally different than a New York street.—After the contemporary liberation of the arts we will see artists under no flag emerge with the strings of their spirits vibrating to different kinds of music.

We cannot use Impressionism when we paint a huge street in New York, nor can we use Futurism when we paint a beautiful woman who is before us. May our brush keep time with our vibrations.

Have you been working much in the studio?[14] I would be pleased if you were able to use it. Let's see if this winter we can do the same thing we did last year—get together to work with a model.

To E. C. Ricart. Barcelona
[October 1, 1917?][15]

I am writing from Barcelona now, already wearing the hateful disguise of a soldier. But what can you do? . . .

Don't worry about whether I have enough to fill the space at Dalmau's. Before leaving Montroig I set up the 14 canvases I did this summer in front of me; I find them interesting although all of them are not complete. I think I'll start doing good work when I'm 70.

Yesterday, Sunday, when I got off the train at 12 midnight and was strolling slowly down Paseo de Gracia, I ran into our friend Sunyer.[16] We were together till 2 A.M. with him chattering and communicating his enthusiasm about your carob trees and your "carobs" (i.e., girls).

A lot about the "Vilanova School" and a lot about Ricart in the paragraph where you tell me what you have been doing this summer.[17] I am really anxious to see what you have done, you and Sala. I think that in your "School" there is the synthesis of what will be pure painting in the future, stripped of all pictorial problems and with the harmonious vibration of the pulsations of the spirit. As I told Ràfols in a letter—I think that after the grandiose French Impressionist movement which sang of life and optimism, and the post-Impressionist movements, the courage of the Symbolists, the synthesism of the Fauves, and the analysis and dissection of Cubism and Futurism, after all that we will see a free Art in which the "importance" will be in the resonant vibration of the creative spirit. This modern analytical trend will have brought the spirit to a radiant Freedom.—Since the spirit will be strong and free, if, when we start a canvas, we still commit the error of wanting to rally around some flag, instinct will take over, despite our very selves; like Cézanne who wanted to do "serious" painting and win "medals" at official exhibitions.

I am anxiously waiting to savor the Futurist writings against outmoded Rome and its moonlight nights.[18] Down with all sentimentalism, sickly light of the half-moon, weeping sunsets in canary yellow, and clouds of dark red feathers, twilights, sun rays gilding a mountain

for a last few moments. Down with all that, made by crybabies! Let us be masculine. Let's transplant the primitive soul to ultramodern New York, inject his soul with the noise of the subway, of the "el,"[19] and may his brain become a long street of buildings 224 stories high that scorns the woman who moves there like a snake and surrenders to an insatiable female. Down with Rome, down with Venice and all that has been. Let the weepers blubber over the past and leave us to stroll through the great city of New York.

Here, in Barcelona, we lack courage. When the critics who are most interested in the modern and ultramodern movements find themselves in front of an outmoded academic, they melt and end up speaking well of him.

No one dares proclaim before those gentlemen who go to the opera and those young ladies whose low-cut necklines reveal flesh that seems painful rather than sensuous, no one dares proclaim that the operas of the lachrymose Italians, Rosetti, etc., are prostitutes compared with the great, vibrant, masculine art of the "moixiganga" and the "Macariana."[20] No one dares insult our museum![21]

We the younger generation, could get together and exhibit every year, all together, under the name of the "Chrome Yellow Salon,"[22] for example, and pronounce virile manifestos.—Because otherwise there is no salon that will have us. The members of the "Salon de les Arts i els Artistes" are still perfect "pompiers."[23] We have to be men of action.

. . .

I plan to exhibit in February.

To E. C. Ricart. Barcelona, May 11, 1918

Yesterday was the opening of the exhibition. The "Courbet" group, considering our lack of preparation, looked good, my friend.[24] Nonell was tremendous, Sunyer admirable, Delaunay musical.[25]

We have to prepare for next year—the Courbet group has to step over all the rotting bodies and fossils.[26]

Very amusing, according to Llorens[27] who was at the opening for the authorities and delegates and board members.

The Governor indignant when he went into our room. Upon seeing our paintings, "Kilos" Vázquez[28] made this lapidary observation, "If this is painting, then I am Velázquez."

It is raining here and that is very irritating. At the beginning of next week Ràfols and I will start a nude of Trini. I am going to do a 1.20m × 1.52m canvas. We shall see what comes out.[29]

To E. C. Ricart. Montroig, July 16, 1918

I started working only a few days ago.—I have been at Montroig since the beginning of the month; the first week I was here I didn't want to think about dirtying a canvas or about anything at all.—In the morning to the beach to lie belly up and change my skin and in the afternoon an excursion or bicycling for kilometers.—The second week I began thinking about working and in the middle of last week I started two landscapes. No simplifications or abstractions, my friend. Right now what interests me most is the calligraphy of a tree or a rooftop, leaf by leaf, twig by twig, blade of grass by blade of grass, tile by tile.[30] This does not mean that these landscapes will not finally end up being Cubist or wildly synthetic. But we shall see. What I do plan to do is work a long time on the canvases until they are as finished as possible so that at the end of the season and after having worked hard, if I only appear with a few canvases, it won't matter. Next winter the gentlemen critics will continue to say that I persist in my disorientation. Those unhappy people will be horrified by our zigzag and prefer the inertia of the people they say are oriented, and with what a pitiful orientation. This even includes some men of undeniable talent who, upon reaching a certain point, always do the same thing without any pain or congestion and because they have gone to Paris and seen the Impressionists— they haven't gone any further than that as though there was nothing more to the modern sensibility than painting light.—They come back to Barcelona and in order to "épater,"[31] they do things influenced by Manet, Monet, Cézanne, and now they don't think about anything else, and they keep on going, and Apa[32] calls them great painters, and all the hicks from here are happy.

I am firmly convinced that no man who in modern times is preoccupied by all this and who, in addition to visiting the Louvre and the Durand-Ruel or Vollard collections[33] and immersing himself in the much admired Impressionist masters, is interested in the tone of an

Allied canon (tone in the musical sense, of sound) and the spiral of an airplane in space will begin to know how to paint until he is 45, and from that age until he dies if he leaves 3 canvases that are good, that's enough. By canvases that are good I mean that they arrive at a classicism toward which one should strive as an expression of modern life.

I believe that a superartist has to appear who, as Cézanne said, wanting to make something solid, something for *museums* out of Impressionism, brilliantly puts in all the modern preoccupations and *makes them* something for museums. . . .

Now that I think of it—I have changed my way of preparing the canvas—much to the horror of my mother who complains about the rise in the cost of living. I prepare it with egg yolk, according to a recipe of Sunyer who learned it from Matisse.[34] If you are interested I will send you the formula. If you continue preparing your canvases with that thick paste, if you have a show in Madrid next winter, you will have to transport your paintings in a sleeping car with a nurse to watch over them to make sure they don't crack on the trip. Otherwise they will arrive in the Capital in a pitiful state.

Excited about going to Madrid[35]—what I don't know is if my financial situation (everything depends on my benefactor)[36] will permit me to stay with the rest of you. If he doesn't loosen his purse strings, I will go with Ming[37] who, I suppose, will be going very democratically; a matter of eating chickpeas without oil in any old farmhouse and traveling third class. Damn it, it's tough not to have a penny! And so many imbeciles who, with this business of the war, have become millionaires selling potato peels. . . .

> VIVE LA FRANCE!
> ONWARD THE COURBET GROUP!

To E. C. Ricart. Montroig, August 4, 1918

I continue working. I have not yet been able to finish a single canvas (with the exception of a sketch of a thresher[38] and some drawings).— Doing calligraphy[39] is very time-consuming, my friend!. . . .

Trip—Llorens sent me a postcard (I'm waiting for a letter with all

the details) about the trip to the Capital[40]—they already have economical lodgings (3.50 pesetas a day plus slight charges for laundry and ironing) 5 minutes from the Prado.—If I have money I plan to go either before or after Christmas. After all these years of having to go to Barcelona on October 1st to be a soldier, I am hoping this year to have a long stay in the country and spend the autumn here until the bad weather drives me away (I think it will be October and part, or all, of November). With three months I didn't have time for anything.—It is a shame I can't make the trip with you and Ràfols. I won't insist that you wait for me when there is this doubt about the existence or lack of bank notes, and if it is the latter (all-powerful motive) I would feel badly at having spoiled your plans. . . .

I am very glad that Dalmau is making you propositions about buying #13. He had already spoken to me about it (I told Ràfols to tell you). He also told me that the construction work would not permit him to make the purchases he had planned (No. 13 and my *Landscape, Coll*).[41] If, when we return to Barcelona, the construction work on Carrer Bisbe still keeps him from buying anything from us, I think it would be more profitable for us to work as bricklayers for him because with our help the work will be finished quickly, and once it is finished he could devote himself to the task, very agreeable for us, of buying things from us.—I see that he is very interested in the news of our going to Paris—[42] if he does what he says, he will save us many headaches and facilitate the opening of many doors.

As far as what I said about showing in Barcelona, I must confess that I don't give a damn (pardon me) about Barcelona. What will happen if we show there? (I don't mind so long as it doesn't cost a cent). It will happen like this; Apa[43] will blow up (thank God). Some other gentlemen will praise us.—No one will buy (people who claim they are admirers of ours and who have large fortunes will play dumb in order to see if we will give our work away or sell it for a pittance). I must tell you that if I have to live much longer in Barcelona I will be asphyxiated by the atmosphere—so stingy and such a backwater (artistically speaking).—Once away I think they will only see me again when I come to spend Christmas with the family or when I am just passing through to go to the country. The "Minister of Public Instruction" continues writing his tracts about how one should not leave Barcelona, as though we had to be apostles. If they want to keep people from leaving, those gentlemen who control the purse strings ought to think about us too instead of giving stipends to just any member of the Lliga[44] so they can go to New York and learn how to give manicures to cats.

To J. F. Ràfols. Montroig,
August 11, 1918

This week I hope to finish two landscapes (the first I will have completed, except for some sketches—drawings—and a sketch of the thresher).[45] As you see, I work very slowly. As I work on a canvas I fall in love with it, love that is born of slow understanding. Slow understanding of the nuances—concentrated—which the sun gives. Joy at learning to understand a tiny blade of grass in a landscape. Why belittle it?—a blade of grass is as enchanting as a tree or a mountain.— Apart from the primitives and the Japanese, almost everyone overlooks this which is so divine.[46]—Everyone looks for and paints only the huge masses of trees, of mountains, without hearing the music of blades of grass and little flowers and without paying attention to the tiny pebbles of a ravine—enchanting.

I feel the need for great discipline more everyday—the only way to arrive at classicism—(that is what we should strive for—classicism in everything). I consider those who are not strong enough to work from nature to be sick spirits and I refuse to believe in them.—When his apples rotted or his roses lost their petals, Cézanne worked— necessarily—from wax apples or cloth roses.

I do not—unfortunately—believe in the creative power of the person who shows me some apparently beautiful sketches and does not show me a well-resolved academic study or a still life or landscape.

I do not believe in those who are trying to invent new schools.—I detest all painters who want to theorize.

The great Impressionists work brilliantly in front of light—By impulse—Cézanne impulsively—Picasso impulsively.

The only path of the chosen few—swept along by the impetus of the great spiritual motor.

To E. C. Ricart. Montroig,
October 18, 1918

I am truly happy here.—Autumn in the country is wonderful (convulsive recollection of Haydn's "Seasons").[47]—Divine orchestration of the clouds in the sky. . . . I have not been able to work as much as I would

have liked. I have encountered a series of very windy days, and today, after raining all night long, the new day dawned very windy.—In other words, on the days when the weather does not permit me to work out of doors, I am simply incapable of shutting myself up in a room and doing a still life. Here I am only attracted by the countryside.—When it is windy or raining I spend the entire day among the vines and the trees and running about with a rifle, hunting down nothing more than some sparrow or other.[48]—Never mind, the thing is to intoxicate yourself with this great optimism the country gives.

To E. C. Ricart. Montroig, October 27, 1918

Good God, man! How did you prepare the canvas? I imagine you took the yolk exactly as it came out of the egg.—The secret of making a yolk increase its volume considerably is to beat it well, as though you were going to make an omelet (your maid will tell you how to beat an egg).

Here is the recipe for preparing canvas according to *Matisse and Sunyer*:[49]

First you must give the canvas a coat of *rabbit glue and water*, taking care that the mixture is thin (too much paste will cause the canvas to crack).

Once the canvas is dry, apply the following paste with a spatula, filling in the pores of the canvas:

> *well-beaten* egg yolk
> 1/2 painter's plaster
> 1/2 zinc white

Explanations: You use zinc white in order to attenuate the absorbency of the plaster. The more plaster you use the more the color is absorbed.

The color of the mixture ranges from *egg yolk yellow* to *white*. You adjust it to your taste by adding more or less white to the yolk. I prefer the canvas to have a slightly toasted color. . . .

The weather here is wonderful, with a summerlike sun; this allows me to work a great deal. Right now I am doing a canvas with a house with a sun dial, a palm tree, and a bird cage hanging in the doorway.[50]

To E. C. Ricart. Montroig, November 10, 1918

I have received your letter, which resembles a *Treatise for the Young Painter.*—I see that you are very preoccupied by technique. Really, nowadays people are very concerned about things like that.—I will be very interested to read those articles and do something about them when I arrive in Barcelona. I have so little time left here now that it isn't worth the effort. I plan to re-form my palette as the "Green Devil"[51] suggests and introduce, above all, some earth tones, which, incidentally, I like better every day.—As I think I told you when you were here, I have eliminated the pure colors to a great extent, only using them as a last resort. Chrome yellow and bright green; terrible— I haven't used them for ages. If the "Green Devil" has no objection, I recommend *cadmium lemon.* It's wonderful and it is cadmium—which you tell me Apa recommends. Next to cadmium lemon, chrome yellow is opaque and dull. As regards cadmiums, Sunyer told me he had discovered *cadmium red*, which Lefranc[52] has recently started manufacturing; he says it is wonderful. I will look for it when I go to Barcelona!

Regardless of Apa's opinion (I will look into that in detail in Barcelona), I recommend the *Terre de Pouzole* and *red ochre* which I discovered (!). The two of us will go round the shops looking for the colors recommended by the "Devil" and, as for me, I will supply my palette with earth colors.

To set your mind at rest, I must tell you not to worry too much about this. At home I have a list of the colors Cézanne used and a lot of them are terrible. Van Gogh used that awful *Prussian Blue*, which was also used by our Nonell, and that is why Nonell's canvases are blackened and cracked.[53] Let's take this seriously from now on, but without tearing our hair about it. Cézanne was pleased that his son took a knife to the canvases with buildings on them because that proved they really looked like buildings. Despite that and despite the canvases that rotted in the treetops where he disdainfully tossed them, despite all that, *Cézanne was Cézanne.*

Strontium yellow.—Your assumptions to the contrary, I do not know or use this color.

The great Llorens has now deigned to write me a letter, also telling me about the Courbet General Assembly which is to be held in Vilanova and telling me that I will be kept informed of all the plans.

The following is a summary of my ideas about how the Courbet should proceed and I ask you to communicate it to the meeting.

Get the Courbet Group officially constituted so that no one can ever have any objection to it and so that it can be active in the official art world (art exhibits in Spain and abroad) and have a vote and voice in the committees and all artistic matters on which the opinion of artistic associations is requested.

As regards the planned exhibitions in Madrid, Bilbao, and Gerona (like a summer stock tour when the theaters in the capital are closed and you've got to bring home the bacon no matter where you find it), I do not think this is the time to consider anything like this.—The war will be over at any moment and we do not have to put on a show in the provincial theaters (artistically and civilly speaking, *all* of Spain) and we will be able to appear in the Capital (Europe). You know as well as I do the welcome we get in Barcelona, which is the egg yolk of Spain. Just imagine then, Good God, the welcome they would give us in Madrid, Bilbao, and Gerona.—As far as exhibitions are concerned, we could paraphrase Foch (long may he live!). During the current offensive Foch said, *fight, fight, fight!* We can say

PARIS

PARIS

PARIS

. . .If my pocketbook is not anemic (an incurable disease), I plan to go to Madrid in the spring. Think about it![54]

Tomorrow, Monday, at 11 o'clock, Germany will have replied to her Parliament's negotiations with Foch.

To E. C. Ricart. Montroig, July 9, 1919

I have been here at the farm since St. Peter's Day.[55] The first week, strolling about and taking it easy.—The second, this week, starting to think about what has to be done. I have the canvases prepared: this afternoon or tomorrow morning I will begin to work like a slave. In the early mornings I will continue the canvas of the village of Montroig[56] begun last year; in the afternoons a large canvas with a landscape of olive trees, carobs, vines, mountains (a torrent of light).[57] I can work comfortably on this canvas from my room (terrific convenience).—You

must remember the landscape: it is the same as the one in the drawing of the sun, adding more trees and mountains. I think it will turn out well; I want to study it carefully, spending all summer on it and alternating my work with some light sketching so as not to tire myself out too much by spending so much time on one canvas.

And, believe me, you must work hard and be careful with the black lines and the iridescence (Apa). . . .

Very witty, the "Ràfols Sketch" by our friend Junoy.[58] What a difference between his elegance as a pure dandy of the spirit and his language and heavy-handedness as critic of *La veu*. Disgraceful or laughable, the article in *La veu* about Picasso/Domingo.[59] These people have no idea of *responsibility*, so necessary in all orders and human activities.—You have to be a real brute or very cynical to put a 25-year-old kid, whom nobody likes but Llorens and his Art School emulators (complete nothings as far as artistic criteria and ability are concerned), next to the great Picasso, the painter who most interests the civilized world (few, very few, know how to understand him; they only see one aspect of him). What a difference between the perfumed spirit of Picasso (a true modern classicism) and the smell of medicine emitted by the "sick boy."[60] The winged spirit of the painter from Malaga[61] perfumes all realism, no matter how crude (apaches, poor people, whores) with his divine (that is not strong enough) sensibility. Real art, the spirit calmly strolling through the work, a joy to the spectator. Furthermore, these twisted hands and arms are certainly stolen from Picasso. Shortly before leaving I was at Mingo's studio; a lot of things started (all from memory!!!!!!) and some landscapes, a lot of very bad ones. That boy, who really has talent, is poisoning himself by not working from nature and by listening to Llorens, and the poor fellow won't realize it in time. Whenever I think about this business of *never* working from nature, a physiological comparison comes to mind. The artist in continuous contact with real life and nature reminds me of the healthy, virile man who has balls, as sung by Walt Whitman,[62] in energetic contact with the glorious womb of the opposite sex and breeding healthy men and athletes who will honor the race. The person who *always, invariably* avoids painting from real life (coitus of the artist with nature) invariably reminds me of the man who indulges in masturbation and ends up in a madhouse or a tuberculosis sanitorium or sexually impotent and, by extension, creatively impotent.

I spent a lot of time at the Exhibition (you know it is hard for me to form an opinion of things).[63] The only thing in the "arts" that interests me is Picasso, Humbert (delectable and sensual), Manolo (who has a tremendous concept of sculpture and plasticity), and Casanova.

The rest is shit, as the Futurists say. Vayreda—whom I liked a lot at first, I find very ordinary.

Impression of optimism, of life in the country upon entering the "Courbet" room. Really, there is something that unites us all. The proximity of one "Courbet" to another is not detrimental: unity. . . .

The self-portrait is already finished.[64] Dalmau has it to send to Paris along with a landscape, this fall. I was not able to finish the nude.[65] I made Dalmau a gift of the "Sketch of the Thresher." . . .

Don't forget to get all the details you can so that we can see about going to Paris in November. I'll be asking for details, too.

To J. F. Ràfols. Montroig, August 10, 1919

Ricart must have told you that he is determined to go to Paris in a few months. I am afraid that he will get a fright unless he realizes that life in Paris is expensive and if he does not manage to go there with a good guaranteed monthly allowance. I am *definitely* going at the end of November. You have to go there as a *fighter* and not as a *spectator of the fight* if you want to do anything.

I am working hard—all day long. I am continuing with the canvas of the village and am doing another one—the light-flooded landscape of olive and carob trees and vines that you see from my room (you will remember it).[66] I think these two paintings will keep me busy all summer. I am making the one of the village as simplified as I can, trying to solve as many problems as possible in order to reach a balance.—I don't know how the one of the olive trees will turn out: it started out being cubist and is now becoming *pointilliste*.

We must make every effort, Ràfols my friend, to do *good painting*. If we only do *"interesting"* things we will soon run out of resources. With the little bit of talent one has at age 20, the hell with *"interesting"* things. What we have to do is learn to paint—look at that devil Picasso! If we keep wasting time and being content with doing interesting things—it won't be long before they are not talking about us anymore. We must forget about that and keep on always searching and digging deeply and preparing ourselves for the day we are mature enough to *start* doing *really interesting* things.

To J. F. Ràfols. Montroig,
August 21, 1919

I continue working hard. I have studied a lot this summer. My two paintings have been changed a thousand times.[67] I am just beginning to see something, I am pleased with the one of the village; after much studying I have gradually seen—intense joy—the marvels of light, the unfocused images about which Cézanne, our great precursor, spoke. Imagine the tremendous joy of working a long long time and discovering new problems!! I have not undervalued any aspect of *reality*, convinced that everything is contained within. There is nothing superfluous (no shadows, no reflections, no twilight)—the thing is to *paint it*. The afternoon painting—the one of the trees—is also going well. Light, light and the serious problems which derive from it. The horizontally sliding sun has caused me to use a kind of *pointillisme*; unfocused planes. Perhaps this summer's paintings will be a *struggle* more than a *result*—so much the better. I have faith in what I am going to do this winter. This summer's work will help me get into it. We must move toward classicism, not toward the death that Junoy preaches, the cadaverous return to the Greeks and to David.[68]—We must flee from the sick sermons of Torres-García[69] (Art in relation to the eternal man and the transient man), discarding the entire past. Both these things are endemic to incomplete spirits.—I always remember our visit to Picasso's mother's house.—Remember what Togores[70] said in front of those Picassos, that he was the *forerunner*, that we had to work to achieve the discipline of David together with the freedom and the complete abstraction of Picasso's Cubist paintings. I share Togores's views: remember how I told you that we had to get to *classicism* via *Cubism* and to a *pure* art (le cubisme n'est que la promesse d'un art pur et simple—G. Apollinaire),[71] completely free, but *classic*. Dig, dig deeply, as I am always telling Ricart, and digging deep inside will reveal new problems in all their splendor, problems to be resolved, and they will carry us along the escape route from deadly *momentarily interesting* work to really *good painting*.

I am determined to go to Paris this winter. I will be here until the middle of October, and once back in Barcelona I will try to settle the matter of Manyac,[72] and if I can't, I will see about taking up Dalmau's offer to send my work to a dealer in Paris to prepare my going there. The essential thing is to have the road paved and a safety net so I won't break my neck if I fall.—Obviously, life is expensive there. I think that

the best time to try to do anything is as soon as possible. If living were cheaper, it would only get us more comforts of the kind I am willing to do without and sacrifice in order to get there at the best time for the fight. . . . If I were only going to see Manet and Cézanne naturally I would wait.—I detest people who are afraid to fall in battle and content themselves with a relative, very meager triumph among a handful of imbeciles in Barcelona.

To E. C. Ricart. Montroig, September 14, 1919

It's good that you are working hard: I am working too and am happy with what I am doing.

I am sending you here a copy of the main paragraphs of a letter I received from the friend in Paris about whom I spoke to you:

"Here in Paris artistic activity is always considerable and important because, in addition to the official exhibitions, there are innumerable galleries and exhibitions organized by dealers, experts, etc.

"As for material existence, I am going to give you an idea of the most current prices.

"It is very difficult to find a studio, but if you do, you have to count on a normal studio costing 1,500–2,000 francs a year. In a *Cité d'artistes* (buildings that consist entirely of studios, sometimes as many as 80 or 100) you might find one for less, but it would be at least 1,000 francs per year plus fees for the concierge, cleaning woman, etc.

"Average cost of meals, without any luxuries, 20 francs per day.

"You can rent a room for 30 francs a week and 5–7 francs per *repas* (I don't know if that really means a meal or if it just means *soup*) other than breakfast.

"All living expenses are very high (clothes, streetcars, tobacco, shoes), and if you come, come well equipped so that you will need to buy as little as possible.

"In short, this is the country of struggles and ideals; the person with aspirations lives intensely here."

It would be a good idea for you to keep the address of the restaurant that's a refuge for artists. I would be eternally grateful if you would note down any details that might be of interest.

I am *fully* determined to go to Paris this winter, *so long as there is artistic activity there.*

I don't give a damn about anything else. What do you plan to do? If you come it would be cheaper. I advise you to put your hand to your heart and seriously examine your conscience. If you have the heart to come and fight to get ahead in the capital of the world, then shake off the dust of cowardice, forget everything else, and come along. . . . If you plan to go to Paris only as a *spectator*, in order to study, to see the great Impressionists, the moderns, then there is no hurry. In that case, as your friend I would advise you to keep living in the *country* until the world is in better shape and then go there at your leisure.

If you plan to go there as a fighter, it is a crime to keep on wasting time because it is *easier* to go on thinking that perhaps things will be better *tomorrow.* I don't give a damn about *tomorrow*, what interests me is *today.* Besides, I would a thousand times rather—and I say this in all sincerity—fail *utterly, totally* in Paris than go on suffering in these filthy, stinking waters of Barcelona.

To E. C. Ricart. Montroig [November 1919?][73]

The weather is terrible here which makes it very difficult to paint: rain, wind, and more clouds. It seems likely that I will be coming to Barcelona on the 22d. . . .

When you come we will talk at length about going to Paris. Meanwhile I am taking stock of the current situation, as I oblige myself to do now and then.

I'd appreciate if you would read this to Ràfols to see what he says.

A. I am 26 years old.
B. Of the small capital I earned as a clerk I have only 25 or 30 pesetas left (this capital went for paints, a studio); lately now I have dared to admit that my "fortune" was running out and have asked, with great distaste on my part, my mother for some money.
C. I know confidentially that when I leave home I will have enough money to permit me to live and function for a while.
D. If I stay in Barcelona I see no other solution but to do any old

thing in order to be able to paint and earn the money I need to
do it.

E. I, who currently have NOTHING, must earn my living whether
it be here or in Paris or in Tokyo or in India.

Well, we will talk about that; let's see if the people who say that I
am unreasonable can give me a different solution.

II

Paris and
Montroig, 1920–28

Letters to J. F. Ràfols
and E. C. Ricart, 1920–22[1]

Miró arrived in Paris in early March of 1920.
According to correspondence with Ricart (not
included here), the last two months of 1919 and
January 1920 were devoted to passport formalities,
negotiating with Dalmau for an exhibition in Paris,
and procuring papers from the French embassy
certifying that he was financially solvent. Miró's first
known letters from the French capital are dated
March 1920. And his earliest autobiographical notes
situate his arrival in March as well.[2]

The texts in this chapter span the period from
Miró's arrival in Paris until his departure from the
rue Blomet where he worked in a studio rented him
by Pablo Gargallo and was a neighbor of André
Masson. These are the years when he discovered the
Parisian artistic scene and his true identity as a
painter.

Miró's first letters from Paris (written to Ràfols
who stayed behind) express his initial reactions to the
French capital. He was overwhelmed. As he would
state in an interview over forty years later: "When I
arrived in Paris, I was disoriented, paralyzed. For
three or four months, I was incapable of painting.
My companions set to work without a problem. But
at heart I was pleased with my incapacity. It proved
that I had been jarred."[3]

Miró left Paris in mid-June after this first visit to

return to Montroig in July. There, as he explains, stimulated, inspired, and nourished by his Parisian sojourn, he set to work "madly."

For the next few years Miró would spend approximately the first four months of the year in Paris and then return for long periods to Montroig. While the artistic life in Paris was a necessary stimulus, the farm and landscape at Montroig were as necessary, providing a source of inspiration and the desired tranquillity and concentration for conceiving and beginning new paintings. Usually when he left Montroig, Miró took his unfinished canvases with him, first to Barcelona where he showed them to Dalmau and friends like Ràfols, and then to Paris. His stays in Barcelona were deliberately brief. Clearly his opinions of the Barcelona art scene had not changed.

To J. F. RÀFOLS. PARIS, HÔTEL DE ROUEN [MARCH 1920?][4]

I am starting this letter at 11 o'clock the night before Dalmau arrives to really put my exhibition into motion.[5]—We'll see what happens.

Paris admirable, pink sun and the Seine kissed by fog. Gray patina of the old buildings. Musical speech of the Parisians.—Utmost politeness and affability.

I have seen museums and private exhibitions.—

Rodin Museum.—Divine nude of a girl by Renoir.—van Gogh wonderful. Rodin makes my head spin.

Luxembourg Museum, in the Caillebotte collection:[6] Renoir still divine. Manet (*The Balcony*) better even than the Spaniards (the great ones). Sisley exquisite—Pissarro a great painter. Monet very well represented. Berthe Morisot extremely sensitive.

Louvre Museum.—You would have to go there for weeks on end to get an idea of it.—What I have looked at most closely are the Impressionists in the Camondo collection.—I do not like the *Monet* things there at all.—Canvases of an extraordinary vulgarity and detracting from all their glorious companions.—Let us leave these bad paintings of Monet's and admire the ones in the Luxembourg (*Gare St. Lazare!*). I am unable to like *Degas*. *Cézanne—The Cardplayers*, admirable (Venetian—classic), tremendous still life.—*Manet*. The *Man with the Flute* and *Lola of Valencia* surpass the giants Goya and Velázquez.—I still have not had time to study the other rooms (the Louvre goes on for kilometers). Ingres exciting (*The Turkish Bath*).

I have seen exhibitions of the moderns. The French are asleep.—*Rosenberg Exhibition.* Works by Picasso and Charlot.[7]—Picasso very fine, very sensitive, a great painter.—The visit to his studio made my spirits sink. Everything is done for his dealer, for the money. A visit to Picasso is like visiting a ballerina with a number of lovers. Charlot surpassed by our Vayreda.[8]—In other places I saw paintings by Marquet and Matisse; there are some that are very lovely, but they do a lot just for the sake of doing them, only for the dealers and the money. In the galleries you see a lot of senseless junk. The French tradition is broken—that great Impressionist shower of colors and light was picked up by the *classic* Cézanne in order to make *museum pieces* and it now stagnates.—After Impressionism comes anarchy—except for the work of Matisse, Marquet, etc., when they are pure and immaculate.—Organizing effort of Cubism—following the great Cubist discipline of

Braque, Picasso, there exists an army of parasites—Cubist exhibition at the Galeries La Boétie.

My homage to the pure, the highly sensitive Maurice Utrillo!

The new Catalan painting is infinitely superior to the French; I have absolute confidence that Catalan Art will be our savior.—When will Catalonia allow her pure artists to earn enough to eat and paint? Catalonia's rough way of treating spiritual things might be the Calvary of redemption.—The French (and Picasso) are doomed because they have an easy road and they paint to sell.

To J. F. Ràfols. Paris, Hôtel de Rouen, May 8, 1920

This Paris has *shaken me up* completely.—*Positively*, I feel kissed, like on raw flesh, by all this sweetness here. Let me enjoy, now, leisurely, this new world.

The Louvre powerful (Can't you just imagine my awe—I who have never been out of Barcelona).—Utterly divine—the light marvelous, of an inexplicable delicacy, the Diana in the Luxembourg Gardens, the avenue de l'Observatoire, the *Seine*.

My dear friend, come see all this!

I spend the entire day at museums and looking at exhibitions.— You know me, you know that even before leaving Barcelona everything I started was for me like starting to paint for the first time, with new problems and new sensations.—Imagine me now that I have seen all this abundance of things!—Furthermore, you know my hand is not agile (thank God, rather that than a sluggish brain and a dexterous hand). I console myself, remembering my glorious patron Saint Cézanne.

This summer, with all this *good nourishment* for my body, I will work madly.

Remember the book by our admired and beloved Junoy.[9]—The seed must form within the artist as within the earth, in order to bear fruit.

And with this harvest of things I have seen here!

I admire (the way I admire circus tricks like eating with your feet or walking on your hands) the frozen people who come to Paris and sketch as calmly as though they had still seen nothing more than the pathetic museum in the Park.[10]

Souls of ice that have not felt this fire of passion and will yield withered fruit.

I am fully convinced, dear Ràfols, that the *new Catalan painting is better* than the new French painting. A pity our country refuses to let its artists live!—Perhaps this lack of protection is a healthy discipline.—Thus, after this pain and disparagement we will be purer.

Here just the opposite happens—many extremely talented artists turn out paintings that are obviously only done to get money from their dealers.—*Remember Father Cézanne* when you slash them!

Great artistic activity—today I saw an exhibition of portraits; a marvelous Matisse and a Rousseau. Cubist exhibition at the Galerie Rosenberg.

I am expecting Dalmau any day now. He wrote that he is coming to finish making arrangements for me. Since he left I have had no more news of his negotiations so I still don't know when I will be exhibiting. While Dalmau was in Paris he worked very hard for me. A lot of the big fish here saw my little drawings. He managed to get paintings of mine into some private collections that are very well known in the art world. Commercially speaking, I obviously have no business being there, but it is great publicity for me and it will save me years of struggle here.

Besides, the important thing here is that people realize you *exist*. Once you've managed that, you can be happy. So, as you see, I have a good start on the road.

TO E. C. RICART. MONTROIG, JULY 18, 1920

Before coming here I suffered for 12 terrible days in Barcelona. Fierce girls and backward peasants, with an intellectual life that is 50 years behind the times. Definitely, *never again Barcelona*. Paris and the country *until I die*.

I do not know what it is that makes people who lose contact with the world's brain fall into a slumber and become mummies. *No painter in Catalonia has arrived at maturity*. Let's just take a look. Sunyer, if he didn't spend time in Paris, would fall asleep forever! That business about our native carob trees performing the miracle of awakening him is fine when the intellectuals of the Lliga[11] say it.—You have to be an *International Catalan*; a *homespun* Catalan is not, and never will be, worth anything in the world.

To J. F. Ràfols. Montroig,
July 25, 1920

Away now from all the *spiritual fermentation* of Paris, so *necessary* and of *capital* importance, and tranquil now in the Catalan countryside, so *necessary and important too*, I am writing to you.

Are you planning to come to Paris this winter?

I expect to be in Montroig till the middle of October, and afterwards, if the dates of my Paris exhibition permit, I will go to Majorca to paint for a while so that I can show a good stock of paintings done *post-Paris* and a selection of *avant-Paris*.

I am working hard; going toward an art of *concept*, using reality as a point of departure, never as a stopping place.—Convinced that that is how art should be: *concept*, or *David and Raphael*, not Ingres (who is a great revolutionary). *Pantherlike agility* (admirable phrase from Josep de Togores);[12] go from *abstraction* to *Raphael and David*. This panther is Pablo Picasso, *neither understood nor comprehended* by the people back home.

Josep de Togores and Pablo Picasso, the more we talked the better we understood one another, are both in Paris now which is like saying they are *alive*.

In the beginning Picasso—naturally—reserved with me—lately now, after having seen my work, very effusive; hours of conversation in his studio, very frequently:

—"Catalonia lacks *passion and heroism*; *that's why its art is as it is*. Believe me, if you want to be a painter, don't move from Paris."

—"I agree completely."

To E. C. Ricart. Montroig,
August 22, 1920

I am working as *much as I can*. People who have managed to do something have followed different paths, *but they have never deviated from hard work*. That has to be the most powerful objective of an artist's life.— When a person is really an artist this is an inexorable fact, the way night follows day. Picasso once said: "Everyone in your country (mine) strikes me as being an amateur."

To J. F. Ràfols. Barcelona,
November 18, 1920

Thank you for the postcard. I am very happy that you liked mine.

From the depths of my soul I deplore the fact that you like that insipid Marchand.[13]

Disappointed in French art, you say. Did you imagine that everyone in Paris was Cézanne? In present-day France I admire only Picasso, Derain, Matisse, and Braque. The others leave me cold.

You must look at French art with an *eagle eye*. I think it was Pascal who said that from afar the zigzag of a moving ship looks like a *straight line*.

I much prefer a man who fails in his search, who bangs his head against the wall, to the one who unconcernedly does what others sweated blood to do.

I much prefer the nonsense of Picabia or any one of the silly Dadaists to the easygoing ways of my compatriots in Paris, stealing from Renoir (whose only value now is as a classic) or producing a watered-down mixture of Sunyer and Matisse. I loathe somnolent spirits.

My present state permits me only to contemplate a *classic* Raphael, for example, or the vertigo of disquieting people who, nonetheless, exist as undeniable facts. . . .

I am waiting to finish a 1.40 m × 1.12 m canvas[14] before going to Paris.—I do not want to finish it there because I have a feeling I will experience another jolt in Paris. May God continue to give me these jolts!

To J. F. Ràfols. Montroig,
August 15, 1921

I appreciate your interest in wanting to see what I am doing. These canvases[15] will keep me in Montroig the best part of the winter, until it is time to go to Paris. I will have worked on them about 6 months in all. Now that I am only at the beginning—I've been working 1½ months on them—you can see absolutely nothing; I hope that will make you understand and respect my system of not showing anyone

my paintings in progress. I don't know whether Dalmau has ever told you how religiously he respected that when I was working on *The Table* in his studio on calle Perrot lo Lladre.[16]

I promise you that when they are *finished* I will let you know so that you can see them before I take them to Paris.

Too much painting has been *produced* and *too little ART* is being done.

TO J. F. RÀFOLS. MONTROIG, OCTOBER 2, 1921

I continue working with the same intensity and the *same humility as a worker who works all day long to support his family*.

My two paintings continue to be absolutely invisible.

I imagine you will be surprised when you see the big canvas;[17] that is, when it is *finished*, and that you will find it interesting because you don't judge things with the same narrow-minded spirit with which people here judge everything. . . .

I have rented the same studio as Gargallo in Paris, and I will be able to live there[18]—so I will be able to work really intensely this winter.—I am being tormented by some 3-meter paintings I want to do in Paris.—Every morning when I wake up I draw them mentally on the wall.—I have been thinking about them for nearly a year and now I am itching to start on them. They are larger than life-size figures. At the same time I will do a still life with some marvelous things made by nuns I have discovered (Fra Angelico blue flowers) which I will show you in Barcelona. I will paint that with *tempera*,[19] which requires *devotion and love of the technique, the humility of a workman*, and, inside the soul, *the fire of a volcano* that *burns continually*, not just intermittently (*spurts of madness, false genius*).

TO J. F. RÀFOLS. BARCELONA, JUNE 30, 1922

When I got to Paris I spent still another whole month working on my painting,[20] not seeing anyone and locked in my studio.—When I finished it I started my *offensive*, but not letting that stop me from

working about 5 hours a day. This work, together with the activities involved in seeing people in Paris and being a man of the world and the tremendous intellectual activity all that requires, left me with no time to reply to my friends.—At night I went to a gym to box.[21] My intellectual work all day long required physical limbering up. Besides, you must be healthy in order to arrive at maturity with the physical and intellectual powers to do our work. The responsibility of our generation is immense, and we must work and study hard in order to live up to it.

My painting is at Léonce Rosenberg's and it has quite a success.[22] If you go to Paris, let me know. I will give you a letter of introduction to Mr. Rosenberg.

More convinced than ever of my aesthetic ideas and my immensely growing love for *Catalan* art, that is, as opposed to false Frenchified Catalan work.

4

Letter to
Roland Tual, 1922[1]

The following letter to Roland Tual, the first letter
included here to a French rather than a Catalan
friend, gives a much more detailed description of
Miró's working process than any previous account. It
was written from Montroig in the summer of 1922,
after Miró had finished *The Farm* in Paris; now he
turned to more modest subjects. The small-format
still lifes of grills, carbide lamps, and an ear of grain,
executed in a tight precisionist style, were begun that
summer and show the passion and discipline Miró
describes here.

Roland Tual was an extremely poetic personality
who unfortunately left no writings. A friend of the
Surrealists, and in particular of André Masson, he
was a frequent visitor to the rue Blomet where Miró
and Masson had adjacent studios.

To Roland Tual. Montroig, July 31, 1922

I wanted to write to you earlier, but I have been working a lot, especially on the early stages of my canvases, and this demands a great effort—to capture the total idea of the painting. During my off-hours I lead a primitive existence. More or less naked, I do exercises, run like a madman out in the sun, and jump rope.

In the evening, after I've finished my work, I swim in the sea. I am convinced that one's serious work begins only in maturity, and to get to that point of development, we must lead a good life. Moreover, I am convinced that a strong and healthy oeuvre requires a healthy, vigorous body. I see no one here, and my chastity is absolute. Quite a change from my busy social life in Paris, a fact that must not be overlooked either.

I am working on figures and still lifes, and I put in seven hours of labor every day. I have not been involved with the things I spoke to you about in Paris, such as plants and birds and snails. The effort required by my latest picture has not allowed me to take on these subjects.

I look through the kitchen for humble things, any kind of thing, an ear of corn, a grill, and make a picture from them.

In order to give a communicative emotion to these things, we must love them enormously. If you don't, you can be sure that you will do a picture of no interest at all. Each day I become more exacting with myself, which means that I will redo a painting if a single corner is off by one millimeter to the left or right.

In the room that serves as my studio I always have books, and I read during the breaks in my work. This demands a constant spiritual vibration from me.

When I paint, I caress what I am doing, and the effort to give these things an expressive life wears me out terribly. Sometimes after a work session I fall into a chair, totally exhausted, as though I had just made love! Excuse me, dear friend, for this crudity of language I express myself with, but I can't find any other words.

A friend, a well-known art critic in Paris, told me that I was too demanding and that when a thing pleased you for a minute, you should stop there. I am absolutely against this widespread idea. Too much charm.

I am sure that we, the young people who had the good fortune to

be born after Picasso, that we others have a goal of capital importance. I am sure that we are living in a wonderful time, a blessed time that will bear fruit. This is a period that demands a great sense of individual responsibility. We must, dear friend, do things that will hold up against the classics.

Modern things are often only sighs of love and not the fruits of childbirth!

You already know my ideas about Art. You know very well that I do not attribute the word classical to those unfortunate ones who only see the outer layer of classicism—formulas, etc., and even less to those gentlemen of learning who are no better than imbeciles. A good Cubist canvas by Picasso is as classical as a work by Raphael and holds up well beside it.

5

Letters to J. F. Ràfols, 1922–23[1]

In the following three letters, Miró evokes once again
the discipline and passion he described in some detail
in his letter to Roland Tual. But more significantly,
these letters mark the passage from the meticulous
realism of *The Farm* and the still lifes of 1922–23, to
the magic realism of *The Tilled Field*, *Pastoral*, and
Catalan Landscape (The Hunter), all begun in the
summer of 1923. Whereas up to now, the real
landscape at Montroig had served as Miró's direct
source of inspiration, the paintings started this
summer show a new freedom in relation to his
model. The image of a tree with ears is found in his
painting *The Tilled Field* and is a convention that he
borrowed from Catalan Romanesque frescoes and
transferred to the familiar surroundings of Montroig.
The "inclusion of things extraneous to painting"
refers to poetic verbal images from Miró's readings,
and specifically to Apollinaire's *L'enchanteur pourrissant*
from which much of the iconography of *The Tilled
Field* derives.[2] The peasant, with a barettina, rifle,
and pipe, is seen in his *Catalan Landscape (The
Hunter)*.

Although the new freedom seen in the paintings
of this summer surely resulted from the artist's
broader exposure to art and poetry in Paris, it also
appears in an absolutely logical progression from his
earlier painting styles.

To J. F. Ràfols. Montroig,
November 12, 1922

I continue working all day long, like a *laborer*, trying to conceive things with the *utmost passion*, *really thinking them out* and resolving them *coldly*.

To J. F. Ràfols. Montroig,
September 26, 1923

I am working really a lot, with absolute regularity and method.—This year I am really attacking the landscape and, when I need to relax, still lifes.[3]—I have already managed to break absolutely free of nature and the landscapes have nothing whatever to do with outer reality. Nevertheless, they are more *Montroig* than had they been painted *from nature*. I always work in the house and use real life only as a reference.—Influx of figures (some of them very large) and animals. In the still lifes I am using horribly ugly objects. I know that I am following very dangerous paths, and I confess that at times I am seized with a panic like that of the hiker who finds himself on paths never before explored, but this doesn't last, thanks to the discipline and seriousness with which I am working and, a moment later, confidence and optimism push me onward once again. Inclusion in my current painting of things extraneous to painting to give greater emotional power to the work.

I am in a period where my vision of things is very clear.—I try to resolve these sensations as I go along, not worrying about when I will finish!—I work on several paintings at once in order to work only with the natural fatigue caused by work, but never exhaustion. This means that when I pick up my brushes to execute a canvas, after having meticulously drawn it, thought about it at length, and seen it absolutely clear in my mind, and after various periods of several weeks with it turned facing the wall and without my looking at it, I finish it with utter self-confidence, without *pentimenti*, without retouching.—I am very happy with all this and I think it will cause a certain sensation in Paris.

I will not show you anything until Barcelona this winter.

They are works that are in a repulsive embryonic state and are as incomprehensible as fetuses.

To J. F. Ràfols. Montroig, October 7, 1923

Hard at work and full of enthusiasm. Monstrous animals and angelic animals. Trees with ears and eyes and a peasant with his barretina[4] and rifle, smoking a pipe.

All the pictorial problems resolved. We must explore all the golden sparks of our souls. Something extraordinary! The acts of the Apostles and Brueghel (forgive the irreverence of the comparison).

6

Two letters to
Michel Leiris, 1924[1]

In the late summer of 1924, Miró's painting evolved
to a looser, more open, linear style. These paintings
and those of the immediately ensuing years show the
impact of written poetry on the artist's creative
process, and in particular of the Dada, Surrealist,
and other poets who visited the rue Blomet. Miró
himself always attributed this transformation to the
poetry he was reading and the poets he was seeing,
without any specific references or explanations. The
first of the following two letters to Michel Leiris
offers a rare insight into how Miró's pictorial
priorities were shifting at exactly that moment; it
expresses his desire to reduce his vocabulary to a
strict minimum in order to evoke a basic and
immediate emotional response.

Miró's allusions to his objectives, combined with
his detailed description of a painting that shows a
loose articulation of visual motifs in the manner of a
poem, reveal to what extent he was affected by the
verbal experiments of his poet-colleagues. In the
second letter, the artist projects different kinds of
extrapictorial experiences and sensations that he
aspires to capture. His references to Rembrandt and
Hokusai confirm his preoccupation with capturing an
essence through the sparest graphic signs. Even his
writing style is that of a prose-poem or a Haiku
verse.[2]

Michel Leiris, the poet and writer, made his first visit to the rue Blomet in October 1922 in the company of Max Jacob. Thereafter he was virtually a daily visitor. In the beginning, Leiris was friendlier with André Masson than with Miró and even did some of his writing in Masson's studio.

To Michel Leiris. Montroig, August 10, 1924

I am working furiously; you and all my other writer friends have given me much help and improved my understanding of many things. I think about our conversation, when you told me how you started with a word and watched to see where it would take you. I have done a series of small things on wood, in which I take off from some form in the wood.[3] Using an artificial thing as a point of departure like this, I feel, is parallel to what writers can obtain by starting with an arbitrary sound; the R.R. from the song of a cricket, for example, or the isolated sound of a consonant or vowel, any sound, be it nasal or labial. This can create a surprising metaphysical state in you poets, even when you use the sound of vowels[4] or consonants that have no meaning at all.

In leafing through my notebook I have also noticed the extremely disturbing quality of the dissociated drawings I sometimes do—meant for canvases I am preparing and on which I jot down a number of remarks: names of colors or simply the monosyllable *yes* when I feel that an idea should be carried out.[5] I intend to do all these drawings. In other drawings, of objects that fly around on a flat surface, I write isolated letters. I agree with Breton that there is something extremely disturbing about a page of writing.

More or less total destruction of everything I left behind last summer and which [I] thought I would pick up again. Still too real! I am moving away from all pictorial conventions (that poison). In spreading out my canvases, I have noticed that the ones that have been painted touch the spirit less directly than the ones that are simply drawn (or that use a minimum of color); the intromission of exciting materials (colors), however stripped of pictorial meaning, *shakes up* your blood and the exhalted sensation that *claws at* the soul is ruined. You already know the pictorial process: 1. Pure line. 2. Pure colors. 3. Nuances, the charm and music of colors. Final stage of degeneration.[6]

There is no doubt that my canvases that are simply drawn, with a few dots of color, a rainbow, are more profoundly moving. These move us in the elevated sense of the word, like the tears of a child in its cradle. The others are like the screams of a whore in love.

My latest canvases are conceived like a bolt from the blue, absolutely detatched from the outer world (the world of men who have two eyes in the space below their forehead).

Figuration of one of my latest *x*'s (I can't find the word for it here;

don't want to say either canvas or painting). Portrait of a charming lady friend from Paris—I begin with the idea of touching her body *very chastely*, beginning with her side and going up to her head. Profile drawn in charcoal. A vertical line for the breasts; one is a pear that opens and scatters its little seeds (those wonderful little hearts of a fruit). On the other side, an apple being pecked at by a bird. Sparks fly out of the wound caused by this pecking. Below, going across the sex (I insist on my very chaste and respectful intentions) a comet with its luminous tail; blond hair; one hand holds a flower with a butterfly circling around it; the other hand is trying to take hold of an egg that is turning, a luminous circle around it.—In the upper corner of the canvas are stars.[7]

This is hardly painting, but I don't give a damn.

Are you working? Tell me what you are doing and don't forget to write to me.—I owe a lot to all of you, and a word from you would make me extremely happy.

I am not forgetting the issue of *Valori plastici* devoted to G. De Chirico;[8] I will order it when I return. I spent my last days in Paris extremely broke.

To Michel Leiris. Montroig, October 31, 1924

My dear Michel,

The spiral staircase in *The Philosopher* by Rembrandt.—Hokusai said that he wanted to make a line or a dot perceptible, that's all.

A line in the form of a zigzag drawn on a piece of white paper; at the end a kind of egg (an ovum) with sparks shooting out of it.[9]

The beauty of stars and letters.

Interjections.—Pain; surprise.—Amazement.[10]

The eloquence of a cry of admiration made by a child in front of a blossoming flower.

Thank you for your letter.

And Roland?[11]

I am working a lot and still don't know when I will be back among you.

Very encouraged and I hope that my latest works will amaze you a little.

Greetings to André and Odette; to Salacrou and his lady; to Limbour; to the silent Roland.[12]

My respects to your mother.

Until soon I hope.

Cordial handshakes,
Joan.

P.S. There is always an aristocracy in art.

7

Tableaux-poèmes
(Poem-paintings),
1924–27

Miró's more concentrated attention to poetry in the 1920s inspired him not only to structure his paintings as though they were a kind of free verse but even at times to inscribe poetic phrases on the field of the canvas. These written verses consisting of one or several lines not only evoked images (such as snails or women) but also articulated the painting visually. The resulting tableaux-poèmes, or poem-paintings, show a complex interlacing of graphic signs and poetic allusions.

On later occasions Miró would attribute poetic titles to his paintings or even write words or stencil letters on his canvases. But the deliberate effort to create conflated images through the integration of verbal poetry (thereby expanding the function of the painterly object) would not be found again after the decade of the twenties.

Miró stated that this was the only period during which the words or phrases came to him first and he created a painting around them. In later works with poetic titles, the title came to him during the act of painting.

TABLEAUX-POÈMES (POEM-PAINTINGS).
1924–27

1924

The Smile of my Blond

1925

Stars in the form of Snails' Genitals
Photo: This is the Color of my Dreams
The body of my dark-haired woman
 because I love her
 like my pussycat dressed in salad green
 like hail
 it's all the same
Oh, one of those gentlemen who did all that!

1927

A Bird pursues a bee and embraces it
Music, Seine, Michel, Bataille, and I

8

Interview. *La publicitat*
(Francesc Trabal), 1928[1]

Miró's first published interview appeared in *La publicitat*, a Catalan nationalist newspaper published in Barcelona from 1922 until the arrival of Franco's troops in the Catalan capital in January 1939. The interview was conducted in Barcelona, probably in early to mid-June, between Miró's arrival from Paris and his first trip to Madrid later that month. It is an interesting and fairly complete firsthand account of the artist's early years in Paris.

Although, as we have seen, Miró had never lacked in inner conviction, his recent success at the Georges Bernheim gallery in May of that year allowed him to be more candid about the disappointments and setbacks of his earlier career. His repeated allusions to his own Catalan nationalism and culture, although absolutely authentic and consistent with earlier statements, were surely made for the benefit of *La publicitat's* readers, since his choice no longer to live and work in Barcelona could have been interpreted as a denial of his origins.

"A CONVERSATION WITH JOAN MIRÓ" BY FRANCESC TRABAL. IN *LA PUBLICITAT* (BARCELONA), JULY 14, 1928

I've been doodling all my life. When I was little I was always drawing. When I was fifteen, although I still hadn't started taking things seriously, I had to keep the books at Dalmau Oliveres, a big hardware store. You should have seen me struggling over the Assets and Liabilities for hours on end.

But then I felt a tremendous need to study at the Lonja and at Galí's art academy. I am very fond of Galí. When I finished there, it was the middle of the war and I hardly imagined I would ever be leaving here. That was when I had my first exhibition—the first and only one in Barcelona—at the Dalmau Gallery. At that time I was weighed down by many influences. I was influenced by everyone from the Impressionists to the Futurists. Nobody bought anything at that exhibition except Dalmau himself, who bought out the whole show so I would have enough money to go to Paris, which I did at the beginning of 1920. I had dreamed of getting to know Paris, of living and working there, but it had always been impossible.

I was thoroughly overwhelmed by Paris. I was completely disoriented for one entire year. So much so that I tried to go to an art school and I couldn't even draw a line. I'd set myself up in front of the models but I couldn't draw a thing. I'd lost the hang of it, and I didn't get it back again until I went back to Montroig the following summer, and I immediately burst into painting the way children burst into tears. I was mostly influenced by Picasso and the Cubists, and when I got back to the Tarragon countryside I was seized with a mad desire to work and I produced a number of things, including a self-portrait and *The Table*.[2] Dalmau introduced me to Picasso, and when I was back in Paris again, Picasso told Dalmau I was going to be a success, and I know that Picasso started talking a lot about me to people he knew and that was obviously a help. Picasso has the self-portrait I did at Montroig, which was shown in a Catalan group show in Paris.

But what really got Picasso interested in my work was *The Table*[3] which isn't known at all here. Because of that painting Picasso sent me a lot of dealers. It was an extremely dense, disciplined canvas that hinted at the way my work would go in the future.

I had a show at La Licorne in Paris—a gallery that no longer exists—and again, I didn't sell a thing. That show wasn't talked about

very much, but the few people who did talk about it had high hopes for me and were sure I'd end up being accepted.

I came back here again after that exhibit. And again Montroig reached out to me with all its light, all its life, and I wanted to capture that whole period that I could see so clearly from Montroig and I painted *The Farm*. Nine months of constant hard work! Nine months of painting every day and wiping it out and making studies and destroying them all. *The Farm* was a résumé of my entire life in the country. I wanted to put everything I loved about the country into that canvas—from a huge tree to a tiny little snail. I don't think it makes sense to give more importance to a mountain than an ant (but landscape artists just can't see that), and that's why I didn't hesitate to spend hours and hours making the ant come alive. During the nine months I worked on *The Farm* I was working seven or eight hours a day. I suffered terribly, horribly—like a condemned man. I wiped out a lot and I started getting rid of all those foreign influences and getting in touch with Catalonia.

Now let me talk about something that's important to me. I know that someone has said I was getting a little too far away from Catalonia. I'd like to clear up that misunderstanding if it really exists. I feel that of all the painters from here I'm the one who's closest to Catalonia, even though I spend long periods abroad. And people abroad feel that way too. No foreign critic has ever said I belonged anyplace else. They've always said right out that I am a Catalan. No matter where you see my name, it's always "Joan" and that's more than you can say of other painters from Barcelona who have gone abroad. I can assure you that I am happiest in Catalonia, in Montroig, which I feel is the most Catalan place of all. I think that the province of Tarragona is pure Catalonia. I'm much happier going around dressed in a sweater and drinking wine from a "porró"[4] with the farmers of Montroig than I am wearing a dinner jacket in Paris and going about with duchesses in great palaces. All my work is conceived in Montroig. Everything I've ever done in Paris was conceived in Montroig without even a thought of Paris, which I detest.

When I painted *The Farm* I was feeling very aggressive toward people from here, people I thought were from here. The deeper your roots the more aggressive you feel toward people from here who aren't really from here. I remember once Domenec Carles and I were on our way to the Club de Natació (Swimming Club) together and he was furiously criticizing the light here and raving about the light in Paris. I am just the opposite—I can't abide the ladylike landscape of Paris. *The Farm* made me even feel physically aggressive.

When I finished it I went back to Paris, and because of that canvas I nearly went under there. No dealer wanted *The Farm*. Nobody even wanted to look at it. I wrote to a lot of people, but nothing happened. I offered it to [the collector] Plandiura, but he wasn't the least bit interested. Finally, Rosenberg[5] agreed to take it on consignment at his gallery—probably as a favor to Picasso—but he stuck it down in the cellar and it was there for ages. As the months went by I was getting more and more impatient, and so I went back to see Rosenberg again. He was trying to be helpful when he made this suggestion. He said, "You know that times are tough in Paris and people are living in smaller and smaller places. Tiny, low-ceilinged apartments. Well, look, there is one thing we could do. . . . we could divide this canvas up into eight parts and sell them piecemeal." Rosenberg was really serious about that. A couple of months later I took the canvas from Rosenberg and brought it back to my studio where we lived together in utter misery.

Around that time my life began to change for the better. A lot of people came to see me, and I became very friendly with some poets and intellectuals who brightened up my life a little. That was when I got to know the American writer Hemingway, and Evan Shipman[6] and Ezra Pound who devoted an entire issue of New York's *Little Review* to me, presenting me as a Catalan.

Because Hemingway was a friend of mine, *The Farm* finally ended up in his hands (I can't remember whether he gave me 2,000 or 3,000 francs for it—this was in 1923).[7] Later Hemingway gave it to his wife. *The Farm* is in New York now, and Mrs. Hemingway has been offered tens of thousands of francs for it, but she didn't want to sell it then and she still doesn't want to sell it now.

When summer came, I came back here, and for a whole year I went about systematically destroying everything I'd done. My inner rebellion was just beginning. There is absolutely nothing left from that period. All I had then was a vague idea about *The Tilled Field*. I went back to Paris with nothing at all. I was in a state of utter rebellion and, most of all, I was completely against everything realistic.

I made friends with still more of the young intellectuals who were living in Paris then and got to know people like Michel Leiris, Roland Tual, Georges Limbour, Salacrou, the painter André Masson, etc. One day, before I came out of my negative period, Picasso came to see me, and he said that I was the only person after him to have taken a step forward in painting.

I began working again. Starting from real life, I managed to lose contact with reality—in *The Spanish Dancer*, for example, and especially

in the *Portrait of Mrs. K.* I was getting rid of any sort of pictorial influence and any contact with realism and I was painting with an absolute contempt for painting. I was painting from necessity and to do something more than just simply paint. The idea of painting has no spiritual value whatsoever. I painted the way I did because I couldn't tolerate any other way. I was feeling aggressive, but at the same time, I was feeling superior. I didn't sell anything. Not a single thing.

I felt contempt for my oeuvre. I still do and I feel the same contempt for my future . . . for what people call *lasting*. I was encouraged in everything I did by my friends, by those people who were like brothers to me. That kind of comradeship just isn't known here—it's impossible here.

When I did the *Portrait of Mrs. K.* (who actually sat for it), I was planning to do something realistic, but then I started eliminating, eliminating until I got to the point where I was completely anti-Cubist and then I even eliminated Cubism from my work. Maybe Picasso was right when he said what he did.

Back in Montroig again, I threw myself into work on *The Tilled Field*. From then on I was producing like mad, breaking with all traditions and never tearing up anything! I was tightly disciplined in *The Tilled Field*, but not at all in the other things I did. That was in 1925, and when I went back to Paris with everything I'd done here, all the dealers who came to see me died laughing. Kahnweiler said I ought to make a bonfire with all my work.

Breton and Eluard came to see me. They struck me as being revolutionary, but within the limits of the blandest sort of traditionalism. Both of them were alarmed and really disoriented by my work. On the other hand, Benjamin Péret and Robert Desnos were openly on my side in everything. And some time later Evan Shipman, the American, brought Jacques Viot to see me. At that time he was head of the just-opened Galerie Pierre. Viot is a great adventurer. I admire him tremendously and am very fond of him. As soon as he saw my work he invited me to dinner, and while we were eating he offered me a very good contract. . . . Viot left the Pierre Loeb gallery and started working as my dealer, with incredible guts. Later on he suddenly disappeared from Europe, and I believe he's now a justice of the peace in Papeete (Tahiti). I still admire him because he's the only man I have ever known who has really risked anything in life.

I don't think there is anything very heroic about being my dealer today. He was the person who arranged my first exhibition in Paris, at the Galerie Pierre, after La Licorne and sent out an invitation signed by

all the Surrealists. That was the first exhibition where I sold anything.
. . . Later Viot and Pierre arranged an exhibition of Surrealists at the
Galerie Pierre, and I had two things in the show: *The Dialogue of Insects*
and *Harlequin's Carnival*. After that, Viot disappeared—nobody knows
where—and Pierre himself offered me a formal contract: Pierre, who
actually admitted that when he first saw my work he started telling
everyone that a new kind of comic painting had appeared on the scene
and was splitting his sides laughing!

In the summer of 1926 I went back to Montroig, and again I
worked very hard. That was when I started feeling a great sense of
responsibility, and I decided on a plan of attack. Pierre and I decided
that I would shut myself up completely and not let anyone see my
work, and I'd prepare a major exhibition showing all the formal innova-
tions and aggressiveness I had inside me. It would be a real knockout.

And so I spent the winter of 1927 closed up in Paris, and I didn't
show anyone anything I was doing.

I decided to work really hard. It was an incredible feat really,
considering that it was a laboratory experiment that had to be a suc-
cess. That summer I went back to Montroig again where I painted
seven huge canvases,[8] and I felt that I had come to the end of that
period. Naturally, the time had come to have that show we had
planned. I had told Pierre I wouldn't enter the ring unless it was for a
championship bout, that I didn't want any friendly sparring match and
that now was the time to go for the title. I wasn't interested in fighting
unless I could win the prize.

Practically speaking, as soon as I had finished these paintings the
show was complete, and once I turned my work over to Pierre I didn't
think about it anymore. The show opened at the end of May.[9] Of the
forty-one things in it, Pierre reserved a dozen for himself and all the
rest were sold. If there had been more, they would have sold, too!

Now what else do you want me to tell you about my life? . . . The
only thing I can say right now is that once I was ready with the show
that opened at the end of May and realized the danger that would be
involved were it to be a success—and it is—I felt that rather than
capitalizing on that success (in a superficial sense) it would be better to
throw myself into new adventures—and that's what I'm doing. Right
now the opposition I'm getting from dealers and "art lovers" is spurring
me even harder to go straight ahead without worrying about anything
else. And it's such a luxurious feeling to baffle the people who believe
in me!

What I'm doing now closely parallels my other work, but people
won't be able to see that until a couple of years from now. By then

they'll certainly discover the links between what I am doing now and the rest of my work. I feel that if you're going to do anything in this world you've got to love risk and adventure and, more than anything, you've got to give up that middle-class idea that what you do has to last.

One of the things I am most interested in now is broadening the international repercussions of my work. I love my kind of aggressive nationalism, and I think it's much more effective than the lethargy of those Frenchified parasites who never move from here. I was delighted one day when I read an interview with Honnegger in *L'humanité*.[10] He'd just arrived from Moscow, and he said there were canvases of mine in all the galleries there. And I was delighted, too, when the New York Museum of Modern Art bought two things of mine on the opening day of the Bernheim show.[11] I think that's more effective than when the "Catalan genius," Joaquim Sunyer, shows his "Catalan paintings" at the Tuileries and is completely overshadowed by any one of the other people showing there, insignificant people—the sons of porters in Warsaw or housepainters from Brazil or amateurs from Bucharest or New Zealand.

Things like that remind me of that unfortunate song the Orfeo Catalá[12] sings. The one from "The Emigrant" that goes, "Sweet Catalonia, country of my heart, when I am far from you I die of longing." I hate that. I'm convinced that as far as nationalism is concerned, it's better to make a lot of noise than sit around crying about it. Instead of singing funeral dirges, our young men should be singing marching songs.

I also think that it has been a mistake, and a lethal one for Catalonia, that we have too often patterned ourselves after France. As far as the passionate spirit is concerned, it will always be easier for me to understand the man who kills three people because somebody's touched a hair of his wife's head than it will be to understand a French ménage à trois.[13]

The most abject impotence often hides itself under the cloak of art. I am far more interested in, much more moved by, a human action than by all the museums in the world. As far as I'm concerned, there are only two kinds of people: the ones who have soul and the ones who don't. And I don't need to tell you which ones I like best—the ones with soul, and that soul contains pure magic. Feliu Elias doesn't know how to find that soul, that magic in the great Dutch masters, whom I admire greatly. Men like Apa[14] have interpreted the world in a really stupid way. They can only imagine it as a kind of vessel and can't see the immense mystery of a little dot or a reflection in that vessel.

People are talking so much about Goya nowadays, but all they've been able to see are the externals, and absolutely nothing of the revolutionary part of his oeuvre. They haven't been able to see that Goya was passionately anti-French. He was fanatically anti-French. The people who see Goya in that other, false way are the same people who've only seen the externals all their lives—like that phony Manet, a worthless man, with that completely Parisian attitude that makes him hateful to us Catalans.[15]

Recently I've seen what Togores is doing. I think he's a perfect ass, and he's even worse now that he thinks he's a genius because he's in all the museums and is doing those cadaverous, "superrealistic" experiments.[16] I think the only people who matter are the ones who are alive, the ones who put their blood and soul into even the finest line or the smallest dot. Hokusai said he wanted even the smallest dot in his drawings to vibrate. And anything that isn't alive like that is null. If you just keep getting better and better in the external sense of the word, you're heading for pure decadence. You've got to perfect yourself on the inside, even though that often means you'll be a failure to the outside world. . . .

As I told you, the May show was finished last summer. Since then, the most recent things I've done—which haven't been shown yet—are drawings and canvases that have no relation to conventional pictorial practice. After all the work I put into the show I feel like I'm in the middle of the desert, absolutely lost. But I'm never afraid to risk my neck in another new adventure. What does terrify me is the idea that my work might someday stink of death and decay. That's what people who speculate with my work want, regardless of whether they're art lovers or dealers. Right now I can see a new light ahead of me, gaily beckoning me to take off down new paths. And right now I'm obsessed by this light, by these new ideas, and this drives me to extremes even for me. As soon as I finish something I've got to call my dealer right away and have him come and get it because I can't bear to have it there in front of me—I find it horrible![17]. . .

What I mean is that when I've finished something I discover it's just a basis for what I've got to do next. It's never anything more than a point of departure, and I've got to take off from there in the opposite direction. For me it's outdated, already passé, no more than a point of departure. I'd paint it over again, right on top of it. Far from being a finished work, to me it's just a beginning, a hotbed for the idea that's just sprouted, just emerged. Besides, do I have to remind you that what I detest most is what is lasting?

9

Text. Unpublished (transcribed by Jacques Dupin), 1977[1]

The following recollections were transcribed by
Jacques Dupin in 1977 for a publication on the heroic
period of 45 rue Blomet (1921–27). The volume,
which was to contain texts by Miró, André Masson,
and Michel Leiris, never appeared in its projected
form.[2] Despite the decades that had passed since the
events discussed, this is Miró's most vivid and
detailed account of those years, and although there is
some repetition, it seems desirable to publish it in its
entirety.

"Memories of the rue Blomet,"
Transcribed by Jacques Dupin, 1977

The rue Blomet was a decisive place, a decisive moment for me. It was there that I discovered everything I am, everything I would become. Robert Desnos had not yet made the Bal Nègre[3] famous. The rue Blomet belonged to the ordinary people of Paris. At number 45, you entered through a hall that went past the concierge's apartment and led to a courtyard with a lilac bush and a few modest studios. Masson's studio and mine were right next to each other. On one side there was a mechanic who made an infernal racket. On the other side there was an academic sculptor with a beard and frock coat. He did huge plaster sculptures of generals and important government figures. With him our relations were simply neighborly, artist to artist. . . .

How did I wind up on the rue Blomet one fine day in the winter of 1920? It was Gargallo's studio. Like his old friend Artigas, he spent the winter months teaching at the School of Arts and Crafts in Barcelona, a very free and open school—although they eventually fired him for signing a manifesto against the dictator Primo de Rivera.[4] Gargallo offered me his studio for the winter; when he came back to Paris, I left for my farm in Montroig, near Tarragona. Gargallo was from Aragon, and he was a stalwart fellow—a good sculptor and friend, very honest and extremely generous.

A few days before I moved in, I went to see Max Jacob at the Savoyarde in Montmarte—the café where he used to meet people. It was there that I met André Masson for the first time. He told me that he had just rented a studio at 45 rue Blomet. We were going to be neighbors. We became friends and have remained friends ever since. Our studios were in adjoining rooms and each of us could hear everything that went on in the other's place. It was very noisy in his and very quiet in mine. Masson lived with his wife Odette and small daughter Lili—in the midst of indescribable disorder and filth. But I was a maniac for order and cleanliness. My canvases were neatly arranged, my brushes were clean, and I waxed and polished the floor. The studio was perfect, just like a ship's cabin. I lived alone in total poverty, but every time I went out I wore a monocle and white spats. I liked to leave my monk's cell and go to the studio next door, with its unbelievable clutter of papers, bottles, canvases, books, and household objects. I liked little Lili and would give her candy and bounce her on my knee. We would talk, drink, listen to music. Before his contract

with Kahnweiler,[5] Masson worked at night as a proofreader for the *Journal officiel*.[6] He went to bed at dawn, and when he got up, I had already been working for a long time.

We had very few things. At the flea market I bought an old stove for 45 francs, and for light I used an oil lamp. They both appeared in my paintings, the oil lamp and the stove.[7] I also remember painting an enormous 48 on a very empty canvas.[8] This was the obsessive number that hit me whenever I went outside—the number on the building across the street, 48 rue Blomet.

But I was, and still am, haunted by the number 13. I was born in '93 [quatre-vingt-*treize*], and my first important exhibition, celebrated by the Surrealist group in full force, was held at Pierre Loeb's gallery at 13 rue Bonaparte, on Friday the twelfth at midnight, which is the same as zero o'clock on the thirteenth. Now, I am showing at the Galerie Maeght, 13 rue de Téhéran.[9] And during the rue Blomet period, it was on another thirteenth that I broke an engagement to be married.

More than anything else, the rue Blomet was friendship, an exalted exchange and discovery of ideas among a marvelous group of friends. Among those who came to the gatherings at Masson's studio were Michel Leiris, who has remained my closest friend, and Roland Tual, Georges Limbour, and Armand Salacrou. We talked, we drank a lot. Those were the days of brandy and water, of curaçao tangerines. The others generally came by Metro, by the famous Nord-Sud that served as the link between the Montmartre of the Surrealists and the Montparnasse of the backward artists.[10]

This was the same Nord-Sud that had been the title of Reverdy's magazine,[11] which I had looked at so many times during my youth in Barcelona. The Volontaires Metro station.[12] The famous "entrances" of the Metro[13] reminded me of the great Gaudí,[14] who was such a major influence on me. The frequency of arrows and flying birds in my work comes from Guimard's Metro entrances.

We listened to music (which was scorned by the Surrealists) and read a lot at the rue Blomet. Salacrou, who lived in the neighborhood and was already writing plays, was reading and translating the poems of Byron. Roland Tual, who was writing in secret and did not publish, read with a splendid actor's voice. Limbour read Saint Pol Roux and Jarry—and I remember the strong impression that [Jarry's] *The Supermale* made. We also read Rimbaud and Lautréamont, Dostoyevsky and Nietzsche, about whom both Masson and Leiris were fanatics.

Not far from our street lived the rue du Château group, which was

very different from ours.[15] The rue du Château included Prévert, Tanguy, and Marcel Duhamel. We saw them every now and then. Tanguy especially was just starting out when I met him. He painted very slowly and assiduously, putting in long and regular work hours, after which he would drink—with the same kind of seriousness.

Among the others who came to our rue Blomet gatherings there was Antonin Artaud, who was then acting at Dullin's theater, L'Atelier.[16] He read his first texts to us and gave us theater tickets. And then there was Dubuffet, before he left for Le Havre, Juan Gris, and Robert Desnos, who hung out at the Dôme[17] and would drift over to the rue Blomet.

Aragon sometimes came to see us, but more often than not we saw him at a chic club in Montmartre, Aux Zelis, I think, where his dandyism and colored socks created a sensation.

As for Breton and Eluard, they didn't come down from their hill[18] very often—and would come only to see our paintings. My *Farm* and still lifes never interested them. They ignored my existence until my painting freed itself in the direction of poetry and dreams—*The Tilled Field*, *Harlequin's Carnival*, and what came after. We attended the Surrealist meetings very faithfully. These were held at Cyrano's on the place Blanche at noon. Masson took part in the discussions, but I was usually silent.

On the rue Blomet we were more involved with painting. Masson liked Derain and expected a great deal from him. Not me. I preferred Matisse. But we shared the same admiration for De Chirico—whose paintings could be seen at Paul Guillaume's—and for the Douanier Rousseau. His *Sleeping Gypsy*,[19] which Masson told me was at Kahnweiler's, I remember caused a very great emotion in me.

Because of our friendship, Picasso came to the rue Blomet. He was living then on the rue de la Boétie, and he took the Nord-Sud as well. In the fall of 1924, he was very enthusiastic about my *Spanish Dancer*,[20] which was only a charcoal sketch on canvas. I was blocked on it and unable to continue. He told me to leave it in that state, and so I left it that way. "After me," he said, "you are the one who is opening a new door."

There were also visits from Kahnweiler, who had become Masson's dealer, and from his painter friends Lascaux and Beaudin.[21] I liked them, but their painting was foreign to me. I remember some wild discussions between Masson and Beaudin about Nietzsche—whom Beaudin couldn't stand.

Kahnweiler came to my studio only once. He looked conscien-

tiously at all the paintings without saying a word. And he never came back.

Another day, Aragon sent Jacques Doucet[22] to see Masson, who then sent him over to my studio. He didn't say a word either. But after he left, he said to Masson outside, "Your neighbor is completely mad!"

Masson worked feverishly. Listening to music, in the midst of loud conversations. I could only work alone and in silence, with ascetic discipline. Masson played cards and chess. I didn't play anything. He painted chess players, and Tual, Salacrou, and Limbour all posed for him. For his series of *forests*, he did sketches in the Bois de Boulogne. We were in constant contact. We also went out together sometimes and walked along the banks of the Seine. The river was wonderful at all hours and in every weather. There was a custom of throwing a coin into the water to ward off bad luck. I liked to make circles in the water; I liked the reflections and the colors that changed in the different lights. A little later I painted a picture that evokes these walks by the river; among the dotted circles I wrote: "Music, Michel, Bataille, and I."[23] Yes, Bataille,[24] I knew him well, but after the rue Blomet.

Together, Masson and I discovered Paul Klee, a discovery that was essential to both of us. Through reproductions at first, in a big bookstore on the boulevard Raspail. Then in a small gallery on the corner of the rue Vavin;[25] the owner went to see Klee from time to time and would bring back a few watercolors from these trips. He would let us know when he returned, and we would rush right over. Eluard and Crevel were also interested in Klee—they even went to see him. But Breton was disdainful of him.

I ate little and badly. I have already said that during this period hunger gave me hallucinations, and the hallucinations gave me ideas for paintings.[26] I remember that one time when Arp came to see me, I shared a few radishes with him, which was all I had. Occasionally, Catalan visitors brought me country sausages and provisions. It was a period of intense work. I filled up notebooks with drawings, and these served as the starting points for canvases. I recently discovered dozens of these notebooks, with thousands of drawings in them, some of which were done at the rue Blomet. I had forgotten all about them. They are now at the Barcelona Foundation.[27]

At the rue Blomet I finished *The Farm*, which I had started at Montroig and continued working on in Barcelona. To finish the painting, I even picked some grass in the Bois du Boulogne and brought it back to the studio to give myself an illusion of reality. As soon as the canvas was finished, I was so sure of myself—for once—that I took it

around to all the dealers in Paris. Each time, I was asked to leave it for a while, and each time I received a note asking me to pick it up, and so I had to pay for the ride back in the taxi. The Surrealists were not very interested in it either. Only Masson liked *The Farm*, but he was much more open than anyone else. And then there was Hemingway, who became so crazy about it that he wanted to buy it from my dealer, even though he didn't have a cent in his pocket. He lived on the rue Notre Dame des Champs back then and I went to see him often. Through him I got to know the American writer Evan Shipman,[28] who bet on the races and lost regularly. We often went for dinner at the Nègre de Toulouse,[29] and there we would see Joyce, who was blind, accompanied by his daughter. With Hemingway, I did some boxing in an American club.[30] It was rather comical, since I didn't come up any higher than his belly button. There was a real ring, and all around in the stands, a crowd of homosexuals. I didn't stick with it. But I also worked out in a gym, and I have kept up with that. Masson didn't like sports; his only specialty, which he excelled at, was cossack dancing, where you crouch down on your heels and shoot out your legs. To get back to Hemingway, he wanted *The Farm*, and he managed to get the money together by borrowing it from American friends—and by working as a sparring partner for professional heavyweights.

III

Paris, Montroig, and
Barcelona, 1929–36

10

Statement. *Variétés*, 1929[1]

By 1928–29, the Surrealist movement was
floundering. Many poets, writers,and artists,
disenchanted with Breton's dogmatism, threatened to
withdraw from its ranks. Thus, on February 12,
1929, Breton, Aragon, and Raymond Queneau sent
out a circular letter to approximately seventy-five
persons, requesting a statement of commitment and
formulated in the following terms:

> Do you support the ideal of a group endeavor, or
> should we abandon all hope for concerted communal
> action?
> 1. Do you believe that you should limit your activity to
> one of a purely individual nature?
> 2. a) If so, please explain and define your position.
> b) If not, please define your conception of concerted
> communal action.

Miró's equivocal response expressed his
unequivocal aversion toward all regimented group
activities.

STATEMENT. IN *VARIÉTÉS*, JUNE 1929

There is no doubt that when action is taken, it is always the result of a collective effort. Nevertheless, I am convinced that individuals whose personalities are strong or excessive, unhealthy perhaps, deadly if you like—that is not the question here—these people will never be able to give in to the militarylike discipline that communal action necessarily demands.

[Autobiographical sketch].
Letter to Michel Leiris, 1929[1]

In 1924, Michel Leiris signed the Surrealist manifesto and became an official member of the group until 1929 when he withdrew from its ranks and founded the dissident magazine *Documents*, which appeared until 1931. During his official Surrealist career, he continued to frequent the rue Blomet and maintained his close friendships with Masson and Miró, despite the latter's expressed distaste for the dogmatic doctrines of the movement.

When in 1929 *Documents* decided to run an article on Miró and it was decided that Leiris should write it, Miró was visibly pleased. In order to facilitate Leiris's task, he supplied him with a page of notes about his childhood, much in the manner of those he would send to Jacques Dupin some thirty years later (see Text 1). Leiris quoted a few brief passages in the preface to his article, which still stands as one of the most perceptive texts—and the closest to Miró's own thinking—ever written on the artist.[2]

To Michel Leiris. Montroig, September 25, 1929

Birth Date

April 20, 1893, at 9 P.M. in Barcelona.

Childhood

Sent to the Barcelona School of Fine Arts very young—very clumsy and badly behaved.

Fights with the family; give up painting to work in an office.— Catastrophe; do drawings on account books and am fired, naturally. At 19 I enter the Galí Academy in Barcelona to devote myself entirely to painting. A marvel of awkwardness and incompetence.

Talented as concerns color but with forms a complete failure. Cannot tell the difference between a straight line and a curve. I come to have a *living* sense of form by drawing things I have touched with my eyes closed. From the beginning, I am nevertheless considered at Galí's to be a gifted colorist and to have some talent.

After three years I leave the academy and work alone with passion and faith. I do not have the plastic means necessary to express myself; this causes me atrocious suffering, and sometimes I bang my head against the wall, from despair, from not being able to express myself. Still, passion and faith keep me going. My painting changes often; searching for a means of expression; still, this burning passion drives me forward, keeps me going from right to left.

Arrival in Paris

March 1920.

Exhibitions

Galeries Dalmau in Barcelona, February 16 to March 3, 1918— scandal—zero sales.

Galerie La Licorne in Paris; April 29 to May 14, 1921. Hardly anyone notices me—zero sales.

Poverty and very hard times.

Galerie Pierre; midnight June 12 to June 27, 1925—everyone has a good laugh.

May 19, 1926, fight at the Théâtre Sarah Bernhardt over the ballet *Romeo and Juliet*.

Galerie Georges Bernheim et Cie; May 1 to 15, 1928.

Galerie Le Centaure in Brussels from May 11 to 23, 1929.

12

Two letters to René Gaffé,
1929 and 1931[1]

René Gaffé, a Belgian businessman and journalist, was Miró's first private collector. Gaffé was a close friend of André Breton and Paul Eluard and, starting in the 1920s, he assembled one of the greatest and earliest collections of Surrealist painting, with special emphasis on Miró, Max Ernst, and René Magritte.

The *Interior* mentioned in Miró's first letter to Gaffé is *Dutch Interior III* of 1928. The three Dutch interiors inspired by a trip to Holland in the spring and painted that year mark Miró's momentary return to a more precise, detailed style.

In the second letter, Miró evokes his collaboration with Tristan Tzara, the pioneering Dada poet, on the book *L'arbre des voyageurs* (1930).[2] Miró met Tzara on the rue Blomet in the early 1920s and immediately appreciated the poet's attitude and objectives, which were astonishingly parallel to his own. *L'arbre des voyageurs*, although it contains only four spare (lithographed) line drawings, shows a complete harmony of spirit between the graphic images and the poetic verse.

To René Gaffé. Paris,
22 rue Tourlaque
[June 19, 1929?]

You do me honor, dear Monsieur Gaffé, by the way you consider my painting, and I am truly very proud. I am very happy that the *Interior* belongs to you, for I feel it was a canvas you should have had. You cannot imagine the drama the painting of that canvas represents for me, a canvas that has an enormous value as a *struggle*, a *human* struggle in my career.

Believe me that if I do somersaults and acrobatics on a tightrope, it is not at all in a gratuitous way—quite the contrary.

If I am constantly risking what I have already won, I am not neglecting for a single minute to build up my muscles for that.

I would like to subject those more or less intelligent gentlemen who brainwash us with their more or less imbecilic absurdities to several minutes of the kind of training I go through very methodically every day, and you would see the wind go out of them rather fast.

To René Gaffé. Paris,
3 rue François Mouthon
March 18, 1931

I have learned with joy that you already had a copy of *L'arbre des voyageurs*—Tzara and I are extremely happy to dedicate this copy for you; you have only to say so.

As for what you ask me about negotiations with Tzara and his asking me to illustrate his book, I should tell you that he was one of the first to see and like my painting. On my end, I have long considered his poetry to be of great spiritual value and his *Dada* position has always been extremely appealing to me, as *clairvoyance* and as a method of action. It was therefore all very simple; I accepted gladly without batting an eye.

If I have done the lithographs in the way I have done them, it was because his poetry—desertlike, with blinding showers of sand— suggested them to me.

13

Interview. *Ahora*
(Francisco Melgar), 1931[1]

The following interview was conducted in Miró's
Paris studio at 3 rue François Mouthon by Francisco
Melgar, a journalist from Madrid. Among other
things, Miró expresses in quite explicit terms his
fundamental differences with the Surrealists. But the
real interest of this interview is in the artist's
formulation of his objectives as a painter. Here his
often-quoted ambition to "assassinate"[2] painting is
clarified and defined as the destruction of the rules
and conventions of painting as a traditional discipline.
This underlying idea is developed throughout the
interview: in his statement of "nausea" with regard to
painting; in his declared lack of respect for all artists
or schools; and in his expressed desire to achieve a
manifestation of the pure spirit. Thus this text is
central to the understanding of many other writings
in which Miró speaks of his search for a form of
painting "stripped of all pictorial problems" and
expressing solely "the harmonious vibration" of the
spirit,[3] or his desire to go beyond the visual object
and achieve poetry.[4]

It is evident that Miró's declarations here are
purposely extreme. Elsewhere he liberally states his
admiration for Goya, van Gogh, Cézanne, Henri
Rousseau, Picasso, and others. The years 1928–30
were Miró's most iconoclastic period. During this
time, he made provocatively spare collages and

assembled objects and constructions, but his painting output was relatively limited; he was uncomfortable with his own facility and undergoing a severe creative crisis. His anger and anxiety are reflected in the categorical tone of this interview.

"SPANISH ARTISTS IN PARIS: JUAN [*SIC*] MIRÓ," BY FRANCISCO MELGAR. IN *AHORA* (MADRID), JANUARY 24, 1931

JOAN MIRÓ: Just as Picasso has been labeled a Cubist, I've been labeled a Surrealist. But what I want to do above and beyond anything else, is maintain my total, absolute, rigorous independence. I consider Surrealism an extremely interesting intellectual phenomenon, a positive thing, but I don't want to subject myself to its severe discipline.

FRANCISCO MELGAR: Weren't you one of the founders of Surrealism?

MIRÓ: No. The truth is that my own development was very slow, and by the time I arrived at an understanding of Surrealism, the school was already established. I was swept along by André Masson, Max Jacob, and I followed them, but not everywhere they went. They form a battalion, a company if you like, and everything they do is strictly disciplined. I want to be independent.

F.M.: What about Luis Buñuel, Dalí?

MIRÓ: Buñuel and Dalí are disciplined Surrealists; they never deviate from the rules established by the school. Rules? Art defies them. But art doesn't exist for the Surrealists. What they understand by art is anti-art. In politics they espouse Bolshevism as the way to destroy present-day social ideals.

F.M.: Nonetheless, you and your friends are the leaders of this movement. Can you give me a simple explanation of what you are trying to do?

MIRÓ: I personally don't know where we are heading. The only thing that's clear to me is that I intend to destroy, destroy everything that exists in painting. I have an utter contempt for painting. The only thing that interests me is the spirit itself, and I only use the customary artist's tools—brushes, canvas, paints—in order to get the best effects. The only reason I abide by the rules of pictorial art is because they're essential for expressing what I feel, just as grammar is essential for expressing yourself.

F.M.: But what do you feel?

MIRÓ: I've already told you: utter contempt for painting.

F.M.: How do you feel about the schools that preceded you, earlier painters, or your own contemporaries?

MIRÓ: I'm not interested in any school or in any artist. Not one. I'm only interested in anonymous art, the kind that springs from the collective unconscious. I paint the way I walk along the street. I pick up a pearl or a crust of bread and that's what I give back, what I collect. When I stand in front of a canvas, I never know what I'm going to do—and nobody is more surprised than I at what comes out.

F.M.: Do you work a lot like that?

MIRÓ: I'm always working, except when I'm traveling. I work here in this studio and in Spain, where I spend several months a year on a farm we have in Montroig in the province of Tarragona. Down there, in the country, I meditate and paint and then I bring my work here to sell.

F.M.: Do you sell a lot?

MIRÓ: I've been selling well ever since I met the dealer Jacques Viot about five years ago. He arranged a show for me at the Galerie Pierre and I'm still working with them. I had a show in New York a month ago. It was a critical success, but the financial results were mediocre because of the depression. . . .

The early days in Paris were really difficult. After two solid years of work I managed to get a show at La Licorne, thanks to Dalmau who had arranged my first show in Barcelona. Not a lot of reviews, but all good ones.[5] I sold a couple of things then, but it all went to Dalmau because I'd given him the rights to my work in exchange for him helping me get started in Paris. Dalmau was a well-known figure on the Paris scene, a friend of Reverdy's and Max Jacob's and all the new generation of writers. Unfortunately, La Licorne went bankrupt and there was another long period of silence. Another very tough period which I worked my way out of slowly, painfully, sweating blood, and then I entered a new period where I was very meticulous and paid a tremendous amount of attention to detail.[6] Then I reacted violently to all that and I wanted to go beyond painting. These reactions are the whole story of my work. They happen like clockwork and regulate the successive phases of my activity. . . .

Painting revolts me. I can't bear to look at my work. I haven't got any at home: I won't even let my wife hang any of these things on our walls.

14

Two letters to
Sabastià Gasch, 1932[1]

In 1932, Miró was commissioned by Léonide Massine
to create the sets, costumes, curtain, and accessories
for *Jeux d'enfants*, a ballet conceived by Boris Kochno
for a score by Georges Bizet. Miró would always
refer enthusiastically to this project as an exemplary
collective enterprise in which all the participants
worked together toward a single goal.

Premiered in Monte Carlo on April 14, 1932, the
ballet was presented in Paris at the Théâtre des
Champs-Elysées later that same year. It was
presented a third and final time in May 1933 at the
Opera House (the Liceo) in Barcelona.

Sebastià Gasch was a Barcelona author and critic
who was to review *Jeux d'enfants* after its Monte Carlo
opening. Once again, Miró was characteristically
preoccupied with how this project would be
presented and received in his native city.

To Sebastià Gasch. Monte Carlo
[March–April 1932]

The work we're doing is taking on unexpected proportions, and what we are doing will be either sensational or an utter failure. Anyway, you can be sure it won't be mediocre: "to be or not to be." We all share this criterion and we are all willing to go the limit, not overlooking the slightest detail, and risking our necks.

The music by Bizet—the composer of *Carmen*—is as clear and precise as the air you and I breathe deeply when we are in Escullera.[2] I have unlimited freedom and everyone backs me up. We'll do something as sensational as the running of the bulls or a heavyweight prize fight.

This marvelous man called Massine has come especially from La Scala in Milan to collaborate with me: he is doing choreographic wonders and he finds ways to make everything I give him dance. We must not forget that this is the man who created *Parade* and *Mercure* with Picasso and Satie[3] and also *Le sacre du printemps* by Stravinsky. *Belle performance!* If we all keep on going as we are now, I think we will do something as important as the ballets I just mentioned. The male and female dancers are magnificent, and Kochno is a great theatrical experience which is very valuable for me. I am treating everything the same way as my latest work: the curtain, the first *hook* that hits the audience, like this summer's paintings, with the same aggressiveness and violence. This is followed by a rain of swings, uppercuts, and rights and lefts to the stomach, and throughout the entire event—a round that lasts about twenty minutes[4]—objects keep appearing, moving and being dismantled on the stage.

To Sebastià Gasch, Montroig
[Late April 1932]

I still haven't heard anything from Kochno and now I'm going to write him so they'll refuse the Olympia.[5] I don't think there is anything I neglected to say in my previous letters. Perhaps I didn't put enough emphasis on my deep and everyday more intense admiration for Barcelona, which I think it would be interesting for you to stress in your article, as opposed to the little people who have come from Paris. You

can say that the idea of living in Paris was a cliché of the last generation and that nowadays it would be cowardly or provincial.

The few friends that "I can stand being with" here feel the same way. Every day I find fewer people I can bear to be with. Human imbecility has no limits; thus, it is not localized.

You can say in your article that, as far as breadth of the spirit is concerned, it makes no difference whether you see Rusinyol on calle Petritxol or Cézanne on the rue de la Boétie and that I consider each as barren as the other and that I consider the latter a man with absolutely no breadth of spirit, that his painting is the pastime of a "son of a bourgeois" suffering from an obsession, the way raising canaries or collecting numbers that read the same frontwards and backwards become obsessions with certain people. It's a farce to say that Cézanne has steered painting back on its true path;[6] all he did was imitate the Venetians who were also incapable of turning to the great spirits, and he also imitated the pictorial aspect of Greco while remaining insensitive to the mystic flame he "sometimes" possessed.

You can stress all that and my great, very great admiration for Barcelona, far, here as in Paris, from the intellectuals who have become such cretins everywhere in the world, and that I am absolutely not interested in being social, and I hate receptions in great salons, and I am not the least bit interested in being intimate with princesses. Don't write the article until you receive documentation from Monte Carlo.

15

Statement. *Minotaure*, 1933[1]

The magazine *Minotaure* was published in Paris
between 1933 and 1939 under the artistic direction of
E. Tériade, advised by Breton and Eluard. It was
highly colored by Surrealist thinking, though its
perspective was broader in scope. The double issue
of December 1933 contained an essay by Tériade on
the "Emancipation of Painting," followed by a poll of
artists. In his preface to the latter, Tériade claimed
that the "new rules" in painting were accident,
spontaneity, and freedom from reference to a model.
The artists polled included Matisse, Braque and
Picasso,[2] as representative of an older generation, and
Francisco Borès, Miró, André Beaudin, and Dalí,
speaking for a younger group. Predictably, Matisse
and Braque showed little interest in accident or
chance, whereas the "younger" artists tended to
confirm Tériade's thesis.

Miró's response, characteristically laconic, provided
a basis for the myth that his painting was
spontaneous, hallucinatory, and without
premeditation. What he failed to mention, however,
was that, like the mystics he so admired, he
conditioned himself to receive a "jolt" that would
trigger the so-called hallucinations he would then
capture and transcribe.

Statement. In *Minotaure* (Paris), December 1933

It is difficult for me to talk about my painting, since it is always born in a state of hallucination, brought on by some jolt or other—whether objective or subjective—which I am not in the least responsible for.

As for my means of expression, I struggle more and more to achieve a maximum clarity, force, and plastic aggressiveness—in other words, to provoke an immediate physical sensation that will then make its way to the soul.

16

Letters to Pierre Matisse, 1934–36[1]

Miró met the New York dealer Pierre Matisse in
1930. When, in 1932, the effects of the depression
finally hit Paris, and Pierre Loeb, Miró's Paris dealer,
could no longer buy or sell all of Miró's paintings,
Loeb asked Matisse to take on half the artist's
production and give Miró a monthly stipend.

Throughout the 1930s, Matisse came to Paris only
once a year. Because his visits were infrequent, and
he showed Miró's work on an almost annual basis,
the two men maintained an extensive correspondence.
Miró's letters were detailed and precise. In them, he
discussed his general intentions and his position in
relationship to abstraction and Surrealism. He also
described the sequence of his paintings, their
inspiration and techniques, and made practical
suggestions about how they should be presented to
the public.

To Pierre Matisse. Barcelona, Pasaje Credito 4, February 7, 1934

Thank you for your nice letter, which gave me great pleasure. I am very happy to have had this exhibition at your gallery and very touched by the interest you took in it. . . .

The catalog of the show is also very good. I sent one to Hemingway, who is in Africa. If I may make one small criticism, instead of the title *Composition* (which evokes abstract things in a dogmatic or superficial sense), I would have preferred that you had simply put *Painting*, along with the date of the picture.

To Pierre Matisse. Montroig, October 12, 1934

I think it's very good that you have put off my show until January 1935; it's very important that you also exhibit what I have done this past summer and fall.

a) Large gouaches

b) Emery papers which have nothing to do with the earlier ones

c) Large pastels

These pastels *are very painted*. I intend to fix them very solidly, don't worry. You will be able to do a greatly varied show, with many different kinds of things, which I hope will be of considerable interest. . . . In all, there will be about forty things, which I will have finished by the end of November. I will then go immediately to Paris and ship them to you, as you requested, at the very beginning of December.

I have thought a lot about the question of titles. I must confess that I can't find any for the works that take off from an arbitrary starting point and end with something real. In the past I have given titles to my works, but they always seemed like a joke. However, I give you permission to choose titles based on the *real things* my works might suggest to you, provided these titles do not evoke some tendency or other, something I want to avoid completely: "composition," for example (which evokes the Abstraction-Création group), or literary titles in the Surrealist manner. For the pastels that I am now doing, I will give titles, since they are based on reality—but the titles will be unpretentious and very ordinary: figure, personage, figures, personages.

To Pierre Matisse. Barcelona, Pasaje Credito 4, December 17, 1934

As your sister was not in Paris and I did not learn that your father was there until the eve of my departure—which, to my great regret, denied me the pleasure of seeing him—we asked Zervos to represent you for the dividing up of my works; everything went well, without the slightest difficulty.

There was one pastel that André Breton liked very much. It seemed like good politics to me to be on good terms with him, for the Surrealists have become *official personalities* in Paris. Pierre agreed with me and I gave him the pastel as a present. I think I did the right thing.

Even though they are fixed, the pastels are very fragile. With the sandpapers, you must be careful, since the paper can crack.

You see that I have given titles, very simple ones, however, since I wanted to remain within pure painting, at the same time going beyond it, of course.

For this forthcoming exhibition in New York, it would perhaps be intelligent not to show too many things to the Americans, so as not to give them the feeling that we depend exclusively on them, which could do us harm. I talked to Sweeney[2] about it, and he agreed with me. Forgive me for suggesting this idea to you, since you are someone who knows the American mentality so perfectly.

As for the framing, the more *simple* and *less elaborate* it is, the more perfect and successful it will be. The walls of my studio are whitewashed, and it is in this kind of atmosphere—of maximum serenity and simplicity—that I imagine my paintings, as far away from Parisian refinement as possible. For the large exhibition at Georges Bernheim's I had the large paintings framed with a simple strip of *natural wood*, untouched *even by a plane*, which allowed the paintings to stand out and did not rob them in any way of their power and strength.

To Pierre Matisse. Barcelona, Pasaje Credito 4, February 19, 1936

The work continues. In the end, I believe it will transport you into a world of *real unreality*.

To Pierre Matisse. Barcelona, September 28, 1936

Around October 15 I will have finished the paintings that constitute the work from this summer. There will be *26* in all, in a 108 × 78 format on Masonite, which is a very solid material. These paintings have a great expressive power and a great material force. . . .

As you predict clairvoyantly in your letter, I don't deny that one day I will plunge in again and set out on the discovery of a *profound* and *objective* reality of things, a reality that is neither superficial nor Surrealistic, but a deep poetic reality, an extrapictorial reality, if you will, in spite of pictorial and realistic appearances. The moving poetry that exists in the humblest things and the radiant spiritual forces that emanate from them.

I agree with what you say about Surrealism; this school has already come to its extreme limit. Now that the opportunists and weaklings are going to try to turn it to their advantage, you others, the art dealers with dignity, must be on your guard, in spite of the commercial advantages that might be gained in the short run.

In fact, in all schools and movements the only thing that counts is *man*—all the rest is bluff and foolishness. It is only the *individual* with great human force who imposes himself; all the others are no more than absurd marionettes.

You speak to me of my objects[3] and ask how I conceive of them. I never think about it in advance. I feel myself attracted by a *magnetic* force toward an object, and then I feel myself being drawn toward another object which is added to the first, and their combination creates a poetic shock—not to mention their original formal physical impact—which makes the poetry truly moving, and without which it would have no effect.

I am therefore totally removed from the ideas—Freudian, theoretical, etc., etc., etc., etc.—that people apply to my work. If my work exists, it is in a *human* and *living* way, with nothing literary or intellectual about it—which is the sign of a stillborn and rotten thing, destined to disappear almost immediately.

Don't attach too much importance to what I am saying. You know me well enough to see that I am writing all this to you as a *friend*, without any spirit of dogmatism or ridiculous pretentiousness.

IV

Paris and
Varengeville, 1936–40

17

Letters to
Pierre Matisse, 1936[1]

From November 1936 to June 1940, Miró lived in
exile in France. In his many letters to Pierre Matisse
throughout this period, we can see that Matisse not
only represented his sole source of income but also
gave him enormous moral support. These letters are
a moving testimony to the bonds between an artist
and his dealer in troubled times. They also offer a
vivid account of Miró's activities and preoccupations
during his years of exile.

To Pierre Matisse. Paris, Hôtel Récamier, 3 Place St. Sulpice, November 16, 1936

I must begin by thanking you with all my heart for the arrangements you have made for me concerning financial matters and all the precautions and security measures you have taken as regards my wife and child in case something happens to me.

I also want to express to you how moved I am by the enthusiasm and courage you have shown in organizing this exhibition. It is not a question here of being modest; an exhibition launched by a man of action and foresight such as yourself can have enormous repercussions.

For the dividing up of my paintings, it was Madame Duthuit who represented you, strictly following your instructions. I hope that you will be pleased.[2]

The shipment of these paintings took a long time because of the highly annoying paperwork demanded by French customs; rest assured that it had nothing to do with negligence on our part—quite the contrary, we spent days on the phone.

I hope these paintings will not suffer any damage during the crossing; as you can see, the material is *very* solid. Nor should you worry too much if a stone falls off, *that has already been taken into account* and will make these recent works lose their *beautiful object* quality and *gain* even more *power*. It will make the surface of the ground look like an old crumbling wall, which will give great force to the formal expression. . . .

Enclosed is a card for the presentation we made; it was a triumph, about 500 people came between 9 o'clock and midnight. We played some records of sardanas,[3] which made for a very moving show of sympathy for Catalonia and Spain. . . .

Right now I am preparing and doing drawings for about ten large paintings. Along with these ten or so large paintings on canvas—done in oil without any additional materials—I am thinking of doing several drawings, watercolors, gouaches, small paintings, objects, and sculptures that I would like to finish in June. Unfortunately, I'm afraid that this time I won't be able to accomplish these projects with the same almost mathematical rhythm I always work with and that I will have to give in to the demands of the current drama. I am keeping you up to date on what I am preparing only so that you will be able to plan the future—even though I don't see the possibility of coming to the end of this task because of the uncontrollable circumstances of current events.

I am convinced that you are aware of that.

Along with the paintings, I am sending you:

a) *Dog Barking at a Kite*

b) a poster

c) a layout for the catalog

d) " " " " rug

e) a signature in black

f) " " " blue

I think these are all done in the spirit we agreed on.

To announce the date of my show on the side of the poster, please use the letters and numbers that architects use; their graphic strength, over and above artistic considerations (!), will give great force to the poster.

I did the layout for the catalog in Catalonia, following the dimensions you initially gave me, which are slightly different from those you gave me later. Since it is difficult for me now to recapture the state of mind I was in while doing it, I have left it as it was.

In printing the catalog, it might be interesting to do it on a paper with a *neutral color*, with the signature in black on the front page and the gouache inside, which you can print separately and then paste onto this paper, which will also serve as a frame—in case you want to use the most recent set of dimensions you mentioned. But in case you decide to use a full page the size of my gouache, that would also work. The signature in black, as you can see, can be used in either case, since the technique I used was one of a collage that can be shifted in relation to the center of the page.

I have not sent you the paper samples you asked for. Do as you like, my friend, I am absolutely certain that you will do something wonderful. However, let me advise you to do it with maximum simplicity and a *minimum of artisticness*.

For the layout of the rug, aside from formal and technical considerations, I attach great importance to the poetic aspect, to the emotion that can be created by the feeling of walking on something celestial, walking on blue. . . .

I have not received the article on Surrealism and my painting that you mentioned in a letter. . . .[4]

Could you get me a catalog of the Fantasy Exhibition at the Museum of Living Art, a general catalog from this museum, and one from the Museum of Modern Art in New York?[5] . . .

I don't know whether I will stay here and wait for the storm to die

down or whether I will return to Spain. My wife writes that she is having great trouble getting her passport. I will have a definite answer in a few days and will make a decision then. If she can't come here with my daughter, I will go back to Spain to be with my little family, despite the risks of certain dangers—otherwise it would be cowardly. I will let you know my decision as soon as I have made it.

In case I go back to Spain, remember the censorship when you write to me. You can prepare a big envelope with some catalogs of my show, articles, etc., etc., and hold it for me. I will tell you when you can send it, and if not, you can keep it for me until I see you in Paris again next summer. But *don't forget* to keep everything I ask for, my friend. . . .

Your idea about how to ask for money is very good. "Send me a catalog" (1 catalog = 100 dollars).

Would you please be kind enough to write to the bank to alert them about this code. I enclose a sheet of paper with my signature.

I will keep you posted about whether I leave or stay in Spain.

The only thing left, my dear Pierre, is to thank you once more for all you are doing for me and to tell you how touched I am by the courage and faith you have put into dealing with my work.

TO PIERRE MATISSE. PARIS, HÔTEL RÉCAMIER, DECEMBER 14, 1936

I have learned through friends who wrote to congratulate me that my exhibition has already opened. Afterwards, two catalogs arrived. I gave one to Pierre, who was then obliged to give it to someone else; so there is only one left for me.

I hoped that you would drop me a line as soon as you had received the paintings.

I would be very grateful if you would send me a few catalogs by the next boat. I am perfectly aware of the effort you have made to organize this show, but you mustn't forget that I was the one who painted the pictures, which, it seems to me, after all, is the point of departure for everything else.

Allow me to point out to you that the signature you put on the first page has absolutely nothing to do with mine, as you can easily see by comparing it to the original.

I was also surprised to see that you did not show any of my recent

canvases, which, in my opinion, if I may say so, was a huge mistake. In these times of pederasts and snobs, we should have hit very hard to beat this group of imbeciles. I had worked with enthusiasm and faith, thinking that the overall effect of this show could be sensational; it's very clear that you were not standing in my corner to help me put my fight plan into action for kayoing that whole gang of sissies and weaklings.

The catalog looks a little too much like the French flag.

It's too bad that you didn't send me a cable, which would have allowed us to show these paintings for a few days here in Paris, where they created a sensation—and spared me the futile work of gouaches, large signatures, etc., that you never even used.

I saw that the exhibition of Fantastic Art[6] has also opened. I suppose that something of mine is in it, too, and, if so, would you be so kind as to tell the gentlemen who organized it to be polite enough to send me a catalog which, as a participant, it seems to me that I have a perfect right to. . . .

From now on may I request that you deposit my monthly payment in dollars every month at the Royal Bank of Canada, 3 rue Scribe. May I also request that you deposit these payments precisely on the first of every month. With my wife and little daughter here, you will understand that I have obligations that can in no way be ignored. You will understand also that beyond that the financial situation of my family has completely changed since the revolution and that it is now up to me to help my mother and my sister who was widowed after the current events began.[7]

TO PIERRE MATISSE. PARIS, HÔTEL RÉCAMIER, DECEMBER 18, 1936

I received your letter of the 8th of this month with photos of the exhibition, which looks like it was beautifully hung. I was very worried, since I was afraid that you had not shown the paintings from this summer. Did you replace them with the earlier paintings mentioned in the catalog or did you show them all at the same time? . . .

My wife and child arrived in Paris two days ago, which has reassured me, since I was extremely worried. We are going to remain in Paris until life returns to normal in Catalonia. I am continuing to do studies for a series of large paintings I left in Barcelona and would like

to be able to go on with again soon. At the same time I am also writing some poems in French, or rather some poetic texts that are conceived simultaneously with the pictorial ideas that go along with them—as the Japanese and Chinese masters used to do in the past—those great lords of the spirit.[8] I am working on the layout of this book as though it were an art object; it is thus a kind of poetry art or art poetry, which could be of considerable interest. It is the expression of man's mind that counts, the baring of his soul. Alas, these are two things that are fatally lacking today, when all human thought grovels in the most disgusting filth. Aside from all this, I am preparing, as I told you, some paintings of great breadth and scope. Will I be able to carry them out?

Notebook of poems, 1936–39[1]

Starting in November 1936, Miró filled the pages of
a large drawing pad with poetic verse and prose. It is
the only document of its kind from his hand and a
unique verbal expression of his acutely poetic
sensibility. In a manner similar to that of his
painting, his poetry is written in loose irrational
clusters of abrupt, vivid images.

At the time Miró wrote these poems, the
devastating reality of events in Spain was beginning
to be clear to him. Stuck in France in a hotel room
far from Barcelona, from his studio, and from his
wife and daughter, he wrote this poetry as a
substitute, a compensation for the painting he could
not do.

The poems are in French, which was Miró's
poetic language. But there are notes in Catalan in
some of the margins: indications of layout,
illustrations, or collage-elements to be affixed to a
page, or other miscellaneous ideas. For at some point,
the idea came to the artist to make a book—an idea
that was suggested in a letter to Pierre Matisse[2] and
that is indicated specifically on the last pages of the
drawing pad in notes that can be dated 1938–39:

"reproduce paintings with very poetic titles.
parallel between poetry and painting like that
between music and poetry.

"intersperse throughout book etchings,

lithographs, etc., and reproductions of several poetic paintings.

"also reproduce a beautiful page of astronomy.

"rather than a score of music by Wagner, reproduce a music with notes that follow a rhythm like my paintings.

"There should be a good reproduction of a painting (in color).

"Use Japanese brushes and pens of different thicknesses.

"Print certain pages with printer's lettering; others should be written in my handwriting with certain magic letters; if they are not legible enough, add small printed type."

The style of Miró's poetry echoes Surrealist poetry at its best, in particular that of Benjamin Péret and Robert Desnos, the two poets to whom Miró felt closest and who reciprocally had immediately understood his paintings on the 1920s. The scatological images evoke Alfred Jarry, one of Miró's avowed heroes. The notebook shows three forms of writing, all of which derive from automatic writing, the stream-of-consciousness idiom practiced by the Surrealists, where one word triggers another, one image calls up another, with no attempt at coherence, logic, or reason. In the first group of poems, written in verse form, there is an attempt to achieve a certain rhythm or cadence, but no rhyme. Somewhat further on there is an uninterrupted flow of words with seemingly no beginning or end. Finally some of the poems are organized like *calligrammes*. Miró discovered Apollinaire in 1917 in Barcelona and always stated an allegiance to the poet.

Miró's images are a painter's images: disjunctive, frontal, and colorful. It is clear that in both painting and poetry his process was identical. Indeed one might call these verbal images poèmes-tableaux, rather than tableaux-poèmes.

Although the draft of this book was never published in its original form, excerpts or poems from its pages appeared later in diverse publications.

In 1946, many verses were printed in *Cahiers d'art* under the heading "Jeux poétiques," and a few are found in the bibliophile edition of *Le lézard aux plumes d'or* (text and illustrations by Miró), prepared around the same time. Finally, most of the poems (in a different sequence) appeared in *Ubu aux Baléares*, published by Tériade in 1971. In the original manuscript, however, the text is more virulent and less self-conscious than in any of the later versions.

NOTEBOOK OF POEMS, 1936–39

A star fondles a black woman's breast
a snail licks a thousand tits
gushing the pope-king's blue piss
so be it
 25–XI–36

rose petal salad . . .
dressed
rosy-pink yoghurt

The red dots on my tie
pricked the sky above
and went off to the botanical garden
to visit the aquarium
in Berlin Park
sitting in the A.S. bus
going along Walterstrasse
a bedbug
stings me on the ass
I push the alarm button
and a frog
chaste-virgin-maid-holy-and-chaste
sits down beside the conductor.
A beggar picks up
blue coins from the sidewalk
And a naked dancer with red hair
runs after violet fish
in the deep blue Seine.
That, my good man, is life
 Paris, 26–XI–36

rain falls
pink baby
sucks the tit of the downpour
dark-haired mama
in the hollow sockets of a limbo-tomb
breathes blue
in the black void of despair

PURE LOVE
that tickles the throat
of swallows

 Paris, 27–XI–36

The beautiful countess
flashes her old thigh
her entrails cook
 the clouds
her round fan belly
braves the round sun
her armpit hairs
 stick to the lashes
 of cherubs
Her man's cock
 pierces the flowering tree
 syphilitic vegetable garden
a bird perches on her man's nose
 and makes the moon
 set
the moon perches on her man's asshole
 and falls
 in love with the rainbow
the rainbow hides in the casket
and the casket says to the squirrel *shit*! get it over with
 27–XI–36

The horses

who grow out of my belly button
and spiral down in a mush of
apricots toward the stove where the sunny-
side-up eggs are fried to smash eggs naturally against
the rare steak
without too much mustard and served with floating potatoes
that take a powder,
like the spitfire of a machine gun
with a swarm of brilliant butterflies
to gnaw at the pearly music
of the Pre-Raphaelists [*sic*]—umbrellas
of the National Gallery in London.

 3–12–26

The balls of a Javanese hunchback tugged by the mustaches of an ant who was reading the Bible while drinking coffee at the counter of a Hollywood diner and cleaning the hole of his rear end with a fork as clean as an all-purpose maid who eats kidneys on skewers and wipes herself every time she is going to piss the dandelions with vinegar that she tasted every morning and again a second time late in the morning making her more unhappy and sour she scratched her head and plunged it into a caramelized onion soup while listening to a record on the phonograph she bought at the Flea Market these fleas become jealous of the thumb that presses gently on the chocolate mousse which at certain intervals during the day the neighborhood kids squeeze before the mailman brings them the feather duster made of browned cauliflower flowers which the old camel must post on his head a few days before his birth and on the occasion of the beast's twin sister's marriage to the god of the storm.

 fart 1 (burp)
 farts 2 (burps)
 farts 3 (burps)

 5–12–36

all this was told by a soldier to his commanding general, a cactus propped up by his rifle

 5–12–36

legs in the air and the head tilted back the better to see a pigeon devouring the brain of a panther who was wearing an engagement ring made of gilded ivy leaves that measured the gothic windows of his cathedral-belly and turned themselves into peacock feathers to make the artillery shells burst better and excite the spread legs and Byzantine-fleshiness of comets that have been pregnant for about nine months due to a slight pagan caress with a bright red proletarian truck

 5–12–36

that skirted the smoke that was smoking up and down boulevard Sébastopol first to the left and then to the right and stopping in the middle to face the corner that leads to the balcony of the Méditerranée where my lemon-juice statue has been standing ever since a few years before the time of Homer

 7–12–36

The clapping hands are white doves that beat their wings before the caress of blue velvet

Shells on a white tablecloth to cover the braids of an eighteen-year-old girl who has fainted

Two tall thin society ladies dressed in black with a long canary feather in their hats leave the concert

fish that slips through my hands

the breath of Venus

A bee plays the cello with a harp made from a blade of grass

A yellow butterfly makes his nest in my girlfriend's neckline as she walks barefoot on the ocean to make poppies grow

Night sky filled with electric stars

1936

A glass of white milk on a white tablecloth
a red cherry
green scarab beetle
rainbow
shooting star
a guitar
falls from the sky
the strings of this guitar crisscross in space
swallows
nest on each string
this string strangles a woman who was beautiful.

26–IX–37

The flaming tree of the peacock's tail that bites the snouts of bats smiling before the charred corpse of my grandmother who was buried by a dance of transparent glass nightingales with rocket wings who dance the sardana around the phosphorescent carcass while pecking with the gold of their pincers the metal seeds of silver cypresses rushing down in waterfalls from the grandmother's big toe.

soaring flame of passionate love spiral whirling toward the ether of the inaccessible ideal tragedy of man.

2–X–37

My feet walk on the golden leaves of autumn trees lizards water spurt-
ing from my hands dipping into the river that wets the throat of my
dark-haired darling my skin made iridescent by a thousand constella-
tions and by the buzzing of a green fly zigzagging around a golden
toilet . . . triangle of the lit-up Eiffel Tower that licks the beautiful blue
poem of the sky

<div align="right">24–X–37</div>

a red carnation bursts at the end of an umbrella carried by a whiting
with the tail of a parrot lying on the snow (strewn with rose petals and
the electrified scales of fish)

<div align="right">19–XII–37</div>

The sun's fire makes the desert flower hysterical.
> Moonlight Nocturne

The rooster sings to the glory of the sun the woman undoes her hair as
a sign of many-colored happiness woman in the meadow at dusk two
women trees birds stars woman attacked by a lion
> Bather
> > rebellious woman
>
> Woman in revolt
> the toilette of Violette
> Bird
> a person in front of the mountains

<div align="right">V/38</div>

half brunette half redheaded girl slipping on the blood of frozen hya-
cinths on a blazing football field

<div align="right">(II–1939?)</div>

19

Poem, 1937[1]

The following short poem, signed and dated on the reverse, was transcribed on a sheet of paper surrounded by Miró's familiar emblematic signs (see ill. 16). We do not know if it was initially part of the book project above, but it is clearly related to it in spirit and form.

POEM, 1937

Summer

A woman burned by the
flames of the sun catches a butterfly who
flies off pushed by the breath of an ant
resting in the shade rainbow
of the woman's belly before the sea
the needles of her breasts turned toward
the waves which send off a white
pink smile to the
crescent
moon

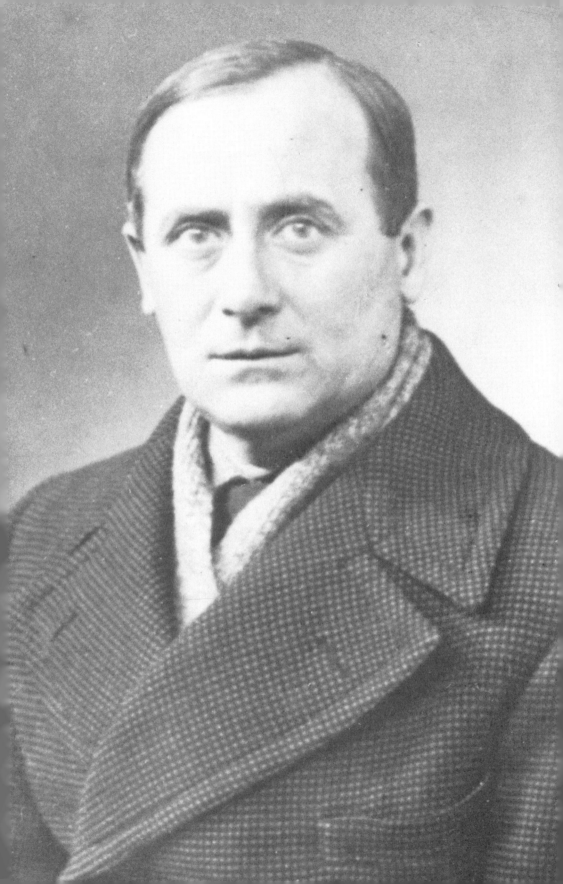

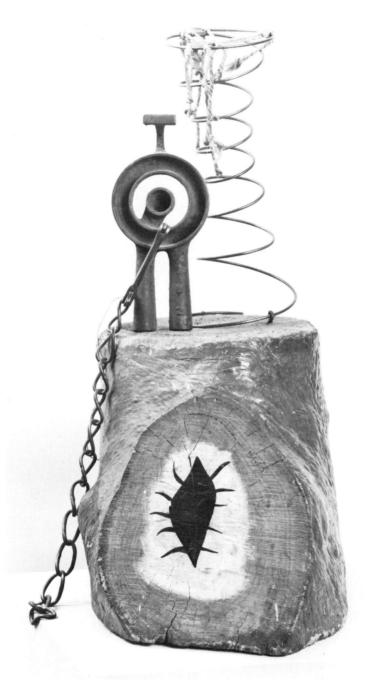

15 *L'Objet du couchant*, 1936.

14 Previous page: Miró, 1937.

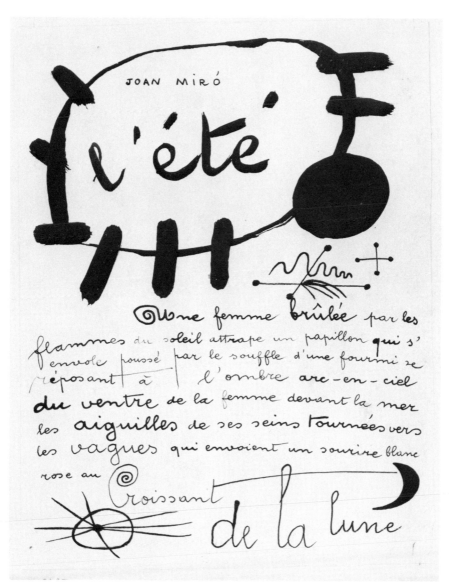

16 *L'été*, 1937.

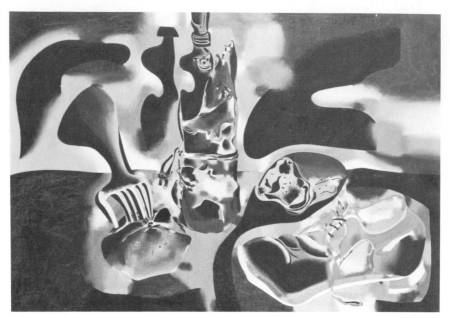

17 *Still Life with Old Shoe*, 1937.

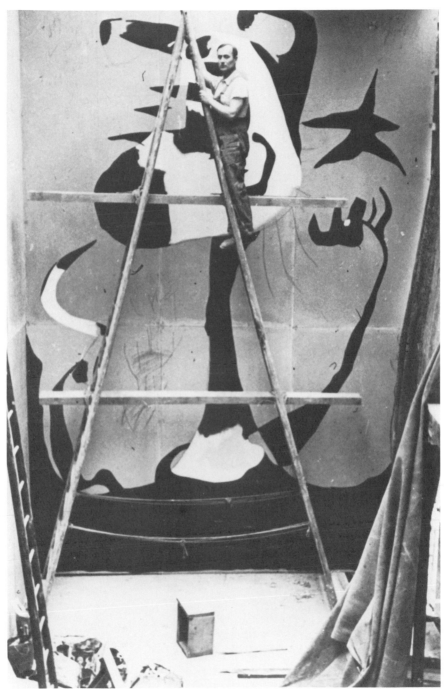

18 Miró painting *The Reaper* for Spanish Republican Pavilion, Paris World's Fair, 1937.

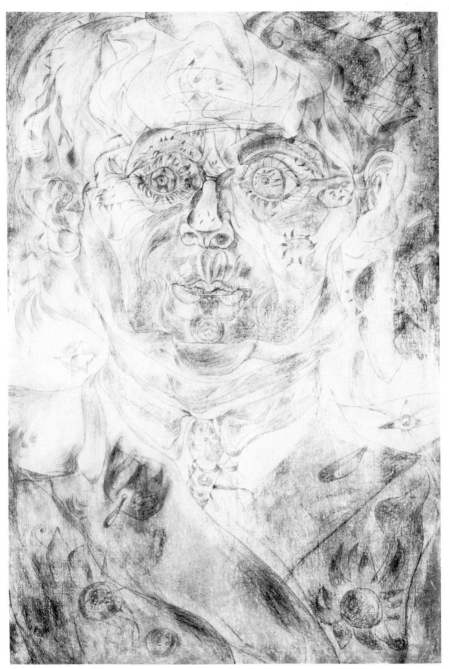

19 *Self-portrait I*, 1937–38.

20 Villa "Clos des Sansonnets," Varengeville (Normandy), where Miró lived, 1939–40.

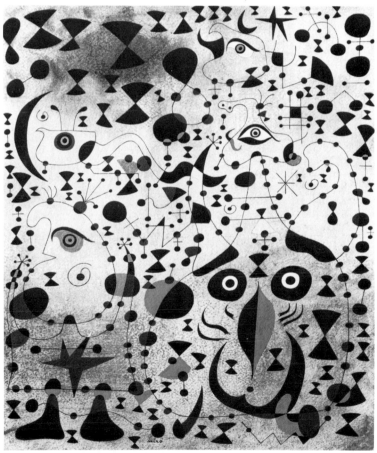

21 *The Beautiful Bird Revealing the Unknown to a Pair of Lovers*, 1941.

22 Miró and Yves Tanguy, New York, 1947.

Letters to Pierre Matisse, 1937[1]

In January 1937, Miró began to realize that his hopes
for returning to Barcelona and continuing his works
in progress would not be fulfilled for some time.
Since he was unable to find either a frame of mind
or working conditions that would allow him to
elaborate his earlier ideas, he decided to embark on a
series of works that were entirely different in
concept. This ambition would lead to *Still Life with
Old Shoe* and the *Self-portrait* of 1937, which reflect
the artist's apprehension of a reality shattered by
world events.

To Pierre Matisse. Paris, Hôtel Récamier, January 12, 1937

I have now finished all the preparatory drawings for the series of large paintings (between 10 and 12). After doing these preliminary studies, the conceptions are very clear and alive in my mind, and this will allow me to complete them very quickly. I started these large canvases in Barcelona, and that is where I have to go on with them. I left all my work material in Barcelona—about a hundred things in progress—that was where I was living in an atmosphere of work; here it is impossible for me to improvise all that, as you can understand.

Given the impossibility of going on with my works in progress, I have decided to do something absolutely different; I am going to begin doing *very realistic* still lifes. I was already thinking of doing that, *but later*, and alternating with other things in which I would have attempted to escape reality entirely—and create a new reality, with new figures and fantasmagoric beings, but ones filled with life and reality.

I am now going to attempt to draw out the deep and poetic reality of things, but I can't say whether I will succeed to the degree I wish.

We are living through a terrible drama, everything happening in Spain is terrifying in a way you could never imagine.

I feel very uprooted here and am nostalgic for my country. But what can be done? We are living through a hideous drama that will leave deep marks in our mind.

I do not despair, however, of being able to finish that series of large paintings before the summer; in the meantime, I will see what develops from this plunge into the reality of things, which will give me new impetus for the next works. . . .

All my friends advise me to stay in France. If it were not for my wife and child, however, I would return to Spain.

To Pierre Matisse. Paris, Hôtel Récamier, February 12, 1937

My friend, the work moves ahead. I am now doing a 50 P. canvas[2]. Subject: a still life from nature.[3]

As I work on it, I don't lose contact with the model for a single

minute. I have put all the elements of the composition on a table. These are the various elements:

1 empty gin bottle wrapped in a piece of paper with a string around it.

1 large dessert apple

1 fork stuck into this apple

1 crust of black bread

1 old shoe

I am going to push this painting to the limit, for *I want* it to hold up against a good still life by Velázquez.

It is somewhat reminiscent of *The Farm* and *Table with Glove*—less anecdotal than the first and more powerful than the second. No sentimentalism. Realism that is far from being photographic, and also far from the realism exploited by some of the Surrealists. Profound and fascinating reality.

To look nature in the face and *dominate it* is enormously attractive and exciting. It's as though by the strength of your eyes you bring down a panther at your feet in the middle of the jungle.

This down-to-earth undertaking, this brushing of the ground, will give me new possibilities and allow me to find a new and more powerful impetus for further escapes.

"My most fertile routine, the one most necessary to my development, is to copy reality directly, attentively reproducing the objects of external nature in their most particular and accidental aspects. After making the effort to do a meticulous copy of a pebble, a blade of grass, a hand or a profile, I then need to let myself go to the representation of an imaginary world. Nature, thus measured out and infused, becomes my source, my leaven, my ferment" [Redon].[4]

I will send you a photo of this painting as soon as it is finished.

As I had already suggested to you, this idea has been cooking in my mind for some time. *Human events* have precipitated this need in my mind. *An inner necessity*, not at all to show off and prove that I can paint, which would be a *pretentious* and *tendentious* society game.

In the next issue of *Cahiers d'art*, which will be devoted to ancient Catalonian art, there will also be a section devoted to me. There will be about a dozen reproductions, a literary portrait of me by Jacques Viot and a very fine article by Duthuit in the form of a conversation with me.[5] I express myself very violently and strike out very hard at the things we are fed up with. You will readily see who and what I am striking out against, and I'm sure that you will share most of my opinions.

To Pierre Matisse. Paris, 98 boulevard Auguste Blanqui, March 7, 1937

I am enclosing a photo of a design I made for a stamp that is supposed to be printed to give a little aid to poor unfortunate Spain.[6]

For the time being I am no longer thinking about the canvases I started in Spain. I have not given up hope of continuing them one day, unless they are destroyed by bombs. I already feel that I possess many means of expression that will allow me to express myself in a varied and powerful way as soon as I am able to settle down somewhere and pick up my life of concentrated work again—if we don't all kick the bucket first.

The drawings that I sometimes do before doing certain paintings are an *intimate* document, so to speak—they help me arrive at a complete formal divestiture and thus attain *the true expression of the spirit*. Once the paintings are finished, I destroy these drawings or else hold on to them to use as a springboard for other works. The drawings you have are not at all preparations for paintings, but definite drawing-drawings.

If I sometimes work very quickly, letting myself be carried away by the purest and most disinterested mental impulse, at other times I work very slowly, like a *humble laborer*, as with the canvases I left behind in Barcelona, and which will occupy my attention for several years. This procedure allows me to work without interruption and without feeling excessive fatigue, which would be a *handicap*.

I have not worked any more on my drawing-poems or poem-drawings. No doubt I will return to this means of expression later; once I have several of them, they should be published as a book-object, something that could be highly interesting, I hope.

Interview. *Cahiers d'art*
(Georges Duthuit), 1937[1]

Miró's first major published text in French appeared in *Cahiers d'art* in 1937. This interview is one of the primary sources most often quoted in the Miró literature. It was transcribed by the art historian Georges Duthuit, Henri Matisse's son-in-law and a friend of the Surrealists. Here certain aspects of Miró's artistic personality were developed, including the idea of total risk, his definition of his art as a realistic art, and his rejection of the term *abstract*. He also discussed his tastes in painting, poetry, and music and his admiration for popular anonymous expression. Although most of these ideas had been expressed earlier in private correspondence, in 1937 Miró seemed to feel that the time had come to make a public statement.

"Where Are You Going, Miró?" by Georges Duthuit. In *Cahiers d'art* (Paris), nos. 8–10 (1936)

JOAN MIRÓ: Our generation lacks heroism and a deeply revolutionary spirit.

GEORGES DUTHUIT: It seems to me that in Spain, however . . .[2]

MIRÓ: I am confining myself exclusively to the realm of painting.

G.D.: How nice to have a solid realm!

MIRÓ: Think about the Impressionists who grew their own potatoes; about the Cubists . . .

G.D.: Whereas today?

MIRÓ: Today, my young contemporaries know how to struggle when they are poor, but all that stops the moment they balance their budgets. Compared to these people who begin their shameful decline at the age of thirty, how much I admire artists like Bonnard or Maillol. These two will continue to struggle until their last breath. Each year of their old age marks a new birth. The great ones develop and grow as they get older. But what can I say about those buffoons who think only of the next cocktail party, who need no more than a living room carpet and a princess to begin groveling and showing off!

G.D.: They're made of soft stuff! It's the same old story. One must avoid, or rather fight against . . .

MIRÓ: Society—whether bourgeois or aristocratic; one must resist all societies, even those that are not yet born, if they aim to impose their demands on us. The word *freedom* also has a meaning for me, and I will defend it at any cost.

G.D.: Isn't this the so-called tragic position of the artist? But where? With whom? Why?

MIRÓ: Not in a nice warm restaurant, that's for sure. Not with intellectuals who have no responsibilities. Not in the service of their absurd theories. Let them chew on their abstractions if they can't find any real food or real rhythm or human facts.

 Have you ever heard of anything more stupid than "abstraction-abstraction"?[3] And they ask me into their deserted house, as if the

marks I put on a canvas did not correspond to a concrete representation of my mind, did not possess a profound reality, were not a part of the real itself! And then, as you can see, I give greater and greater importance to the materials I use in my work. A rich and vigorous material seems necessary to me in order to give the viewer that smack in the face that must happen before reflection intervenes. In this way, poetry is expressed through a plastic medium, and it speaks its own language.

Because of this, I cannot understand—and consider it an insult—to be placed in the category of "abstract" painters.

G.D.: If we make a distinction between pictures that are satisfied with the empty, featureless space of geometry, between immobile works, lost in mathematical space and inaccessible to the heart and the senses, on the one hand, and, on the other, creations that reveal the fluidity of life, the unpredictability of change, the works chosen by the future, by the "wonderful unknown future," I would bet that we couldn't find very many things to put in the second group.

MIRÓ: A painting by Poussin or Seurat, however, cannot be compared to a diagram. What touches us in Poussin is the prodigious vitality of thought, in Seurat both an exquisite popular sense and a phantasmagoric vision of truly hallucinating things. Science, in this case, only serves to justify the play of human forces.

G.D.: But it can also go against them. Seurat, with all his noble talents, spent a whole year adding thousands of complementary strokes of color to his *Models* but, placed too close together, they dulled the surface rather than brightening it. The poor painter died at the age of thirty-two. According to his biographers, it was this curious work that did him in.

MIRÓ: Scholars are not as dangerous as literary men,[4] however. Literary men are among the worst enemies of MAN. They should be treated like criminals and punished accordingly. I know of some who even managed to call a man like van Gogh "limited"—that radiant soul—and to treat marvelous beings like Cézanne and Rousseau as poor fools. Those are some good examples of intellectual cretinism!

I'd trade in a thousand literati for one poet! And I make no distinction between painting and poetry. I have sometimes illustrated my canvases with poetic phrases, and vice versa. The Chinese, those great lords of the spirit—isn't that what they did?

G.D.: To such an extent that elegant stories wound up covering the

images that master artists had drawn on the scrolls. Poetry wound up pushing out painting. There must have been a wrong turn somewhere.

MIRÓ: It doesn't matter. What counts is to bare our soul. Painting and poetry are done in the same way you make love;[5] it's an exchange of blood, a total embrace—without caution, without any thought of protecting yourself. Even those who refuse to give in to the charms of Picasso recognize an overwhelming meaning in his work. His possible weaknesses, his vulnerable points only serve to reveal his personality more fully—which is too close to us, I believe, for us to be able to talk about it.

G.D.: Picasso asks us not only to avoid discussing painting but to avoid any effort to make sense of it. On the other hand, he admits that painting and poetry can sometimes represent a danger to society, thus giving art a certain role in the definition if not of the beautiful and ugly, of good and evil and other metaphysical inventions, then at least of the good and bad. A question of hygiene!

MIRÓ: A question of personal experience. In a period of solitude, Huysmans,[6] with his need for revolt and desire for escape, helped me a lot.

G.D.: While to me he seemed to have slipped from the gutter to the holy font, passing by the antiquarians along the way, with great slowness and innumerable detours.

MIRÓ: Roussel . . .[7]

G.D.: . . . who strikes me as a kind of dentist, equipped with horrible little instruments . . .

MIRÓ: . . . on the other hand brought me refreshing emotions. Éluard enchants me with his precision. Bach . . .

G.D.: . . . a clockmaker from day one, a mechanic of the Lord . . .

MIRÓ: . . . teaches me lessons about great architecture. Mozart . . .

G.D.: At last!

MIRÓ: Mozart brings forth love through his purity, his generosity, and the simplicity of his love. Those people help us to survive in the midst of so many contemptible things. And in the first rank of these geniuses, I would place Antonio Gaudí . . .

G.D.: . . . and I'm sure you're sorry that he didn't completely rebuild Barcelona. That would have made it a childhood game. What a city we would have had for our vacations! A living forest of symbols! I see

octopus-banks, slug-schools, toad-stores, the whole thing connected by roads of broken dishes and cable cars shaped like winged dragons.[8] Then there is the wandering cathedral, made of dried saliva, hard sponges, and hair clippings, from which luminous waterfalls come shooting out, while the heroes of the Old and New Testaments, accompanied by their favorite animals and set in motion by a clockwork mechanism, begin their dance.[9] . . . A mirage-city, as you said, an eczema-city, a swamp-city. How I would have loved to see M. Breton and M. Dalí there, walking hand in hand, exchanging smiles and hopes—on the days when they are not fighting on the barricades!

MIRÓ: Gaudí's genius will always escape the tourists. It would be better, given the number of misunderstandings that exist between countries, never to travel again. It breaks my heart to see a Catalan following the example of Claude Monet (of beloved memory) and wanting to illustrate Mallarmé. Another of my friends, a Frenchman, wants to go to Castille to look for examples of cruelty and persists in wanting to illustrate Cervantes.[10] What a mess! What a tragedy!

G.D.: You're saying that each person travels with his own light . . .

MIRÓ: And that wherever you are, you can find the sun, a blade of grass, the spirals of the dragonfly. Courage consists of staying at home, close to nature, which could not care less about our disasters. Each grain of dust contains the soul of something marvelous. But in order to understand it, we have to recover the religious and magical sense of things that belong to primitive peoples. . . . The people are always the same, in fact, and everywhere—spontaneously—they create marvelous things. This is the reason for my attraction to anonymous things, graffiti, the art of common people, the expressions and gestures that leap out at you. . . . But you have to have kept yourself pure enough in order to be moved. To lose contact with the people is to lose yourself.

G.D.: We know very well what the silent masses can give us. But what can we give them in exchange?

MIRÓ: The worst thing that could happen would be to put ourselves above the crowd, to flatter it by telling miserable little stories. The present leaders, the bastard products of politics and the arts who claim to be regenerating the world, are going to poison our last sources of renewal. While they talk about nobility and tradition or, on the contrary, about revolution and the proletarian paradise, we see how their little bellies grow and how the fat invades their souls.

G.D.: The politican, alas, survives all shipwrecks. Give him a deck

chair, since he loves the storm. I think we could get along much better with the unions.

MIRÓ: Provided that we are not asked to lower the artist to the level of a society that, on the contrary, needs the artist to regain its dignity. I'm sure that individualism is a sign of decadence. In great periods the individual and the community march together. But today, what can we expect? For the moment, I content myself with measuring images and sensations with the greatest possible precision, with no second thoughts at all. What I am told about these operations leaves me completely indifferent. The changes that take place in my consciousness happen without my knowledge. I am guided by events that are located in front of me I later realize, and that compel me to act as I do.

It's just as well not to attach any importance to our works. The less we look for some beautiful success, the better we succeed: I mean, the greater our chances of obtaining an honest result. A painting, after all, comes from an excess of emotions and feelings. It's nothing more than a kind of evacuation, and you don't turn back on it.

G.D.: Here again you agree with Picasso, who talks of indigestion; and the same is true of Braque, I believe. Juan Gris claimed that each of his compositions was a theorem; once it was carried out, it became unimportant. Just before, however, you spoke of love and its blissful confidence. There's more to it than a physiological act: it is procreation, the attempt to bring a living creature into the world. Therefore, how can you be totally indifferent to the fate of your painting; how can you be so lighthearted and ignorant about who adopts it and what is done with it?

MIRÓ: You asked it yourself: Where to go? Who can you ally yourself with? If historical events are strong enough, we follow them without knowing it. To join up with one position or another would be to act like a dilettante.

G.D.: Soon, there will probably be no choice. Everyone will have to answer the question the rival parties are asking—by a no or a yes, as under the tyrant of Athens. But at the same time admitting that these general mobilizations take away many precious things from us.

MIRÓ: Here, I am pessimistic, tragically pessimistic. No illusions are permitted. More violently than ever before, there will be a struggle against everything that represents the pure value of the spirit.[11]

G.D.: *Babes in the wood!* Let's turn away from these prophetic dark-

nesses. Somewhere among the trees there must be one of those hidden treasures that the cold and hungry children discover at the last moment. And if the road seems too long to them, you can always show them the way—and, merely by lifting your finger, teach them how to transform rubble into castles, into beautiful, burning castles, surrounded by dancing and cries of joy.

Letters to Pierre Matisse, 1937–38[1]

Throughout 1937–38, Miró continued to live on the boulevard Auguste Blanqui in Paris and to paint in a spare room loaned to him by Pierre Loeb at his gallery. Here he finished *Still Life with Old Shoe* and the *Self-portrait*, two pictures he considered among his most important works since *The Farm*. His return to what he considered a realist style of painting (in contrast to the more oneiric sources of the 1920s and early 1930s) was clearly of great significance to him.

In April 1937, Miró was commissioned to paint a monumental work for the Spanish republican pavilion at the Paris World's Fair, which was to open on July 12. This painting, a tortured and symbolic portrait of a reaper (an interpretation of his Catalan peasant motif of earlier years), was painted in oil on celotex and measured 5.50 × 3.65 meters. Along with Picasso's *Guernica*, commissioned for the same pavilion, it was one of the great images of the Spanish civil war. Unfortunately, all traces of it have been lost.

To Pierre Matisse. Paris, 98
boulevard Auguste Blanqui,
March 21, 1937

Now that we have taken an apartment in the same building as Nelson,[2] as I already told you, I have been able to organize my life. The work is going very well; the still life will soon be finished; this painting is completely absorbing me, and I believe that along with *The Farm* it will be the capital piece of my oeuvre—which I nevertheless hope to surpass later. At the same time, I am doing drawings, and in the afternoon I sometimes go to the academy to sketch nudes.[3] I hope all this will lead to something important and powerful.

To Pierre Matisse. Paris, 98
boulevard Auguste Blanqui,
April 25, 1937

The Spanish government has just commissioned me to decorate the Spanish pavilion at the 1937 Exposition. Only Picasso and I have been asked; he will decorate a wall 7 meters long; mine measures 6. That's a big *job*! Once the Exposition is over, this painting can be taken off the wall and will belong to us.

The stamp[4] has still not been printed.

To Pierre Matisse. Paris, 98
boulevard Auguste Blanqui,
November 3, 1937

Here everything is more or less the same. I am working a lot; my portrait[5] was started several weeks ago, and if I succeed, as I hope I will, it will be the most sensational thing I have ever done—in the deep sense of the word, naturally, not at all in the affected sense, quite the opposite. An 80 P. canvas,[6] the bust only, representing a head about three times larger than natural size. A very elaborate work, very detailed, without, however, neglecting large masses and volumes. That's

hard, and real *work*, my friend! At the same time I am doing many drawings, gouaches, pastels, etc.

Balthus is doing a portrait of Dolores and me;[7] when it's finished, I'll have much more free time.

To Pierre Matisse. Paris, 98 boulevard Auguste Blanqui, February 5, 1938

Balthus has already finished the portrait of Dolores and me—it is very beautiful. I already told him that he should lend you this painting for his show.[8] This painting does not belong to me at all, my friend; I posed for him as a friendly gesture, that's all.

The work moves ahead. I have destroyed my portrait several times; I now feel that I am on the right track. It will be drawn in a few days, and then I will have it photographed and send you a print so that you can get an idea of what it's like. It will be a work that sums up my life, and it will be very representative in the history of painting. Besides that, I am doing drawings, gouaches, etc. I am going to etch on copper now, something that will open up new possibilities for me.[9] Also, I am working on a series of drawings of nudes, which I started a year ago with the models at the academy[10] and which I am now continuing in the studio. I think it will be very good.

We had lunch with Hemingway, who was passing through Paris on his way back from Spain.

To Pierre Matisse. Paris, 98 boulevard Auguste Blanqui, March 4, 1938

Here, the work is moving along—my portrait is already drawn, after having been completely destroyed several times; I have now turned the canvas against the wall and will leave it there for several days so that I can begin painting with fresh eyes. I think this will be the most important work of my life. I might do a tracing to preserve the drawing, which in itself is something of considerable breadth. I am simultane-

ously doing a series of large drawings and gouaches, besides the nude drawings, and will now do two large paintings and a series of small ones that I will get done very quickly. At the same time I am learning how to etch on copper and think that once I have learned the craft sufficiently I will be able to do fine etchings. This method of work—alternating between very tight execution, things done quickly, and manual work allows me to stay in good shape and at the same time opens up new avenues to me and enriches me with new possibilities and expressive resources. . . .

We are still living in the same apartment, fortunately, waiting for the damn day when we can make a decision and have a very large studio, which is the first thing I want to take care of.

To Pierre Matisse. Paris, 98 boulevard Auguste Blanqui, April 7, 1938

The situation in Spain is very agonizing, but far from being desperate; we have the firm hope that some event will take place to tip the balance in our favor.

In this same mail I am sending you a photo of the drawn portrait. It is an 80 P. canvas. This way you can have a sense of it before you leave. I am going to save this canvas, drawn on a very fine material, and later I will do a tracing on another canvas to paint it, making further changes in the formal conception. It's a good idea, for it would be too bad to lose this first stage as it is now. To relax myself, I am now doing a series of small paintings, which I believe will be interesting; once I am finished with them, I will attack my portrait again. Luckily, I have managed to keep my working enthusiasm and discipline.

Text. *XXe siècle*, 1938[1]

Miró's second long text in French appeared in the
magazine *XXe siècle*. The original French version
appears to have been transcribed by the magazine's
editor Giuseppe di San Lazzaro in a somewhat
approximate fashion with little concern for accuracy.
It is filled with misspellings of proper names as well
as with errors in dates and events. Since this is one
of Miró's earliest published articles, it has generated
much confusion concerning this period of the artist's
life. Although the misspelled names have been
corrected here, it was not possible to correct the text
throughout. The reader is invited to consult the
Chronology for an accurate account of the events
described below.

In 1938, Miró was living and working in an
apartment on the boulevard Auguste Blanqui,
occasionally using a room at the Galerie Pierre for
larger works. His "dream of a large studio" expressed
a real and urgent preoccupation at this time.

"I Dream of a Large Studio." In *XXe siècle* (Paris), May 1938

When I arrived in Paris in March of 1919, I stayed at the Hôtel de la Victoire on the rue Notre-Dame des Victoires.[2] I remained in Paris through the winter and then returned to the Spanish countryside for the summer. The following winter, I went back to Paris. I stayed at another hotel, at 32 boulevard Pasteur. That was where I received a visit from Paul Rosenberg.[3] Picasso and Maurice Raynal had spoken to him about me. Soon afterward Pablo Gargallo, who was spending the winter in Barcelona as a professor of sculpture at the School of Fine Arts, gave me his studio—at 45 rue Blomet, next to the Bal Nègre, which was then unknown to Parisians and would later be "discovered" by Robert Desnos.[4] André Masson was in the next studio on the other side of a partition. At the rue Blomet I began to work. I painted the *Head of a Spanish Dancer*, which belongs to Picasso, *Table with Glove*, and so on. It was a very hard time; the windows were broken, and my stove, which cost me forty-five francs at the flea market, didn't work. But the studio was very clean. I did the housework myself. Because I was very poor, I could afford only one lunch a week: the other days I settled for dried figs and chewed gum.

The next year, I couldn't have Gargallo's studio again. At first, I stayed at a small hotel on the boulevard Raspail, where I finished *The Farmer's Wife*, *Ear of Grain*, and other pictures. I left the hotel for a furnished room on the rue Berthollet. *The Carbide Lamp*. Summer in the country. Return to Paris and the studio on rue Blomet. I completed *The Farm*, which I had started in Montroig and continued working on in Barcelona. Léonce Rosenberg, Kahnweiler, Jacques Doucet, all the Surrealists, Pierre Loeb, Viot,[5] and the American writer Hemingway came to see me. Hemingway bought *The Farm*. At rue Blomet I painted the *Harlequin's Carnival* and the *Spanish Dancer*, now in the Gaffé collection. In spite of making my first sales then, that was a hard time. For the *Harlequin's Carnival* I did many drawings based on the hallucinations that had been brought on by my hunger. I would come home at night without having eaten and put down my feelings on paper. I saw a lot of poets that year, because I thought it was necessary to go beyond the "plastic fact" and arrive at poetry.

Several months later, Jacques Viot organized my first exhibition at the Galerie Pierre. Afterwards, I had a contract with Viot that helped keep me going. I rented a studio at 22 rue Tourlaque, in the Villa des

Fusains, where Toulouse-Lautrec and André Derain had lived and where Pierre Bonnard still has his studio. Also living there at that time were Paul Eluard, Max Ernst, a Belgian dealer from the rue de Seine, Goemans, René Magritte, and Arp.[6] I put a sign that I had found in a shop on my doors: THIS TRAIN MAKES NO STOPS. Things were better, but they were still rather tough. Once, Arp and I shared a meal of radishes and butter. As soon as it was possible, I took a larger studio in the same villa on the ground floor, but I didn't keep it for long.

I went back to Spain, I got married, I came back to Paris with my wife and left the Villa des Fusains—where I had painted a whole series of blue canvases—for an apartment on the rue François Mouthon. I worked a lot, spending most of the year in Spain, where I could concentrate better on my work. In Barcelona, I worked in the same room where I was born.

In Spain, where I went often, I never had a real studio. Early on, I worked in tiny cubicles where I could hardly turn around. When I wasn't happy with my work, I banged my head against the wall. My dream, once I am able to settle down somewhere, is to have a very large studio, not so much for reasons of brightness, northern light, and so on, which I don't care about, but in order to have enough room to hold many canvases, because the more I work the more I want to work. I would like to try my hand at sculpture, pottery, engraving, and have a press, to try also, inasmuch as possible, to go beyond easel painting, which in my opinion has a narrow goal, and to bring myself closer, through painting, to the human masses I have never stopped thinking about.

At this moment I am living on the boulevard Blanqui, in the house where the architect Nelson lives. It was in this house that Mrs. Hemingway kept *The Farm* before sending it to America.

Once, I wanted to go back and see the studio on the rue Blomet. In the courtyard there was a very beautiful lilac bush. The building was being torn down. A big dog jumped on me.

Text. *Verve*, 1939[1]

The following text, inspired by Miró's painting *The Harlequin's Carnival* of 1924–25, is one of the artist's better known so-called Surrealist texts. The "torrential flow" (as Breton had described automatic writing in 1938)[2] of words and rich visual images is reminiscent of Desnos's and Péret's verses of the 1920s, some of which were produced in a hypnotic trance. By 1939, Miró was far removed from these experiments, but he nonetheless tried to recapture the dense convulsive narrative style seen in *The Harlequin's Carnival*, a painting that, according to his own testimony, derived from hunger-produced hallucinations.

"HARLEQUIN'S CARNIVAL." IN VERVE
(PARIS), JANUARY–MARCH, 1939

The ball of yarn unraveled by cats dressed up as smoky harlequins
twisting around inside me and stabbing my gut during the period of
my great hunger that gave birth to the hallucinations recorded in this
painting beautiful bloomings of fish in a poppy field marked down on
the snow-white page shuddering like a bird's throat against the sex of a
woman in the form of a spider with aluminum legs coming back in the
evening to my place at 45 rue Blomet a number that to my knowledge
has nothing to do with 13 which has always exerted a tremendous
influence over my life by the light of an oil lamp the beautiful haunches
of a woman between the wick of the bowels and the stem of a flame
that threw new images on the whitewashed wall during this period I
had pulled out a nail from the pedestrian crossing and put it in my eye
like a monocle a gentleman whose fasting ears are fascinated by the
grace of a flight of butterflies musical rainbow eyes falling like a rain of
lyres a ladder to escape the disgust of life a ball thumping against the
floor the revolting drama of reality guitar music shooting stars crossing
blue space to pin themselves on the body of my fog that goes around in
a luminous circle before diving into the phosphorescent Ocean.

Statement. *Cahiers d'art*, 1939.[1]

In the spring of 1939, *Cahiers d'art* published a short
survey based on the following question:

"Is the creative act affected by contemporary
events, when these events involve no less than the
destruction of the forms of that very civilization
which the painter or the sculptor was consciously
trying to enrich at the beginning of his career?"

The context and underlying implications of this
question posed by Georges Duthuit to artists living
in France in 1939 are worth examining before
presenting Miró's response.

The dominant realities in European minds in 1939
were the rise of fascism, the Spanish civil war, and
impending war. In this context, the question of
whether an artist can remain indifferent to world
events is acutely pertinent. For Miró, the personal
tragedy of the Spanish war and his own exile
sharpened his perception of the cruelty and
senselessness of human history.

At the same time, the avant-garde movements
that had flowered in France since the turn of the
century, from Fauvism and Cubism to later abstract
and figurative styles, appeared to reflect a disengaged
or politically naive stance in regard to world politics.
Hence the two referents of an artist's creative life
were evoked: the existential reality of daily events
and the aesthetic reality of his art. How does an
artist in good conscience accommodate the two?

STATEMENT. IN *CAHIERS D'ART*
(PARIS), APRIL–MAY 1939

The outer world, the world of contemporary events, always has an influence on the painter—that goes without saying. If the interplay of lines and colors does not expose the inner drama of the creator, then it is nothing more than bourgeois entertainment. The forms expressed by an individual who is part of society must reveal the movement of a soul trying to escape the reality of the present, which is particularly ignoble today, in order to approach new realities, to offer other men the possibility of rising above the present. In order to discover a livable world— how much rottenness must be swept away!

If we do not attempt to discover the religious essence, the magic sense of things, we will do no more than add new sources of degradation to those already offered to the people today, which are beyond number.

The horrible tragedy that we are experiencing might produce a few isolated geniuses and give them an increased vigor. If the powers of backwardness known as fascism continue to spread, however, if they push us any farther into the dead end of cruelty and incomprehension, that will be the end of all human dignity.

On the other hand, a revolution interested only in comfort will end in the same disgrace as the one the bourgeoisie has plunged us into. To offer the masses no more than material satisfactions is to annihilate our last hope, our last chance of salvation.

There is no longer an ivory tower. Retreat and isolation are no longer permissible. But what counts in a work of art is not what so many intellectuals want to find in it. The important thing is how it implicates lived facts and human truth in its upward movement. Pure formal discoveries have absolutely no significance in themselves. One must not confuse the commitments proposed to the artist by professional politicians and other specialists of agitation with the deep necessity that makes him take part in social upheavals, that attaches him and his work to the heart and flesh of his neighbor and makes the need for liberation in all of us a need of his own.

26

Two letters to
Pierre Matisse, 1940[1]

The following two letters from Varengeville-sur-Mer
in Normandy, where Miró took refuge at the
beginning of World War II, suggest that the artist,
despite current events, had found once again the
tranquillity of country life he formerly knew in
Montroig. It was here, in January 1940, that he
began the Constellation series, works on paper in
which he experimented with complex textures in
ways he had rarely explored before. Although a lack
of materials probably forced him to work on paper,
these works nonetheless show the same intensity of
expression and concentration on technique as many of
his larger paintings. Moreover, Miró's lapsed
references to these works as "paintings" and
"canvases" affirm that he considered them to be as
important as major works on canvas.

To Pierre Matisse. Varengeville, January 12, 1940

I am now doing very elaborate paintings and feel I have reached a high degree of poetry—a product of the concentration made possible by the life we are living here.

To Pierre Matisse. Varengeville, February 4, 1940

Here is a detailed list of the finished paintings in landscape formats, the series of large canvases that you saw in its early stage (9 paintings in all). Braque and Zervos have seen them and found them very strong; they will appear in *Cahiers d'art* along with the ones from the summer on raspberry grounds. I am now working on a series of 15 to 20 paintings in tempera and oil, dimensions 38 × 46, which has become very important. I feel that it is one of the most important things I have done, and even though the formats are small, they give the impression of large frescoes. With this series and the one before it, you could do a very, very fine exhibition. I am planning to work on these paintings, using a very elaborate technique, for about 3 months—making allowance for the fact that, fortunately, they will lead me to conceive of other works which I will prepare at the same time. . . .

With the series of 38 × 46 canvases I am working on now, I can't even send you the finished ones, since I must have them all in front of me the whole time—to maintain the momentum and mental state I need in order to do the entire group.

Poem-titles, 1939–41[1]

In the mid-1920s, Miró had experimented with poetic titles, sometimes transcribing them directly on the canvas. By the early 1930s, however, he had decided that poetic titles or in fact almost any titles except those of the most banally descriptive kind (see pages 124–25) lent themselves to interpretations he wished to avoid. Yet, as we have seen, in the late 1930s, during his exile in France, a need for poetry once again pressed forward in his mind. Not only did he write poetry, but he once again invented poetic titles for his paintings. From that time forward, this practice would never leave him, even though he also gave some works more succinct, descriptive titles.

In most cases, the poetic titles came to him during the act of painting. They were a verbal expression that echoed the images coalescing on the canvas. These verbal images or titles contain combined references to real subjects (women, birds) and nonreal events or occurrences, thus creating a mythical reality and jarring the mind's expectations. This parallel verbal poetry, which is never denotative or descriptive, enriches—in fact, mythologizes—the iconography of the paintings.

The following poem-titles correspond essentially to the Constellation series.

POEM-TITLES, 1939–41

1939

A Drop of Dew Falling from a Bird's Wing Awakens Rosalie
Sleeping in the Shadow of a Spider's Web

1940

Figures in the Night Guided by the Phosphorescent Tracks
of Snails

On the 13th the Ladder Brushed the Firmament

Woman with a Blond Armpit Combing Her Hair by the Light of
the Stars

The Nightingale's Song at Midnight and Morning Rain

1941

Women at the Edge of a Lake Made Iridescent by the Passage
of a Swan

Ciphers and Constellations in Love with a Woman

The Beautiful Bird Revealing the Unknown to a Pair of Lovers

The Pink Dusk Fondles the Sex of Women and Birds

V

Montroig and
Barcelona, 1941–45

28

Working notes, 1941–42[1]

The following notebook is a journal of notations and projects that Miró kept over a period of one year. Started in July 1941, when Miró returned to Montroig after his long exile, this notebook expresses the artist's need to collect his thoughts and prepare to begin again. During the war years he had been unable to work at full capacity. Now, at last, he saw the chance to build a large studio and work in all mediums and formats.

The following notes set forth his projects in meticulous detail. They show his manner of organizing and premeditating the different aspects of his production as well as his attention to technical concerns. It must be said, however, that few of the paintings, pastels, sculpture, and prints described below were actually carried out precisely according to the artist's written indications. Despite his long reflection before taking up a given medium, Miró's ideas always came to him during the execution of a work, inspired by his contact with the materials and the forms taking shape before his eyes. Furthermore, it was only in 1944–45 that Miró returned to painting. His canvases, although related, are quite different from the initial ideas found in these notes. He did his first postexile lithographs, the "Barcelona series," also much later, in 1944. His first sculptures date from 1944–45. Perhaps these notes appeared

"dead" to his eyes by the time he got back to work again. It is interesting to note that at some point, he went back through the notebook, systematically crossing out every entry, indicating either that it had been done or that it was no longer valid in relation to the evolution of his oeuvre.

Miró kept this journal between the summer of 1941 and the summer of 1942. At times the order of entries is confusing. It seems that the first notes were set down under headings (for example, "Sculpture and Studio," "Etchings"), leaving blank pages that were filled in at subsequent times. Hence some of the few dates mentioned are out of sequence and there is occasional repetition. The notebook is translated here in its entirety.

WORKING NOTES, 1941–42

begun at Montroig in July 1941

Sculpture and Studio (I)

when sculpting, start from the objects I collect, just as I make use of stains on paper and imperfections in canvases—do this here in the country in a way that is really alive, in touch with the elements of nature. . . . make a cast of these objects and work on it like González does[2] until the object as such no longer exists but becomes a sculpture, but not like Picasso—do it like a *collage* of various elements—the objects I have in Barcelona will not continue to exist as such but will become sculptures.

in order to work in a more vital and direct way, work frequently out-of-doors.

it is in sculpture that I will create a truly phantasmagoric world of living monsters; what I do in painting is more conventional.

build myself a big studio, full of sculptures that give you a tremendous feeling of entering a new world. . . . unlike the paintings that are turned facing the wall or images done on a flat surface, the sculptures must resemble living monsters who live in the studio—a world apart.

melt down the metal of my empty paint tubes and use the resulting shapes as my starting point.

may my sculptures be confused with elements of nature, trees, rocks, roots, mountains, plants, flowers.—build myself a studio in the middle of the countryside, very spacious, with a facade that blends into the earth. . . . absolutely not white, and now and then take my sculptures outdoors so that they blend into the landscape.

with only rare exceptions it would be a great mistake to cast my sculptures in metal; that would be the work of a sculptor, a *specialist*, and I must avoid that as I must avoid at all cost specializing in etchings, burin, etc. . . . If I did that I would be deviating from my oeuvre[3] and

there would be no link with it. . . . Have my sculptures reproduced the way they reproduced Pablo's for the pavilion, in reinforced concrete, I think it was,[4] and then look for weather-resistant paints with which to color them. . . . Splatter white paint on these cement masses and then paint parts of them with really violent colors, reminiscent of the Majorcan whistles,[5] either painting directly on the cement or on the white the way I do in my paintings, in a way that is really alive and direct, respecting the material. . . . That way I would create a link with the rest of my production and with nature's real objects, trees, roots. It would be linked with these things and with the sky, the atmosphere, mountains, etc. Cast in metal, my sculptures would, with rare exceptions, be dead things or museum pieces.[6]

Etchings

Put tin cookie boxes in front of me and, looking at the shapes suggested by the imperfections and reflections, draw them almost automatically on the metal, using a magnetic needle.

How do you store etchings so that the paper doesn't fox? In an open cupboard so the air circulates and keeps the humidity out?

When doing the series of line drawings, try to get the same quality in some of the etchings that I got in 1941 to 42 when I was drawing with a quill pen and India ink on wet paper. . . . Pablo[7] had already done that using a special varnish. . . . to get a new line, like the one you get on wet paper once it has dried, wait till the first proof has been pulled with its etched line; then incise the plate with burin and drypoint.—I could also see what happens when you use burin and drypoint to engrave directly on metal prepared with the special varnish I mentioned and then let the acid bite the plate. . . . I could also add some touches of aquatint to these plates, exactly as I did in 1941–42 when I enhanced my drawings with touches of watercolor and gouache.

Goya used aquatint in all his etchings.—It is essential that I learn this process and use it in my engravings as it will provide me with an infinity of new possibilities.

Doing color etchings is a dead thing.—do them the way they used to be done, engraved in black and colored by hand.

Ask Man Ray if I can get anything by engraving a plate[8] with a punch
. . . coloring the surface afterward like the attached postcards. If possi-
ble, I could also use some realistic *collage* as in the postcard: start from
there.

Remain a self-taught amateur as for technique—as in the 1942
drawings.—that way I will do lovely work.

It would be a big mistake to do as I have done up till now, not wanting
ever to erase the line on the metal. On the contrary, sometime after
engraving a plate I should come back to it, erase the whole thing if I
feel like it, and feel that it is from a sum total of destruction that
something powerful can emerge.

print leaves, skeletons, fishbones, etc., on a plate like the prehistoric
stones in the Barcelona Museum.

Lithography

Don't try to make a line as though it were on paper; remember the
grain of the material, think about the line made with charcoal or chalk
on a grainy wall.

in color lithography I could use the same process I used in the colored
drawings I did in Montroig in 1941. . . . start with some large spots of
color on the stone and then do the linear design in black or vice versa;
start with the lines and then add color. . . . do the drawing sometimes
with pencil, sometimes with a brush. . . . I could also start out with a
shape traced on the stone, using transfer paper, trying to get a texture
like sandpaper, for example. Also see if it is possible to use colors on
this transfer paper and trace colored forms and textures on the stone;
this would make the print richer. . . . I think that by using a quill pen
with ink or maybe a bamboo reed I could get a very vital line like the
one I got drawing with ink on wet paper.

when doing lithos don't feel I have to do them one after the other—do
as I did in Montroig the summer of 1941: prepare them all at once,
keep looking at them whenever I am not working, and do whatever
occurs to me; let them take shape by themselves like my drawings and
paintings. . . . don't make the mistake of doing a series of lithos in ink

after having done them in pencil, try to get the ink now and prepare them at the same time and do them all together. . . . when drawing them see to it that the line is the most important thing, filling in only a few spaces with black like the very rare colored areas in the large pastels, and that the blacks take on the same importance as the points of light in Dutch interiors. . . . by using a goose quill pen or bamboo reed I could get the quality of a line drawn on wet paper.

I am afraid that the things I wanted to print in ink on paper to serve as a point of departure won't be strong enough. . . . I think it would be better to make a drawing by holding a pencil flat (in order to get a thick line) against the paper I had planned to work on with ink.—as I understand it, the pencil would have a beauty and granular texture that I do not think ink would have. . . . what I could do when I print these lithographs is first work in ink on the stone as I had planned . . . and, in others, work afterward on top of the drawing, a process somewhat like overprinted etchings. That way I could get some beautiful surprises. . . . take a stone, coat it with black and incise it with a nail. Everything I had planned to do using lithographic ink as my *starting point* I can do in the series of pieced-together canvases in Barcelona.

Keep a blank sheet of paper for trying out pencils of different numbers and then take the little bits of lead you get from sharpening the pencils, crush them into the paper and start from there.

Dufy illustrated a book by Apollinaire using wash on stone;[9] I could do that, too.

Woodcuts

Do some woodcuts using the grain of the wood as my point of departure.

I could do a series of woodcuts based on the paper scraps from María Dolor's[10] cut-outs. . . . paste these fragments on the wood, start out from these shapes and go on drawing from there; add color later—all this could be very powerful.

Ricart says that collectors of woodcuts prefer the ones that are engraved in black because you can see the technique better; they only color the ones that are meant for framing.

In the old days woodcuts were painted with the fingers.

To see what the woodcut will look like once it is inked, you put talcum powder on top of it.

Linoleum Block Prints

when improvising tools, use the ones my father used in his watchmaking work and which are at Montroig.

Ceramics

Take earthen jars like the ones from Felanitx[11] and make little turds on them with a pastry tube the way pastry cooks do; put birds and shapes on them; incise shapes with a nail, too, as though doing a drypoint.

Go to the Prehistoric Museum in the park[12] and look at the splendid shapes of the jars from the cave era.—these shapes could be redone, searching at the same time for a handsome material—also make quite large jars. You could work with a punch while the clay is still wet and make linear designs on them as well as reliefs with a pastry tube.

make a row of tiles with symbols on them like the "Sausage" canvas[13] and plates.

In Mexican prehistory there were jugs with a burnished red coating (smooth and shiny) and on top of that a black design as on Greek vases.

There are great possibilities in working with jars; take a jar with a varnished yellow ground, add a green spot and then a really sharp drawing in sienna.—Look for the purest, the most ordinary.

When Llorens[14] sprays the jars with a fixative and clear varnish he gets a lovely quality.—Before firing put some deep lines in the clay which suggest shapes. Starting from these shapes, do some sharp drawings before the varnish dries and then paint them, leaving the background unpainted.

Stained Glass

Incise the glass and apply some color.

Monotypes

There are great possibilities here—you can work on glass (I could use irregular, broken bits) and on lithographic plates.—I can pull them at home, without a press; just pushing down with my fist. . . . start by preparing the ground; when printing, juxtapose various plates—oil, gouache, pastel (when used on wet paper it would give a lovely effect) and the final plate with a black linear design. . . . Use a reed to do the drawing by scratching it on a black or dark ground.—print on various kinds of paper, cloth, blotting and deckle-edged papers.—Sanjuan knows the technique.[15]

Pyrography

Inscribe magic signs on bones and wood.

incise ordinary objects like wooden spoons, etc.

find out if you can work on an entire hide like the ones they use for making the wineskins the peasants take when they go out into the fields.

Don't just work with special tools, but also use any kind of hot metal; start off from the shapes and spots you get from these hot metals and work on them afterwards. . . . add some color too. . . . use pieces of wood from the factory.

Pyrograph pumpkins, which have first been painted with white tempera, and once they are drawn, add a little color.

Odette Gomis[16] has a tool and knows the technique. Ask her, too, for the address of the Maison de l'Artisanat in Paris where you can find all kinds of things related to different handicrafts.

Using special needles, you can do pyrographs on fabric.

objects that could be pyrographed: pitchfork, wooden ironing board, wooden clogs, farming tools, sieves, kitchen articles from the 5-and-10, things from Ibiza like very large castanets, drums, etc. Pole for washing clothes.

The wood I used at the Gomis place in 1942 was olive wood.

Mrs. PPaulí knows a pyrography teacher who could give me ideas about materials.

Miscellaneous

Using the lost wax process—which Braque taught me—I could make some designs that could later be made in gold, like the primitive Mexicans used to do.

Painting

The preparation of the series of large canvases for Daphnis and Chloe[17] is very unsatisfactory; if you press on the back of them with your finger the preparatory coat comes off.—Use a solvent to remove that preparation and then give the canvas a coat of white lead or casein, the preparation Braque[18] and Balthus use; cover this with a very thin coat of gray, use a projector to blow up my drawings, apply fixative, sandpaper them lightly to remove any excess fixative that might prevent the colors from adhering to the canvas, finally cover them with gesso, and then settle down to redraw these canvases. Anyway, aside from their unsatisfactory preparation, these canvases are now dead things, and this impression will surely become even stronger when I start working on the rest of these paintings because the ones that are presently in Barcelona would be completely out of place. Draw the entire series in one fell swoop, very simply, making use of my latest work and following the notes I made previously in other notebooks. Use very strong, but smooth, canvas and use the pumice stone at various intervals to get a more beautiful texture.

when organizing my definitive studio, make a careful selection and destroy anything that is not of interest.

Back in my Barcelona studio again, I get the impression that I often let myself be carried away by my genius, in the superficial sense of the word, as often happens to Picasso who, nevertheless, has opened a lot of doors for me. . . . Look to Braque as a model for everything that is skill, serenity, and reflection.—He lacks the genius of the former who,

in turn, lacks the qualities of the latter; this means that often when you see his work again after several years it seems dead and dated, with no strong reason for existing.

Upon returning again to Montroig and reviewing my work, it seemed to me to be very strong, very much a product of this place.—When I saw the countryside around the farm, with those planes that are so grand in their simplicity, I realized that much of my work is simple, grandiose, and brutal, and rightly so; even the symbols of bird songs, the sound of the wind, of a turning cart wheel, of a human cry or the barking of a dog are very schematic. . . . On the other hand, when I go up to the hermitage, "La Roca,"[19] and look down on the immense expanses of land with olive and other trees, round and square ponds, the tilled fields, all this wealth of detail goes straight into my current work; what I loved twenty years ago and tried unsuccessfully to capture then, I will capture now.

looking over this work now and face to face with this landscape, I think it is artificial to want to do realistic things as I had planned to do in the summers, alternating that with sculpture. . . . I am not yet mature enough to do that; this realism would have to be exceedingly rigorous, like Vermeer of Delft or extremely pure like Rousseau[20] and I have still not come that far.

Furthermore, my current spiritual state does not seem right for that. On the contrary, it is full of signs and enigmas like my current painting; if I have years enough left in my lifetime I might possibly evolve toward a magic realism.

Now and again it is a good idea to leaf through the portfolios I have at Montroig, and see drawings done 20 years ago that contain elements that still concern me now. Besides, it is possible that by the end of my life, if it is a long one, I will attain other elements of a magic realism.

Looking at the Masonite *Peinture* from the summer of 1936, you can see that I had already reached a very dangerous impasse from which I saw no possible way out.—the war broke out in July 1936 and made me interrupt my work and close myself into my spirit; the premonitions I had that summer and the need to keep my feet on the ground by using realism took shape in Paris with the still life of the shoe.[21] Later on, writing poems that were of value only to me helped me take off toward pure poetry while still, however, remaining highly graphic.[22]

The self-portrait represents a step away from the realism of the still life of the shoe toward poetry: a painting full of symbols and signs.[23]

I had also planned to do a landscape of Montroig. . . . now I don't feel the need to do it; what I can do in the next self-portrait is make a head-landscape with human features that recall the landscape here, metamorphosing one with the other.

I have found some paper here for drawing with pastels. . . . the quality is very beautiful. I must start with it and enrich it by rubbing more or less hard on it with a pumice stone, surround the drawing with plaster or *case-arti* [white primer]; in other places spread oil paint with a spatula and use all processes when working on it: watercolor, egg, tempera, pastel, etc. . . . really respect the material; it is not a matter of doing *pastel painting* just as when I am engraving I do not try to do a *pointe seche* or a burin or an *eau forte*, but simply a print.

Forget about the series of pastels I had planned. I will replace them with that series of drawings I've mentioned before. . . . they won't be the drawings of a specialist and they will parallel my work. Otherwise it would look as though I wanted to be Degas.

To get rid of the color remaining in the pots, don't do the two big canvases on a white ground as I had planned to do, but first paint a thick but fine smooth canvas with dark ochre. . . . when it is dry, give it a very thin coat of Haarlem siccative; that way you would see the transparency of the ochre and it would be more magical.

when preparing the ground for the series of 120 canvases based on the pure signs begun in Varengeville and finished in Palma,[24] think about the blue vitriol that they use for the vines and that splashes against the walls of the farmhouse.

In the series of 100 canvases that I drew in the same album as Daphnis and Chloe, start out with the trunk of the fig tree and treat the human figures like plants and flowers, with extreme simplicity and poetry.

pass a pumice stone over the two black 100 canvases I have in Paris. That would make a more beautiful texture.

forget about the gouache drawings on moldy colored paper. In the others put *case-arti* here and there instead of sand.

now that I am here in Montroig with its strong and schematic shapes I can better understand the poetry of Palma with its narrow streets and pink light and virgilian countryside. . . . The strength of Montroig together with the poetry of Varengeville and Majorca have done me a lot of good.

in a series of sketches use a burned cork or smoke from candles the way Paalen did.[25]

the velvet finish of the pastel papers I brought from Montroig is not attractive: in order to get rid of it, do the same thing I noted down to do with the black papers.

I think it is a mistake to always use bone black; use other blacks that exist as well, remembering how they have to work with other colors and with the grounds in paintings like *La Toilette Matinale* [The Morning Bath] which have to be shaded; the bone black is excessively raw and hard; use another black, like *brown* black, for instance, which allows a less brutal transition with the other colors and, when shaded, is more luminous; but use bone black in certain places, too: that gives a richer effect.

varnish these canvases where I have used shading afterwards, using a not very shiny varnish so that the part that has not been shaded does not remain matte either and makes a contrast.

because the colors differ considerably depending on the brand of paint, don't use just one brand. Don't be a slave to any one brand; see how the colors work with the ground.

In order to transfer on to canvas drawings like the *Portrait de la Reine Marie-Louise de Prusse* [Portrait of Queen Marie-Louise of Prussia], which are already very pure, enlarge them with a projector. Otherwise I risk falsifying the original feeling, which is the true and absolutely pure one.

Use flat brushes in canvases like *La Toilette Matinale* that have to be shaded; that way I will model them more powerfully and in a more tangible way—as though I were sculpting.

don't do excessively large canvases. That could be a sign of mediocrity

the way it is in towns that want to build big things, without giving a thought to the greatness of spirit they might contain.

In the sketchbook for gouaches, do them more freely than the ones I did in 1940–41; clean my oil-paint brushes right on the paper. Once the paint is dry, sandpaper it lightly and rub it with pumice stone; then cover it with coats of watercolor and pastel.

When doing series like that of the large canvases prepared with white grounds—from the series of women on the beach which is already sketched in a sketchbook, use colors that are fairly *standard* and don't clean the brushes every time I do a canvas—otherwise I would never finish the so-called secondary tasks. put them to soak and work on the whole series *at one go*. . . . nevertheless, don't underestimate the work involved in cleaning brushes when the job calls for it, even though it slows down my work; consider it one of those *incidental* things that are involved in all jobs and that open up new horizons. . . . think what the temperas from 1940–41 mean to my oeuvre; yet little did I suspect it when I started them.[26]

when working, follow a deliberate schedule; for example, do sculptures in the summer, devote myself to printmaking when I am in Paris or print on those afternoons when I am not preparing other work, etc. Otherwise I won't have enough time in my life to do everything I plan to do.

Next time use a pad of very thick paper for cleaning brushes and doing gouaches; this will permit me to really work on it with pumice stone and sandpaper.

in the series on *burlap*, work with a sharp incisive line as through it were an engraving, sometimes using a glass cutter's tool and India ink. . . . do it as spontaneously as possible; use watercolor, gouache, egg, oil, pastel, and India ink wash.

in the series of 24 canvases that I left in Paris, also use an India ink wash.

also use an India ink wash in the series of drawings.

I will make my work *emerge* naturally, like the song of a bird or the

music of Mozart, with no apparent effort, but thought out at length and worked out from within.

in certain parts of the series of 24 canvases I have in Paris, mix the paint not only with turpentine but also with oil and varnish so that they will be more brilliant and give me a new material.

About the unity of my work: the rectangular drawings and the schematic signs done in 1941 derive from what I tried to do for *L'usage de la parole*,[27] but this relationship was not in the least preconceived. . . . when I did the rectangular cover drawing I was thinking back to the square Masonite pieces left in Barcelona in 1936.—thus, there is a perfect logic in the *encounter* of these things and events that momentarily appear as isolated things with no sense of coordination.

In the series done with bits of canvas there will be some that are very thin and I will work on them almost without any preparation, using a Japanese brush. I can forget about painting on bits of silk.

In the series of big canvases based on the sketches started at the Swimming Club, remember the big rectangular temperas on paper begun in Montroig in the summer of 1941.—look carefully at the sketches in the album, then do others on sheets of paper and when they are really alive in my spirit, take a brush with a pale color and draw the entire series of canvases in a really free way and with a very grandiose rhythm. That will be the first step: then draw them carefully with charcoal, sometimes covering the first drawing with very liquid paint, and proceed to paint them, making sure that the original color drawing remains. . . . they should be reminiscent of the series of temperas I mentioned in their utter spontaneity . . . gigantic rhythm like that of a waterfall cascading down a mountainside.

I see two [*sic*] steps in working on this series of canvases: 1st step: after finishing the process described above, draw on the canvases with viridian green and let them rest for several months. . . . 2d step: do the final drawings with charcoal and fill in part of the ground with that same viridian green, again very liquid, and let them rest again for several months. . . . 3d step: paint these canvases in a very intense way, quickly and in the usual spirit. Scumble the grounds with large spots of color so that, since the color is liquid and therefore transparent, you can see the green and the white beneath it; the colors of the volumes

must be intense, very synthetic. . . . this way not only is a link established with my present work but I will get back to my initial idea of painting these canvases with only large colored surfaces over the grounds. . . . when making the outlines, paint some lines with very thick brushes and others with thin brushes. . . . do each of these steps in one operation.

when relating colors don't do as I have done up until now, establishing the relationship according to the colors I used; for instance, after a black I always used a red and that limited me tremendously. . . . do now as I just did in the *Passage de l'oiseau divin* [Passage of the Divine Bird] and as I started doing earlier in other temperas; relate the colors on the basis of the tones used in the ground; that will give me infinitely greater possibilities. I will discover with *surprise* unexpected color relationships and the color and the light will become magical.

consider the series of pieces of canvas as really a "secondary" type of work because they do not correspond to a state of mind. . . . divide them in various series; for example, canvases with colored grounds, canvases with special textures, canvases with linear motifs, etc., and work alternately on them and on the rest of my work. Otherwise, it will take me too long to do. . . . If I draw these canvases now and don't go back to them for years and they clash with the concept of the new forms I will be doing later, it doesn't matter; it will be more interesting, as though it were a canvas done in collaboration or else a collage.

when cleaning brushes on a new drawing pad, work in various stages; first clean off the brushes in oil, then sandpaper over it, apply watercolor or tempera on top of that and then pastel, etc. In other words, keep working on it, always controlling the medium.

in the series of canvases measuring 120 P. or M. with a white and Prussian blue ground for which the drawings were done in Varengeville and Palma,[28] start with the linear motifs directly in oil in those which should be this way and then continue by drawing them.

The large drawings I will start at the end of 1941 can be enriched by first wetting the paper and then adding a few lines in India ink. . . . on the sheets of paper that only have a spot or some line or other, there could also be, as a first step, some drawing on wet paper. . . . I could also wet the paper when working on the series of small sheets of paper

that I have in Palma. . . . I could lightly sandpaper the small sheets of
paper with a black ground, then wet the paper, do a motif with a
Japanese brush and white and then continue. . . . when I start working
in Palma again in the fall of 1941, I can get rid of the paper that is on
the table, using it to finish up the series of drawings I have done by
provoking accidents on the paper.

Provoke accidents on the large sheets of pastel paper as well; that way
there will not only be a greater wealth of possibilities to start out from,
but there will also be a parallel with previous drawings, for it is essen-
tial to always avoid any break in my oeuvre; furthermore, that way the
drawings will draw themselves according to the laws of nature just as
flowers in a field unfurl and bloom when the time is right. . . . above
all, when doing this series don't try to do *pastels*, do not fall victim to
that, limiting myself as in the series of pastels (!) I did a few summers
ago. . . . there has to be a great deal of humor and poetry in this
series. . . . the medium must play a very important role and there
should be hardly any color. . . . very thin tempera used on this paper
has a magnificent quality. . . . also use colored pencils, drawing with a
circular motion, and wax crayons . . . also sealing wax . . . in certain
places spatterpaint with a screen. . . .remember that once a fixative has
been applied pastels look a lot like tempera, which just proves how
dangerous it is to specialize in one technique. . . . when sandpapering
put sandpaper or something else underneath in certain places; that way
I will get a new texture. . . . very often just leave the outline of certain
shapes, which will be really vivid against this texture and punctuate
certain parts of the outline with large spots of various colors in oil or
tempera. . . . use a sponge or wad of paper on certain grounds with
different colors. . . . put few colors in the shapes and give these few
colors the life and mystery of the luminous spots in Dutch paintings;
fill in the ground and certain shapes with bits of lead pencil crushed on
the paper.

in the next series of large and small drawings, don't fall victim to the
dangerous practice of doing one drawing right after another; when I am
not working, keep looking over the entire series and continue doing to
them whatever might occur to me; that way they will emerge by
themselves in a way that is vital and natural.

Achieve the same spontaneity in the paintings as in the drawings.

As soon as I can get to the big canvases I left in Paris, do linear motifs

on the black and white canvases; leave them and continue working on them when the time comes. . . . in the two canvases on a sienna ground, make a drawing in a darker color, an earth color or an earthy green; leave them and when the time is right to prepare them for painting, sandpaper them or spatterpaint them in certain places. . . . on one of these canvases, the big one, I could do the drawing backwards as I did in the etching printed in 1939; that would give it a very magical and unsettling feeling. . . . No matter what, the canvases must emerge by themselves without self-consciousness.

on the large sheet of yellow pastel paper with this drawing on the top: [drawing] sandpaper part of the paper to reveal the black underground and then paste the pink blotting paper I have in Palma over it; put a little case-arti around it and make a drawing with India ink on the damp blotting paper; that will give an impression of magic and force.— if I leave out the eyes or other human features in the heads of certain figures, it does not matter at all. . . . the very few colors used in these drawings must be as sharp as a pinch. . . . use colored and lead pencils frequently in the grounds, applying them with a circular motion as in the drypoints. . . . take a nail and turn it round and round on the paper as though engraving the ground. . . . The forms in these pastels must be very simple. . . . make certain shapes with a Japanese brush and India ink, wetting the paper first; I think that will resemble a line drawn on blotting paper. . . . make other outlines with just a brush and tempera; this will give me a wealth of effects; fill in certain shapes with that black that has such a magnificent quality on this paper. . . . treat the arms of certain figures as though they were leaves. . . . leave the irregular bits of paper as they are because they will have a certain resemblance to the pieces of uralite I have found, but make an exception for that big piece of velvet-finish paper because the shape is not interesting. . . . draw on these irregular pieces with a Paris pencil[29] and don't use any color.

when doing the self-portrait do several canvases with symbols that are simply poetic, recalling the infinite poetry of *Chien aboyant à la lune [Dog Barking at the Moon]*,[30] with its vision of the infinite, which is also reminiscent of the things I did earlier using egg on wood. . . . before drawing on these canvases, sandpaper them to get a handsome texture. . . . the idea I had in Paris of doing a series of small paintings treating certain fragments of *Self-portrait I* as landscapes: see to it that this conception of human fragments is expressed in *Self-portrait I* and that the whole thing resembles a landscape.[31]

In *Self-portrait I*, before covering the drawing with white gouache, sandpaper it to get a nice texture.

Treat the series of 24 small canvases from Paris a bit like the small Masonite drawing I did in Palma on November 19, using pastel and various other mediums.

don't treat the large pastels as such; instead use the beautiful texture of the paper as a point of departure and use pastel only as a pretext, the way I did in the little Masonite I did in Palma on November 19; use various mediums. . . . I could make a design on the sheet of ochre paper with black pastel or better still with green or some other color and juxtapose charcoal drawings on top of it; hold the pencil flat when doing the design in order to get a really thick line.

Think about William Blake when doing the self-portrait.

Sculpture and Studio (II)

Take bamboo reeds, whittle them a bit with a knife and cast them or simply give them a coat of plaster and continue working on them. . . . I could even make a plaster reproduction, like the Majorcan whistles, and color it.[32]

in order to facilitate my work as a sculptor, make sure that my studio has a certain atmosphere. . . . the outside should not be white; together with the farmhouse that would make an excessively white surface. . . . look for a material that would make the walls blend in with the earth and the landscape like, for instance, the stones used in the Poca farm,[33] but use a little bit of white so that it is not totally unrelated to the farmhouse, for instance, around the door and windows or even on some specific volume. . . . then when I enter my studio I will feel as though I am going *inside* the earth and my work will come out more natural and spontaneous. . . . plant some bramble bushes and prickly pear trees around the studio and put an old cart wheel outside. . . . the inside of the studio has to be really human and propitious for my work; the walls completely white and made of a kind of material that I can hammer nails into so I can hang up things that interest me. Also put in some kind of stone benches like Arp used to have in Meudon,[34] where I could place things that would help engender my work.

use things found by divine chance: bits of metal, stone, etc., the way I use schematic signs drawn at random on the paper or an accident. . . . that is the only thing—this magic spark—that counts in art.

make the studio the same size as the cellar. . . . build a sort of cart shed next to it where I can keep things I don't need. . . . paint some corner of the wall white so that this part of the building won't be too disconnected from the farmhouse; it would make a nice effect on the stone.

The bathroom floor could serve as a solarium. . . . tear down the chapel roof, but use the side walls to build a sort of studio there, making two small arches to connect it to the rest of the farmhouse. . . . in other words, this part of the building would have two stories. . . . the ground floor could be an intimate place.

In a corner of the studio there could be a sofa where I could concentrate, curtained off so that no one could see what I was doing. . . . put in a lot of electric outlets so I could see the sculptures or paintings better.

in order to find handsome building materials for the outside of the studio, go to Vilanova d'Escornalbau where there are a lot of houses built of stone and then totally (or partially) whitewashed.

In Palma they make little earthenware figures for the crèches and later bake them; they put wire in certain places so they will hold their shape. . . . they paint them with enamel mixed with turpentine and flatting varnish.

always have the Bible open when I am sculpting; that will give me a sense of grandeur and of gestation of the world.

Won't it be too windy where I had planned to build the studio in Montroig? I shall have to look into it.

There is a quarry in Santanyí with stone that would be very good to work and which the Majorcan sculptors use. . . . in Parreres there is an extremely soft stone that can even be worked with a knife.

Take square bits of stone from Santanyí and incise them in a very simple way, like the incised roof tiles in the museum in Tarragona.

make clay bas-reliefs, making shapes like little turds with a pastry tube and also put in some well-proportioned solid volumes.

One could cast different objects . . . think about the doves I saw at Sunyer's place in February 1942; they were very handsome with the feathers that were visible and a whole silvery tone.—Gaudí[35] also cast various objects; he even cast children who pleased him and living beings and later used them as models and as his point of departure. I believe that there is a great similarity between my way of working and Gaudí's. . . . I could also enlarge objects I find, like that bit of coal on the wheel, and then work with them the way I work in paintings with spots of color and lines that I also *find* on the paper or canvas.

Make a mold of a fish on an irregular piece of plaster, like the prehistoric stones; then incise signs and make some relief, and later have it cast in bronze.

Painting

In the canvases with the Pozzolana red ground, which are in Paris, make a drawing in another color—for instance, emerald green—and then on top of that draw the figures that are to be printed.

Remember that in primitive, nondecadent races the sex organ was a magic sign of which man was proud, far from feeling the shame that today's decadent races feel.

when doing Daphnis and Chloe go see the mountains in the Barcelona park so that they can suggest shapes to me.

in the series of large canvases I prepared with white this winter of 1942—the Club series[36]—inscribe linear motifs with burnt sienna; this way there will be a continuity in the oeuvre and a clash and juxtaposition of concepts.

in the series of paintings on *burlap*, prepare the ground by smearing on case-arti with the palm of my hand as though I were going to ink it; this will give me much more vivid effects and a finer texture than if I did it with a spatula.

In the series of large canvases taken from the sketchbook done at the club, I will start out by doing the drawing; once it is done paint the ground green so that when I organize the painting on this ground, it will be more alive. . . . in the ones where there will be no linear motif, start out by quickly laying out the first idea of the canvas the way I did in the pastels I did in Montroig and then immediately do the ground; this way, when correcting the drawing afterwards, it will be done against the ground and that will make it richer and stronger, and these canvases too will emerge all by themselves with no apparent effort, and getting away from the idea that a canvas has to be done systematically from start to finish.

I would subdivide the series of canvas remnants into two series: the first—bits of canvas without a stretcher—are inside the portfolio and could be done after the canvases from the Montroig sketchbook. . . . I have left several of these canvas bits as is, without even preparing them with paste, so that the process will be more vital. Draw on them while they are in this state, starting from the folds, wrinkles, and accidents in the canvas; then apply a fixative and wet them so that they will remain taut. . . . prepare some canvases with paste and others without it. . . . draw on them again, some of them with India ink on a wet or dry surface. . . . paint others with a very pointed brush, with watercolor or gouache, pastel, oil, colored inks, etc., in a way that is really alive . . . or use all these styles at once. . . . I should not use paste to prepare the ones on which I want to draw using India ink on a wet surface because the ink will run on the glue and the line will have no life.

I had planned to have someone else draw the big canvases in the Daphnis and Chloe series, but now I think it would be better if I did them myself, using a projector to blow up the drawings; this way my mind will do a job of self-criticism and engender new concepts in the work.

The series of paintings from the club could be done in the following stages:

 I—linear motif in sienna or a more muted color.

 II—quick drawing with a brush and dribbling gray oil paint

 III—green ground

 IV—final drawing in charcoal

Colors I could use for the series of canvases from the club:

> Titian pale green
> Titian brown
> burnt sienna
> this is for the preparation described above.

Technique to use for the series of canvases from the club:

a) very liquid line that dribbles, adding a little oil so it will stick better and drying it with a thick round brush of the kind for doing *pochoirs* [stencils].

b) rubbed green ground.

c) draw with a very fine brush, very liquid paint that dribbles, prepared as for the line.

d) in certain parts of this drawing use a "cod-tail" brush to get a nice thick line and, in certain cases, a very broad line.

e) final drawing in charcoal.

f) very pale colors; in certain places use scumbling.

g) black

h) primary colors

i) black outline

when doing the Daphnis and Chloe series, look at Greek vases.

Do over—naturally in another spirit—the large canvases from 1933? In any case, look at the *collages* and make a canvas of the same size for each one.[37]

Projects

I could do a series of pochoirs, which would make my work better known, along with prints, lithographs, etc.

I could publish a collection of color prints, either etchings or woodcuts or lithographs, as a book or portfolio, with a poem by Eluard.[38]

publish a book with previously unpublished drawings from all periods, starting with childhood.

publish an album with beautiful photos of objects I have found and include a pochoir or color lithograph with a poetic text or poem, or better still, one of my own poems, if possible, to enhance it.

Museum of Folk Art

Trips

Greece
Egypt

Pyrography

In the street where Brossa lives in Palma, across from the Church of St. Nicholas, at no. 13, there is a studio that makes wooden objects.

I could start out by taking red-hot irons and applying them to the wood the way Braque and Mariette did in Varengeville.

Burn designs into the hides of mules or lambs, like the Indians did, and add colors.

Letter to Pierre Loeb, 1945[1]

The following letter to Miró's prewar dealer, Pierre
Loeb, reflects Miró's state of mind at the end of
World War II. Aside from his acute anxiety produced
by current events, he had been virtually cut off from
the art world since 1939–40, and his financial
situation was extremely precarious. At the same time,
these years of isolation had brought him to an
unprecedented stage of pictorial maturity and
self-confidence. He chose to consider the war's end as
a turning point in his development and his career; he
also felt it was time to free himself finally from
financial worries so that he could devote himself
entirely to his art.

Miró's tone is courteous but businesslike. His
determination and manner of presenting the situation
echo a much earlier letter to Ricart in 1919 when,
for the first time, he decided to force his destiny by
leaving Barcelona and settling in Paris (see Text 2,
pages 65–66).

To Pierre Loeb. Montroig, August 30, 1945

I received your letters of July 27th and 31st, which arrived after considerable delays, and was moved to hear from you again. As you were still in France, I have not received any news from you about yourself since the beginning of the war. All I have heard has come to me secondhand through mutual friends. Foreign magazines have fallen into my hands every now and then, and these have also helped me keep up a bit on your activities. . . .

I was very touched by your sympathetic words about my mother's death, and I ask you to accept my very sincere condolences for the losses you have suffered.[2]

Let's move on to other things now. You can absolutely count on me. I will be happy to lend whatever help I can to getting your old gallery started again; and I'm sure that you will manage very quickly. You understand, of course, that I cannot tell you what my terms would be, since everything has been entirely disrupted and I have no idea what things are worth nowadays. The only thing I know for sure is that here, like everywhere else, prices have changed and gone up.

As far as you and I are concerned, this should be a matter of mutual trust.

From my end, this is what I would like from you.

For many years, I've known that you have an open mind and that I cannot ask you to get rid of all preconceived ideas on the subject of painting.[3] I also know that you are not one of those people who thinks that painting stopped with our forebears; their discoveries were brilliant and their works were wonderful, but the horizon always remains infinitely open, and *we* too are marching forward, always forward.

These past years have been very hard for me. Luckily, the war ended when it did—just at the moment when I had spent the last money I had left, when I had nearly exhausted all my resources. During these tragic years, I have continued working every day, and this has helped me keep my balance—my work has kept me on my feet; otherwise I would have gone under; it would have been a catastrophe.

I am going to talk to you in the same terms I used recently with Pierre Matisse.

I am 52 years old, and I must look at things very seriously, in a clear and precise manner, with full awareness of the responsibilities I have in life—which I cannot avoid.

There are only two paths available that are worthy of me:

a) make a financial arrangement similar to the ones made by artists of my age during the last generation—there is no reason for it to be otherwise.

b) sell some property to pay off my debts and with the money that is left retire to the country, where I would continue to work with the same passion and enthusiasm I have always worked with—which is my reason for living—but in total isolation and silence.

What I will no longer accept is the mediocre life of a modest little gentleman. Mediocrity does not have the right to exist.

Think about this, my friend. Perhaps my language is overly brutal—but times like these are not for beating around the bush.

Monsieur Rebeyrol and Docteur Laugier want to do a big exhibition of my work in Paris soon, which I consider a great honor.[4]

I have already asked Zervos and Pierre Matisse—and now I ask you as well—to come to an agreement with our friends, since I want to stay out of this completely. Monsieur Rebeyrol will give you my perspective on the question. Assuming it works out, we will try to arrange for you and Matisse to handle the commercial end—and for the name, Galerie Pierre, which has already had such an important history, to play a significant moral role.

Allow me to tell you that I *believe*—from what I feel in the air— that this is the precise moment when my work should be launched in a truly serious way.

Obviously, you cannot commit yourself now, since you have not seen the work I have done during the past few years.

As soon as I get back to Barcelona, I will take care of organizing my trip to Paris and sending all the material there.

Pierre Matisse has cabled me, saying that he will come to see me soon. I am expecting him any day. He can talk to you about me and all the things I will be showing him, and you will have a better idea of what is involved. He also asked me to tell you how happy he will be to resume his old association with you.

VI

Barcelona and
Montroig, 1947–54

30

Interview. *Possibilities* (Francis Lee), 1947–48[1]

Despite regular exhibitions at the Pierre Matisse Gallery in New York from the early 1930s onward, Miró's real American following did not begin until the 1940s and was probably triggered by his first museum retrospective held at the Museum of Modern Art, New York, in 1941–42. In 1947, the artist spent nine months in New York, preparing a large mural painting for the Cincinnati Hilton Hotel.[2] This experience was extremely important for him, as it was his first attempt to create a piece of public art. It also put him in contact with another culture, another urban landscape, and with younger artists who had other goals and came from different traditions. Later he would say that his American experience had a liberating effect on his art (See Text 47, page 279).

The following interview, conducted in New York, shows Miró at his most pragmatic. Although few new insights are provided by this text, it is interesting to hear Miró expressing himself in a new, unfamiliar context.

"INTERVIEW WITH MIRÓ," BY FRANCIS
LEE. IN *POSSIBILITIES* (NEW YORK),
WINTER, 1947–48

FRANCIS LEE: Do you like to read, Monsieur Miró?

JOAN MIRÓ: Yes, but only for short periods—15 or 30 minutes at a time, rarely more. My favorites? The poets—the pure poets—Rimbaud, Jarry, Blake, and the mystics.

F.L.: Do you ever read novels or stories?

MIRÓ: Very seldom. But when I do it's crime stories. Georges Simenon,[3] Fantomas,[4] etc.

F.L.: When you don't feel like painting, what do you usually do?

MIRÓ: But I always feel like painting! If I don't paint, I worry, I become very depressed, I fret and become gloomy and get "black ideas" and I don't know what to do with myself.

F.L.: Generally speaking, what is your daily schedule of painting?

MIRÓ: Well, here in New York I cannot lead the life I want to. There are too many appointments, too many people to see, and with so much going on I become too tired to paint. But when I am leading the life I like to in Paris, and even more in Spain, my daily schedule is very severe and strict and simple. At 6:00 A.M. I get up and have my breakfast—a few pieces of bread and some coffee—and by seven I am at work. I paint straight through from 7:00 A.M. until noon. At 12:00 I take physical exercise for half an hour. Something violent, like running or boxing. Then lunch; food, well prepared, but in small quantities. After that a cup of coffee and three cigarettes; no more, no less. Then a siesta of exactly five minutes, never more. By this time it is 2:00 P.M. and that is the hour when I take a walk or meet friends or attend to business, etc., etc. By 3:00 I am at work again and paint without interruption until 8:00 P.M., at which time I have dinner. After dinner I like to listen to music or sometimes I read.

F.L.: What music do you like?

MIRÓ: The classics and swing music both. The classics—Bach, Mozart, Beethoven, and the modernists—De Falla, Stravinsky, Ravel, etc. And I adore your swing music.

F.L.: Do you paint also on Sundays?

MIRÓ: No, Sunday for me is a day of repose. I spend most of my time eating and sleeping and after dinner a liqueur and a small cigarillo.

F.L.: Can you paint better in Paris, Spain, or New York?

MIRÓ: Spain. I can concentrate more in my place in the country where I am never disturbed. Secondly, in Paris; but even in Paris there are distractions. In New York, my life is not the same. There are so many appointments and so many people to see. I have finally solved the problem and at present I am working hard.

F.L.: Do you miss the stimulation of Paris?

MIRÓ: Yes. I must go there.

F.L.: When in Paris, do you have much of a social life? Openings, parties, etc.?

MIRÓ: Merde! I absolutely detest openings and nearly all parties! They are commercial, "political," and everyone talks so much. They give me the "willies." No, when I am in Paris, I lead a more or less isolated life.

F.L.: When you started in Paris, in the early days, did Picasso help you out?

MIRÓ: Yes, very much. He encouraged me, and we are the best of friends.

F.L.: It is said that you once refused to take part in an exhibition of abstract painting in Paris. (The "Abstraction-Creation" group.)

MIRÓ: Yes, that is true. It was because their aims were too limited.

F.L.: I suppose you have been to the Metropolitan Museum of Art in New York. I have often wondered who your favorite old masters or schools of painting are?

MIRÓ: My favorite schools of painting are as far back as possible: the cave painters—the primitives. To me the Renaissance does not have the same interest. But I have a great respect for the Renaissance. In the work of Leonardo da Vinci I think of the "esprit" of painting. And in the work of Paolo Uccello, it is the plasticity and structure which interest me. This I think happens often in painting. Some painters are better for the spirit and the force they represent. And other painters one likes because they are better as painters. With me, I find that I like Odilon Redon, Paul Klee, and Kandinsky for their "esprit." As pure

painting—from the point of view of plasticity—I like Picasso or Matisse. But both points of view are important.

F.L.: Today there are many kinds of painting. In the older epochs, the Egyptian, the Greek, the Renaissance, there was more or less one kind of painting in each period. Why is that?

MIRÓ: There are always different kinds of painting in an epoch. What we see in the museums today is only the résumé of what has come through all the others.

In a period of transition (like the present), where there are many different efforts and views, one finds many trends in art. It is for this reason that I isolate myself from others in order to see clearly. I regard the past and I work with the future in mind as well.

F.L.: What do you think is the direction that painting ought to take?

MIRÓ: To rediscover the sources of human feeling.

F.L.: Why is painting so esoteric today?

MIRÓ: We live in a period of transition. It is necessary to make a revision of everything that has been done.

F.L.: How do you like the painting in America? I mean the younger, forward-looking painters.

MIRÓ: Yes, I understand. I admire very much the energy and vitality of American painters. I especially like their enthusiasm and freshness. This I find inspiring. They would do well to free themselves from Europe's influence.[5]

F.L.: Do you think America will influence you?

MIRÓ: Yes, very much so. Especially as force and vitality. To me the real skyscrapers express force as do the pyramids in Egypt.

F.L.: Are there any things here that have especially impressed you or that you like?

MIRÓ: Yes—the sports! I have a passion for baseball. Especially the night games. I go to them as often as I can. Equally with baseball, I am mad about hockey—ice hockey. I went to all the games I could this year.

F.L.: In our present society, what do you think is the place of art?

MIRÓ: To liberate society from its prejudices—so that feeling and sentiments may be freshened.

F.L.: And as a last question, Monsieur Miró, what advice would you give to a young painter?

MIRÓ: Work hard—and then say, nuts.[6]

31

Interview. *Partisan Review* (James Johnson Sweeney), 1948[1]

James Johnson Sweeney, who in 1941–42 organized Miró's first museum retrospective at the Museum of Modern Art in New York, met Miró in 1927 at the Galerie Pierre. Sweeney, who aspired to be a poet and accompanied Miró to poetry readings,[2] was singularly qualified to understand Miró's stated objectives: to go beyond painting and achieve poetry.

By the time of this interview, the myth of Miró's primitivism had taken its hold on the public's imagination. Sweeney's preliminary comments (not published here) attempted rigorously to define the term *primitivism* in relation to Miró's art, as well as to present a truer understanding of the artist's creative process and his iconography. To illustrate his premises, Sweeney drew Miró into a discussion of specific works, techniques, and preferred motifs. Miró, speaking to an old friend and kindred spirit, was open and precise in his comments. The result is one of the most detailed descriptions of his process and aspirations.

"JOAN MIRÓ; COMMENT AND
INTERVIEW," BY JAMES JOHNSON
SWEENEY. IN *PARTISAN REVIEW* NEW
YORK, FEBRUARY 1948

JOAN MIRÓ:* For me a form is never something abstract; it is always a sign of something. It is always a man, a bird, or something else. For me painting is never form for form's sake.

In my early years I was an extreme realist. I worked constantly at realistic painting up to *The Farm*.[3] Even that painting which I made in Paris to keep me in touch with Montroig was so dependent on reality I used to go out to the Bois de Boulogne to pick twigs and leaves to use as models for the plants and foliage in the foreground. The picture represents all that was closest to me at home, even the footprints on the path by the house. It was Montroig in Paris. I am very much attached to the landscape of my country. That picture made it live for me.

Besides this, *The Farm* is a synthesis of much that went before. I had always admired the primitive Catalan church-paintings and the gothic retables. An essential factor in my work has always been my need of self-discipline. A picture had to be right to a millimeter—had to be in balance to a millimeter.[4] For example in painting *The Farmer's Wife*,[5] I found that I had made the cat too large: it threw the picture out of balance. This is the reason for the double circles and the two angular lines in the foreground. They look symbolic, esoteric: but they are no fantasy. They were put in to bring the picture into equilibrium. And it was this same need that had forced me the year before to sacrifice reality to some degree in *The Farm*: the smooth wall had to have the cracks to balance the wire of the chicken coop on the other side of the picture. It was this need for discipline which forced me to simplify in painting things from nature just as the Catalan primitives did.

Then there was the discipline of cubism. I learned the structure of a picture from cubism. . . .

And there was the influence of two early teachers: Urgell and Pasco. Urgell's was very important. Even today I recognize forms constantly appearing in my work that originally impressed me in his painting, though it is true Urgell was a romantic follower of Böcklin and saw

*The following remarks do not pretend to be verbatim, but are based on several formal and informal discussions with the artist.—Author's note.

things in a sad light while these forms in my work always take a gay character.

I remember two paintings of Urgell in particular, both character-ized by long, straight, twilit horizons which cut the pictures in halves: one a painting of a moon above a cypress tree, another with a crescent moon low in the sky. Three forms which have become obsessions with me represent the imprint of Urgell: a red circle, the moon, and a star. They keep coming back, each time slightly different. But for me it is always a story of recovering: one does not discover in life. . . .

Another recurrent form in my work is the ladder. In the first years it was a plastic form frequently appearing because it was so close to me—a familiar shape in *The Farm*. In later years, particularly during the war, while I was on Majorca, it came to symbolize "escape": an essentially plastic form at first—it became poetic later. Or plastic, first; then nostalgic at the time of painting *The Farm*; finally, symbolic.

Pasco was the other teacher whose influence I still feel. He was extremely liberal and encouraged me to take every liberty in my work. Color was easy for me. But with form I had great difficulty. Pasco taught me to draw from the sense of touch by giving me objects which I was not allowed to look at, but which I was afterwards made to draw. Even today, thirty years after, the effect of this touch-drawing experi-ence returns in my interest in sculpture: the need to mold with my hands—to pick up a ball of wet clay like a child and squeeze it. From this I get a physical satisfaction that I cannot get from drawing or painting. . . .

At the time I was painting *The Farm*, my first year in Paris, I had Gargallo's studio. Masson was in the studio next door. Masson was always a great reader and full of ideas. Among his friends were practi-cally all the young poets of the day. Through Masson I met them. Through them I heard poetry discussed. The poets Masson introduced me to interested me more than the painters I had met in Paris. I was carried away by the new ideas they brought and especially the poetry they discussed.[6] I gorged myself on it all night long—poetry princi-pally in the tradition of Jarry's *Surmâle*. . . .

As a result of this reading I began gradually to work away from the realism I had practiced up to *The Farm*, until, in 1925, I was drawing almost entirely from hallucinations. At the time I was living on a few dried figs a day. I was too proud to ask my colleagues for help. Hunger was a great source of these hallucinations. I would sit for long periods looking at the bare walls of my studio trying to capture these shapes on paper or burlap.

Little by little I turned from dependence on hallucinations to forms suggested by physical elements, but still quite apart from realism. In 1933, for example, I used to tear newspapers into rough shapes and paste them on cardboards. Day after day I would accumulate such shapes. After the collages were finished they served me as points of departure for paintings. I did not copy the collages. I merely let them suggest shapes to me.[7] . . .

Between the years 1938 and 1940 I once again became interested in realism. Perhaps the interest began as early as 1937 in *Still Life with Old Shoe*.[8] Perhaps the events of the day, particularly the drama of the war in Spain, made me feel that I ought to soak myself in reality. I used to go every day to the Grande Chaumière to work from a model. At the time I felt a need to control things by reality.

This realistic discipline gave me the strength to take a fresh stride—much as the discipline of cubism had given me the courage earlier. . . .

At Varengeville-sur-Mer, in 1939, began a new stage in my work which had its source in music and nature.[9] It was about the time that the war broke out. I felt a deep desire to escape. I closed myself within myself purposely. The night, music, and the stars began to play a major role in suggesting my paintings. Music had always appealed to me, and now music in this period began to take the role poetry had played in the early twenties—especially Bach and Mozart when I went back to Majorca upon the fall of France.

Also the material of my painting began to take a new importance. In watercolors I would roughen the surface of the paper by rubbing it. Painting over this roughened surface produced curious chance shapes. Perhaps my self-imposed isolation from my colleagues led me to turn for suggestions to the materials of my art. First to the rough surfaces of the heavy burlap series of 1939; then to ceramics—

Nowadays I rarely start a picture from a hallucination as I did in the twenties, or, as later, from collages. What is most interesting to me today is the material I am working with. It supplies the shock which suggests the form just as cracks in a wall suggested shapes to Leonardo.

For this reason I always work on several canvases at once. I start a canvas without a thought of what it may eventually become. I put it aside after the first fire has abated. I may not look at it again for months. Then I take it out and work at it coldly like an artisan, guided strictly by rules of composition after the first shock of suggestion has cooled.

—Then after the heavy burlap series of 1939 I began a group of

gouaches which were shown here in New York at the Pierre Matisse Gallery just after the war—an entirely new conception of things. I did about five or six of them before I left Varengeville for Spain and Majorca at the fall of France. There were twenty-two in all in the series.[10] They were based on reflections in water. Not naturalistically—or objectively—to be sure. But forms suggested by such reflections. In them my main aim was to achieve a compositional balance. It was a very long and extremely arduous work. I would set out with no preconceived idea. A few forms suggested here would call for other forms elsewhere to balance them. These in turn demanded others. It seemed interminable. It took a month at least to produce each watercolor, as I would take it up day after day to paint in other tiny spots, stars, washes, infinitesimal dots of color in order finally to achieve a full and complex equilibrium.

As I lived on the outskirts of Palma I used to spend hours looking at the sea. Poetry and music both were now all-important to me in my isolation. After lunch each day I would go to the cathedral to listen to the organ rehearsal. I would sit there in that empty gothic interior daydreaming, conjuring up forms. The light poured into the gloom through the stained-glass windows in an orange flame. The cathedral seemed always empty at those hours. The organ music and the light filtering through the stained-glass windows to the interior gloom suggested forms to me. I saw practically no one all those months. But I was enormously enriched during this period of solitude. I read all the time: St. John of the Cross, St. Teresa, and poetry—Mallarmé, Rimbaud. It was an ascetic existence: only work.

After having finished this series of paintings in Palma, I moved to Barcelona. And as these Palma paintings had been so exacting both technically and physically I now felt the need to work more freely, more gaily—to "proliferate."

I produced a great deal at this time, working very quickly. And just as I worked very carefully in the Palma series which had immediately preceded these, "controlling" everything, now I worked with the least control possible—at any rate in the first phase, the drawing. Gouaches: in pastel colors, with very violent contrasts. Even here, however, only the broad outlines were unconsciously done. The rest was carefully calculated. The broad initial drawing, generally in grease crayon, served as a point of departure. I even used some spilled blackberry jam in one case as a beginning; I drew carefully around the stains and made them the center of the composition. The slightest thing served me as a jumping off place in this period.

And in the various paintings I have done since my return from Palma to Barcelona there have always been these three stages—first, the suggestion, usually from the material; second, the conscious organization of these forms; and third, the compositional enrichment.

Forms take reality for me as I work. In other words, rather than setting out to paint something, I begin painting and as I paint the picture begins to assert itself, or suggest itself under my brush. The form becomes a sign for a woman or a bird as I work.

Even a few casual wipes of my brush in cleaning it may suggest the beginning of a picture. The second stage, however, is carefully calculated. The first stage is free, unconscious; but after that the picture is controlled throughout, in keeping with that desire for disciplined work I have felt from the beginning. The Catalan character is not like that of Malaga or other parts of Spain. It is very much down-to-earth. We Catalans believe you must always plant your feet firmly on the ground if you want to be able to jump up in the air. The fact that I come down to earth from time to time makes it possible for me to jump all the higher.

Two letters to Gérald Cramer, 1948–49[1]

In March 1947, the Geneva-based publisher Gérald
Cramer wrote Miró in New York to ask him to
illustrate a bibliophile edition of Paul Eluard's
collection of poems, *A toute épreuve*, originally
published in 1930. Miró and Eluard had been close
friends since the early twenties in Paris. He was one
of the poets the artist admired most, and in 1942,
quite independently, he had imagined a collaboration
with the poet (see Text 28, page 194). Miró accepted
with enthusiasm.

Cramer's original proposal was followed by a
lengthy correspondence. Miró understood the project
as an opportunity to go beyond the traditional
concept of the illustrated book, evoking Mallarmé's
"Un coup de dès . . ." as a model.[2] Elsewhere he
evoked his admiration for Gaugin's wood-block prints.
Miró himself chose the wood-block technique as that
best suited to his ambitions, allowing different kinds
of textures, flat, broad gestures, and the introduction
of collagelike or assemblage techniques. Miró's stated
goal was to create an accompaniment, a visual poetry,
attentive to the rhythms, tones, and textures of the
written verse. The tenor of his commitment to the
project is visible in the following letters.

A toute épreuve finally appeared in a limited
edition of 130 copies on March 25, 1958, exactly
eleven years after the first exchange of letters. It is

considered one of the great poet-painter-publisher
collaborations of the twentieth century.
Unfortunately, Eluard, who died in 1952, did not see
it completed. In 1984, George Braziller, Inc.,
reprinted an unlimited facsimile edition with an
introduction by Anne Cushing.

TO GÉRALD CRAMER. BARCELONA,
JUNE 10, 1948

Thank you for the beautiful catalog that just arrived. The reproduction on the cover is very good; thank you also for all the care you took to accomplish this. The rest of the catalog is very elegant; all my congratulations.[3]

We will be arriving in Paris—all three of us[4]—next Thursday, and will be staying at the Hôtel Pont-Royal. I hope that I will have the pleasure of seeing you there.

New ideas are constantly occurring to me about the book. Walking through the woods a few days ago in Montroig, I thought of using the marvelous bark forms of the fir trees as a point of departure. I am exhausted physically and need a long stay in Montroig—with the concentration and calm I am able to get there to synthesize all these things and get to work.

The responsibilities involved in doing this book are immense. I hope you will not be angry with me over the delay in getting it out. This delay will be well worth it when you consider how much the quality will be improved. I have made some experiments that have allowed me to see what it means to *make* a book, as opposed to illustrating it, which is always a secondary thing. A book must have all the dignity of a sculpture hewn from marble.

For wood engraving, Gauguin is the only modern artist whose work I find acceptable. Not to brag, but my ambition is to go even further.

Until soon, then, I hope—with all my affectionate greetings,

 Miró

Long conversations with a friend who spent several years in Japan and who has done wood engravings himself have shown me the technical riches that can be obtained—with the preliminary preparations of the paper and the printing, quite apart from the method of engraving—and then adding them to the techniques of Western engraving, which can enrich the whole process.

<div align="center">

To Gérald Cramer. Barcelona (?),
October 2, 1949

</div>

I am extremely happy to tell you that the layout has just been finished. Several pages were set in various ways in order to reach a definitive solution. This was just as I had expected; I was already totally convinced that even the successful drawings would need changes—a simple comma on the preceding page or the dot over an *i* on the following page could destroy what I had done out of context. A book should be made with the exactitude and precision of a clock. I have always had total respect for your typography. I must congratulate you, both you and Eluard, for it is very successful—the idea of pages in color and pages of *rest* is very beautiful. . . . The journey we have made to get to a point of complete agreement among the three of us has been long and hard—which has only enriched the final result and made it more moving and powerful.

Miró

Interview. French National Radio (Georges Charbonnier), 1951[1]

Throughout the 1950s, the French critic Georges
Charbonnier had a regular radio program on which
he interviewed a large and diversified group of artists,
including Georges Braque, Max Ernst, Jacques
Villon, Francis Picabia, Alberto Giacometti, Henri
Matisse, and Fernand Léger. The following interview
was thus aimed at a large nonspecialized audience
and emphasized Miró's concerns in regard to a
publicly accessible art. By 1951, Miró had worked in
a broad range of manners and mediums. In addition
to his paintings and drawings, he had produced his
first ceramic and bronze sculptures and prepared large
mural paintings for semipublic spaces; and he was
working with Gérald Cramer on the woodblocks for
A toute épreuve. All these endeavors reflected his
ambition to reach a wider audience. And indeed,
both his tone and his focus in discussing his art
diverge sharply from the more personal
preoccupations found in the earlier texts and
interviews.

Although the emphases have shifted, Miró's
statements are nonetheless consistent with his earlier
declarations, in which he identified himself with
popular, anonymous artistic traditions and elemental
imagery. As early as 1938, he had stated that his
dream was to create forms of art that would be
accessible to a broad public (see text 23, page 162).
By 1951, this had finally been achieved.

INTERVIEW WITH GEORGES
CHARBONNIER. FRENCH NATIONAL
RADIO, 1951

GEORGES CHARBONNIER: You said something to me in a recent conversation that I found very striking: "This is where I've come to. To a place beyond easel painting."

"To a place beyond easel painting." What do you mean by that?

JOAN MIRÓ: That easel painting is an experimental thing. Valuable in itself, of course, but only as a kind of laboratory research. One must do it, but it must also lead us much further.

G.C.: Is it still necessary for artists to do easel painting, at least at a certain point in their lives?

MIRÓ: Not only useful, but indispensable. The young painter cannot avoid it without doing serious harm to himself; but the artist is a man who must go beyond the individualist stage and struggle to reach the collective stage. He must go further than the self—strip himself of his individuality, leave it behind, reject it—and plunge into anonymity.

G.C.: What do you hope for?

MIRÓ: I hope for a physical contact with people, with ordinary people, with all people.

G.C.: To the point of a collective art?

MIRÓ: To the point of a collective and anonymous art, as in the great periods of the past.

G.C.: Still, your paintings can be recognized at a single glance.

MIRÓ: Because I take off from a very direct thing. There's nothing intellectual about it.

G.C.: You have also said to me that the work of art should be anonymous because it should be integrated into the place where it is put.

MIRÓ: Architecture should be determined by the landscape, by the mountains that surround it, by the sea. It's impossible to create an architectural design by staying inside an office. The rhythm of the light and the surroundings are what determine the work.

In the same way, a mural painting is determined by the architecture, by the surfaces—the forms, the volumes, the surfaces—so that

there can be a complete fusion of landscape, architecture, and painting.

For that reason, it is a completely anonymous and impersonal work.

During great periods, it was always like this. The ancient frescoes were not signed by their creators. Neither were the pyramids.

G.C.: Granted. But let's consider another great period: that of Impressionism.

MIRÓ: Obviously, that was a completely individualist phenomenon. An individualist kind of painting. An individualist way of thinking on the part of the painters.

G.C.: Is it your taste for collective work that has led you to ceramics?

MIRÓ: Yes, because it allows me to work with other people, with artisans. Also, in ceramics the work I do is always determined by the material. When I worked with Artigas for the first time, I said to him: "You must not become Miró—but I, Miró, must become a ceramist."[2]

That was how we started.

G.C.: A collective effort is very frequently found in your art. The bronzes you recently exhibited are a good example.[3]

MIRÓ: Exactly, and in this particular case, working collectively made it possible for us to discover the secret of some very rare patinas—which are very close to those on antique Chinese bronzes.

G.C.: You said to me one day, "The material must be respected . . ."

MIRÓ: Obviously. You must have the greatest respect for the material. That is the starting point. It determines the work. It commands it.

G.C.: Max Ernst says that he "questions" the material.

MIRÓ: A dialogue exists, that's clear; a dialogue with the material begins. When you do ceramics, the material of the clay determines what must be done. It imposes its laws.

G.C.: It goes even further than that. When you prepare the illustrations of a book, for example, aren't these illustrations imposed on you by things other than the text?

MIRÓ: Of course. The typography, the layout, the white spaces. . . . The thing that must guide the artist determines—and I insist on the importance of this word—what he must do. The things I do are not at all haphazard. I work in a highly disciplined way. To repeat what I said a moment ago, I tell the lithographers the same thing I told Artigas:

"It's up to me to become a lithographer. Don't try to do what I do."[4]

G.C.: Let's get back to easel painting. You are in front of your canvas. How do you work? Do you begin with a blank canvas?

MIRÓ: No, never. I never use the kind of blank canvas that you buy in an art supply store. I provoke accidents, a form, a spot of color. Any accident is good.

In the beginning, it's a direct thing. It's the material that decides. I prepare the ground—by cleaning my brushes on the canvas, for example. Spilling a little turpentine can also work quite well. If it's a question of drawing, I crumple the paper. I wet it. The water traces a form.

G.C.: Are we to understand that how a work begins for you is unimportant? Would an arbitrary mark, a mark made by anyone be just as good?

MIRÓ: Yes. This mark determines what happens next. If *you* begin by painting, I will continue in paint. It's the medium that directs everything. I am against all intellectual research—anything that is preconceived and dead. The painter works like the poet: the word comes before the thought. You don't decide to write about the happiness of men! If you do, you're sunk.

Make a scribble. For me, it will be a point of departure, a shock. I attach great importance to the initial shock.

G.C.: Let's get back to collective work. You have a real taste for work done by several people. You collaborate with ceramists and artisans. However, when it comes to painting, you do not collaborate with anyone. Why? You don't have a school or a group of followers as painters used to have in the past. Why?

MIRÓ: Because that has become impossible!

G.C.: Why?

MIRÓ: Because the whole organization of society is based on individualism. Personally, I wish for the coming of an era when artistic production will be purely collective.

G.C.: This ideal existed in the past?

MIRÓ: Of course.

G.C.: How far back must we go? To the time of Rubens, for example?

MIRÓ: Much further than that! We must go back to the sources of

expression to recover the collective spirit.[5] When you talk about Rubens, that's already painting.

G.C.: You think that art must be anonymous in order to return to its deep sources, but does that mean the artist must renounce his personality and origins?

If I understand you correctly, the artist must renounce his individualism, but must he renounce his origins? You told me one day that he must "put down roots."

MIRÓ: Roots in his own soil. Roots in the earth. And by earth I am not referring to one's country in any nationalistic sense. I'm talking about the earth where trees and flowers and vegetables grow. These roots must grow deeper each day.

G.C.: This common basis of art that you will reach by renouncing your personality—you can get to it only by setting down deeper and deeper roots?

MIRÓ: That's it.

G.C.: A Mexican should do Mexican art, a Spaniard should do Spanish art.

MIRÓ: A Mexican should not try to become a Frenchman. He should be what he is—but in a universal way, obviously. It should be a liberation.

G.C.: These views have certainly led you to place great importance on folk art and the products of folk art.

MIRÓ: An enormous importance. A saucer made by peasants, a bowl for eating soup—for me, these things as just as wonderful as a Japanese porcelain that you find in museums.

G.C.: But the object that is used in daily life does not have an arbitrary form!

MIRÓ: Of course not. It has a form determined by the needs and the form of the human body. That's what makes it beautiful. It's exactly like architecture, which is determined by the landscape. In my house, I have only ordinary things, things you can buy for almost nothing. A wooden spoon for taking olives out of the jars used by peasants.

G.C.: This taste for the object leads us to sculpture.

MIRÓ: Directly.

G.C.: Therefore, you sculpt.

MIRÓ: Obviously.

G.C.: How is one led to sculpture?

MIRÓ: Through a very direct contact with the earth, with the pebbles, with a tree. When I'm living in the country, I never think about painting anymore. It's sculpture that interests me. For example: it rains, the ground gets wet, I pick up some mud—it becomes a little statuette. A pebble might determine a form for me. Painting is more intellectual. It's for the city.

G.C.: You sculpt, you shape. I'm repeating your terms. you never use the word *carve*.

MIRÓ: No, because it's less direct, more cerebral. If I shape a bit of potter's clay, I begin with my thumb—it bears the mark of my thumb.

G.C.: At this very moment, you are gesturing as you speak.

MIRÓ: A very Latin kind of behavior. The important thing is the sensation of touching the clay.

G.C.: So, you prefer a material that can be shaped directly, as opposed to plaster, which can later be cast.

MIRÓ: Plaster is a colder, deader thing.

G.C.: You have just finished a sculpture. But this sculpture is destined to occupy a certain place. It must hold up. How do you know that it will hold up?

MIRÓ: A sculpture must stand in the open air, in the middle of nature. It should blend in with the mountains, the trees, the stones; when put together, all these elements must form a whole.

G.C.: Even an insect . . .

MIRÓ: Even an insect that lands on the sculpture. This insect or this spider, this bird or this butterfly must become a part of the work.

G.C.: It's camouflage.

MIRÓ: It's camouflage . . .

G.C.: To the point of identification . . .

MIRÓ: With nature. If you fly over this sculpture in an airplane, it must blend in completely with its surroundings.

G.C.: Therefore, it need not be representative.

MIRÓ: The only necessary thing is that it be determined by nature. This was not the case with Donatello, for example, whose sculptures were made to be shut up indoors! When you're sculpting, therefore, you must not imitate or interpret, not even in a very liberal way.

G.C.: All the more reason to avoid expressionism of any kind.

MIRÓ: Of any kind.

G.C.: All manual acts interest you very much.

MIRÓ: I attach greater and greater importance to them. Which has led me naturally to lithographs and woodcuts.

G.C.: What is the difference for you between these two modes of expression?

MIRÓ: Lithography is more or less a new drawing technique—using different processes—but it is still a question of line, color, and ink mixed with water—whereas wood-block printing is much more direct. You take a piece of wood. You begin to carve with the burin . . .

G.C.: And this time you use the word *carve*.

MIRÓ: The wood requires the act, hence the word.

G.C.: But here we are entering the domain of sculpture again.

MIRÓ: Absolutely. A woodblock is similar to a carved bas-relief.

G.C.: One thing strikes me. You give poetic titles to your paintings, but not to your sculptures. Why?

MIRÓ: Because a painting is a more lyrical thing than a sculpture. A sculpture is more concrete. It is in nature.

G.C.: We have moved from painting to related activities and from there we have been led quite naturally to sculpture. I believe that we could also go to music. I repeat your words: you said that a painting was a musical and poetic rhythm and that you made no distinction between the poet, the musician, and the painter.

MIRÓ: Everything can be put into a painting.

G.C.: But if you make no distinction between the poet, the musician, and the painter, then we come to another form of creation: ballet.

MIRÓ: Certainly. Ballet interests me very much. I did *Jeux d'enfants*,[6]

and I hope to have a chance to do others. Ballet is a way of entering—and I am very keen on this—into direct physical contact with the public. I would like to write the story myself. And I would choose Béla Bartók or Schönberg as the composer. In fact, ballet is a perfect example of what collective art is.

G.C.: To ensure this contact between artist and public, it seems to me that the best method is to put works of art in the home, where people live.

MIRÓ: Certainly. Also, I dream of introducing ceramics into architecture. It is done in Brazil, for example, in very sunny countries where the light plays on the ceramics. It is also done in Portugal.[7]

G.C.: But it's not enough to put the work of art on the outside of the house; it must be brought inside as well. The question then comes up: if the work of art is unique, how can it be put into many houses? Would the problem be solved if one could reproduce a painting so perfectly that the copy could not be distinguished from the original?

MIRÓ: I am against the reproduction of paintings. I believe that a painting must remain a unique object.

G.C.: Why?

MIRÓ: Because a reproduction is a dead object. You can't imitate the texture of canvas.

G.C.: And if you could?

MIRÓ: It will never happen. In any case, it would turn the painting away from its goal. We must not forget that a painting is the manifestation of an individual. It, too, bears the mark of the thumb, the human mark that can never be replaced by a machine. Never.

G.C.: Must one therefore give up the idea of getting painting to a very large audience?

MIRÓ: One should never give up. I suggest the solution of color prints. You can make a million copies. There is nothing dead or artificial about that. If you make large editions, the cost per print becomes very low.

G.C.: One of the obvious difficulties to overcome in educating the public about art is the price of paintings. They cost too much to be within the means of most people. Paintings are bought by collectors, or else by museums, where they are put side by side and cancel each other out.

MIRÓ: The solution is therefore large editions of color prints.

G.C.: I mentioned the problem of getting artworks into people's homes because your art is optimistic. A painting by Miró makes us feel joy.

MIRÓ: Yes, but my nature is actually pessimistic. When I work, I want to escape this pessimism.

G.C.: The Spanish temperament is naturally dramatic.

MIRÓ: One mustn't confuse the Castillian or Andalusian temperament with the Catalan temperament—which is completely different. I am a Catalan.

G.C.: A canvas by Picasso is dramatic. A canvas by Miró evokes humor.

MIRÓ: Because it's Catalan.

G.C.: How can you conquer this optimism?

MIRÓ: By making fun of my figures. By making fun of man—that ᵣ marionette who must never be taken too seriously.

Interview. *Correo literario* (Rafael Santos Torroella), 1951[1]

Rafael Santos Torroella, a Catalan art historian and critic, was the director of the publishing house Cobalto in Barcelona in the 1940s. In 1949, he published an important monograph on Miró (written by J. E. Cirlot) and a special issue of his magazine *Cobalto* in homage to Miró. He also organized an exhibition of the artist's works from Barcelona collections. This show at the Galerias Layetanas was Miró's first exhibition in Spain since 1918.

Miró gave few interviews in Spain during the Franco years. He preferred to have a more subtle subversive effect by exhibiting his works abroad and thus emphasizing the artistic freedoms that existed in other countries. His encouragement to younger artists to go abroad may have been a veiled reference to the situation at home. Since many Spanish artists refused to exhibit in Spain, or else were prevented from doing so, exile offered their only hope for exposure and recognition.

This text also includes Miró's first written expression of admiration for Mondrian, despite his antagonism for geometric abstraction in general. It was Mondrian's authenticity in relation to the natural and cultural milieu of his origins that made his art acceptable to Miró.

"Miró Advises Our Young Painters," by Rafael Santos Torroella. In *Correo Literario* (Barcelona), March 15, 1951

RAFAEL SANTOS TORROELLA: I'd like to ask you to give some advice to young Spanish painters. They've come to their art in the midst of very hard times. What would you advise them?

JOAN MIRÓ: First and foremost, they should keep their sense of Spanishness and they should be sincere. If they have to look to some kind of art, they should look to our great Romanesque painting. What's a Monet, for instance, have to do with the intensity of those painters, the purity of their artistic intentions? He who wants to really achieve something has to flee from things that are easy and pay no attention at all to this artistic bureaucracy, which is completely lacking in spiritual concerns. What is more absurd than killing yourself to copy a highlight on a bottle? If that was all painting was about, it wouldn't be worth the effort.

R.S.T.: What about abstract art then?

MIRÓ: No. This is not the way to spiritual freedom. You don't gain even a centimeter of freedom from art that's governed by cold formulas.[2] You only get your freedom by sweating for it, by an inner struggle.

R.S.T.: Then you don't think there's any justification for this stylistic tendency?

MIRÓ: As a general trend, no. But you've got to make an exception for someone like Mondrian. His work is so genuine that I consider it very important. Deep down, his painting is very Dutch. I mean, it's directly inspired by the atmosphere of the country. When you go to Holland you really understand this.[3] There was a big Vermeer show in Paris recently, and I realized then that Mondrian's work has much the same spirit.

R.S.T.: Is Spanish art still as prestigious as ever abroad?

MIRÓ: Yes. There's a sort of reaction against Picasso right now, but it's unjust. As individual painters, though, the Spaniards are still the most important.

R.S.T.: Well, then, how do you explain the fact that they only manage to succeed when they leave the country?

MIRÓ: Maybe because it forces them to eliminate a superficial provincialism. Distances no longer exist today. The documentary aspect of art is of no interest. You have to be universal, not boxed in by some narrow outlook.

R.S.T.: I know that you're an avid reader of poetry, that that's practically all you read. Can you tell me your favorite poets?

MIRÓ: The Spanish mystics. Saint John of the Cross and Saint Teresa.[4]

R.S.T.: Do you think they influence your work?

MIRÓ: It's possible, but not directly; more as a consequence of the spiritual tension they produce in me.

Poem-titles, 1948–55[1]

Miró's use of evocative poetic titles became more systematic in the late forties and early fifties. As we have seen, in the late twenties and throughout the thirties—those years immediately following his poem-paintings—the artist shunned titles almost completely (see Text 16, page 124). The Constellations of 1940–41 marked the beginning of the use of long poetic titles as an accompaniment, like words to music, perhaps inspired by the poetry the artist had been writing in the late 1930s or perhaps inspired by music itself. But otherwise, Miró's titles throughout the years remained relatively matter-of-fact: *Painting*, *Woman and Birds*, and so on.

In the late forties, Miró showed a new interest in titles conceived as distinct poetic phrases. Again it would seem that Miró felt the need for a verbal accompaniment so that his motifs would be taken not at face value but as allusive poetic images.

Although most of the poem-titles in this book have been assembled from various sources, the titles from 1951–52 were copied from a single ledger in which Miró listed the paintings executed during those years.[2]

POEM-TITLES, 1948–55

1948

The Red Sun Gnaws at the Spider
The Diamond Smiles at Twilight

1950

The Bird Flies Off to the Zone Where Down Grows on the Gold-Ringed Hills

1951

The Mauve of the Moon Covers the Green of the Frog
The Bird-Rocket Aims at the Pitchfork Skidding down the Cascade toward the Black Dot
The Red Fishbone Pierces the Blue Feathers of the Bird with the Pale Beak
Bird Encircling the Poet's Thought with Sparkling Gold
Sunbursts Wound the Late Star
Dragonfly with Red-Tipped Wings in Pursuit of a Snake Spiraling toward a Comet-Star

1952

The Boom Boom Bird Makes His Appeal to the Onion Skin Head
Jasmines Scent the Girl's Dress with Their Golden Perfumes
The Bird with a Calm Look, His Wings in Flames
Catalan Peasant Disturbed by the Passage of a Swarm of Birds
The Stem of the Red Flower Grows toward the Moon
Girls Using a Dress with Dark Rectangles to Cover Their Transparent Nakedness at Dawn
The Rainbow of the Beautiful Bird's Feathers Reaches the Horizon

And the Bird Flees toward the Pyramids with Sides Bloodied by
the Fall of Rubies

Lady with a Spiral Hat in the Night

The Sun Hugs the Man in Love

The Swirls of Mustaches Facing Birds in Flame

The Bird Unfolds His Beautiful Plumage

The Song of the Blue Moon to a Green Dress with Yellow Sparks

The Bird Escapes into the Deep Blue

The Bird Spreads His Wings to Adorn the Stars with His Feathers

The Setting Sun Caresses Us in the Moonlight

1953

The Bird Dives toward the Lake in Which Stars Are Reflected

Rhythm of the Passing Snake Carried Along by the Blowing of
Hair Let Down at Night

Dawn Perfumed by a Shower of Gold

Eyes Fixed on the Ladder Climbing to the Magic Arc of Bird-
Arrows

The Eagle Flies toward the Summit of Mountains Hollowed by
Comets to Announce the Poet's Word

1954

Night Rises to the Rhythm of Dawn Pierced by the Gliding of the
Snake

The Half-Open Sky Brings Us Hope

1955

A Swallow Plays the Harp in the Shadows of Dandelions

Letter to James Thrall Soby, 1953[1]

The following letter to James Thrall Soby, art historian and director of the Department of Painting and Sculpture at the Museum of Modern Art, New York, in the 1950s (where he organized Miró's second New York retrospective exhibition in 1959), contains the artist's sentiments about *Still Life with Old Shoe* of 1937—some sixteen years after it was painted.[2] It is interesting to compare the artist's comments here with those he made at the time he was painting it (see Text 20, page 146–47).

In Miró's own words, the works from this period of the thirties expressed his need to return to a more concrete relationship to reality, despite the brutal distortions, strident palette, and symbolism described below.

To James Thrall Soby. Barcelona, February 3, 1953

Through our mutual friend Thomas Bouchard[3] I was pleased to hear that you are well.

He also told me about your new apartment and the way you have hung my paintings; I want to tell you that I am honored and touched. In your collection you have my painting *Still Life with Old Shoe*. I attach great importance to this piece, as it represents a unique phenomenon in my painting career. This painting was done when I was in France at the height of the Spanish civil war. Despite the fact that while working on the painting I was thinking only about solving formal problems and getting back in touch with a reality that I was inevitably led to by current events, I later realized that without my knowing it this picture contained tragic symbols of the period—the tragedy of a miserable crust of bread and an old shoe, an apple pierced by a cruel fork and a bottle that, like a burning house, spread its flames across the entire surface of the canvas. All this, as I said, without the slightest conscious thought, and entirely devoid of any narrative or literary intentions, confining myself solely to the eternal and human laws of art.

My *Self-portrait* was done in the same way—by going beyond mere physical resemblance toward a poetic unfolding.[4]

Interview. *L'oeil* (Rosamond Bernier), 1956[1]

In the spring of 1956, the Galerie Maeght in Paris
opened a large exhibition of the ceramics that Miró
had just completed in Gallifa[2] with Llorens Artigas.
Miró had already worked with Artigas in 1944–45,
but the initial results of this collaboration were
considered somewhat experimental. Consistent with
his ambitions to go beyond the traditional parameters
of any given medium, Miró in 1953 approached
Artigas once again, and over the next three years the
two conceived and executed 232 ceramic sculptures.
Miró's objective was to create entirely new forms,
inspired by the natural surroundings and produced in
materials that would appear natural and primitive,
rather than manmade. Artigas, a renowned master
and connoisseur of all aspects of the potter's craft,
served as his mediator, inventing and reinventing new
mediums for his ideas.

 In the following written interview with
Rosamond Bernier, the Paris-based American art
critic, Miró discussed the series with characteristic
circumspection.

"MIRÓ AS CERAMIST," BY ROSAMOND
BERNIER. IN *L'OEIL* (PARIS), MAY 1956

JOAN MIRÓ: I was very happy to hear from you and very happy to know that you will be publishing this report on our ceramics in your magazine, which is such a lively and intelligent publication.

ROSAMOND BERNIER: When did you begin doing ceramics?

MIRÓ: In 1945. As far back as 1922 I did some sculptures directly inspired by natural elements on my farm in Montroig near Tarragona. A few years later, they were molded in plaster, and this served as a starting point for some ceramics. The power of that particular landscape, devoid of any descriptive anecdote, has always been a crucial element in my thinking about art and poetry.

R.B.: Can you give us an idea of the landscape and the studio in which you did the series of ceramics you have just completed?

MIRÓ: It is a rocky, powerful landscape: the mountains are shaped like those of Montserrat,[3] a place that has always haunted me; it has the same vinegar-red mountains. Before beginning work on the ceramics, I sometimes painted directly on the enormous rocks—in order to enter this landscape and put my mark on it.

We worked in Artigas's studio, which is a true *artisan's* studio. It's very rudimentary, without the slightest trace of industrialization.

R.B.: What materials did you use for your ceramics?

MIRÓ: Traditional materials, mostly: chamotte, sandstone clay, faience, lead glaze, pewter enamel, metallic oxides.

R.B.: Were you limited by ceramic techniques or could you use all the colors you wanted?

MIRÓ: In some pieces I used a very limited range of colors—which made them all the more powerful and expressive—but in other pieces I let myself go and used all the techniques and colors according to where the work was taking me—completely ignoring questions specific to the "craft."

R.B.: Do the themes and materials of your ceramics reflect the landscape where they were made (rocks, mountains, vegetation)?

MIRÓ: Yes, very much so. I experimented with putting them outside in

the middle of nature: they blended in completely with the land'scape. When we put a realist painting in among the mountains, however, it was a dismal failure.

R.B.: How long does it take to do a piece of pottery from beginning to end?

MIRÓ: That depends, and it's difficult to say, since we often work on several pieces at once. Artigas does his preparatory work, and then I do mine, and then there is the firing, the enameling, and the decorating, and this can mean several days on a single piece. Other pieces are done very quickly, but they often require a great deal of concentration and meditation beforehand.

R.B.: How many pieces are in your last series, and how long did it take to do them?

MIRÓ: There are about 200 pieces in this series. Artigas and I talked about it for a long time, and we began work in 1953. As early as 1948, I had been thinking about it on my own, imagining all the possibilities.

R.B.: Did you participate directly in making the ceramics?

MIRÓ: I followed the work constantly and directly from beginning to end. Nothing was drawn in advance, but all the pieces were thrown according to my instructions and were based on traditional and classic forms, in the same way that I make use of traditional formats when doing my painting.

R.B.: Exactly what are these ceramics?

MIRÓ: There are all sorts of things: sculptures, plates, pebbles, engraved stones, little objects, architectural ceramics, tiles, compositions, assemblages, eggs, circles, stones, vases.

R.B.: Is the folk art of Catalonia an inspiration to you?

MIRÓ: Yes, folk art from Catalonia and everywhere else as well. Human roots spring from the same sources on this planet.

R.B.: In the photos there are forms that seem to resemble gourds. Are these real gourds that have been painted or gourds made out of clay? Other pieces look like stone plaques with marks made by fossilized plants.

MIRÓ: They're all made out of sandstone or chamotte that has been enameled and painted; each one has been worked on and composed.

You can't work with stones and bake them: they split in the fire. There were stones in the countryside bearing the marks of fossils, and these were an inspiration to me and served as a point of departure for certain pieces.

R.B.: Weren't stones and other materials embedded in the glaze to vary the surface?

MIRÓ: No. All the materials used in my ceramics are executed in the same medium. The added materials were also ceramic, a noble material. The technique was always determined by the material, and elements were added to attain even greater expressive force.

R.B.: How is this group of works different from other ceramics you have done in the past?

MIRÓ: They seem more powerful to me, enriched by my experiences as a man and a painter.

R.B.: Would you like to describe some of the pieces you are particularly fond of?

MIRÓ: It is always the most recent one that excites me the most, the one just coming out of the kiln. Some of these new ceramics are very big. I worked in a monumental spirit, dreaming about a possible connection with architecture. It would be a way of ennobling large apartment buildings—of refusing to treat the people who have to live in them like insensitive robots.

VII

Palma de
Majorca, 1957–78

Statement. *XXe siècle*, 1957[1]

In 1955, while Miró was working with Artigas on a large series of ceramic sculptures (see Text 37, pages 233–36), he was invited by UNESCO to design two walls for the organization's new headquarters in Paris. Miró proposed two ceramic walls on the themes of the sun and the moon. His points of reference, typically, were the prehistoric cave paintings at Altamira, the Romanesque frescoes of his native Catalonia, and Antoni Gaudí's Park Güell in Barcelona. The first two were executed by anonymous hands, which naturally appealed to Miró; and all three were created for a broad undetermined public.

Statement. In *XXe siècle*
(Paris), June 1957

The real life of a man, the one that others know, is not a man's true reality. That is an image that people make of him. The real Miró is as much the person I am, the person I know inside myself, as the one I have become for others, and perhaps even for me. Is it not the essential self in the mysterious light that emanates from the secret source of one's creative work—the thing that finally becomes the whole man? His true reality is there.

It is a deeper, more ironical reality, indifferent to the one before our eyes; and yet, it is the same reality. It need only be illuminated from below, by the light of a star.

Then everything becomes strange, shifting, clear and confused at the same time. Forms give birth to other forms, constantly changing into something else. They become each other and in this way create the reality of a universe of signs and symbols in which figures pass from one realm to another, their feet touching the roots, becoming roots themselves as they disappear into the flowing hair of the constellations.

It is like a secret language made up of magic phrases, a language that comes before words themselves, from a time when the things men imagined and intuited were more real and true than what they saw, when this was the only reality.

23 Miró watching the Flamenco dancer "La Chunga," ca.1950.

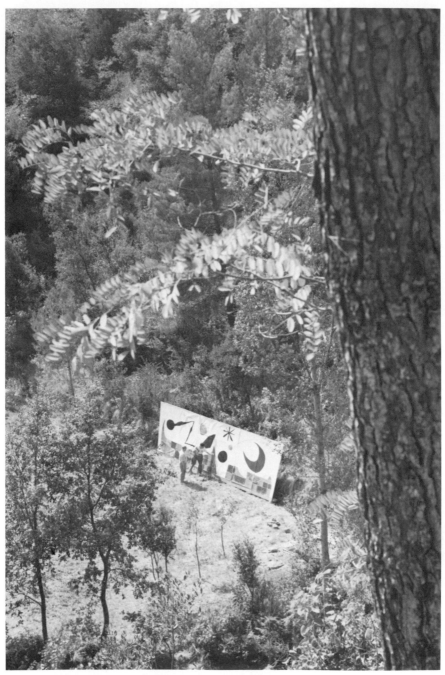

24 Miró working on UNESCO walls, La Gallifa, 1956.

25 Facing page: Miró retouching *Blue II*, Galerie Maeght, Paris, 1961.

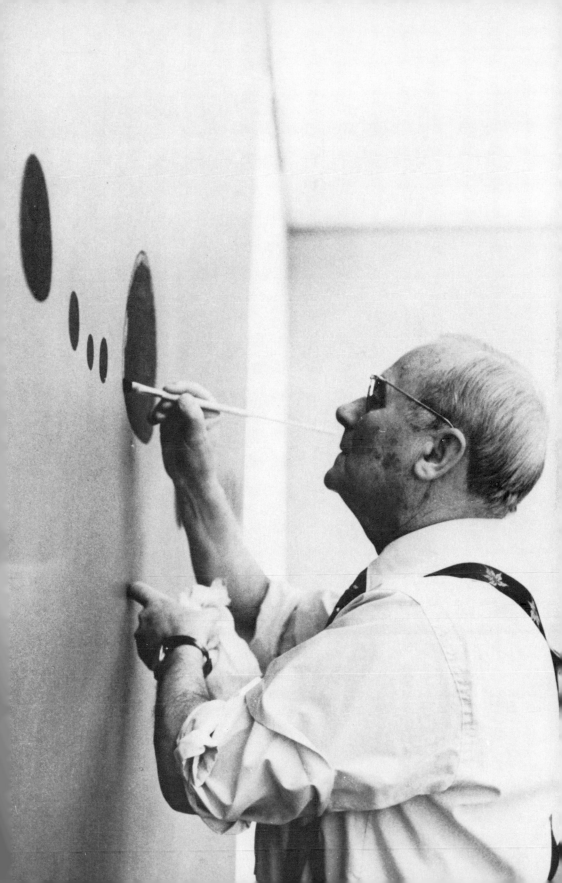

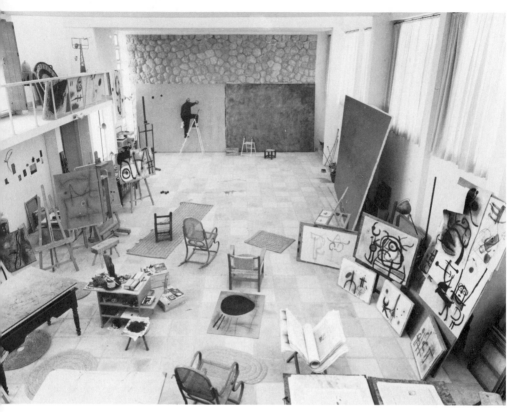

26 Miró working in his studio, "Son Abrines," Palma, 1962.

27 Miró and Pierre Matisse, Barcelona, 1960s (?).

28 Miró in Japan, 1966 (?)

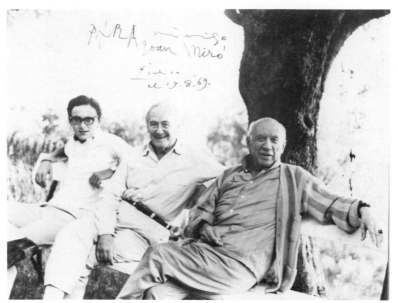

29 Miró with Picasso, and Miró's grandson David, 1969.

30 Miró at the Prado, Madrid, 1972 (?)

31 Miró and Alexander Calder, Grand Palais, Paris, 1974.

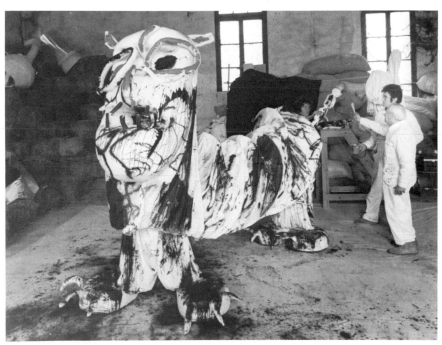

32 Miró working on *Mori el Merma*, 1978.

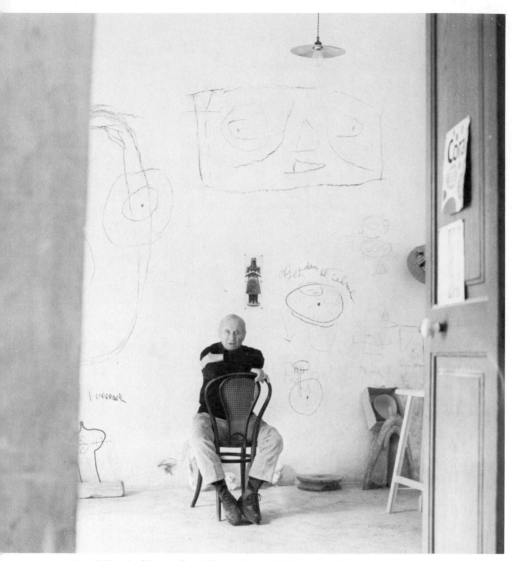

33 Miró in his studio, "Son Abrines," Palma (n.d.)

Text. *Derrière le miroir*, 1958[1]

In 1955, while Miró was working with Artigas on a large series of ceramic sculptures (see Text 37, page 00), he was invited by UNESCO to design two walls for the organization's new headquarters in Paris. Miró proposed two ceramic walls on the themes of the sun and the moon. His points of reference, typically, were the prehistoric cave paintings at Altamira, the Romanesque frescoes of his native Catalonia, and Antoni Gaudí's Park Güell in Barcelona. The first two were executed by anonymous hands, which naturally appealed to Miró; and all three were created for a broad undetermined public.

Although Miró had already executed large-scale commissions, they had been paintings on canvas. A ceramic mural posed another set of problems and necessitated a close collaboration between artist and craftsman. The conscientious perfectionism of Miró and Artigas, each in his given area, produced an outstanding example of public art. In 1958, shortly after they were installed in Paris, the walls received the Guggenheim International Award.

"MY LATEST WORK IS A WALL." IN
DERRIÈRE LE MIROIR (PARIS),
JUNE–JULY 1958

In 1955, the directors of UNESCO asked me to participate in decorating the new buildings the organization was putting up at the place Fontenoy in Paris. They offered me two perpendicular walls near the conference building. Each was 3 meters high; one was 15 meters long and the other was 7.5 meters long. I suggested doing them in ceramics with the help of Llorens Artigas—following the same high-temperature kiln procedures we had used recently in making over 200 pieces, which were exhibited at the Galerie Maeght in 1956. My idea was accepted, and I met with the architects. I wanted to work closely with them so that my walls would blend in as perfectly as possible with the overall architectural design. Mural art is the opposite of solitary creation; but although you must not give up your individual personality as an artist, you must engage it deeply in a collective effort. It is a fascinating experience, but one filled with risks—one that takes place on a construction site rather than in the solitude of a studio. I therefore looked for my ideas on the site itself; it was there that I conceived and developed my project. I was given a room next to the architect's office. My conversations with them, as well as with the engineers and the workers, my study of the mock-ups, and especially my periods of meditation before the concrete walls, the scattered materials, and the commotion of the construction site were a great help to me. The forms of the buildings themselves, their spatial organization, the light conditions—all these things suggested forms and colors for my walls. I wanted my work to be part of the overall effect, but I also wanted it to serve as a contrast to the architecture. Thus, as a way of reacting against the huge cement surfaces that would surround it, the idea of a big bright red disk began to emerge for the large wall. Its counterpart on the smaller wall would be a blue crescent—because of the narrower, more intimate space it would occupy. These two forms, which I wanted to be very brightly colored, would be further enhanced by hollowing them out. Certain details of the construction, such as the design of the windows, inspired checkered patterns and the shapes of the figures. I wanted a brutal kind of expression for the large wall, a hint of something poetic for the small one. Inside each composition, I also looked for a contrast between the brutal and dynamic black lines and the calm forms colored in flat monochromes or diamond patterns. And so I drew and painted small

models at 1/100th scale and submitted them to the committee in charge, which accepted them.

These first compositions underwent considerable changes when I worked on larger models. As a matter of fact, there were changes at every step along the way. Like going from paper to clay, each move to greater dimensions necessitated important alterations of form and color.

The second stage of the job was to work with Artigas and investigate the ceramic techniques the project would require. No ceramist had ever had to pit himself against a work of such proportions. In addition, we had to take into account the resistance of the materials to fluctuations in temperature, humidity, and sunlight, since the two walls were to be placed outside without any protection. All these problems were extremely difficult to solve, and there is no doubt that only Artigas could have done it. The techniques used today produce either faiences or stoneware. The first would not resist the Paris climate well; the second does not lend itself to my palette. Artigas devised a mixed technique: a chamotte covered by a white slip fired at 1000° and then coated with a sandstone-based enamel (different for each tile) and baked at 1300°. Then the firing for the decoration—enamel and color—at 1000°. Everything was baked with wood fires, which create effects that cannot be obtained with gas, coal, or electricity.

Llorens Artigas worked like an old alchemist to find the clays, the sandstone enamels, and the colors he would be using. This research was a true creation that combined many natural elements—feldspar from Palamos, clay from Alcañiz, sand from Fontainebleau, metallic oxides, copper, cobalt, uranium, etc., from all provenances—in doses and proportions that are secrets as old as the world, secrets that were lost and found again through Artigas's science and intuition. During this time, I worked with Joan Artigas[2] on a full-scale model of my project, which I drew in charcoal on paper and colored with gouache. The preparatory stage was finished; we were ready to begin the work.

At that point we decided to travel to Santillana del Mar to have another look at the famous cave paintings of Altamira and ponder the oldest example of mural art in the world. In the old Romanesque church of Santillana, the Collegiata, we marveled at the extraordinary beauty of the texture of an old wall eaten away by dampness. Artigas would remember it when choosing the material for his grounds. After this journey to the source, we also wanted to absorb the spirit of the Catalan Romanesque and of Gaudí. The Barcelona Museum[3] contains admirable Romanesque frescoes that have been a lesson to me ever since my earliest days as a painter. I hope they have inspired me again,

and I feel that the rhythm of the big wall especially owes a great deal to them. Finally, we went to visit the Gaudí of the Park Güell. My imagination was struck there by an immense disk hollowed out in a wall and uncovering the bare rock below, which was very similar to what I was planning to engrave and paint on the big wall. I took this encounter as a confirmation, a sign of encouragement. . . .

We returned to Gallifa, the old village of stones and greenery where Artigas has his kiln and studio. The village is dominated by an immense cirque of steep rocks; I pretended that these rocks were the tall concrete walls at UNESCO. I prepared my large-scale models with them in mind. Confronting this grandiose landscape was a necessary test, and it suggested many changes to me. The surface was divided into identical rectangles that corresponded to the tiles. These now had to be modeled in clay, dried, and fired with only one layer of sandstone clay to give them the necessary resistance. After that, I was to paint them with sandstone enamel and color before the second and last firing.

When Artigas had fired 250 tiles in 33 batches, he called to tell me that he was worried. He was not satisfied with the material as a ground, and he also felt that the geometric regularity of the pieces endangered the sensitivity and even the life of the work. He recognized that his technical virtuosity had carried him too far and that the grounds he had obtained, no matter how extraordinary in themselves, were not suitable. It was then that he remembered the wall of the Collegiata. After a number of experiments, he was able to capture its marvelous sensitivity. The irregular walls of the old chapel in Gallifa also opened our eyes. We felt that the vibrant irregularity of the stones should inspire us in dividing up the surface of our walls. Everything had to be redone with tiles of different dimensions. This unfortunate experience cost us 4,000 kg of clay, 250 kg of enamel, and 10 tons of wood, not to speak of the work and time that were wasted.

Now that we had found the structure of the tiles and the substance for the grounds, the first firing took place without incident. Then it was my turn to come in and carry out my design, using colored enamels to paint the pieces spread out on the ground. Once again my forms were modified. As for the colors, I had to rely on Artigas's expertise, because the enamels do not attain their true color until after firing. In spite of the precautions one can take, however, the ultimate master of the work is fire. Its action is unpredictable, and its power can be deadly. That is what creates the value of this means of expression. Another difficulty: the huge dimensions of the surface I had to paint. Certain forms and strokes had to be done in a single gesture to preserve

the dynamism of their original inspiration. In order to do this, I used a broom made of palm fronds. Artigas held his breath when he saw me grab the broom and begin to trace the five- to six-meter-long motifs, with the good possibility that I would destroy months of work.

The last firing took place on May 29, 1958. Thirty-four firings had come before it. We used 25 tons of wood, 4,000 kg of clay, 200 kg of enamel, and 30 kg of colors. So far, we have only seen our work in pieces, spread out on the ground, and have not had a chance to step back from it. That is why we are so anxious and impatient to see the small wall and the big wall go up in the space and the light they were made for.

Interview. *XXe siècle*
(Yvon Taillandier), 1959[1]

The following long interview, printed as a
monologue, contains one of Miró's most extensive
descriptions of his inspiration, his manner of
working, and his preferred images. Although the
ideas are clearly Miró's own, the precision of
language in describing so many facets of the artist's
creative process may be at least in part attributed to
the interviewer. Yvon Taillandier was a friend and
poet whom Miró greatly admired.

"I WORK LIKE A GARDENER," BY YVON TAILLANDIER, IN *XXe SIÈCLE* (PARIS), FEBRUARY 15, 1959

My nature is tragic and taciturn. . . . When I was young, I went through periods of profound sadness. I am rather stable now, but everything disgusts me: life strikes me as absurd. This has nothing to do with reason; I feel it inside me; I'm a pessimist. I always think that everything is going to turn out badly.

If there is something humorous in my paintings, it's not that I have consciously looked for it. Perhaps this humor comes from a need to escape the tragic side of my temperament. It's a reaction, but an involuntary one.

The thing that is voluntary in me is mental tension. But in my opinion this tension should not be produced by chemicals such as alcohol or drugs.

The atmosphere that lends itself to this tension is something I find in poetry, music, architecture—Gaudí, for example, is extraordinary—in my daily walks, in certain noises: the noise of horses in the country, the wooden wheels of carts creaking along the road, the sound of steps, cries in the night, crickets.

The spectacle of the sky overwhelms me. I am overwhelmed when I see a crescent moon or the sun in an immense sky. In my paintings there are often tiny forms in vast empty spaces. Empty spaces, empty horizons, empty plains—everything that has been stripped bare has always made a strong impression on me.

In the visual climate of today, I like factories, night lights, the world seen from an airplane. One of the most exciting experiences I ever had was flying over Washington at night. Seen at night from an airplane, a city is a marvelous thing. And then, from an airplane, you can see everything. A small person, even a tiny dog, you can see them. And this takes on an enormous importance when you're flying in total darkness over the countryside at night, for example, and you see one or two lights from a farm below.

The simplest things give me ideas. The plate that a peasant eats his soup out of is much more interesting to me than the ridiculously rich plates of rich people.

Folk art always moves me. In this art there are no tricks, there is

no fakery. It goes straight to the heart of things. It surprises, and it is so rich with possibilities.

When I was starting out, the painters who made a strong impression on me were van Gogh, Cézanne, and the Douanier Rousseau. By liking the Douanier Rousseau, I already liked folk art. The further I get in life, the more important this art becomes for me. A pitchfork, a fork that has been carefully made by peasants—that's very important to me.

For me, an object is alive. This cigarette, this box of matches— they contain a secret life more intense than that of many human beings. When I see a tree, I get a shock, as though it were something that breathes, that talks. A tree is also something human.

Immobility strikes me. This bottle, this glass, a big stone on a deserted beach—these are immobile things, but they unleash a tremendous movement in my mind. I do not feel that when I see a human being moving around like an idiot. People who go swimming at the beach and who move around touch me much less than the immobility of a pebble. (Immobile things become enormous, much more enormous than things that move.) Immobility makes me think of vast spaces that contain movements that do not stop, movements that have no end. As Kant said, it is a sudden irruption of the infinite into the finite. A pebble, which is a finite and immobile object, suggests not only movement to me but movement that has no end. In my paintings, this translates into the sparklike forms that leap out of the frame, as though from a volcano.

If he did not feel these movements in my painting, the viewer would be like an actor reading a poem that makes absolutely no sense to him.

But it's quite possible that he will not feel them. For him, the painting is similar to what the pebble is for me; the movement is only suggested.

What I am looking for, in fact, is an immobile movement, something that would be the equivalent of what we call the eloquence of silence—or what Saint John of the Cross, I believe, called soundless music.

In my paintings, the forms are both immobile and mobile. They are immobile because the canvas is an immobile support. They are immobile because of the cleanness of their contours and because of the kind of framing that sometimes encloses them. But precisely because they are immobile, they suggest motion.

Because there is no horizon line or any indication of depth, they shift in depth. They also move across the surface, because a color or a

line inevitably leads to a change in the angle of vision. Inside the large forms there are small forms that move around. And when you look at the painting as a whole, the large forms also become mobile. You could even say that although they keep their autonomy, they push each other around.

But that doesn't mean that the relations between them are not just as rigorous as the relations that hold the various parts of the body together. It's enough for the tip of one finger to be missing for the whole hand to be ruined.

Just as the whole of a body is similar to its parts—an arm, a hand, a foot—everything in a painting must be homogeneous.

In my paintings, there is a kind of circulatory system. If even one form is out of place, the circulation stops; the balance is broken.

When a painting does not satisfy me, I feel physically uncomfortable, as though I were sick, as though my heart were not working properly, as though I couldn't breathe anymore, as though I were suffocating.

I work in a state of passion and excitement. When I begin a painting, I am obeying a physical impulse, a necessity to begin. It's like receiving a physical shock.

Of course, a canvas cannot satisfy me right away. And in the beginning I feel the discomfort I have just described. But since I'm a fighter, I continue the struggle.

It's a struggle between myself and what I am doing, between myself and the canvas, between myself and my discomfort. This struggle excites and inspires me. I work until the discomfort goes away.

I begin my paintings because something jolts me away from reality. This shock can be caused by a little thread that comes loose from the canvas, a drop of water that falls, the fingerprint my thumb leaves on the shiny surface of this table.

In any case, I need a point of departure, whether it's a fleck of dust or a burst of light. This form gives birth to a series of things, one thing leading to another.

A piece of thread, therefore, can unleash a world. I invent a world from a supposedly dead thing. And when I give it a title, it becomes even more alive.

I find my titles in the process of working, as one thing leads to another on my canvas. When I have found the title, I live in its atmosphere. The title then becomes completely real for me, in the same way that a model, a reclining woman, for example, can become real for another painter. For me, the title is a very precise reality.

I work for a long time on the same painting, sometimes years. But during this period there are moments, sometimes very long moments, when I don't work on it at all.

What is important for me is that the point of departure be perceptible, the shock that provoked the painting in the first place.

If a painting that I am working on stays in my studio for years, it doesn't bother me. On the contrary, when I am surrounded by paintings whose point of departure is lively enough to produce a series of rhymes, a new life, new living things, I am happy. . . .

I think of my studio as a vegetable garden. Here, there are artichokes. Over there, potatoes. The leaves have to be cut so the vegetables can grow. At a certain moment, you must prune.

I work like a gardener or a wine grower. Everything takes time. My vocabulary of forms, for example, did not come to me all at once. It formulated itself almost in spite of me.

Things follow their natural course. They grow, they ripen. You have to graft. You have to water, as you do for lettuce. Things ripen in my mind. In addition, I always work on a great many things at once. And even in different areas: painting, etching, lithography, sculpture, ceramics.

The medium and the instrument I am using dictate my technique, which is a way of giving life to a thing.

If I attack a piece of wood with a gouge, that puts me in a certain frame of mind. If I attack a lithographer's stone with a brush, or a copper plate with an etching needle, that puts me in another frame of mind. The encounter between the instrument and the material produces a shock, and this is a live thing, something that I think will have an effect on the viewer.

A burnished sheet of copper puts me in a state quite different from the one I am in when I am looking at a piece of dull-finished wood. Shiny and dull surfaces inspire me to create different forms.

The brightness of ceramics appeals to me: it seems to produce sparks. And then there is the struggle with the elements—clay and fire. As I said before, I am a fighter. You have to know how to control fire when you do ceramics.

And it's unpredictable! That, too, is very seductive. Even when you use the same formula, the same kiln temperature, you do not get the same result. Unpredictability causes a shock, and that is something that appeals to me now.

Etching also has its unpredictable aspects. The more unpredictable it is, the more it interests me.

In my painting, when there is a small line with a large shape at the end of it—that's unpredictable, too. I am the first to be surprised.

In a painting, you should be able to discover new things each time you look at it. But you can look at a painting for a whole week and then never think about it again. You can also look at a painting for a second and think about it for the rest of your life. For me, a painting must give off sparks. It must dazzle like the beauty of a woman or a poem. It must radiate like the flints that shepherds in the Pyrenees use for lighting their pipes.

Even more important than the painting itself is what it gives off, what it projects. It doesn't matter if the painting is destroyed. Art can die, but what counts are the seeds it has spread over the earth. I like Surrealism because the Surrealists did not consider the painting as an end in itself. One must not worry about whether a painting will last, but whether it has planted seeds that give birth to other things.

A painting must be fertile. It must give birth to a world. It doesn't matter if it depicts flowers or people or horses, as long as it reveals a world, something alive.

Two and two do not make four. Only accountants think that. But that is not enough: a painting must make this clear; it must fertilize the imagination.

I do not exclude the possibility that when looking at one of my paintings, a businessman might discover a way to do business, or a scholar might find the answer to a problem.

The answer given by the painting is a general sort of answer, and it can be applied to all sorts of other areas.

My desire is to attain a maximum intensity with a minimum of means. That is why my painting has gradually become more spare.

This tendency toward economy, toward simplification, can be seen in three areas: shading, color, and the representation of figures.

In 1935, the space and the forms in my paintings still gave an illusion of relief. There was still chiaroscuro in my paintings. But, little by little, all that disappeared. Around 1940, shading and chiaroscuro were completely eliminated.

A shaded form has less impact than one that is not shaded. Shading prevents this shock and restricts movement to one in visual depth. Without shading or chiaroscuro, there is no precise indication of depth: movement can go on to infinity.

Little by little, I came to use only a small number of forms and colors. This is not the first time that painting has been done with a reduced range of colors. The frescoes of the tenth century were painted in this way. For me, these are magnificent things.

My figures underwent the same simplification as my colors. Simplified as they are, they are more human and more alive than they would be if represented in all their details. Represented in detail, they would lose their imaginary quality, which enhances everything.

When a viewer recognizes himself in one of my figures, he does not think about what separates him from other men, he thinks about what unites him with everyone else, whether he is black or white, from the North or South, from Africa or China.

There is a saying by Confucius that I always remember: "All men are the same," he says. "Only their customs are different."

All this business about nations is a question of bureaucracy. The important thing is not to be a bureaucrat, but to be a man. By truly becoming a man, you become capable of touching all men, an African as well as a Chinese, a person from the South as well as from the North.

But truly becoming a man means getting away from your false self. In my case, it means no longer being Miró, that is to say, a Spanish painter belonging to a society that is limited by frontiers and social and bureaucratic conventions.

In other words, you must move toward anonymity.

Anonymity has always reigned during the great periods of history. And today the need for it is greater than ever.

But, at the same time, there is a need for the absolutely individualistic gesture, something completely anarchic from the social point of view.

Why? Because a profoundly individualistic gesture is anonymous. By being anonymous, it can attain universality, I am convinced of it. The more local a thing, the more universal it is.

This accounts for the importance of folk art: there is a great unity between the whistles made in Majorca and certain Greek artifacts.

Mural painting interests me because it requires anonymity, because it reaches the masses directly and because it plays a role in architecture.

Truly successful architecture, such as the town of Ibiza, is anonymous.

This anonymity does not thwart what is human. On the contrary. In Ibiza, an architect friend showed me the white paint on the walls

surrounding the windows. These areas, which formed a frame around each window, had been painted from the inside of the house by someone leaning out the window and painting the wall as far as his outstretched arm and brush could reach.

That gave a human scale to these white frames.

A housepainter could not have done that. He would not have painted from the inside but from the outside, after building a scaffold. Everything would have been ruined.

This taste for anonymity leads to collective work. That is why doing ceramics with Artigas interests me so much. I do my prints with a team of master printers and assistants. They give me ideas, and I have complete confidence in them, but all this is impossible if you want to be a star.

By working in a group this way, I am not creating my own little country, or, if I am, it is a universal country.

Anonymous work must be both collective and very personal. Everyone must do what he wants; it should be as natural as breathing. But you can't be overly conscious about it or want to put your signature on your breathing.

The world is moving toward collectivity. Houses are no longer conceived in isolated units. People no longer build private houses for themselves. Buildings are constructed today on such a large scale that it seems quite natural to ask a painter to contribute to the project.

Anonymity allows me to renounce myself, but in renouncing myself I come to affirm myself even more. In the same way, silence is a denial of noise—but the smallest noise in the midst of silence becomes enormous.

The same process makes me look for the noise hidden in silence, the movement in immobility, life in inanimate things, the infinite in the finite, forms in a void, and myself in anonymity.

This is the negation of the negation that Marx spoke of. In negating the negation, we affirm.

In the same way, my painting can be considered humorous and even lighthearted, even though I am tragic.

41

Poem, 1960. (Perls Galleries, 1961)[1]

Miró and Calder met in Paris in the late 1920s.[2] Despite differences in personality and background, they would become lifelong friends. In 1961, the Perls Galleries in New York organized a joint Miró-Calder exhibition and asked each artist to write about the other for the catalog. Calder wrote a poetic page, evoking their early days together. Miró wrote the following poem.

[FOR ALEXANDER CALDER]. IN
ALEXANDER CALDER–JOAN MIRÓ
(NEW YORK), FEBRUARY–APRIL 1961

My old Sandy, this burly man with the
soul of a nightingale who blows on mobiles
 this nightingale who makes his nest
 in his mobiles
these mobiles scraping the bark
 of the orange-colored
 sphere
where my great friend Sandy lives

 Miró
 12/XI/60

Interview. *L'oeil* (Rosamond
Bernier), 1961[1]

In this 1961 interview, Miró speaks of his current
production and its motivations. After moving into a
vast new studio in Palma in 1956, he virtually
stopped painting and instead went through a process
of reassessing his oeuvre. In 1959, he began to paint
again, and in the spring and summer of 1961 his
recent work was shown at the Galerie Maeght in
Paris. This was something of an event in that Miró
had not exhibited in Paris since 1953.

"COMMENTS BY JOAN MIRÓ," BY
ROSAMOND BERNIER. IN *L'OEIL* (PARIS),
JULY–AUGUST 1961

You say that many people were surprised by my new paintings that were just shown in Paris? Well, so much the better. That means that I am making my presence felt, a new presence, since all these paintings were done since 1959. For several years before that I had stopped painting altogether, not only because I was involved in doing ceramics with Artigas in Spain, or doing engravings in Paris, or because of my move from Barcelona to Majorca in 1956. It was not so much the fact that I had to get used to my new surroundings as my encounter with work from an earlier period, work that spanned almost my whole life.

In the new studio I had enough space for the first time. I was able to unpack crates of works that went back years and years. I had not seen these things since leaving Paris and the boulevard Blanqui before the war. When the Germans arrived, they were packed up and stored at Lefebvre-Foinet's.[2] When I finally unpacked them in Majorca, I went through a process of self-examination. I "criticized" myself coldly and objectively, like a professor at the Grande Chaumière art school[3] commenting on the work of a student. It was a shock, a real experience. I was merciless with myself. I destroyed many canvases, and even more drawings and gouaches. I would look at a whole series; I would put a group aside to be burned; I would come back with more, and then, zap, zap, zap, I would destroy them. There were two or three big "purges" like this in a few years.

There are many paintings left that I would like to work on again. Some were shown in Paris following my corrections. Others will remain as they are. I leave them against the wall in my studio. In that way I can see them and not lose contact. My current work comes out of what I learned during that period.

You want me to talk about the old canvases that I reworked? All right, let me explain the *Self-portrait*.[4] I started it in 1937. I wanted it to be very precise. I took one of those magnifying mirrors that people use for shaving and held it up in various positions around my face, drawing everything I saw very meticulously. I made a big drawing, bigger than life. It was sold and went off to America. But I was sorry that I didn't have it anymore. It was finished, and yet I would have liked to have kept it with me. So I took a photograph of the painting to an architect friend.[5] Architects know how to do the kind of work I wanted: he took

a piece of graph paper and made an enlargement of the photograph in the exact dimensions of the painting. This was one of the things I pulled out of the crates in Majorca. One day last year I decided to go on with the *Self-portrait*. I painted a new version on the drawing, an adjustment, a synthesis. But the new painting follows the old one, the outline of the eyes, the shoulders. There are not two portraits, one over the other. I don't want this painting to get away. My wife is very fond of it; it belongs to her.[6]

I also reworked another painting that I had started in 1939. Its title now is *The Awakening of Madame Boubou at Dawn*. It was a very pale drawing. I repainted it, changed it, wiped it out. Often, the old painting was no more than a point of departure, but something from the earlier work always remained. And I would start out on a new adventure. Of the earlier canvas all that existed was a support, a reference. In the painting *Three Birds in Space*, for example, the background dates from 1938, to which I added a few signs.[7]

Were these signs necessarily birds for me? When I start to paint, I have no intention to make a bird, or a woman, or a precise subject. Sometimes, an object appears, as in *Three Birds in Space*. There are three birds there, but I did not realize it until after they were there. I did not set out to paint birds. They appeared almost in spite of me.

The titles? I invent them after the paintings are finished, sometimes just to amuse myself. A painting suggests a title to me, not the other way around. One painting is called *The Bather of Calamayor*. Why not?

In the exhibition there were a number of paintings in series. I worked on the ten canvases of the *Woman and Bird* series at the same time,[8] as a group, beginning methodically with the biggest ones and ending with the smallest ones. Each day, I worked on a different canvas. What happened on one could suggest a change or correction on another, so I would rework the one of the day before. I sketched out the whole series first, spread them all out, and then began to paint. I took things out and added things until I reached a balance within the whole group. This took me several months.

There are five paintings in the *Seated Woman* series.[9] I drew them all in one go. And then I didn't know how to go on. I abandoned them. And then, after a year, all of a sudden, I finished them all: boom, boom, boom. . . .

The very last works are the three large blue canvases.[10] They took me a long time. Not to paint, but to think them through. It took an enormous effort on my part, a very great inner tension to reach the

emptiness I wanted. The preliminary stage was intellectual. . . . It was like preparing the celebration of a religious rite or entering a monastery. Do you know how Japanese archers prepare for competitions? They begin by getting themselves into the right state, exhaling, inhaling, exhaling. It was the same thing for me. I knew that I had everything to lose. One weakness, one mistake, and everything would collapse.

I began by drawing them in charcoal, very precisely. (I always start work very early in the morning.) In the afternoon, I would simply look at what I had drawn. For the rest of the day, I would prepare myself internally. And finally, I began to paint: first the background, all blue; but it was not simply a matter of applying color like a house-painter: all the movements of the brush, the wrist, the breathing of the hand—all these things played a role. "Perfecting" the background put me in the right state to go on with the rest. This struggle exhausted me. I have not painted anything since. These canvases are the culmination of everything I had tried to do up to then.

You ask me if my work in other mediums has influenced my paintings? Yes, enormously. There are the effects that I discovered while working on the etchings *The Giants*.[11] Etching technique requires great speed: I found that what I had done was too soft, that it lacked definition. I splattered the plate and managed to obtain the effect I wanted. In preparing the ceramic wall for Harvard with Artigas, I also had to work very fast. I took a large brush for painting theater sets and let the paint fall in large drops. Artigas was frightened out of his wits. I was in a trance, splattering paint all over the place. That allowed me to discover new possibilities. But chance has always been extremely important to me, of capital importance.

You say that I have influenced a generation of younger painters.[12] Perhaps, but it is also true that I have been greatly influenced by my own period. No, not by any particular artist, but by a general spirit. The air is full of bubbles and grains of dust, and they fall on you. That's inevitable.

Where will my painting be going now? It will be emptier and emptier. I will continue to work on a very large scale.

I have a great many projects. Here in Paris, I am making prints: I am doing a large album of nineteen lithographs with a text by Queneau.[13] It is almost finished. I am also working on copper plates. The printers in the studio sometimes make suggestions. They show me accidents in the acid bath, or an old piece of twisted copper, or a sheet of paper with a curious texture, and we try to see what we can do with these things. In a way they are my collaborators.

I am working on some ceramics projects with Artigas. We have new ideas that we want to try out. Finally, I want to do sculpture, enormous sculptures. I am preparing myself by amassing piles of things in my studio. These objects are there for "observation."

Luckily, I have room. The new studio, which seemed so big, is already full. Fortunately, a large house near mine recently came up for sale, a beautiful seventeenth-century house. I bought it right away. It's filling up very fast.

43

Interview. *Aujourd'hui: Art et architecture* (Denys Chevalier), 1962[1]

Although Miró's first museum retrospective was organized in New York in 1941–42, it was not until 1962 that the artist had a major museum showing in Paris. The following interview by Denys Chevalier, a Parisian art critic, was conducted at that exhibition in the Musée National d'Art Moderne, then located at the Palais de Tokio. Although this text repeats many ideas found elsewhere, they are here set forth with a remarkable precision and clarity.

"MIRÓ," BY DENYS CHEVALIER. IN
AUJOURD'HUI: ART ET ARCHITECTURE
(PARIS), NOVEMBER 1962

DENYS CHEVALIER: In the recent works we have just seen, what do you consider to have been the most important influences?

JOAN MIRÓ: There are so many that they almost cancel each other out, or complement each other, if you like. First, there were my two teachers at the Lonja School of Fine Arts: Modesto Urgell and José Pasco. The first was more of an artist than the second, but it was Pasco who taught me craftsmanship, to be patient with technique. At the Galí School of Art a little later, I was exposed to nineteenth-century French painting for the first time. It was there that I also learned to draw without seeing, to draw solely from touch. You had to hold an object behind your back and then you had to reproduce it—without having seen it. There is no better way to develop an intuitive memory of forms, to get a sense of form.

D.C.: Perhaps that is why your painting is so clear, why the relations between the elements in your pictures are so precise. It is said, in fact, that you are very clean when you paint and that your studio is as neat as a laboratory.

MIRÓ: Yes, I hate dirt, disorder, encrusted palettes. Everyone paints a bit in his own image, you know.

D.C.: Several people have pointed out a kind of predestination in the meaning of your name in Catalan.[2] Of course, I don't think it had the slightest influence on your choice of career, but still, what do you think about it?

MIRÓ: Nothing. What am I supposed to think? It's a coincidence.

D.C.: Don't you believe in signs?

MIRÓ: That depends. In any case, I didn't become a painter because my name is Miró, but I am known as Miró because I am a painter. And besides, it was in Paris a bit later, around 1920, that my life as an artist really began. Now in French, in French slang I should say, Miró means exactly the opposite of seeing.[3] Also, whereas my last name is Catalan, it is specifically Spanish. It does not exist in French Catalan.

D.C.: Fine. Let's get back to painting.

MIRÓ: Good. In 1915, I began studying drawing at the Sant Lluc Circle, and I stayed there until 1918. The ten or so paintings you see here date from that period. I painted still lifes and landscapes. My first portraits were done in 1917. I also did some canvases with a Cézanne-like construction, but above all I was studying distortion and looking for a certain balance between expression through color and the autonomy of objects in the unity of the composition.

D.D.: When were your first contacts with Dada?

MIRÓ: In 1917, when I met Marcel Duchamp and Picabia in Barcelona. Afterwards, and even in my portraits, where I tried to capture the immobility of a presence, my art became freer and freer. I tried to get the vibration of the creative spirit into my work.

D.C.: This doesn't seem to apply to your paintings of the so-called *détailliste* period, which includes works such as *Vines and Olive Trees, Montroig*.

MIRÓ: Of course, but that painting was done in 1919, and my work had evolved in the meantime. My détailliste paintings were highly reflective and meditated works, and they almost never gave way to spontaneity and abandon. During that period, I was influenced by Far Eastern art, and the miniaturization of my vision corresponded naturally to a miniaturization of the means of expression.[4] The arabesque became calligraphy.[5] There was great modesty in all this, and there was almost something religious about the way I painted.

D.C.: What kept you from Cubism?

MIRÓ: Few things or many things, depending on how you see it. But certainly a need to tighten up my forms, and also a kind of spiritual discipline. The *Nude with Mirror* [1919] that you see here is definitely not Cubist, but it derives from it, if only because of its geometrical qualities, which I was trying to use as a way to kill perspective.

D.C.: Nevertheless, your art seems to revert to a new realism between 1920 and 1923, with paintings such as *The Farmer's Wife* and *The Tilled Field*.

MIRÓ: Yes, but this was not a reversion, as you say, because it was not a return to what I had done in the past. It was a breakthrough. I began doing frontal representations. Because of their monumentality, they enriched the pure exteriority of the object and simplified it at the same time. I painted in flat planes of pure color, rarely shading them. The

relations were highly contrasted and abrupt—which is something very Catalonian, very solid and real, in fact. My most important painting from this period, the one that inspired all the others, is unfortunately not here. It's *The Farm*, which was bought by Hemingway. Do you know it?

D.C.: Through reproductions.

MIRÓ: When you do an exhibition like this one, you always regret something. Either there are paintings you would have wanted to include and couldn't, or paintings you would have wanted to leave out. I also had to protect myself against a number of abusive collectors who wanted to lend works to the show for speculative reasons. Many people who own my works would have liked to see them in the exhibition. They proposed them, even insisted in several cases, but I saw through their commercial calculations and didn't go along with them.

D.C.: Your schematization and stylization of reality, somewhat in the manner of purism, led you toward the creation of a new space. Do you think they also emphasize your taste for the marvelous, for a kind of marvelous world that issues directly from reality?

MIRÓ: Absolutely. In fact, in his book about my work, Dupin describes the period that comes immediately after the one we are talking about as the "revelation."

D.C.: What did he mean by that?

MIRÓ: That the signs of an imaginary writing appeared in my work. I painted without premediation, as if under the influence of a dream. I combined reality and mystery in a space that had been set free. I owed this lighthearted atmosphere to the influence of Dada. I was inspired by games, toys, automatons. Later, a deepening sense of the marvelous led me to the notion of the fantastic. I was no longer subjected to dream-dictation, I created my dreams through my paintings.

D.C.: In other words, in your attempt to express the pure dream, the pictorially pure dream, you realized that conventional dream imagery was no longer valid?

MIRÓ: Yes, I escaped into the absolute of nature. I wanted my spots to seem open to the magnetic appeal of the void, to make themselves available to it. I was very interested in the void, in perfect emptiness. I put it into my pale and scumbled grounds, and my linear gestures on top were the signs of my dream progression.

(*We were standing in front of* Person Throwing a Stone at a Bird [*1926*]. *Miró went on:*)
This painting is typical of what we have just been talking about.

D.C.: Yes, there is a rather singular quality of absence in this painting, and the vibration of another, invisible world. But since we have now come to the paintings that are connected to Surrealism, tell me about Surrealism and your relationship to it. *The Concise Dictionary of Surrealism* says that you became a Surrealist painter in 1922 and calls you the "Sardine Tree."[6] Why?

MIRÓ: I wonder. Well . . . it was around 1922 when I met most of my Surrealist friends: Masson, Leiris, Artaud, Desnos, etc. But it was not until two years later that I met Breton, Eluard, and Aragon, and that I became a friend of the group. However, I didn't follow all the ins and outs of their various positions. Although I agreed with a lot of things, I remained a painter, strictly a painter.

D.C.: People have often pointed out the symbolism of the foot in your work. . . .

MIRÓ: Yes, in different paintings over the years, I have painted feet, more or less realistically, outrageously enlarged, or distorted. The foot has always been intensely interesting to me—its form, its function. Isn't it the foot that allows man to make contact with the earth? And there's irony in it, too. We talk about putting our foot in our mouth, don't we? No matter, during those years [1925] my painting no longer showed the pull of gravity; I wanted to give it an astral quality. My preoccupation with dreams became mixed up with eroticism, whereas my open writing was enhanced by the addition of dotted lines. I also made poem-paintings, with written texts. My last works from this dream period were painted on white backgrounds. Their sharper linear quality reminds some people of frescoes.

D.C.: And afterwards? I believe that you went through a period of transition, with a return to a balance between the imaginary and the real.

MIRÓ: Exactly. The reaction took place in Spain, in Montroig. I painted a series of "imaginary landscapes" [1927], in which nature erupted into the fantastic. In 1928, it seems that Arp and I were influenced by each other. Why not: We lived in the same building on the rue Tourlaque in Montmartre. Another influence was that of the Dutch masters—Jan Steen, Vermeer, etc.—that can be seen in the

Dutch interiors I painted that same year. But there aren't any of those canvases here. On the other hand, my imaginary portraits are represented. Here are *Portrait of a Lady in 1820* [1929] and *Queen Marie Louise of Prussia* [1929]. By struggling with descriptive and abstract forms and the ambiguity of meaning that is born from this conflict, I was hoping to discover the mother form.

D.C.: Was it this ambiguity that inspired you to do what you call antipainting?

MIRÓ: I don't think so. Antipainting was a revolt against a state of mind and traditional painting techniques that were later judged morally unjustifiable. It was also an attempt to express myself through new materials: bark, textile fiber, assemblages of objects, collages, and so on [1929–36].

D.C.: It was a true assassination of painting, then.

MIRÓ: Yes. Even though it came out of Dada and my admiration for Marcel Duchamp, these experiments had just as much to do with a kind of inner protest, a crisis of personal consciousness.

D.C.: Don't you think that this attitude was marked by puritanism? To force one's nature to its limits and amputate it in the name of aesthetic principles—isn't that a sign of puritanism?

MIRÓ: Yes, of course. But a refusal to make "pretty" things pushed me to use the most sordid and incongruous materials possible. I denied my own gifts and turned against my facility, refusing the "miracle" as a sign of my contempt for success.

D.C.: Yes, but rather like the poet who twisted the neck of lyricism and still wound up producing poetry. This *Collage* of 1929 and this *Painting-Object* of 1930 are still successful. That is why they are here.

MIRÓ: What can I say, I can't be anything other than a painter. Every challenge to painting is a paradox—from the moment that challenge is expressed in a work. But in my progression toward nonpictorial painting, I also acquired an extreme formal tension.

D.C.: How did you work your way out of this impasse?

MIRÓ: First, through a freedom of mind. Second, through music, as a source of inspiration and exaltation. Third, through drawing, as a technique of execution. . . . I began working in three dimensions in the thirties—not sculptures or objects, but constructions of a sort. Whatever they were, the crisis was under control. But for a certain time,

until 1934, I kept my taste for an art devoid of all visual charm and chromatic interest.

D.C.: What Dupin calls your period of formal concentration.

MIRÓ: Yes. By using austere colors, my motifs underwent a process of steady and progressive organic distortion. Here are several canvases done in that spirit. Look at them. The space-form complex appears in the grounds that I wanted to be both subtle and resonant. As for the sign, I retained its power of suggestion, considering it, in fact, to be the elementary manifestation of a new pictorial language.

D.C.: The father-sign, in short, replaces the mother-form, just as the space-form complex takes the place of the texture-structure research of antipainting.

MIRÓ: If you like. My forms in space have always influenced each other, constantly changing, shifting, until they reach an optimum point of dynamic balance.

D.C.: However, the paintings that we are looking at right now, these paintings on Masonite [1936], seem to have an additional element, a kind of brutality or violence that is very different from the normal characteristics of your art, the things that everyone is familiar with: poetry, eroticism, humor, and a slight aura of childhood.

MIRÓ: That's because they are more recent. From 1936. They mark the beginning of the cruel and difficult years that the world lived through. They are painted on Masonite. They swarm with oppositions, conflicts, contrasts. I call them my "savage paintings." Thinking about death led me to create monsters that both attracted and repelled me. Detail once again became necessary to me, as did perspective and shading. That was the period when I fled the civil war in my own country and returned to France. But I did not despair for very long. I love life too much. I understood that realism, a certain kind of realism, is an excellent way to overcome despair, whereas mistreating forms leads to mutilation, monstrosity. So I began drawing again. Reflecting on the sign's inexhaustible possibilities of association, I began to see it as an extraordinary element of mobility, and I treated it as such.

D.C.: The series of gouaches you call the Constellations came a little later, I believe. These gouaches were the basis for the etchings and color lithographs that were collected in an album with a preface by André Breton . . .

MIRÓ: And shown at the Galerie Berggruen three years ago. Exactly.

But not all twenty-two[7] of the Constellations are exhibited here. There wasn't enough room. Besides, they come later. I painted them in 1940 and 1941 in Varengeville, then in Spain. They were my refuge during the war.

D.C.: Don't you find that these works are the very opposite of détail-lisme? I see a force and a schematic monumentality in them associated with a suggestion of a space that is curiously nocturnal in its light.

MIRÓ: Perhaps. But they seem very detailed to me from within. Above all, I think they can be considered as a sign of wanting to go beyond the savage paintings. Everyone has noticed, moreover, how they form a cycle, a small island that is perfectly closed, at the heart of my general work. Breton also pointed out how the luminous accents relate to the intersections of superimposed forms.

D.C.: Yes, and the palette, reduced to a few pure tones, further empha-sizes the precise mechanics of these gouaches—their celestial mechan-ics. As for the interactions of overlapping forms that create a kind of color emulsion completely independent of the color of each form, I don't think that the Constellations are significantly different from cer-tain other works. In the rooms we have already visited, I noticed several canvases with the same characteristics: *Composition* of 1933 and *Rhythmic Personages* of 1934, for example.

MIRÓ: Yes, but perhaps I systematized this mode of expression in my Constellations, perhaps I pushed it further. In 1942, I finished the series. I turned to studies of movement and used more brutal tech-niques: spots and splashes, scraping, rubbing, and so on. At the same time, a form of writing was invented: star-spheres, broken lines, spires, etc.

(*We are now standing in front of* The Bullfight, *1945.*)[8]
You see, that year I painted large canvases on light backgrounds in which I joined moving and still forms. It is in the dynamism of the signs and the general rhythm of the composition that the central subject comes to life.

D.C.: Yes, and I also see more precise rhythmic correspondences among the graphic elements of this canvas. Thus, the three parentheses in the upper center rhyme with the broken line for teeth of the animal in the middle, and its eyebrows echo the movement of its mustache. And then the colors also answer each other and reflect each others' sounds, as if by some mysterious resonance, an echo.

MIRÓ: Exactly. Later, I combined what I call my spontaneous manner with my more elaborate manner. New York, where I went in 1947, helped me to take stock of myself. I had to adapt myself to modernity. But that wasn't too difficult. I studied the counterpoint that emerged from the juxtaposition of brutal and spontaneous elements—as in my savage paintings—between drawn forms and precisely painted ones. Around 1950 and 1951 I also painted canvases that were at times reflective—in which the work took precedence over the gesture—and at times impulsive, executed very rapidly, which were like mental vacations for me.

D.C.: Doesn't it seem to you that in the first the subject tends to disappear as the execution progresses, until it is no more than a pretext, whereas in the second it remains more visible?

MIRÓ: Yes, in the latter, the signs reestablish an order in the composition. Without them it would remain murky, as the backgrounds often are, for example.

D.C.: When did you begin to be interested in ceramics?

MIRÓ: Oh, a long time ago! In 1944, with Artigas. Since then, we have not stopped working together. What I like about ceramics is the way in which you have to overcome technical contradictions. And then there is the unexpected, the element of surprise. For me, doing ceramics is a little like becoming an alchemist. I find it more alive than working with bronze. That monumental sculpture you see over there was conceived just as it is. It's not an enlargement. All good sculpture should look immense in the open air. Moreover, I leave my sculptures outside. The sun, the wind, the rain, even dust improves them. Also, I often take my paintings outside to see if they hold up, to assess them.

D.C.: Where does your inspiration come from? From the play of your imagination or from natural forms?

MIRÓ: From both. Look. These forms are invented, but those are taken directly from reality. They're pebbles, gourds.

D.C.: So there it is, your new realism. It's like some of the paintings we just saw. To me, they seem to foreshadow contemporary lyrical abstraction. Which only confirms that many artists in the new wave have not really invented anything. It's true that what counts is not being the first to do something, but discovering it for yourself and thinking it through

yourself for the first time. Finally, it's the best work that lasts, that wins out. But let's return to painting.

MIRÓ: There are no paintings from the late fifties in the exhibition. I did very little painting during those years. First, I did my *terres de grand feu* [high-temperature ceramics]; then, there was the construction of my new studio, the two walls for UNESCO in Paris, several illustrated books, and so on. I also did a lot of prints. In 1959 and 1960, I did not do figurative painting, but I evoked an earlier figuration. Sometimes, on a solid background, I scattered expanding spots; at other times I filled the space with an abrupt and schematic writing, like graffiti. I also re-worked some old paintings—like this one, *The Swallow Dazzled by the Flash of the Red Pupil*, which dates from 1925. It used to be three times the size. It was sold, then rolled up during the Occupation, and then cut up to make potato sacks. When I found it again, this was all that was left. I added new elements in order to reestablish some unity.

D.C.: According to the catalog, there are two other similar cases: *Three Birds in Space* and *Self-portrait* [*I*].

MIRÓ: Yes, they were from 1937, I think. By reworking my portrait, for example, which was unfinished, it became something absolutely new—much more violent and assured than the old one.

D.C.: Were the recent large, almost monochromatic paintings isolated from the others on purpose?[9]

MIRÓ: Yes. I painted them to be presented in this way, together, separate from the others. In fact, I wouldn't like them to be sold separately. That would be a betrayal of my intentions, I think.

D.C.: In the *Derrière le miroir* (no. 125–126) that appeared in 1961 in connection with your exhibitions at the Galerie Maeght, Jacques Dupin makes a distinction between the "fascination with the void" that is found in your works from 1925 and your great silent field paintings of today. Isn't it that the void for you now doesn't open up onto nothing-ness but, on the contrary, onto a kind of plenitude of light, which is also fascinating, like the curve of the celestial vault?

MIRÓ: No doubt. Also, if only in their sheer monumentality, they already represent a new stage for me. By limiting myself to a few spare lines, I tried to give the gesture a quality so individual that it becomes almost anonymous—like a universal act. Because of this, perhaps, there is a certain similarity between these works and what you could call contemplative or meditative painting. That is why I asked for a bench

to be put in front of these canvases. So that people can sit down and contemplate them, so that they can immerse themselves in them.

D.C.: Doesn't this refusal of the picturesque and the particular remind you of a kind of "praise of banality"?

MIRÓ: Yes. And that was exactly what I wanted. To suppress all hierarchies in the world of objects and signs. In front of these canvases, you should feel as though you are in a temple where nothing will distract you from the object of your meditation.

D.C.: Isn't this also the reflection of a pictorial Jansenism that we noticed in your work before?

MIRÓ: It's very likely. This need to destroy my own signs corresponds to my old desire to "break the guitar" of Cubism. Afterwards, however, I applied this asceticism to myself.

44

Letter to Nina Kandinsky, 1966. *XXe siècle*, 1974[1]

In 1966, *XXe siècle* devoted a special issue to Wassily Kandinsky. Miró's letter to Kandinsky's widow, was published on that occasion. The special edition was reprinted in 1974.

Kandinsky settled in Paris in 1933. He would find few friends there and little recognition. His art had little to do with the post-Cubism or geometric abstraction then current on the Parisian art scene, and his friendship with the Surrealists was short-lived. It appears that his most faithful friends and allies were Jean Arp, Jean Hélion, and Miró, whom he affectionately described as "this little man who paints large canvases, a real volcano bursting with images."[2] Conversely, Miró always expressed great admiration for Kandinsky. Although Miró did not live permanently in Paris in 1934–35, he managed to maintain a friendship with Kandinsky and visited his exhibitions regularly when he was in Paris.

LETTER TO NINA KANDINSKY, JANUARY 19, 1966. IN *XXE SIÈCLE* (PARIS), DECEMBER 1966, JUNE 1974.

I had the honor of knowing Kandinsky after he left Nazi Germany and came to Paris—settling on the banks of the Seine, in the very spot where Seurat was inspired to do the masterpiece I saw recently in Chicago.[3]

At that time, all the painters politely refused to see him. The critics called him a schoolteacher and called his paintings woman's handiwork.

This great Prince of the Mind, this Great Lord, lived in extreme isolation, seeing only a handful of people who were completely devoted to him.

At our gatherings at the Café Cyrano on the place Pigalle, André Breton used to speak to us about him. This was during a period when post-Cubism was sinking into a cold formalism lacking all spiritual substance. Breton spoke of him as someone who had gone beyond painting and who brought with him the breath of the Orient.

I remember his small exhibitions at the Galerie Zak and with Madame Jeanne Bucher on the boulevard du Montparnasse.[4] Those gouaches touched me to the bottom of my soul. At last, one was allowed to listen to music and read a beautiful poem at the same time. It was much more ambitious and profound than the cold calculations of the Section d'Or.

Now, the light of his work has become more and more blinding. Unfortunately, most of the painters of the past no longer give us an electric shock—or in any case, they give us one that has been greatly diminished.

I salute you, dear Nina, for your devotion to Kandinsky. Every time I come to visit you, I feel I am making a pilgrimage, and I am moved by the relics you show me, by the sacred armchair that is draped in cloth to protect it from dust—the dead dust, perhaps, of the people who were not touched by the miracle of this work many years ago—and I embrace you, Nina, his dear companion.

Article (excerpts). *Les nouvelles littéraires* (Pierre Bourcier), 1968[1]

The following two excerpts are from an article published on the occasion of Miró's seventy-fifth birthday exhibition at the Maeght Foundation in Saint-Paul-de-Vence during the summer of 1968. The three paintings mentioned in the first paragraphs consist of a single line on a white ground and were appropriately entitled *Mural Painting for the Cell of a Solitary Man*. They are among the most austere paintings of Miró's entire production.

The evocation of "long" paintings surely refers to *The Song of the Vowels* of 1966,[2] painted upon Miró's return from his first trip to Japan. It may be suggested that the unusual tall narrow format and the loose calligraphic style of this painting were inspired by Japanese scrolls.

ARTICLE (EXCERPTS), BY PIERRE
BOURCIER. IN *LES NOUVELLES LITTÉRAIRES*
(PARIS), AUGUST 8, 1968

Yes, it took me only a moment to draw this line with my brush. But it took me months, perhaps even years of reflection to form the idea of it.

For me, these three paintings are decorations for the solitary life. They could be hanging in the cell of a man condemned to death. This simple line proves to me that I have conquered freedom. And to me, conquering freedom means conquering simplicity. At the very limit, then, one line, one color can make a painting.

I worked for a long time on this line, sketching it, trying it out in charcoal, going back to it, over and over, for several years. It was not an intellectual decision that led me to say to myself one day that I was finally right. I have a much more personal and instinctive method: I am physically ill at ease until I have found a way to open up my painting. I detest the closed line, the line that turns upon itself. One day, looking at my most recent attempt, my uneasiness left me and was replaced by joy. I picked up my brush and drew the line in a single gesture. But I did not accept it as final until after another month of silence. . . .

I might look calm, but underneath I am tormented. Surrealism opened up a universe that justified and soothed my torment. Fauvism and Cubism taught me only severe and formal disciplines. There was a silent revolt inside me. Surrealism allowed me to go beyond formal research; it took me to the heart of poetry, to the heart of joy: the joy of discovering what I am doing after I have done it, of feeling the meaning and the title of a painting grow inside me as I work on it.

When I pick up my brush, most of the time I don't know what I am going to paint. It's not always clear, even when I have finished. For example, on certain canvases I have painted stenciled letters. I still don't understand why, but I know that there is a deep and powerful reason for it.

I paint what I am, perhaps what I was in another life. These long paintings, for example, evoke Japanese writing. That is because I feel deeply in harmony with the Japanese soul. Why?

I believe in obscure forces. I believe in astrology. I am a Taurus, with Scorpio in the ascendant. Perhaps that is why there are spheres and circles in many of my paintings—to evoke the governing planets.

Poem-titles, 1967–70[1]

Many of the poem-titles of the 1960s are analogous to
those of the 1950s; they are full of vivid images
linked together in a somewhat meandering syntax.
Others (particularly of 1968) have the brevity of a
Haiku poem. Moreover, the paintings "accompanied"
by these titles show an emptiness filled by a few
concentrated gestures, reminiscent of Japanese painted
scrolls.

POEM-TITLES, 1967–70

1967

Woman with Hair Tousled by the Wind before the Eclipse

The Lark's Wing Encircled with Golden Blue Rejoins the Heart of the Poppy Sleeping on the Diamond-Studded Meadow

1968

The Smile of the Star to the Twin-Tree of the Plain

Drop of Water on the Rose-Colored Snow

Hair Pursued by Two Planets

Man and Woman before the Azure

Bird Awakened by the Cry of the Azure Flies Off across the Breathing Plain

The Painful Path Guided by the Flaming Desert Bird

1970

Birds of Prey Swoop Down on Our Shadows

Undated

The Poppy Snake Loitering in a Field of Violets Inhabited by Mourning Lizards

The Bird Joins Its Song to the Tenderness of the Woman Whose Throat Is Turned toward the Sun

The Glow of the Moon Lights the Tracks of the Snail with Diamond Horns

The Bird's Feathers Unleash the Piercing Music of the Meadow

Interview. Unpublished
(Margit Rowell), 1970[1]

In the spring of 1970, when Rosalind Krauss and I were preparing the exhibition "Joan Miró: Magnetic Fields" for the Solomon R. Guggenheim Museum in New York, we were particularly interested in Miró's relationship to postwar American painting. In order to discuss these questions, I interviewed Miró in Paris on April 20, 1970.

Miró's influence on American painting in the 1940s is visible and obvious. But the artist's precise awareness of American painting was not documented until this time. The larger scale and open space of many paintings—particularly in the 1960s when Miró had a big enough studio to paint large formats—may be attributed to the combined influences of thc "new" American painting and Miró's 1966 visit to Japan.

INTERVIEW WITH MARGIT ROWELL
UNPUBLISHED. PARIS, APRIL 20, 1970

MARGIT ROWELL: When did you first become acquainted with American painting?

JOAN MIRÓ: During my first trip to America in 1947 and again at the Jackson Pollock exhibition in Paris at the Galerie Facchetti in 1952.

M.R.: Could it have influenced your work—the freedom, the boldness or daring of this painting?

MIRÓ: Yes, definitely. It showed me a direction I wanted to take but which up to then had remained at the stage of an unfulfilled desire. When I saw those paintings, I said to myself, "You can do it, too; go to it, you see, it is O.K.!" You must remember that I grew up in the context of the school of Paris. That was hard to break away from.

M.R.: Did you see another exhibition at Facchetti's, just before the Pollock show, organized by Michel Tapié and called "Signifiants de l'informel" with Hartung (I believe), Fautrier, perhaps Dubuffet, Mathieu?

MIRÓ: No, I don't think I saw it. But it was really American painting that inspired me. Perhaps I wasn't in Paris at the time of that other exhibition.

M.R.: In looking at your work since 1960, one is struck by what one could call two series of paintings: one gestural, calligraphic, with an accent on emptiness, which one could almost call abstract, if you'll pardon the expression; the other which shows figures, an extension of your mythical or mythological personages. Is this correct?

MIRÓ: Yes. Absolutely.

M.R.: Did you find interesting or useful your trip to Japan and your firsthand acquaintance with Japanese painting: the method of concentration to a state of trance and then an execution at lightning speed?

MIRÓ: Absolutely. I was fascinated by the work of the Japanese calligraphers and it definitely influenced my own working methods. I work more and more in a state of trance, I would say almost always in a trance these days. And I consider my painting more and more gestural.

M.R.: However, there are these two cycles: one dominated by gesture

and emptiness; the other where the space is completely filled: with women, birds, etc. One is calm, the other seems turbid, nervous.

MIRÓ: Yes, you are right. One thing comes as a reaction to something else. Both my life and my work are governed by alternating phases. When I am traveling, I am always on the move, but when I return home, I spend twenty-four hours in bed, I eat nothing, I drink only water. It is the same in my work. After a series of calm austere pictures there will be colorful dynamic ones. Yes, indeed, one can speak of cycles in my painting.

48

Interview. *XXe siècle*
(Yvon Taillandier), 1974[1]

In May 1974, after the opening of Miró's large
retrospective at the Grand Palais in Paris, he was
interviewed by Yvon Taillandier. Taillandier had
interviewed Miró in 1959 (See Text 40, pages
246–53) and the title as well as the opening phrases
of this interview suggest that it was conceived as a
sequel to the first. Miró's relaxed conversational tone
and choice of topics echo the earlier interview, as
though the artist were picking up where he had left
off fifteen years earlier. Once again it seems that
Taillandier reshaped Miró's characteristically lapidary
phrasing in order to create a smoother flow of ideas.

"Miró: Now I Work on the Floor," by Yvon Taillandier. In *XXe siècle* (Paris), May 30, 1974

No, I don't know where my capitipedes come from. They just came like that, without my thinking about them. And they have been there for a long time. But you are absolutely right to call them capitipedes— from the Latin *caput*, *capitis* ("head") and *pes*, *pedis* ("foot"), as you say. That's very exact and very appropriate. It really does describe those big heads with lines below them for the legs. Sometimes, even, there is just one leg jutting straight out from the head. But where they come from, I can't tell you.

On the other hand, it's not hard for me to tell you where those other figures come from, the ones that have eyes all over them: an eye on the face, an eye on the leg, an eye on the back, or the eyes on stems, as though on the tip of some kind of horn. They come from a Romanesque chapel where there is an angel whose wings have been replaced by eyes.[2] Another Romanesque angel has eyes in its hand, right in the palm. I saw that in Barcelona when I was still a baby. Moreover, the eye has always fascinated me. In one of my paintings, *The Tilled Field* (1923–24), there is a tree that has an ear and an eye: the eye that sees everything; the ear that hears everything. The ear is an element I don't use very often. That ear is an exception. But the eye . . .

Am I afraid of the eye? No, not at all. I don't mistrust it. No fear whatsoever. I would call it a mythological element. For me, the eye belongs to mythology. What do I mean by mythology? By mythology I mean something that is endowed with a sacred character, like an ancient civilization. Even a tree is mythological. A tree is not from the vegetable kingdom. It is something human. A beautiful tree breathes and listens to you; it falls in love with its buds as they turn into flowers and its flowers as they turn into fruits; it resists the wind and it loves you. For me, that kind of human presence in things is mythology. That is why I don't think of a pebble or a rock as something dead. Basically, what I paint is this mythology.

When I go back home, I will think back on these large exhibitions of my work at the Grand Palais and the Musée d'Art Moderne de la Ville de Paris. Seeing my work like that is of course moving to me; but, even more than that, it's a chance to engage in some serious self-criticism. There are paintings in those shows that I haven't seen for years. And then, for other paintings, it's a test. You saw the *Friends'*

Message [1964], for example? It holds up well, don't you think? However, it's a somewhat unusual painting for me. It includes a horizon line and a large black form. But several recent paintings pick up this theme of the large black form.

After this canvas, you will remember, I painted *The Ski Lesson* [1966]. And then I started two paintings on the theme of Queen Marie Louise of Prussia. One of them, the *Portrait of Queen Marie Louise of Prussia*, was shown at the Salon de Mai in 1966. The other one I am changing all the time. It is drawn very meticulously in charcoal, with a good deal of white. On these white backgrounds, the painting will be done like a mural painting executed on a whitewashed wall. I pinned a little piece of paper to it to indicate Marie Louise's escape. You've just reminded me that I spoke to you about that descendant of the queen who was found drowned in the Rhine on the same day that I sent my portrait of Queen Marie Louise to the Salon de Mai. That can create a rather bizarre parallel—on one side the drowned prince, on the other side the escaping queen.

When I am back in my studio, I will look at everything I have been doing, coldly and calmly. What subjects will I deal with next? Well, beside Queen Marie Louise, there will be the *Women and Birds in the Night*. Where does this theme come from? Good Lord! Perhaps the bird comes from the fact that I like space a lot and the bird makes one think of space. And I put it in front of the night; I situate it in relation to the ground. It's always the same kind of theme, my kind of theme.

What others are doing? Yes, I keep up on what they are doing. If what they do is authentic, I'm interested. I'm very broad-minded, and I'm not attached to any one idea. If what others do is carried by the spirit of authenticity, I welcome it completely. Whatever it is.

Would I like to do environments? Of course I would like to. Moreover, I have already done some, and I will do more. When I work, it comes about very naturally. Since I work on several things at once, all these works surround me, and they constitute an environment. The exhibition at the Grand Palais is an environment. That was why it was so important for me to be there when the paintings were hung. I wanted to participate. I had thought about it a lot and even made notes. For the Salon de Mai next year, I have talked to Gaston Diehl, and we will put together a group of recent things that no one has seen. Again a kind of environment. As is the sculpture for Central Park in New York. It will be an object like a house that children can go into; and we're studying ways to paint it on the inside as well as the outside.[3]

You want to know if I am interested in comic strips? Certainly.

And first of all in strips as strips, very long strips, like scrolls. There is a scroll of this kind in Zurich, for example. And I also did a very large strip on silk in Lyon. These scrolls allow you to follow a formal rhythm. Yes, yes, I have considered the mythology of comic strips, and I am interested in their narrative aspect. Besides, I have done narration myself. For example, in *The Harlequin's Carnival* (1924–25) and in *The Hunter* (1923–24), which is at the Museum of Modern Art in New York. You can see the hunter's heart. He's in the act of peeing. You can see his penis. An airplane flies across the sky while a fisherman fishes from a boat. There is also a big tree, a carob tree; on one side there is a rifle, and on the other, a fish, the first letters of the word *sardine*, and a fire for cooking the fish. All that makes up a story. I don't know if I will be telling stories like that again; in any case, if I do, it won't be with any preconceived idea. I won't think it out first and then go to it with the story decided in advance.

You say that in this kind of story everything happens at the same time. The fisherman fishes while the airplane is flying overhead and the hunter is peeing. It's not a story in which events happen one after the other, in which the same character is repeated in different situations. No, I have never been tempted by that kind of repetition. On the contrary, when I paint strips, my work consists of constantly adding new elements. No repetition. One figure leads me to another figure. I have nothing against a story that brings back the same character and the same forms, but I have never done anything like that. For me, the essential things are the artistic and poetic occurrences, the associations of forms and ideas: a form gives me an idea, this idea evokes another form, and everything culminates in figures, animals, and things I had no way of foreseeing in advance.

This drawing that was brought to me for authentication is indeed a work of mine. The figure on the right has four wings—four wings attached to the legs, two on each leg. Here is the eye, there is the nose, and there is the mustache. This form that is attached to the head is not the neck; it's the entire body. When I do a head, I rarely put it on a neck. The neck and the body form a single block. Next to this figure with the mustache, there is another figure who has an arm without a hand, in the form of a hook. Maybe this hook replaces the hand. Look at the nose: the nostrils are shaped like testicles.

You ask me why these individuals are transparent. Well!—because here I started with the ground. The ground dictated my figures, and since it was painted in watercolor and watercolors are a transparent medium, my figures were transparent. But you could also say they are

transparent because they contain empty spaces through which the background can be seen, the background that dictated the figures in the first place.

I do not always begin with the ground. Very often, I draw a black line on the empty canvas, and then I complement it with splattered or dripped paint. This method of dripping is fairly recent. I pour paint on the canvas, which is lying flat on the floor, and then I stand the painting up. The color then runs down. I check the flow. When it seems right, I lay the canvas flat on the floor again. I am doing this more and more. But it is rather recent.

It's like the burned paintings [1973]. I discovered that you can burn the canvas and the stretcher by pouring gasoline on them and lighting it, or by using a blowtorch. It's not difficult to control the progress of the fire, and in this way you can obtain some very beautiful textures.

In the same way, I'm interested in the textures you can obtain with slow-drying colors. I sometimes use acrylics, because they dry very fast. But I'm not very keen on quick-drying paint. You know that I am not impatient. I work in stages. First stage, the blacks; and then the rest, which is determined by the blacks. So, I'm not in a hurry. That's why I'm in the habit of using normal paints, oil paints, which dry more slowly than acrylics. Then I can take advantage of this slow drying. If I apply a color when the one before it is not yet dry, certain mixtures and nuances ensue; a yellow mixed with a green will give a greenish tonality. That produces nuances, textures. It's richer. And I can't obtain that richness with a paint that dries right away.

But let's get back to the drawing that was just brought to me. You see, during this period I drew almost exclusively with very fine lines. Later, I instinctively thickened my lines. Now, I draw by dipping my finger in paint. Of course, in order to obtain contrasts, I sometimes make very fine strokes; and I often play the broad strokes against the narrow strokes. I do not make these fine strokes with my finger. If I am working with brushes, I use a very thin brush. If not, I draw with a Conté crayon or a Japanese bamboo dipped in India ink, or sometimes I even use a toothpick.

This method of using my finger to paint is fairly recent. In my monograph,[4] there is a photo of me using this technique. I have been relying on my fingers more and more. Now I even spread out the color with my fist; like this, rubbing it around in a circle.

Sometimes I use an easel. But that has become quite rare. I put my paintings on sawhorses or on the floor. When they're on the

ground, I can walk on them, and that's convenient, especially in the case of a large canvas. When I'm finished, I put it on the wall with someone's help, or put it on the easel, or lean it against something to stand it up. Then I can see what has to be corrected. After that, I put the canvas back on the floor to do the corrections. On the floor I work flat on my stomach. Oh, yes!—paint gets all over me. My face and hair get all dirty, completely splattered. As for my work clothes, they become a real painting.

When I get back home and am in my studio again, I think I will do things of normal dimensions, but also some very large paintings. I feel in great shape.

49

Poem, 1976[1]

In 1976, Alain Jouffroy, then editor of *XXe siècle*, prepared a special issue on Japan. Aside from a number of articles devoted to Japanese culture, the issue also included a poem by Takiguchi[2] and a cover, color lithograph, and two *dessin-poèmes* (poem-drawings) by Miró.

These poem-drawings were composed in two phases. First, Miró composed the poem, and then he broke it apart and scattered the words in all directions on the page, along with a few large signs or symbols. The effect is that of an open field animated with sounds, odors, and visual images. The following poem (unpublished in this form) formed the basis of one of the dessin-poèmes.

Poem, 1976.

A scent of jasmine
Music of hair
Japan
Calligraphy of insect wings
Circles of a river going round
 stem bamboo body
 of women.
Sash of joy

 Miró
 15/I/76

50

Interview. *Gaceta ilustrada*
(Lluis Permanyer), 1978[1]

The following statements were made by Miró a few
days before his eighty-fifth birthday. The Catalan art
critic Lluis Permanyer chose ten paintings covering
some forty years of the artist's creative activity and
asked Miró to comment on them. Faced with such a
concrete task, Miró was at his best. For each picture,
he recalled details that had never been recorded in
print before; these concerned not only technique, but
also the particular reality or lived experience·that had
provoked or inspired each work. The texts confirm
Miro's meticulous attention to subject matter, process,
and detail in his paintings, which allowed him to
relive them many years later.

"REVELATIONS BY JOAN MIRÓ ABOUT
HIS WORK," BY LLUIS PERMANYER. IN
GACETA ILUSTRADA (MADRID),
APRIL 1978

The Farm (1921–22)

It took me practically two years to finish it, but not because I had any
trouble actually painting it. No, the reason it took so long was that
what I saw underwent a metamorphosis. The painting was absolutely
realistic. Everything that's in the painting was actually there. I didn't
invent anything. I only eliminated the fencing on the front of the
chicken coop because it kept you from seeing the animals. Before this
metamorphosis occurred I had to capture even the smallest detail of
that farm I had right there before my eyes in Montroig. For instance, I
very carefully copied that big eucalyptus tree in the center of the
canvas. Every time I strayed from the model, I'd take one of those
pieces of blackboard chalk that schoolchildren use and I'd chalk over
what I'd done and make the necessary corrections. I was thoroughly
convinced that I was working on something very important, attempting
to summarize the world around me. I used to spend three months a
year in my house in Montroig, you know. My parents would go away
and I'd stay there alone with the animals: cats, dogs, barnyard fowl,
immersed in the country atmosphere—so far removed from the bustle
of the city. The only light I had was a kerosene lamp.

I didn't deliberately set out to synthesize my earlier work, but the
more I worked on the canvas the more I did synthesize. I must confess
that I never realized at the time that *The Farm* was the end of my
realistic period and the beginning of a new period, because I had no
idea of what I was going to do from then on.

The Harlequin's Carnival (1924–25)

I painted this in my studio on the rue Blomet. That was when I was
friends with the Surrealists. I was hungry and I was trying to capture
the hallucinations caused by my hunger. I wasn't painting things I saw
in my dreams like Breton and his followers said you should. It was

simply that hunger sent me into a sort of Oriental trance. That was when I made preliminary sketches of the general layout of the painting so that I'd know just where everything was going to go. Then, after having thought about it for a long time, I started painting and making changes as I went along. I admit that I was very interested in Bosch, but I wasn't thinking about him when I was working on the *Carnival*.

There are some things in this canvas that I used again in other works: the ladder, which is a ladder for flight, for escape, but also for elevation; the animals and especially the insects, which have always interested me a great deal. The black circle on the right represents the earth because, at that time, I was obsessed by a single idea: "I've got to conquer the world!"; the cat who was always with me when I was painting. The black triangle in the window represents the Eiffel Tower. I was trying to capture the magic side of things. For instance, the cauliflower has a secret life and that interested me more than its physical appearance.

Painting on Ingres Paper (1931)

This is the way I painted when I was obsessed with "assassinating painting."[2] There was a whole kind of decrepit art, an old concept of painting that I wanted to tear up by the roots so that a new, purer, more genuine one could be born. So this was a positive "crime." I was fully aware that although I was not creating a new kind of painting, I was at least clearing the ground so that sooner or later it could sprout forth. It required a complete purity of spirit. Work from this period, like this *Painting*, was done without any preliminary sketching. I took the sheet of paper, wet my brush and unconsciously drew a motif in black. I did exactly what Matisse said to do and more profoundly than the Surrealists did: I let myself be guided by my hand. I put in the color later. It was very important in these paintings because the black lines were very strong and left large white spaces; I would then put in spots of color, using oil paint to make the color as rich as possible and, particularly, to create an atmosphere. Because the subjects of the paintings weren't clear enough, I would almost always give them realistic titles that came to mind while I was working on the canvas and its composition led me to depict a man or woman. I never did it the other way around—that is to say, adjusting the painting to the title.

Dutch Interior I (1928)

I went to Holland for two weeks in order to visit the museums. When I got there I became interested in the beauty of the countryside as well; it was the season when the flowers were at their most splendid. I was tremendously interested in Vermeer and the seventeenth-century Dutch masters. I bought a lot of postcards featuring reproductions of their most typical and most famous paintings. When I got back to Paris, I decided to copy some of them in my own style and I did it the same way I did *The Farm*—with the model in front of me. In other words, I had the postcard pinned up on my easel while I painted this *Dutch Interior*. I had no intention of making fun of Sorgh's realistic concept. What happened is that the result reflects the tragicomic mixture of my character. There was nothing preconceived about this canvas; this is simply the way it turned out. I admit that perhaps I didn't succeed in doing everything I was trying to do at that time, but I am satisfied with this stage of my work.

Man and Woman in Front of a Pile of Excrement (1936)

I had that unconscious feeling of impending disaster. Like before it rains; a heavy feeling in the head, aching bones, and asphyxiating dampness. It was a physical rather than a moral sensation. I had a feeling a catastrophe was about to happen, but I didn't know what: it was the Spanish civil war and the World War. I tried to depict this sensation of tragedy that gripped me deep inside. You are right in suggesting that there is a certain relationship, a similarity between the paintings of this period and the *Still Life with Old Shoe*. I hadn't realized that! The drawing alone didn't create a dramatic enough atmosphere: I got the maximum feeling of aggressiveness through my use of color. Why did I give it that title? At the time I was obsessed by Rembrandt's words: "I find rubies and emeralds in a dungheap."

Aidez l'Espagne (1937)

If I'm not mistaken, it was Zervos who asked me to paint something that could be reproduced as a stamp. This was shortly before we did the republican pavilion at the World's Fair in Paris. The stamp cost one

franc. This same painting was used to print a limited edition poster where the figure was enlarged and the following text appeared: "In the current struggle I see the antiquated forces of fascism on one side and, on the other, those of the people, whose immense creative resources will give Spain a drive that will amaze the world." I painted the figure of a Catalan peasant wearing a barretina because it's a human being I know very well and because he is a person who stems from the earth. This was more genuine than the figure of an intellectual would have been. I wanted it to have great visual impact. That was the important thing. If I managed to get that, then it would have intellectual impact as well. Did I realize what I was doing when I took this stance? Of course I did. I was standing up against everything I considered antiquated and vesting my hopes in something that seemed to me more human, more genuine. After painting this, I was really afraid. When the bombings began and the Nazis invaded France, I had to get out. In Perpignan I was lucky enough to run into a Spanish consul who was anti-Franco. He gave me a passport right away. In Figueras I caught the train to Barcelona. I was shaking with fear when the police checked to see if my name was on the blacklist. A friend came to pick me up before the train reached its destination and he suggested that I hide in Majorca. Everyone there was fed up with the dictatorship, so everything was all right.

Still Life with Old Shoe (1937)

I was very depressed and disconcerted. Let me tell you about the starting point for this still life. I was living in Paris, in the Hôtel Récamier on the place Saint Sulpice. It was very close to the rue des Grands Augustins where I used to eat in a bistro called La Grenouille. As I was leaving the bistro one day, I found a broken bottle wrapped in paper on the ground. I said to myself, "I'm going to paint a still life with this." I was very likely thinking about van Gogh's *Still Life with Boots* when I put in the old shoe. I asked my wife to go and buy me an apple. I stuck the fork in it. When I did it, I wasn't thinking about the soldier sticking his bayonet into the enemy's body. I put in the fork because it was a utensil for eating the apple. I didn't intend the crust of bread to be a symbol of hunger.

The civil war was all bombings, deaths, firing squads, and I wanted to depict this very dramatic and sad time. I must confess that I wasn't aware that I was painting my Guernica. This comparison was

made much later. What I do remember is that I was fully aware that I was painting something tremendously serious. The color is certainly what helps give it a penetrating strength; it's what hits the eye most directly. The composition is realistic because I was paralyzed by the general feeling of terror and was almost unable to paint at all. That was why I was doing studies from life at the Academy of the Grande Chaumière. It was precisely then that I did my *Self-portrait* in a meticulously figurative manner.

Ceramic Wall for Harvard University; Fragment (1960)

I have looked for other media of expression besides painting: ceramics, sculpture, tapestries, mosaics, prints. I always wanted to do stained glass. I finally managed to do some. The pianist Cziffra bought the royal Chapel in Senlis, France, which was being used as a garage. It is a superb gothic church. He had it restored and turned it into a major cultural center. Cziffra asked me to do eight stained-glass windows. I am very pleased that I was able to do this. Doing work for public places is one of my passions. The first mural I did was commissioned by an American university. I was fascinated by the idea because it would put me in touch with those students who would pass the mural every day, and maybe one day one of them, who would have been influenced by my work, would become president of the United States. I have always been interested in working in media other than paint, but I was afraid I wouldn't be able to acquire enough training and experience to be able to express myself properly. That was not the case. I have managed to concentrate and express exactly what I wanted to express in every medium.

The Beautiful Bird Revealing the Unknown to a Pair of Lovers (1941)

I painted the Constellations series in Varengeville, Palma, Barcelona, Montroig, and again in Barcelona where I finished it. I was very pessimistic. I felt that everything was lost. After the Nazi invasion of France and Franco's victory, I was sure they wouldn't let me go on painting, that I would only be able to go to the beach and draw in the sand or draw figures with the smoke from my cigarette. When I was

painting the Constellations I had the genuine feeling that I was working in secret, but it was a liberation for me in that I ceased thinking about the tragedy all around me. While I was working, my suffering stopped, but the small format made my work difficult. First I drew it in charcoal. It wasn't an easy thing to do, so when I was finished I gave myself a reward: I went out and had a coffee and a pastry; it was a big reward because I didn't have a cent. You're right, discovering the ground was the point of departure that suggested all the rest. It happened like this. In Paris I had bought a pad for cleaning my brushes. The first time I used it, I was amazed at the results. After that, whenever I finished one of the Constellations, I would clean my brushes on a clean sheet of paper, which provided a ground for the next one. In Paris I met the cultural attaché of the Brazilian embassy. He sent the 23 Constellations to my New York dealer, Pierre Matisse, in the diplomatic pouch. The exhibition had a tremendous impact. It aroused a great deal of interest and enthusiasm because it was the first exhibition of European art since the war had started. I gave the paintings very poetic titles because that was the line I had chosen to take and because the only thing left for me in the world then was poetry.

Catalan Peasant in the Moonlight (1968)

Don't look for any meaning beyond what it represents: a peasant. I have painted a lot of them. There is nothing odd about that. For me the image of a peasant is something tremendously strong. These are people I know very well because I have lived close to them all my life. I painted the moon because it is a very important and poetic motif in my world of images. Despite what you might think, it is not incongruous for the peasant to be working in the moonlight. Certain things are, in fact, planted at night and at a particular phase of the moon. Obviously the title also has a profound poetic meaning as well, where the idea of something as coarse and rough as a peasant contrasts with the subtle, poetic moonlight. This canvas is not so much an homage to Catalonia as it is to the peasants of that soil who are a symbol of my country. Yes, it is an expression of the loyalty I have always felt toward my country.

51

Interview. *El païs semanal*
(Santiago Amón), 1978[1]

The following interview was conducted on the
occasion of Miró's first museum retrospective in
Spain, an exhibition that he had waited for virtually
all his life. Over a sixty-year period, Miró had
exhibited only four times in Spain: in 1918, 1949,
1968, and 1972. Under Franco, the artist had been
unwilling to exhibit there in any official capacity.
Thus, his exhibition at the Museo Español de Arte
Contemporáneo in Madrid, three years after Franco's
death, was an extremely moving experience, a kind of
homecoming for the artist at the age of eighty-five.
Indeed, the exhibition meant so much to Miró that
he wrote personal letters in order to secure the loans
from museums and collectors, who were hesitant to
lend pictures because of uncertainties about Spain's
political stability.

"THREE HOURS WITH JOAN MIRÓ," BY SANTIAGO AMÓN. IN *EL PAÍS SEMANAL* (MADRID), JUNE 18, 1978

"This boy's going to go places," Joan Miró says, smiling ironically to himself as he gazes unblinkingly at his early works. . . . Barely taking a breath, he continues in a rush. "Those were really hard times! Some of these paintings are from my first show in Barcelona at the beginning of 1918. It was at the Dalmau Gallery (Dalmau was an incredible type, mad, brilliant, farsighted, an adventurer!) and it was a complete failure, but there was one thing it definitely taught me: how tremendously provocative, how irritating something as apparently harmless as painting can be! Way back at the time of the show in Barcelona, some people were so furious they actually destroyed some of my canvases. Ever since then I've put my money on aggressiveness. . . .

"This show is a good summing up of my life and a well-chosen selection of my work. I'm moved at coming upon *my children*, even the *most rebellious* of them suddenly like this, and I'm glad that it's here in Madrid after so many years of absence, such a feeling of hopelessness. I know that I am somehow helping open the doors of the new Spain to the rest of the world, and I know that because of the voluminous correspondence I've been having with well-known people on the international cultural scene ever since preparations for this exhibition first started." . . .

Miró stops in front of *Still Life with Rabbit* (1920), proudly crowned with a rooster.

"That rooster was torture. There was absolutely no way to keep him quiet. Finally, he just fell into place and there he is. That wasn't the case with this other painting [*The Farmer's Wife*, 1922–23]. The model was so impatient that I lost my holy temper and had to finish it from memory."

"A memory of the Romanesque? Both the dress and the face of *The Farmer's Wife* are reminiscent of the altar paintings of Tahull. Are you influenced by Catalan Romanesque art?"

"Definitely. Before I was even ten years old I was going by myself on Sunday mornings to the Museum of Romanesque Art in Montjuïc Park.[2] I'm certain that *The Farmer's Wife* and many other of my paintings are, as you say, reminiscent of all that." . . .

I tell Miró how certain museums have announced that they have exclusive rights of reproduction and absolutely prohibit photographs being taken of any of the paintings they've lent. He smiles and says:

"Well, we're going to break the rules. I think that I've still got some rights to these paintings. They're my intellectual or artistic property or whatever you call it. . . .

"Prohibitions, rights and stock certificates! There comes a time when art takes a back seat. All they can see are the dollar signs. If people only knew that I painted all these canvases when I was half starving to death!" . . .

"How is it that in the 65 × 100 cm of *The Hunter* there are over fifty figures and more than sixty in the 66 × 93 cm of *Dutch Interior*?"

"The size depends on the size of the concept. I was telling complicated stories about nature, about life, and I had to set the stage with a multitude of characters and situations, people, animals, and things."

In the thirties, Miró opened his work to calligraphy,[3] harmonies, Miró-style eurythmics. The paintings became considerably larger and sonorous, space filled with clearly euphonious words (*étoile*, *femme*, *flamme*, *hirondelle*, *sein*, *fleur*, *soleil*, *caresse*, *matinale*, *étincelle*), generally in French.

"Why French?"

"All we painters who were living in Paris used to write in French—and quite naturally so. Furthermore, French is a language that's rich in poetic sounds. These paintings are fields of sound, fields of calligraphic and musical rhythms. They were conceived and painted as poems." . . .

Miró moves closer to the poster he designed for the Spanish pavilion (the celebrated and powerful cry: *Aidez l'Espagne!*) at the 1937 World's Fair in Paris. He puts on his spectacles and reads, thoroughly absorbed, utterly attentive, the text that he scrawled by hand beneath the dramatic figure with the raised fist: "In the current struggle I see the antiquated forces of fascism on one side, and, on the other those of the people, whose immense creative resources will give Spain a drive that will amaze the world." He makes an affirmative motion, a gesture of approval, and says, "This text of mine is a prophecy. It may or may not sound immodest, but I'm convinced I have a certain talent for prophecy just as this text proves and as you can deduce from several other works in this show. We have just awakened from a long nightmare and we have to believe in our own resources, which are capable, very capable, of amazing the rest of the world."

Highly typical of Miró's work in the forties is the series entitled the Constellations.

"What made you go back to the smaller format? A matter of economy? Intimacy?"

"Economy and intimacy, not to mention secrecy. I came back to Spain in 1940 and I didn't have a thing. I lived—and this is the truth— off my mother's generosity. I kept strictly anonymous and lived in constant fear that everything was going to collapse around me. I painted the Constellations (these very same ones we're looking at now) under the impression that I was doing something furtive. I had the feeling they were going to forbid me to paint, that they were going to destroy my brushes the way the Nazis did to Nolde[4] and that I would have to content myself with drawing in the sand or with the smoke from my cigarette. Five years later the Constellations were shown in New York and they were a great success."

"Did you know that the success of that show coincided exactly with Hitler's suicide and Mussolini's execution?"

"I told you there's something prophetic in all my work, including my exhibits. For instance, when I had my last show in Céret in France [1977], I sent an invitation to Tarradellas who was still in exile. Well, the very day the show opened the Spanish government granted him de facto recognition as president of the Generalitat (the Catalan regional government). That very day our president crossed the border for the first time, officially summoned by the authorities in Madrid."

Between the end of the forties and the beginning of the fifties Miró started limiting his palette to the unencumbered, heightened effusion of the primary colors.

"The simpler the alphabet," the painter explains, "the easier it is to read."

At the same time his canvases got bigger again and even their titles became longer. Miró's poetic universe began to require extensive poetic-literary titles, like the one that appears beneath a painting dated 1951: *Dragonfly with Red-tipped Wings in Pursuit of a Snake Spiraling toward a Comet-Star*.

"That business about *magnetic fields*[5] is pretty good. That painting of the *Dragonfly* . . . it breathes, it lives, it flies. Furthermore, I believe it has emotion and silence." . . .

Even the most distracted visitor cannot fail to be surprised by the contrast between the poetic title (*Woman Surrounded by a Flight of Birds in the Night*) and the rough material (a waxed, tar-stained tarpaulin filled with knots and patches and across which a huge black graphic symbol flies) of one of the last works of the sixties. Even the painter himself appears surprised by it, but for other reasons.

"You can't imagine all the symbolism that's been attributed to this work. And, the truth is, it's one of those tarpaulins they use in Catalonia for carting grapes during the harvest. A farmer gave it to me, figuring it was useless, and all I did was add this nocturnal graphic symbol and the multicolored patches like stars in the night, and emphasize the passage of time and the passage of tones, the work, the sweat that this old tarpaulin has absorbed and endured in its lifetime. An image, perhaps, of life, with traces of life itself."

The transition from the sixties to the seventies is exemplified by the dates themselves (1968–73) of a painting that is a ferocious contrast: bold strokes, tenacious black slashes dripping dramatically against a muted background that, once again, uses the colors of the rainbow.

"What's the meaning of such a deliberate, abrupt contrast?"

"I think that's it all explained by the title of the work and the years in which it was painted: *May 1968.* Drama and expectation in equal parts: what was and what remained of that unforgettable young people's revolt, which was so characteristic of our times."

"Did you burn those canvases as a sort of vanguard experiment?"

"As a sort of personal satisfaction or a disenchantment, depending on how you look at it. Although perhaps the real reason is what I have said on other occasions: the joy of being able to say *merde!* to people who only see art for its commercial value, the people who think these paintings are worth real fortunes and go around telling everyone so."

"Still, there are people who feel that the very fact of exhibiting them makes them valuable. You've already shown them in the retrospective at the Grand Palais in Paris and you're showing them again here now. Why?"

"Because they are a testimonial of my life and my activity and no less valid than other paintings that critics consider to be *masterpieces.*"

The overwhelming *Triptych to the Hope of a Condemned Man* (1974) occupies three walls of a separate room. The walls are severely hung with black. . . . Joan Miró contemplates the triple scene, absorbed. After a moment he appears to come back to the present and says approvingly:

"They've hung it really well with that black backdrop, austere, liturgical. This triptych creates a religious space, a place for meditating, for being alone and silent. It's a chapel in both senses of the word."[6]

"Does it also contain a prophecy?"

"Just a little while ago I told you that it did: a terrible prophecy. I finished it, quite unaware, the very day they garroted that poor Catalan nationalist boy, Salvador Puig Antich [1974]."

The earliest and the latest works are the ones to which Miró pays most attention. He gazes at them silently, moving back and forth before them like an automaton. His wife, Pilar, tells him again and again to sit down. The painter grumbles: "Damn it, let me see them standing up. I painted these paintings in a frenzy, with real violence so that people will know that I'm alive, that I'm breathing, that I still have a few more places to go. I'm heading in new directions."

I comment that the most recent canvas, painted just one week before the show opened, is, in fact, very different from all the others. Miró nods his agreement, as though flattered at receiving a compliment that is no more than the strictest truth.

"You still haven't heard the last of me!"

Interview. *L'express*
(René Bernard), 1978[1]

In this interview, Miró discussed *Mori el Merma*,
which was the first complete theater piece in which
he not only designed the costumes and the sets but
contributed to the writing of the scenario.[2] Although
in the 1920s and 1930s Miró had worked for the
Ballets Russes (*Romeo et Juliette*) and for Massine (*Jeux
d'enfants*), this was the first time that he actually
worked with the director and the actors and
participated in the stage direction.

 Mori el Merma was obviously inspired by Miró's
admiration for Jarry's *Ubu roi*. This is reflected in the
use of man-sized puppets (*Ubu roi* was first staged for
marionettes), and the brutal, aggressive, provocative
aspects of the piece. The play was produced by the
theater group La Claca, under the direction of Joan
Baixas. This troupe, one of the most remarkable in
Spain in the 1970s, played only in the Catalan
language. It was prohibited from performing in Spain
under Franco, and many of its members lived in
exile. Bringing them back to their native Catalonia in
a play that was a blatant parody of bourgeois values
and that included veiled but precise references to the
Franco era obviously meant a great deal to Miró.

"Miró to *L'express:* Violence
Liberates," by René Bernard. In
L'express (Paris),
September 4–10, 1978

RENÉ BERNARD: *Mori el Merma* is your first true theater piece. After the performances in Berlin, Rome, and Belgrade this summer, it is clearly an international success. You must be overwhelmed.

JOAN MIRÓ: Overwhelmed, what does that mean? Very proud, yes. After Picasso's death, it was up to me to carry on for Spain.

R.B.: For Spain?

MIRÓ: Picasso and I were always opposed to Francoism. But working as I did, unknown and in the margins, I opened some doors.

R.B.: The evening of the triumph of *Mori el Merma* in Barcelona, one had the impression that you had become the symbol of Catalonia.

MIRÓ: I am a Catalonian. I have always liked to have my feet on that soil. If Catalonia has become what it is today, I think I have played some part in it.

R.B.: And yet you have never engaged in any direct action.

MIRÓ: Don't you think that the revolution of forms can be liberating? Unsettling people, forcing them to wake up.

R.B.: You went to the first performances of *Mori el Merma*, and after that I don't think you went back. What did you think of the premiere?

MIRÓ: That it was good, very good. But it could have gone even further. I said to the actors: "You should look for a greater force. The performance can become purer and more aggressive."

R.B.: What interested you the most? The puppets, the sets, or the acting?

MIRÓ: I wasn't the director. And the puppets weren't real puppets because there were actors inside them. But these figures were very exciting to me. They are part of the carnival tradition, the parades with giant puppets. You can make a puppet say everything, with a brusque mobility that can dispense with words and explanations.

R.B.: While working on this project, the idea of "Ubu" was gradually left behind . . .

MIRÓ: You no longer think about it, because bit by bit things become a part of you. But the spiral, which is a frequently used sign in my painting, is the spiral on Ubu's belly. And I drew *Ubu in the Balearic Islands*[3] against all those Ubus who sprawl out on the beaches in August.

R.B.: It must happen sometimes, however, that Ubus buy your paintings . . .

MIRÓ: I'm not responsible for what happens to my paintings! When a work is finished, it has to take care of itself. But I don't work for those gentlemen in business suits who buy paintings as financial investments. On the other hand, I was in Madrid for the opening of my exhibition at the Museum of Contemporary Art [May 1978]. Hundreds of young people from all over surrounded and applauded me. That was a pleasure. An intense pleasure. A reward.

R.B.: Does the enthusiasm of the public surprise you?

MIRÓ: In Spain and often in other countries I am known through the postcards that are sold in museums. With *Merma*, everyone saw that I am a living painter.

R.B.: Did you want *Mori el Merma* to be challenge? A fable?

MIRÓ: I didn't want it to be anything at all. When we began tinkering on the puppets with Baixas and the theater group la Claca, I said to them: "Let's work, we'll think later." To have intentions in advance, a project, a message—no, never! You must begin by plunging in. If not, it's death. You can think—but afterwards, after it's finished.

R.B.: One form give birth to another . . .

MIRÓ: It flows like water.

R.B.: Putting its success aside for a moment, has the show taught you something as a painter?

MIRÓ: Of course! It's like having some new capital to work with. I'm like a Catalonian peasant. I keep everything I am given. I put it in my wallet, and then one day I find it all there with interest.

R.B.: The audience laughs, and sometimes it gives the impression of having been hit in the face.

MIRÓ: So much the better! You should hit hard. Violence is liberating.

R.B.: Juan Carlos has decorated you with the Order of Isabel la Católica.

MIRÓ: Yes, fine, the king is my neighbor in Palma. But what interests me now is that people are talking about the return of "Guernica" to Madrid. This is an important sign of change, of liberation, of reconciliation. I hope I don't die before it happens. Because if Spain retrieves "Guernica," I will be able to say that Spain owes it to me.

Notes

Introduction

1. See Text 21, pp. 150–51.
2. See Text 2, p. 54.
3. It is important to note that Dalmau was the first to use the term *Cubist* in the title of an exhibition (in 1912).
4. See Text 9 for the fullest account of this period.
5. Information provided by David Sylvester, London.
6. For example, *Still Life with Old Shoe*, *Self-portrait*, and *The Reaper* for the 1937 Paris World's Fair (now lost); also the drawings of nudes done at the Académie de la Grande Chaumière in 1936–37.
7. At the Galería Vandrès, Madrid.
8. In a letter of May 14, 1867, to Cazalis. In Robert Greer Cohn, *Mallarmé's "Un coup de dès": An Exegesis*. Yale French Studies Publication (New Haven: Yale University Press, 1949), p. 126.
9. Quoted in Roland Penrose, *Miró* (London: Thames & Hudson, 1970), p. 194. See also Text 40, p. 253.
10. Unpublished letters to Ricart, December 11, 1914, and June 10, 1915. Courtesy Museu Balaguer, Vilanova i la Geltru.

Part I.

1. [AUTOBIOGRAPHICAL SKETCH] LETTER TO JACQUES DUPIN, 1957.
 1. In French. Courtesy Jacques Dupin. Excerpts are published in Jacques Dupin, *Miró* (New York: Harry N. Abrams, 1960).
 2. To appear in 1960.
 3. Dialect of the island of Majorca.
2. LETTERS TO E. C. RICART AND J. F. RÀFOLS, 1915–19.
 1. In Catalan. Courtesy Biblioteca-Museu Balaguer, Vilanova i la Geltru (letters to Ricart); and Biblioteca de Catalunya, manuscript department (letters to Ràfols).

2. Miró accompanied his mother to Caldetas, a coastal village north of Barcelona, for her convalescence from typhoid fever.
3. December 28.
4. The *Cercle Artístic de Barcelona*, which Miró found superficial and frivolous.
5. Reference to the *Cercle Artístic de Sant Lluc*.
6. The preceding paragraphs express Miró's Catalan nationalist sentiments.
7. In French in the text: "Suffering is the sacrament of life."
8. Reference to Miró's military service. See Chronology 1915.
9. Josep Dalmau, avant-garde art dealer in Barcelona between 1906 and 1930. Albert Gleizes exhibited in November-December 1916, but there is no mention of a "Simultanéiste" or a Marie Laurencin exhibition in the gallery's 1916 program. However, the Delaunays and Laurencin were in Barcelona around that time, and there may have been plans to exhibit their paintings. An exhibition of French art was held in Barcelona in 1917, which apparently made a strong impression on the artistic community. See Chronology.
10. A village near Montroig, where Miró painted that summer.
11. Josep Llorens Artigas, whom Miró knew since 1915. There were workers' demonstrations in Barcelona in August 1917, which fact helps to date this letter.
12. A reference to Italian Futurism, which is evoked throughout this paragraph.
13. In French in the text: "To paint any old thing."
14. Reference to the studio Miró and Ricart shared on the Baja de San Pedro from 1914 to 1919.
15. Although undated, this letter was presumably written on October 1, 1917, since Miró traditionally began his annual military service on that date. The year is confirmed by his references to his forthcoming exhibition at Dalmau, which would take place in February-March 1918.
16. Ramon Sunyer, a jewel smith, painter, and colleague at Sant Lluc, whose portrait Miró painted this same year.
17. See Introduction, pp. 7–8.
18. Reference to Marinetti's Futurist manifesto, "Tuons le clair de lune" ("Let's kill the moonlight") of 1909. Ricart had been in Florence in 1914 where he was in direct contact with the Lacerba group.
19. The "El": the aerial tram system in New York.
20. Translator's note: The *moixiganga* is a traditional Catalan dance performed only by men and said to date from the Middle Ages. It is still performed in certain parts of Catalonia. The *macariana* is probably a festival in honor of the Virgin of the Macarena, patron of Seville.
21. Barcelona's Museo de Arte Moderno, which to Miró's eyes was filled with academic painting.
22. Chrome yellow was a new artist's color, invented around 1913–15; it was brighter, more stable, and considered more modern than earlier yellows.
23. In French in the text: slang term for academic or official artists.
24. Salon de Primavera where the Courbet group exhibited in the Sant Lluc room.
25. Isidre Nonell, Joaquim or Ramon Sunyer (not clear), Robert Delaunay.
26. See Introduction, p. 8.
27. Llorens Artigas who apparently did not exhibit that year.

28. Probably Carlos Vázquez, an academic painter who because of his girth was known as "Kilos."
29. Trini was a model who often posed for Miró. The painting may be identified as *Standing Nude* (Dupin, 55). The format was large for Miró and this was one of his last paintings in a brash colorful style.
30. Note Miró's use of the term *calligraphy*. This letter marks the beginning of Miró's more reflective Montroig style. It also contains the first indications of Miró's custom (continued throughout his lifetime) of working on several canvases at one time. Dupin catalogs three landscapes for the summer of 1918: *Vegetable Garden with Donkey*, *The Trail*, and *The Tileworks at Montroig*.
31. In French in the text: "to impress."
32. Apa: Feliu Elias, a critic, painter, and political cartoonist.
33. Impressionist and Cubist dealers in Paris.
34. Joaquim Sunyer, twenty years Miró's elder and a Noucentiste painter, had worked in Paris and Banyuls where he had known Matisse.
35. This projected excursion to Madrid never took place for Miró who would not visit the Spanish capital until 1928.
36. Reference is unclear. Either the dealer Dalmau or the dealer Per Manyac who also took an interest in Miró.
37. The painter Francesc Domingo, member of the Courbet group.
38. *Wheat Threshing* (Dupin, 58), actually an oil painting.
39. See p. 54 and n. 30.
40. Madrid.
41. Miró's *Landscape, Coll* (Dupin, 32), exhibited at Dalmau's in 1918, as no. 45.
42. First reference to Miró and Ricart's projected trip to Paris.
43. See n. 32.
44. *La Lliga regionalista*: conservative Catalan nationalist party, which controlled Barcelona cultural life and to which Miró was in opposition.
45. See n. 38.
46. Miró's first reference to Japanese prints, which he knew from Barcelona; by "primitives" he was probably referring to Catalan Romanesque painting, whose influence he will evoke throughout his career.
47. Miró was introduced to music by his professor Galí.
48. This description of Miró's life in the country suggests that the hunter in *Catalan Landscape (The Hunter)* of 1922–23 may be a depiction of himself.
49. See n. 34.
50. *House with Palm Tree* (Dupin, 59).
51. "Demon vert" (Green Devil) seems to refer to Apa (Feliu Elias) who had a variety of pseudonyms.
52. Lefranc: one of the oldest and best-known manufacturers of artists' colors in Paris.
53. Isidre Nonell: a Barcelona artist whom Miró's and Picasso's generation greatly admired. His dark-toned blue palette may have influenced Picasso's Blue Period.
54. See n. 35.
55. June 29.
56. *The Village of Montroig* (Dupin, 63).
57. *Vines and Olive Trees* (Dupin, 64).

58. J. M. Junoy, a Barcelona poet and critic for *La veu de Catalunya*, the conservative nationalist newspaper. Wrote preface for Miró's 1918 Dalmau exhibition.

59. Picasso and Francesc Domingo.

60. Although Domingo was a member of the Courbet group, Miró seems to have had little respect for his art.

61. Picasso.

62. Walt Whitman's *Leaves of Grass* was translated into Catalan in 1909.

63. The Salon de Primavera.

64. *Self-portrait*, 1919, which would later belong to Picasso. Exhibited at the Salon d'Automne in 1920.

65. *Nude with Mirror* (Dupin, 68).

66. See n. 56, 57.

67. Ibid.

68. J. M. Junoy, consistent with the aesthetic of Noucentisme, preached a return to neoclassical values in the style of Jacques-Louis David (see Introduction, p. 5).

69. Joaquin Torres-García, a Noucentiste painter at that time.

70. Josep de Togores, a Noucentiste painter who became a member of the Courbet group.

71. In French in the text: "Cubism is only the promise of a pure, simple art."

72. Per Manyac, one of Picasso's early dealers.

73. This letter can be dated November 1919, based on Miró's stated age (twenty-six), his evocation of the forthcoming trip to Paris, and his declared intention to return from Montroig to Barcelona on "the 22d." There is correspondence to Ricart sent from Barcelona and dated November 25. The preceding year, 1918, Miró remained in the country until early December.

Part II

3. LETTERS TO J. F. RÀFOLS AND E. C. RICART, 1920–22.

 1. See Text 2, n. 1.

 2. See Text 11.

 3. In Pierre Schneider, *Les dialogues du Louvre* (Paris: Denoël, 1972), p. 117.

 4. Although undated, this is obviously one of Miró's first letters from Paris, written slightly before March 19 since, in closing, he wishes his friend a happy saint's day (St. Joseph: March 19).

 5. Dalmau had promised Miró to organize an exhibition for him in Paris.

 6. Famous Impressionist collection at the Musée du Luxembourg. Today at the Jeu de Paume.

 7. Exhibition of Picasso and Louis Charlot, a fairly academic landscape painter at the Galerie Léonce Rosenberg.

 8. A Barcelona painter who painted in an Impressionist style.

 9. J. M. Junoy, whom Miró admired as a poet, not as a critic (see Text 2, n. 58).

 10. Another reference to the Museo de Arte Moderno of Barcelona, in the Parc de la Ciudella (see Text 2, n. 21).

11. See Text 2, n. 44.
12. See Text 2, n. 70.
13. André Marchand, a painter.
14. Possibly *Still Life with Rabbit* (Dupin, 71); the dimensions are close but not exactly the same.
15. Only four paintings plus *The Farm* (dated 1921–22) are cataloged by Dupin for the year 1921. Presumably *The Farm* is one of the paintings referred to here, since it was begun in the summer of 1921.
16. Based on correspondence, this is *Still Life with Rabbit* of 1920 (Dupin, 71), which Miró referred to simply as *The Table* at that time.
17. Probably *The Farm*.
18. Studio at 45 rue Blomet (see Chronology, 1921). During the first years (until 1924), Miró lived in a hotel and only painted in the studio rented him by Gargallo.
19. The technique suggests that Miró is referring to *Flowers and Butterfly*, dated 1922–23 by Dupin, the sole tempera still life known from this period.
20. Here Miró is definitely referring to *The Farm*.
21. Miró boxed at the Cercle Américain on the boulevard Raspail (predecessor of the present-day Centre Américain, but at a different street number).
22. Once again *The Farm*. Miró's subjective view of the painting's "success" is contradicted in a later interview (see Text 8).

4. LETTER TO ROLAND TUAL, 1922.
 1. In French. Courtesy the Museum of Modern Art, New York. Partially published in English in William Rubin, *Miró in the Collection of The Museum of Modern Art* (New York: Museum of Modern Art, 1973), p. 19. Published in French in Denise Tual, *Le Temps dévoré*, (Paris: Fayard, 1980), pp.105–6, 203.

5. LETTERS TO J. F. RÀFOLS, 1922–23.
 1. In Catalan. Courtesy Biblioteca de Catalunya, Barcelona.
 2. See *Joan Miró: Magnetic Fields* (cat.) (New York: Solomon R. Guggenheim Museum, 1972), pp. 70–75, for an extensive discussion of this painting's iconographical sources.
 3. Beginnings of *The Tilled Field*, *Pastoral*, and *Catalan Landscape (The Hunter)*. There are no cataloged still lifes dated 1923 or 1923–24.
 4. The red Catalan nationalist beret, which will recur frequently in paintings of 1925. This is a precise reference to *Catalan Landscape (The Hunter)*.

6. TWO LETTERS TO MICHEL LEIRIS, 1924.
 1. In French. Courtesy Michel Leiris, Paris.
 2. Unlike the others, the second letter is printed in its entirety, including opening and closing salutations.
 3. Miró's first precise reference to the role of accident, a spot, or stain, or something *given* that would set off his imagination.
 4. See Miró's drawing dated November 3, 1924, called *The Writer* (Dupin, p. 169) which shows a head (perhaps Apollinaire?) juxtaposed to a line of vowels.
 5. See the *Carnets Catalans* (Geneva: Skira, 1976). For years, the existence of these sketchbooks was generally ignored and it was assumed that the paintings of the 1920s emerged without preliminary drawings.
 6. Miró's meaning seems to be that the more you add to a painting, the more you ruin its freshness, and it degenerates.

7. Many works of the period contain one or several of the described motifs but a work corresponding exactly to this image has not been found.

8. Note Miró's interest in De Chirico.

9. See drawing dated October 23, 1924, and thus a week before this letter, for a variation on this image (Dupin, p. 169).

10. The painting "*Oh! un de ces messieurs qui a fait tout ça*," 1925 (Dupin, 109), expresses an exclamation or amazement.

11. Roland Tual.

12. André and Odette Masson, Armand Salacrou, the playwright, Georges Limbour, the author, and Roland Tual.

8. INTERVIEW. *LA PUBLICITAT*. 1928.

1. Published in Catalan in *La publicitat* (Barcelona), July 14, 1928.

2. Here Miró confuses his dates. The *Self-portrait* was painted in 1919, prior to Paris; *The Table* refers to *Still Life with Rabbit* of 1920.

3. *Still Life with Rabbit*, 1920 (Dupin, 71).

4. A double-spouted earthenware jug.

5. Léonce Rosenberg.

6. Expatriate American writer who served as Hemingway's secretary.

7. In fact, *The Farm* belonged first to Shipman and then to Hemingway. It was exhibited as Shipman's property in 1925 at the Galerie Pierre.

8. Known as "the Montroig Landscapes" (Dupin, 179–84).

9. Exhibition organized by Pierre Loeb at the Bernheim Gallery in 1928.

10. The French Communist newspaper. The account of Miró paintings in Russia is undocumented.

11. Although New York's Museum of Modern Art bought several important Miró paintings in the 1930s, there is no record of a purchase from the Bernheim show.

12. Catalan choir group.

13. Three-part household.

14. Feliu Elias. Apa was one of several pen names.

15. Here Miró's opinion has changed from the enthusiasm he showed for Manet upon his arrival in Paris in 1920. See Text 3, p. 71.

16. See Text 2, n. 70.

17. This is an unusual statement in that usually Miró kept his work around for the transition to the next stage. See also Text 26, p. 168.

9. TEXT. TRANSCRIBED BY JACQUES DUPIN. 1977.

1. In French. Courtesy Jacques Dupin.

2. Leiris's essay was published in Spanish in a special Miró issue of *Los cuadernos del norte* (Oviedo) 4, no.18 (March–April 1983): 10–14.

3. Le Bal Nègre: popular dance hall at 33 rue Blomet, frequented mostly by West Indians who came in native dress. The poet Robert Desnos and the Surrealists "discovered" it around 1927–28 and appreciated its picturesque "unspoiled" qualities.

4. The dictator Primo de Rivera came to power in Spain in 1923.

5. Ca. 1923.

6. Official parliamentary publication appearing daily and publishing all official government decisions.

7. See, for example, *The Farmer's Wife*, 1922–23 (Dupin, 77), and *The Carbide Lamp*, 1925 (Dupin, 80).

8. *48*, 1927. (Dupin, 216).
9. Since 1948.
10. Breton and the Surrealists concentrated their activities in the neighborhood of Montmartre and Pigalle, whereas Miró, Masson, and others remained in the Left Bank Montparnasse district, made famous by an earlier generation of artists. Thus they were considered outdated or old-fashioned by their Surrealist colleagues.
11. *Nord-Sud*: monthly literary review published by the poet Pierre Reverdy in 1917–18, which Miró saw first at the Galeries Dalmau in Barcelona.
12. Volontaires: the closest subway station to the rue Blomet.
13. The subway entrances by Hector Guimard, in an extravagant Art Nouveau style.
14. The famous Catalan architect, Antonio Gaudí.
15. This group proposed a more populist approach to art, exemplified by the poet Jacques Prévert.
16. Theater in Montmartre, directed by Charles Dullin.
17. Café in the heart of Montparnasse where various groups of artists met.
18. Reference to the hillock of Montmartre.
19. Now in the collection of the Museum of Modern Art, New York.
20. Of 1924 (Dupin, 87).
21. Elie Lascaux, a naive painter and Kahnweiler's brother-in-law; André Beaudin, a post-Cubist School of Paris painter.
22. The couturier and collector. Doucet would nonetheless purchase paintings from Miró shortly thereafter.
23. Refers to a painting of 1927 (Dupin, 192).
24. The writer Georges Bataille.
25. Galerie Vavin-Raspail. See Chronology, 1925.
26. See Text 23, p. 161.
27. Study Collection, Fundació Joan Miró, Barcelona. Also see Text 6, n. 5.
28. See Text 8, n. 6.
29. Restaurant on the boulevard du Montparnasse.
30. See Text 3, n. 21.

Part III.

10. STATEMENT. *VARIÉTÉS*, 1929.
 1. Published in French in *Variétés* (Brussels), June 1929, Special Issue, p. xi.
11. [AUTOBIOGRAPHICAL SKETCH]. LETTER TO MICHEL LEIRIS, 1929.
 1. In French. Courtesy Michel Leiris, Paris.
 2. Michel Leiris, "Joan Miró," *Documents* (Paris), no. 5 (October 1929): 263–69.
12. TWO LETTERS TO RENÉ GAFFÉ, 1929 AND 1931.
 1. In French. Courtesy Jacques Dupin. Received by Dupin from an anonymous source who apparently purchased the letters at auction. The exact date of the first letter is not clear but appears to be June 1929.
 2. Paris: Eds. de la Montagne, 1930. Edition of 502 copies. 4 lithographs.
13. INTERVIEW. *AHORA*, 1931.
 1. Published in Spanish as "Los artistas españoles en Paris: Juan [*sic*] Miró," in

Ahora (Madrid), January 24, 1931, pp. 16–18. Brief excerpt printed in *Cobalto* (Barcelona), 1949, n.p.

2. See Tériade in *L'intransigeant* (Paris), April 7, 1930, p. 5. Tériade quotes an artist who said "I want to assassinate it [painting]," without citing his name. Miró always maintained that the reference was to him. The phrase has been widely quoted since.

3. See Text 2, p. 52.

4. See Text 23, p. 161.

5. In regard to his first Parisian exhibition at the Galerie La Licorne in 1921, Miró is more positive here than on earlier occasions.

6. Reference to the period of the "Dutch interiors" (1928).

14. LETTERS TO SEBASTIÀ GASCH, 1932.

1. Published in Catalan in Sabastià Gasch, *Joan Miró* (Barcelona: Eds. Alcides, S.A., 1963), pp. 54–56.

2. A mountain area Miró used to visit.

3. In 1917 and 1924, respectively.

4. Note Miró's boxing metaphor. See Text 9, p. 104.

5. The Paris music hall. The piece would not be mounted there but at the Théâtre des Champs-Elysées.

6. Note how Miró's admiration for Cézanne has waned in comparison with his earlier letters, from 1918, for example.

15. STATEMENT. *MINOTAURE*, 1933.

1. Published in French in *Minotaure: Revue artistique et littéraire* (Paris), nos. 3–4 (December 1933): 18.

2. For Picasso's statement, an earlier text was reprinted.

16. LETTERS TO PIERRE MATISSE, 1934–36.

1. In French. Courtesy Pierre Matisse, New York.

2. James Johnson Sweeney. See Text 31.

3. Here Miró is referring to the poetic assemblages of found objects he began to make in 1931, and of which he made several more in 1936–37.

Part IV.

17. LETTERS TO PIERRE MATISSE, 1936.

1. In French. Courtesy Pierre Matisse, New York.

2. Marguerite Duthuit, Matisse's sister.

3. A Catalan dance.

4. This reference is unclear.

5. The reference is to "Fantastic Art, Dada, Surrealism," held at the Museum of Modern Art, New York. See Chronology, 1936. The Gallery of Living Art (The Gallatin Collection in which Miró had paintings) was then at Washington Square, New York.

6. See this text, n. 5.

7. Reference to the Spanish civil war.

8. See Text 18.

18. NOTEBOOK OF POEMS. 1936–39.

1. In French. Courtesy Fundació Joan Miró, Barcelona.

 2. See Text 17, p. 134.

19. POEM. 1937.

 1. In French. Courtesy Fundació Joan Miró, Barcelona.

20. LETTERS TO PIERRE MATISSE, 1937.

 1. In French. Courtesy Pierre Matisse, New York.

 2. See Text 28, n. 28. *50 P.* corresponds to the dimensions 116 × 81 cm.

 3. *Still Life with Old Shoe.*

 4. Newspaper clipping with quotation by Odilon Redon, cut out and pasted on page of letter. Understandably, Miró expressed interest in Redon whom he first discovered in Barcelona.

 5. See Text 21.

 6. Apparently the stamp, representing a Catalan peasant, was commissioned by Tériade. See also Text 50, pp. 292–93.

21. INTERVIEW. *CAHIERS D'ART*, 1937.

 1. Published in French in as "Où allez-vous Miró?" in *Cahiers d'art* (Paris) 11, nos. 8–10 (1936): 261–66. Although dated 1936, the issue came out in May 1937.

 2. Reference to the Spanish civil war, which broke out in July 1936.

 3. "Abstraction-abstraction" is a reference to the Abstraction-Création group, founded in 1932, in response and resistance to Surrealism. The group invited Miró to join them, but he refused.

 4. Reference to the Surrealists.

 5. See Text 4, p. 79.

 6. Georges Huysmans, Symbolist author of *A rebours*, extremely popular with the Surrealists.

 7. Raymond Roussel, whose best known novel was *Impressions d'Afrique* (1910); greatly admired by the Surrealists. Also see Chronology, 1924.

 8. Reference to Antonio Gaudí's Park Güell in Barcelona, where a long sinuous line of benches is encrusted with colorful ceramic shards.

 9. Reference to the Cathedral of the Sagrada Familia, Gaudí's unfinished masterpiece.

 10. The first reference is unclear. The second is presumably to André Masson, who sojourned in Spain between 1934 and 1936 and upon his return prepared sets and costumes for Jean-Louis Barrault's production of *Numance* by Cervantes.

 11. Reference not only to the Spanish war but to the rising threat of fascism. The same issue of *Cahiers d'art* carried an article by Christian Zervos condemning the aesthetic position and regulations of the Third Reich.

22. LETTERS TO PIERRE MATISSE, 1937–38.

 1. In French. Courtesy Pierre Matisse, New York.

 2. Paul Nelson, American expatriate architect.

 3. The Académie de la Grande Chaumière in Montparnasse.

 4. See Text 20, p. 148 and n. 6.

 5. *Self-portrait I*, 1937–38 (Dupin, 489).

 6. See Text 28, n. 28.

 7. Now at the Museum of Modern Art, New York.

 8. Pierre Matisse also handled Balthus's work.

 9. See Chronology, 1938.

 10. See this Text, p. 157.

23. TEXT. *XXE SIÈCLE*, 1938.
 1. Published in French as "Je rêve d'un grand atelier," in *XXe siècle* (Paris) 1, no. 2 (May 1938): 25–28.
 2. In fact it was March 1920, and the Hôtel de Rouen.
 3. Léonce Rosenberg's brother Paul, also a dealer in Paris, handled Picasso's work.
 4. See Text 9, p. 100 and n. 3.
 5. Jacques Viot, a dealer who worked with the Galerie Pierre.
 6. René Magritte never lived at the rue Tourlaque, but he visited the Belgian dealer Camille Goemans regularly there.
24. TEXT. *VERVE*, 1939.
 1. Published in French as "Carnaval d'arlequin," in *Verve* (Paris) 1, no. 4 (January–March 1939): 85.
 2. In *Dictionnaire abrége du surréalisme* (Paris: Galerie Beaux-Arts, 1938), p. 4.
25. STATEMENT. *CAHIERS D'ART*, 1939.
 1. Published in French in *Cahiers d'art* (Paris) 14, nos. 1–4 (April–May, 1939): 73.
26. TWO LETTERS TO PIERRE MATISSE, 1940.
 1. In French. Courtesy Pierre Matisse, New York.
27. POEM-TITLES. 1939–41.
 1. In French.

Part V.

28. WORKING NOTES. 1941–42.
 1. In Catalan. Courtesy Fundació Joan Miró, Barcelona.
 2. Julio González, the Catalan sculptor whom Miró knew personally. Here is Miró's first reference to the casting of natural objects as a basis for his sculpture.
 3. Here Miró stresses the importance of retaining a somewhat awkward hand-crafted style.
 4. Reference to the pavilion of the Spanish Republic at the 1937 Paris World's Fair where Picasso exhibited several sculptures, including *Woman with a Vase*, 1933, in cement.
 5. The famous clay "ciurells," in the form of animal or human figurines, painted white with touches of green and red.
 6. Note that Miró would start casting in bronze in 1944–45.
 7. Picasso. The dates indicate that this is a later entry.
 8. Probably refers to a photographic plate.
 9. Apollinaire's *Le bestiaire* (*The Bestiary*).
 10. Miró's daughter, then eleven years old. (Catalan spelling.)
 11. Village in Majorca.
 12. Archeological Museum, in Montjuïc Park, Barcelona.
 13. Reference unclear. In 1917, Picasso painted a canvas called *The Sausage*, which Miró knew, but this does not seem a logical reference.

14. The potter Llorens Artigas.
15. Reference unclear.
16. The wife of Miró's old friend Joaquim Gomis.
17. Although Miró made many sketches for these paintings, it seems that the large paintings he projected were never executed.
18. This and other references to Braque relate to the period 1939–40, when Miró lived near Braque in Varengeville-sur-Mer.
19. A small hermitage on a rocky precipice near Montroig with a view of the Tarragon countryside.
20. Henri Rousseau, the painter.
21. See Text 20, pp. 146–47.
22. See Text 18.
23. See Text 22, pp. 157–58.
24. Reference to the Constellations. Closely related paintings on canvas were not done; however, paintings of 1944–45 show a somewhat related inspiration. The figure "120", or "100" found in subsequent paragraphs, refers to stretcher sizes. See n. 28 below.
25. The painter Wolfgang Paalen, who exhibited at the Galerie Pierre in the 1930s.
26. Another reference to the Constellations.
27. *L'usage de la parole*, no. 3 (Paris: Apriquo, 1940). A supplement to *Cahiers d'art* edited by Georges Hugnet. Cover by Miró and limited edition of Miró print for 25 deluxe copies.
28. See n. 24. The indication "120 P." (paysage) or "M." (marine) refers to standard commercial stretcher sizes (for example, a 120 P. canvas measures 195 × 114 cm).
29. Brand name of a lead pencil.
30. Painting of 1926 (Dupin, 177).
31. Here Miró speaks of painting *Self-portrait I*, which was originally only a *drawing* on canvas.
32. Here is another precise reference to the method of casting or reproducing natural objects. See n. 2, this Text.
33. Reference unclear.
34. After being Miró's neighbor on the rue Tourlaque in 1927, Jean Arp moved to Meudon outside of Paris where Miró visited.
35. Antonio Gaudí, the Catalan architect.
36. Referred to earlier as the Swimming Club series.
37. These were paintings based on large collages made of scattered newspaper clippings.
38. See Text 32.
29. LETTER TO PIERRE LOEB, 1945.
 1. In French. Courtesy the Musée National d'Art Moderne, Centre Georges Pompidou, Paris.
 2. Miró's mother died in 1944. Loeb lost his father in 1945.
 3. Here Miró suggests that he does not share all Loeb's tastes in painting.
 4. Rebeyrol and Laugier were friends of Marie Cuttoli. Apparently this exhibition never took place.

Part VI.

30. INTERVIEW. *POSSIBILITIES*. 1947.
 1. Published in English as "Interview with Miró," in *Possibilities* (New York), no. 1 (Winter 1947–48): 66–67.
 2. Miró painted this painting in a large studio loaned him by the painter Carl Holty.
 3. Georges Simenon, Belgian author of the popular Inspector Maigret detective series.
 4. Hero of a famous French detective series by Pierre Souvestre and Marcel Alain (ca. 1911). The diabolical exploits of Fantomas, master of the perfect crime, fired the Surrealists' imaginations.
 5. Reference to the influence of Surrealism, which many American artists were undergoing at that time.
 6. Miró's mild swear word, translated incongruously as "nuts," was probably "zut!"

31. INTERVIEW. *PARTISAN REVIEW*. 1948.
 1. Published in English as "Joan Miró: Comment and Interview," in *Partisan Review* (New York) 15, no. 2 (February 1948): 206–12.
 2. As told to this editor. See also *Joan Miró: Magnetic Fields* (New York: Solomon R. Guggenheim Museum, 1972), p. 41.
 3. 1921–22.
 4. See Text 4, p. 79.
 5. 1922–23 (Dupin, 77).
 6. See Text 9, p. 101.
 7. Advertising images from newspapers (a flatiron, a battery, kitchen utensils), cut out, scattered, and glued on sheets of bare paper, suggested the abstract shapes in Miró's paintings of 1933.
 8. See Texts 20 and 36.
 9. The series of Constellations, 1940–41.
 10. Another reference to the Constellations, first shown in New York in 1945. Actually more than ten of these twenty-*three* gouaches were executed in Varengeville before Miró returned to Spain.

32. TWO LETTERS TO GÉRALD CRAMER. 1948–49.
 1. In French. Courtesy of Gérald Cramer, the Collection Gérald Cramer, Genève. The first of these two letters is unpublished. The second was published in *Eluard et ses amis peintres* (cat.) (Paris: Musée National d'Art Moderne, Centre Georges Pompidou, 1982), p. 154.
 2. See letter from Miró to Cramer, May 10, 1948 (unpublished). Collection the Museum of Modern Art, New York.
 3. Reference is to Cramer's publisher's catalog for which Miró had designed the cover.
 4. Miró, his wife, Pilar, and his daughter, Dolores.

33. INTERVIEW. FRENCH NATIONAL RADIO. 1951.
 1. Interview taped in French on January 19, 1951. Published as "Entretien avec Joan Miró," in Georges Charbonnier, *Le monologue du peintre* (Paris: Julliard, 1959). (Reprint. Paris: Eds. Guy Durier, 1980, pp. 129–39.)
 2. Miró's meaning is that he never wanted a practitioner to guess and try to execute what he wanted. No matter how unskilled Miró himself might be

in a given technique, he wanted to manipulate the materials and bring forth forms himself. This was also true of all his graphic work in which he prepared the plates, stones, or woodblocks himself and corrected the imagery as the work progressed.

3. Miró's first small bronze sculptures were exhibited at the Galerie Maeght in Paris in 1950.

4. See n. 2.

5. Once again Miró is referring to the prehistoric cave paintings and Romanesque frescoes he so admired.

6. In 1932 (see Chronology). Also see Text 14.

7. Reference to the Portuguese tradition of ceramic tiles, or *azulejos*.

34. INTERVIEW. *CORREO LITERARIO*. 1951.

1. Published in Spanish as "Miró aconseja a nuestros pintores jovenes," in *Correo literario* (Madrid), March 15, 1951, p. 1.

2. Miró still equated the term *abstract art* with geometric abstraction.

3. We recall that the artist visited Holland in 1928 and painted the series of "Dutch interiors" upon his return to Paris.

4. San Juan de la Cruz and Santa Teresa d'Aquila. These poetic references indicate more spiritual inclinations in contrast with the Surrealist and proto-Surrealist poetry that inspired the artist in the twenties and thirties.

35. POEM-TITLES. 1948–55.

1. In French.

2. Study collection, Fundació Joan Miró, Barcelona

36. LETTER TO JAMES THRALL SOBY, 1953.

1. In French. Courtesy Jacques Dupin.

2. See William Rubin, *Miró in the Collection of The Museum of Modern Art* (New York: Museum of Modern Art, 1973), pp. 72–74, 128, for a lengthy discussion of this painting.

3. Thomas Bouchard was a filmmaker who made two films on Miró: the second, "Around and About Miró," was produced in 1956.

4. *Self-portrait I*, 1937–38. See Text 22, pp. 157–58. Also see Rubin, *Miró*, pp. 76, 129–30.

37. INTERVIEW. *L'OEIL*. 1956.

1. Published in French as "Miró céramiste," in *L'oeil* (Paris), no. 17 (May 1956): 46–51.

2. Gallifa: village in Catalonia where Artigas had his studio and kilns.

3. The mountain range overlooking Barcelona. The name means literally "saw-toothed mountain."

Part VII.

38. STATEMENT. *XXE SIÈCLE*. 1957.

1. Published in French in Pierre Volboudt, "A chacun sa réalité," in *XXe siècle* (Paris), n. 5., no. 9 (June 1957): 24.

39. TEXT. *DERRIÈRE LE MIROIR*. 1958.

1. Published in French as "Ma dernière oeuvre est un mur," in *Derrière le miroir* (Paris), nos. 107–9 (June–July 1958): n.p.

2. Llorens Artigas's son.

3. The Museu d'Art de Catalunya in Montjuïc Park.

40. INTERVIEW. *XXE SIÈCLE.* 1959.

1. Published in French as "Je travaille comme un jardinier . . .," in *XXe siècle* (Paris), no. 1 (February 15, 1959), monthly suppl., pp. 4–6, 15. (Transcribed by Yvon Taillandier.)

41. POEM. 1960. (PERLS GALLERIES, 1961).

1. Published in French in *Alexander Calder–Joan Miró* (cat.) (New York: Perls Galleries, February 21–April 1, 1961).

2. Probably in 1928.

42. INTERVIEW. *L'OEIL.* 1961.

1. Published in French as "Propos de Joan Miró," in *L'oeil* (Paris), nos. 79–80 (July–August 1961): 12–19. (Transcribed by Rosamond Bernier.)

2. Miró left Paris for Varengeville in the spring of 1939. His paintings were stored at Lefebvre-Foinet's (a well-known artists' warehouse) until 1956.

3. Art academy where Miró took life classes several times, first in 1920 upon his arrival in Paris, and later in 1936–37.

4. See Text 22, p. 157–58.

5. Paul Nelson. According to some records (see William Rubin, *Miró in the Collection of The Museum of Modern Art* [New York: Museum of Modern Art, 1973], p. 129, n. 4), it was one of Nelson's draftsmen, "one Fries or Friez," who actually made the enlargement.

6. Now in the collection of the Fundació Joan Miró, Barcelona.

7. Both paintings now dated 1938–60. (Dupin, 893, 891).

8. Dated March 8–June 1, 1960.

9. Dated November 25–December 1, 1960. Here the dates clearly refer to the final finishing touches.

10. *Blue I, II, III,* dated March 4, 1961. Here also, the date indicates the day they were finished.

11. Series of etchings from 1938.

12. See Barbara Rose, "Miró in America" (cat.) (Houston: Museum of Fine Arts, 1982) pp. 5–45, for discussion of the American artists whom Miró influenced. Of course, his influence was strong in Europe as well, particularly in Catalonia.

13. *Album 19,* (Paris: Maeght Editeur, 1961).

43. INTERVIEW. *AUJOURD'HUI: ART ET ARCHITECTURE.* 1962.

1. Published in French as "Miró," by Denys Chevalier in *Aujourd'hui: Art et architecture* (Paris) 7; no. 39 (November 1962): 6–13.

2. In Spanish, *miro* is a form of the verb "to see" (*mirar*).

3. In French slang, *miro* means "blind."

4. The Dalmau Galleries exhibited Persian miniatures in 1913, and Miró was aware of Japanese art at a very early date.

5. See Text 2, p. 54, where Miró refers to his détailliste style as "calligraphy."

6. The "sardine tree" image was first used by Benjamin Péret in his preface to Miró's 1925 exhibition at the Galerie Pierre.

7. Actually, there were twenty-three.

8. Collection the Musée National d'Art Moderne, Centre Georges Pompidou, Paris.

9. The three *Blue* paintings of 1961, each measuring 277 × 350 cm.
44. LETTER TO NINA KANDINSKY, 1966.
 1. Dated January 19, 1966. Published in French as "Ce grand prince de l'esprit," in *XXe siècle* (Paris), special issue "Hommage à Kandinsky" (1966; reprinted 1974): 97–98.
 2. Letter to W. Grohmann, December 2, 1935.
 3. Kandinsky moved to Paris in December 1933, where he took an apartment at 135 boulevard de la Seine (now du Général Koenig) in Neuilly. Miró's reference is to Seurat's *La Grande Jatte* at the Art Institute of Chicago. Miró visited Chicago in 1965.
 4. Kandinsky exhibited at the Galerie Zak in 1929. He exhibited in 1936, 1939, and 1942 at the Galerie Jeanne Bucher, then located at 9ter boulevard du Montparnasse.
45. ARTICLE (EXCERPTS). *LES NOUVELLES LITTÉRAIRES*. 1968.
 1. Published in French as "Au coeur de la joie," by Pierre Bourcier, in *Les nouvelles littéraires* (Paris), August 8, 1968, pp. 8–9.
 2. Now in the collection of the Museum of Modern Art, New York.
46. POEM-TITLES 1967–70
 1. In French.
47. INTERVIEW. UNPUBLISHED. 1970.
 1. Conducted in French, at the Galerie Maeght, Paris, April 20, 1970.
48. INTERVIEW. *XXE SIÈCLE*. 1974.
 1. Published in French as "Miró: Maintenant je travaille par terre . . .," in *XXe siècle* (Paris), no. 43 (1974): 15–19. (Transcribed by Yvon Taillandier.)
 2. Medieval seraphim. See Krauss and Rowell, *Joan Miró: Magnetic Fields* (New York: Solomon R. Guggenheim Museum, 1972), pp. 70–72.
 3. This public commission was never executed.
 4. Jacques Dupin, *Miró* (1960). There is, however, no photograph of Miró painting with his hands.
49. POEM. 1976.
 1. Courtesy Alain Jouffroy.
 2. See Chronology, 1936 and 1966.
50. INTERVIEW. *GACETA ILUSTRADA*. 1978.
 1. Published in Spanish as "Revelaciones de Joan Miró sobre su obra," by Lluis Permanyer, in *Gaceta ilustrada* (Madrid), April 23, 1978, pp. 45–56.
 2. Miró's statement to Tériade, cited in *L' intransigeant*. See Text 13, n. 2.
51. INTERVIEW. *EL PAIS SEMANAL*. 1978.
 1. Published in Spanish as "Tres horas con Joan Miró," by Santiago Amón, in *El Païs Semanal* (Madrid) 2d ser., 3, no. 62 (June 18, 1978): 614–19.
 2. This is a case of lapsed memory, in that the museum cited—the Museu d'Art de Catalunya—did not exist at that time.
 3. By *calligraphy*, the interviewer means the writing of words in script on the canvas.
 4. Emil Nolde, the German Expressionist artist.
 5. Reference to exhibition at the Solomon R. Guggenheim Museum, New York, 1972, by that name?
 6. Translator's note: The expression "to be in the chapel" in Spanish means to be on death row.

52. INTERVIEW. *L'EXPRESS*. 1978.
 1. Published in French as "Miró à *L'express*: La violence libère," in *L'express* (Paris), September 4–10, 1978, pp. 33, 35. (Transcribed by René Bernard.)
 2. See Chronology, 1978.
 3. Prepared in 1953; published in 1976.

Index